CROSS

KELLY KLEIN

With text by Simon Doonan, Father Andrew Greeley, Robert Mapplethorpe,
Patrick McCarthy, Duane Michals, and Bob Morris

Design by Sam Shahid

CALLAWAY

NEW YORK • 2000

PREFACE

I always hope my books contain an element of surprise for the reader, a twist on a supposedly familiar subject. My first book, Pools, was about the architecture and the beauty of water contained in a certain way. Underworld, my second book, was about the shape of the body in various states of undress. Cross is about the shape of the cross, with its minimal, graphic boldness; in its many forms and meanings. All three books primarily celebrate photography and the way that photographers choose to present their subjects. I always select subjects that intrigue me personally. I have not chosen the shape of the cross in order to be confrontational or controversial, or to insult. It is not my intention to offend anyone's beliefs involving this most powerful and beautiful symbol. I chose this subject simply because I love crosses. I have collected them for years, and I have always worn one around my neck. I first noticed the cross in church, as a child. I was raised Episcopalian, and I am a spiritual person. I believe in God. When I was a teenager growing up in New York City, my mother collected Native American artifacts. I became intrigued with the shape of the cross, which I saw in various forms on etchings, blankets, baskets, jewelry, and other decorative objects my mother would bring home. I was astonished to learn that the Indians had adopted the cross shape long before they ever came in contact with the Christian world. The Native Americans of the Southwest use a double-barred cross to represent the dragonfly, which they believe brings the summer rains. In the Sioux tradition, the single-barred cross signifies trees and earth. One fascinating aspect of the collection presented in Cross is the many ways that photographers have treated the cross shape; often very subtly and unexpectedly. Over the three years of researching pictures on this subject, I was amazed both by how many objects form the shape of the cross in some way, and by the number of imaginative observations submitted. While I have always found it compelling that this simple shape is such a powerful sign for so many cultures, religions, and races, it was surprising to discover that the cross has a versatile, even playful, quality, too. We see the cross in so many ordinary places: in the human body, when the arms are outstretched; in the human face, with the eyes forming the horizontal line, and the nose and mouth forming the vertical line; in the shape of an airplane; on street signs; and in countless other ways. But as most of us relate to it today, the cross is the symbol of Christianity and the sign of Christ himself. This was not always the case. The cross is one of the oldest symbols in the world and has a multiplicity of meanings. To the ancient Greeks, it represented the staff of Apollo. The cross as a design element was widely used by cultures as diverse as the Aztecs, pre-Christian Romans, Phoenicians, Hindus, Buddhists, Persians, Assyrians, Babylonians and Native Americans. The swastika is a cross, though we do not usually think of it as such, and it appeared in Norse, Mesopotamian, Buddhist, Mayan, and Hindu art as an emblem of the sun or fire or life, among other things, long before it was adopted by Hitler's regime. Its variety of uses and meanings makes the cross more open to interpretation, perhaps, than any other symbol in the world. Even within Christianity it is paradoxical: an image transformed from an instrument of torture and death into a symbol of hope, life, and love. While ancient and pan-ethnic meanings survive, our contemporary culture has added much to the history of the cross in art and architecture. One example is the church by Japanese architect Tadao Ando shown on page 59. Fashion designers such as Hussein Chalayan and Alexander McQueen have used the cross on clothing and envisioned it in the makeup design of the future. Rock musicians have featured the cross in videos, taking it to a new level of modern chic and youthful trendiness. Because the cross has so many different incarnations, I thought some brief texts about the various ways it is perceived would help provide an entry into the images. I asked people from different creeds and backgrounds to contribute, and they have provided fascinating takes on a symbol that means nothing to some and yet is so powerful in the hearts of so many. There was one very special moment that convinced me that I should do this book. In the course of my research, I came across a photograph by Jeanloup Sieff (page 127) taken in 1965 on the beach of East Hampton, New York. It happens to be an old photograph of my house. In the foreground is a small white cross, painted on one of the large jetty rocks. Those rocks are now covered with sand, so I have never been able to see that particular rock, but it is there, buried 100 yards from where I now sit to write these words. **Kelly Klein**

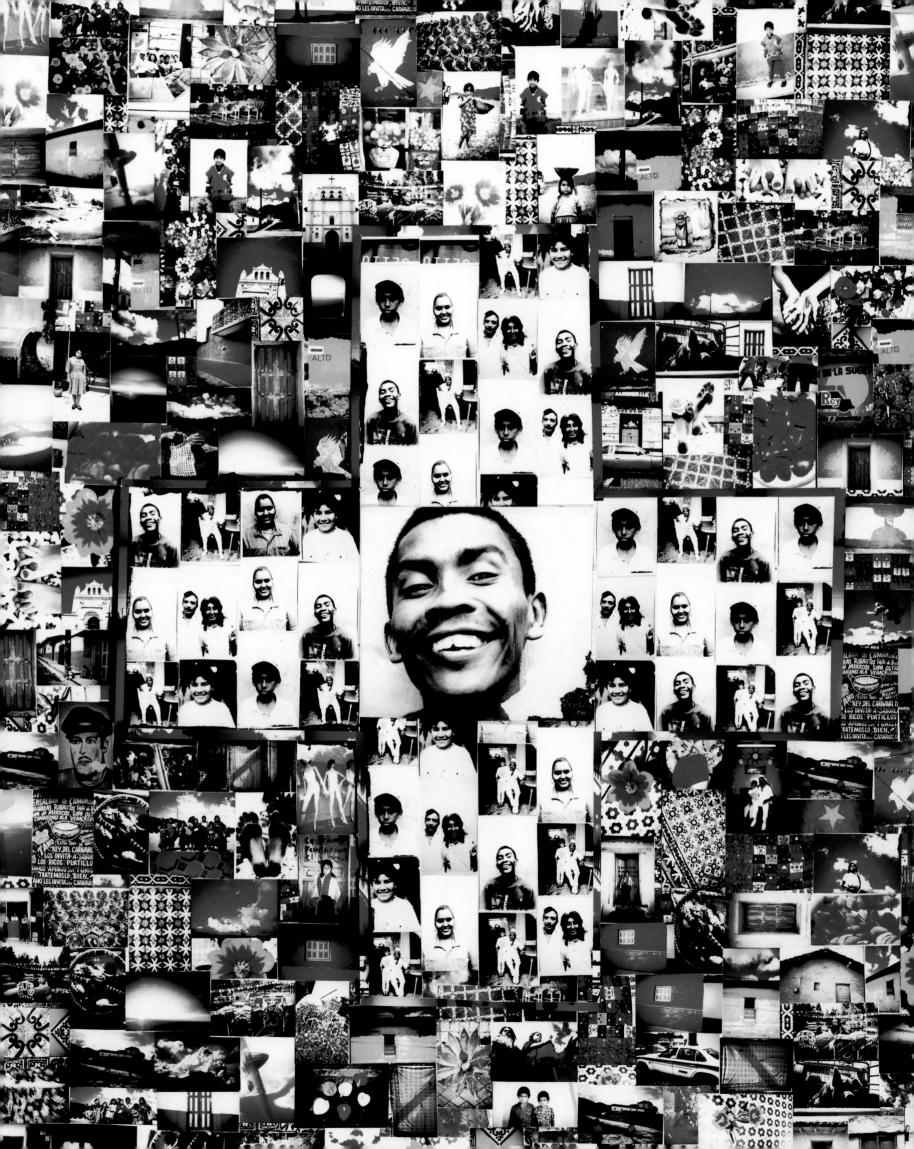

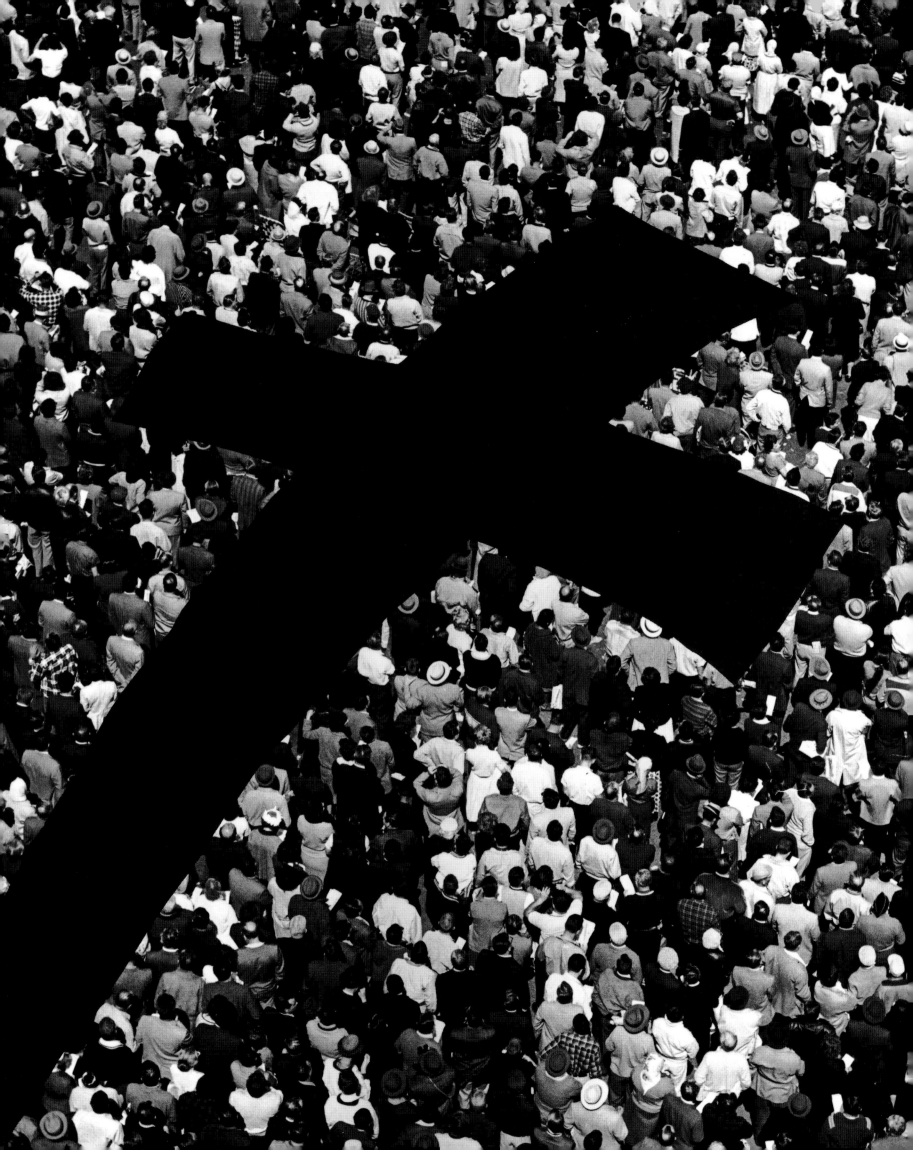

In the tradition of religious metaphors, the cross is the tree of life, uniting heaven and earth; it impregnates the sky to bring down life-giving rains on parched land—the same symbolism of the Teutonic tannenbaum, the Christmas tree. However, in the Christian tradition, the meaning of the cross is profoundly affected and determined by its role as an instrument of hideous death for slaves and criminals. God, who was present in Jesus in some way we do not fully understand, died with Jesus on the cross to show us that when we walk down the lonely road into the valley of death we do not walk alone, no matter how terrible the death is. Jesus walks with us and holds our hand because he's been there before. God joins us in the valley of death. So from a symbol of ignominy it has become a symbol of hope and life and glory. **Father Andrew Greeley, Professor of Social Sciences, The University of Chicago**
I like the form of a cross, I like its proportions. I arrange things in a Catholic way . . . [1] A church has a certain magic and mystery for a child. It still shows in how I arrange things . . . whenever I'd put something together, I'd notice it was symmetrical.[2] **Robert Mapplethorpe** ([1] and [2] see page 224)

I hope that the stylists and fashion designers of the postmodern age will not burn in Hell. I am well acquainted with many of them, and I have distinct reservations about their ability to endure suffering. If they do burn in Hell, it will probably be because they have taken the crucifix and made it into a fashion accessory. The wearing of a visible cross was, in my experience, the prerogative of professional religious devotees or ladies with dubious reputations. Good Catholics wore them discreetly, often concealed under their sweatersets, and extricated them only for specific religious moments. In the punk and goth frenzy of the late seventies, crosses were worn to transmit a confusing, rebellious subtext: "Look at me, I am clearly not religious or conservative, but I choose to wear a cross. Hopefully, this will cause you to regard me as an enigmatic, troubled person." By the 1980s, this fad had filtered down, and the stylists and fashion designers of the postmodern age encouraged middle-class girls to emulate punks and goths. (Think Madonna's "Borderline.") In the early 1990s, ladies wanted to look tarty. A cross, particularly when combined with a black push-up bra, à la Dolce & Gabbana, à la Sophia Loren, à la Guess

Jeans, signifies the sketchy religious commitment of a lady with a dubious reputation. This look is definitely working-class and therefore wildly attractive to stylists and their middle-class clientele. A cross worn with dubious-lady styling suggests, "I, the wearer, regularly do things that make it necessary for me to take out a bit of religious insurance. I, therefore, prominently wear a cross." A cross resting in the cleavage of a young lady, styled to suggest a dubious reputation, is a compelling sight. The stylists and fashion designers of the postmodern age knew only too well that middle-class girls love to toy with the cheeky styles of vulgarians and extremists, and were able to popularize the wearing of a cross as an accessory without too much effort. But what do nuns think of this? The various resonances of the crucifix are exploited by fashion designers, stylists, and fashion followers in a way that must surely make the average nun cringe. Maybe they understand. Maybe forward-thinking nuns even discuss their own crosses as if they were fashion accessories: "Sister Agnes, j'adore the new silver filigree cross you're sporting!" **Simon Doonan, Creative Director, Barneys New York**

Pain and sorrow. Beauty. Terror. Superstition. Even nostalgia. The image of the cross strikes a lot of emotions in me, most of them inconsistent but all of them powerful and unrelenting. Like many people, the first time I remember seeing one was in church. I was three or four, and the whole experience was a bit frightening: the priest, the incense, the solemn faces. The cross struck me with particular horror, however, and the beauty of Christ made the crime of torturing him seem all the worse. I remember being a little bit skeptical when told, "He died for you." But I was still impressed by the pain he must have endured and wondered how even God could still be alive after they put nails through his palms. My second memory of a cross is of the one around the waist of a nun who taught Sunday school. She was a big nun—an enormous nun—and the cross clanked against her shin as she prowled around the classroom waiting for someone to make a mistake. This nun—Sister Marie-Charles, I think she was called—was the single most frightening human being I have ever met, and she has assumed mythic proportions in my head. Even today, when I meet a particularly nasty character, I reassure myself with the thought that at least they're

not as bad as Sister Marie-Charles. My fondest memory of the cross is from the movies. It was near the end of The Adventures of Robin Hood, one of my favorite movies, when Richard the Lionhearted returns to England disguised in a big black cape. Suddenly he and his courtiers decide to make known to Errol Flynn just who they are, and off come the capes to reveal majestic white tunics with giant red crosses down the front. Robin Hood falls to his knees, and tears come to his (and my) eyes: the king is back, and everything is going to be just fine. For the first time, the cross struck me as something good. It was also rather masculine and was finally associated with something I could sink my braced teeth into: knights and armor and the glory of the Crusades. Robbing from the rich to give to the poor only added to the glamour. Time does move on, however, even for adolescents. Church ceased to be scary and became just boring, and I soon abandoned it altogether. Nuns continued (and continue) to terrify me, and so I got away from them—and their clacking jewelry—as fast as my legs would carry me. Twelfth-century England still had its charms, but every

time I read something about Richard the Lionhearted the less I like him: a kinky tyrant with a taste for S & M doesn't deserve a vassal like Robin Hood. Or me. Still, that bright red cross lingers in my mind: proud and pure and downright beautiful. **Patrick McCarthy, Chairman & Editorial Director, W magazine** It is Christmas Eve, and I am looking up from my desk at a small, copper-green cross jutting up into a patch of sky from Saint Veronica's Church on Christopher Street. It is reminding me of growing up in the 1970s as the only Jewish kid in a conservative Catholic suburb, where the countercultural revolution was held firmly at bay and alternatives didn't exist. No nonwhites. No Eastern spirituality. No Woody Allen (who begat Seinfeld) popularizing Jewish kvetchiness. In my hometown, it seemed you were either Catholic or suspect. Everywhere I turned, there were crosses on display: in front of the Catholic high school on the main drag, in front of the church across from the public library, around the necks of popular girls with names like O'Keefe, O'Connor, and LaPenna. There was also the white cross over Good Samaritan Hospital which could be seen from miles away, a constant, towering presence. When my father

was hospitalized there on the first day of Rosh Hashanah, the nuns and priests who visited him were a well-meaning source of discomfort, but not as much as the big crucifix over his bed. Needless to say, I usually waited out Christmas quietly at home. Ah, but New York City—or so I had been hearing ever since I moved here fifteen years ago—is its own world on Christmas—a day for Jews to go to the movies and eat at Chinese restaurants. Instead of partaking, however, I always stayed inside, where the phone would not ring much, and the mail would not come. That has been my own sullen tradition. "On any person who desires such queer prizes," E. B. White once wrote, "New York will bestow the gift of loneliness and the gift of privacy." Indeed, I never felt more alone than on Christmas Day. This year, I decide to go out for a change. On sidewalks still slushy from a recent snow, I walk to a movie theater where the lobby is packed before noon and a line snakes out the door. After the movie, I step outside to find the air percolating with foreign languages. Fashionably-dressed tourists walk past the Nativity scene at Saint Anthony of Padua Church on Houston Street

to look at far less sacred displays in the shop windows of SoHo. The streets are busy, and quite a few stores are open. Muslims, Sikhs, Hindus, Buddhists, pagans, artists, malcontents, leather queens, expatriates, visionaries, punks, waiters, soup-kitchen volunteers, families, couples, singles, a kid in five-inch platform shoes, and several queeny teenagers—all these souls are out on the street, spending the day their own way, like me. It is dusk when I return to my desk, invigorated. Looking up at the cross jutting up into the patch of sky outside my window, I'm not reminded of being the odd man out anymore. I am reminded of the religious tolerance that has made this country a haven from its birth. I'm thinking about how faith should thrive at all costs, and how much crosses mean to the people who need them. I'm also thinking about how miraculously well so many populations get along here in such close proximity. Finally, I'm feeling grateful, as I look at the two lines of that cross intersecting up there against the deep blue beyond, to be able to call my adopted hometown a true cross-section of humanity. Around here, when you say, "God bless us every one," it means something. **Bob Morris, contributor to the New York Times**

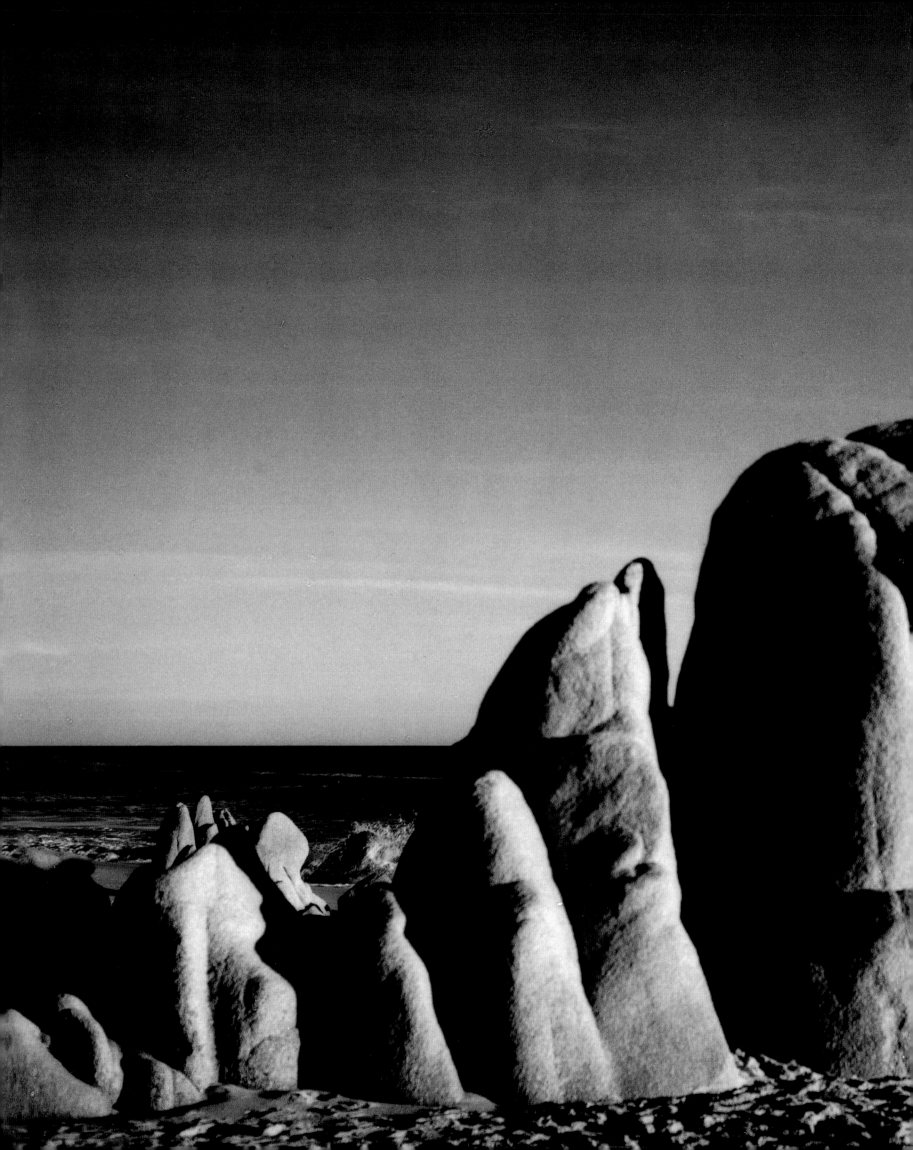

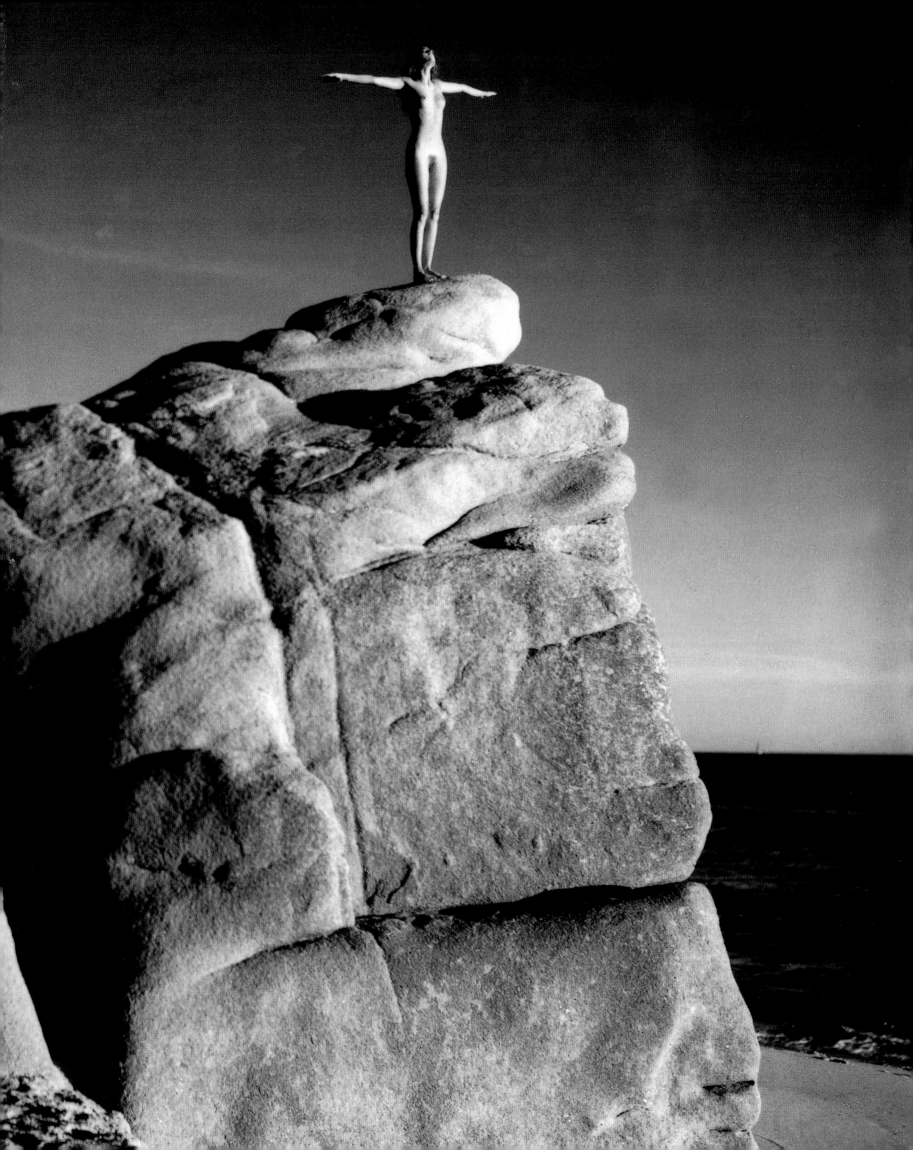

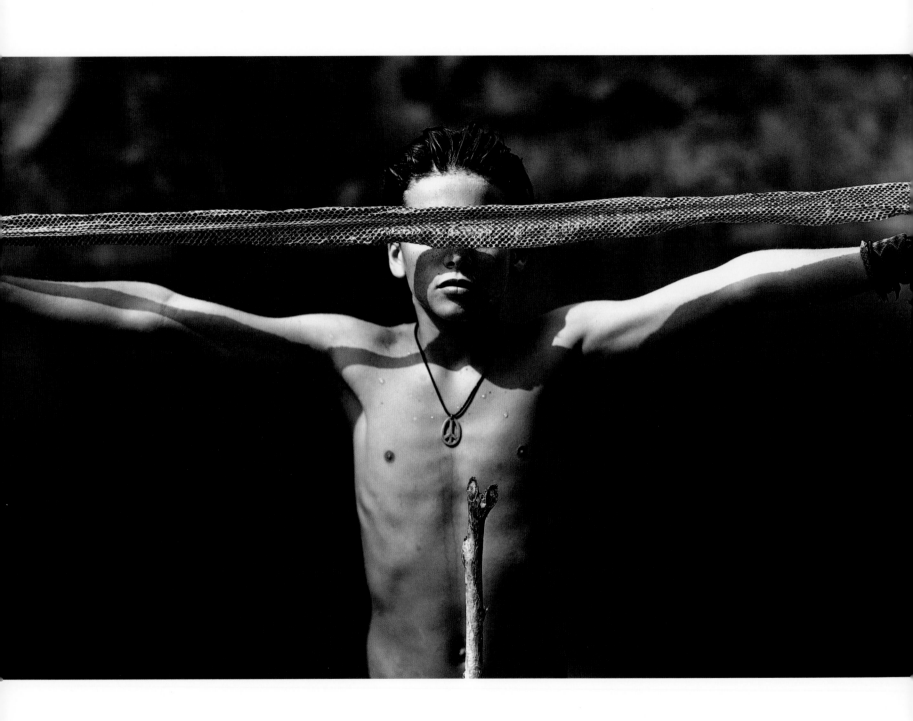

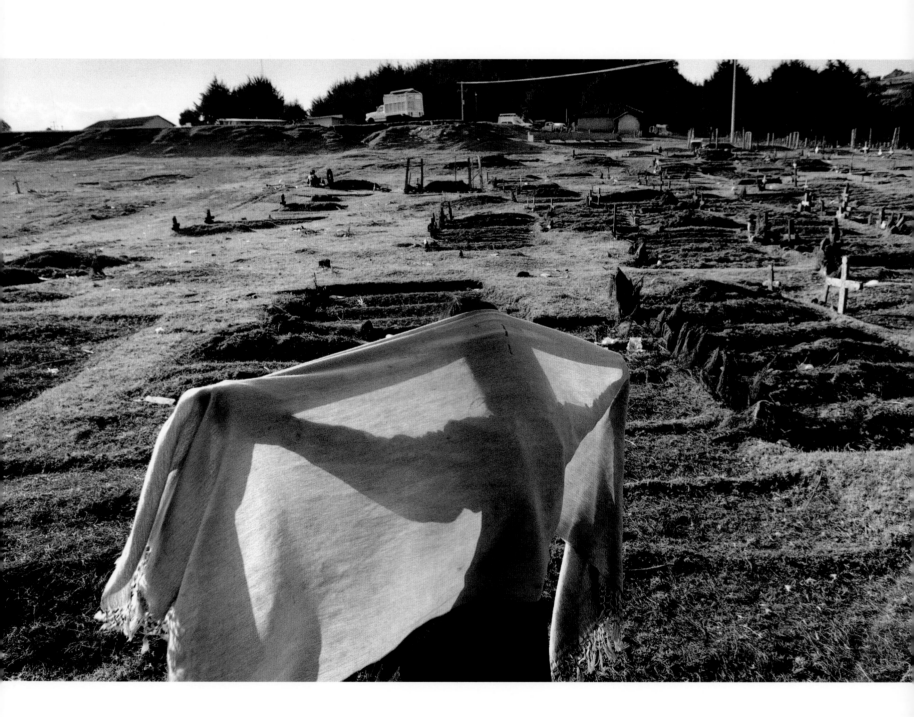

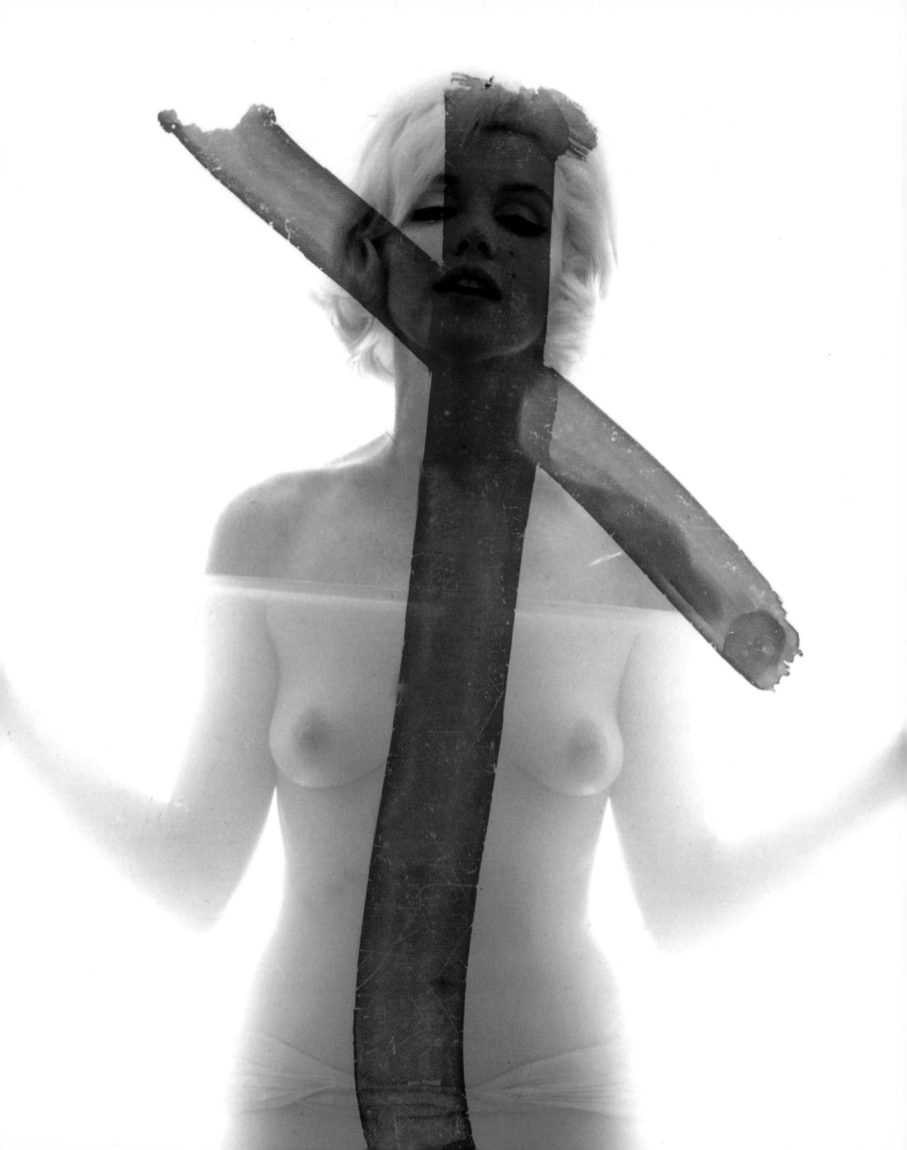

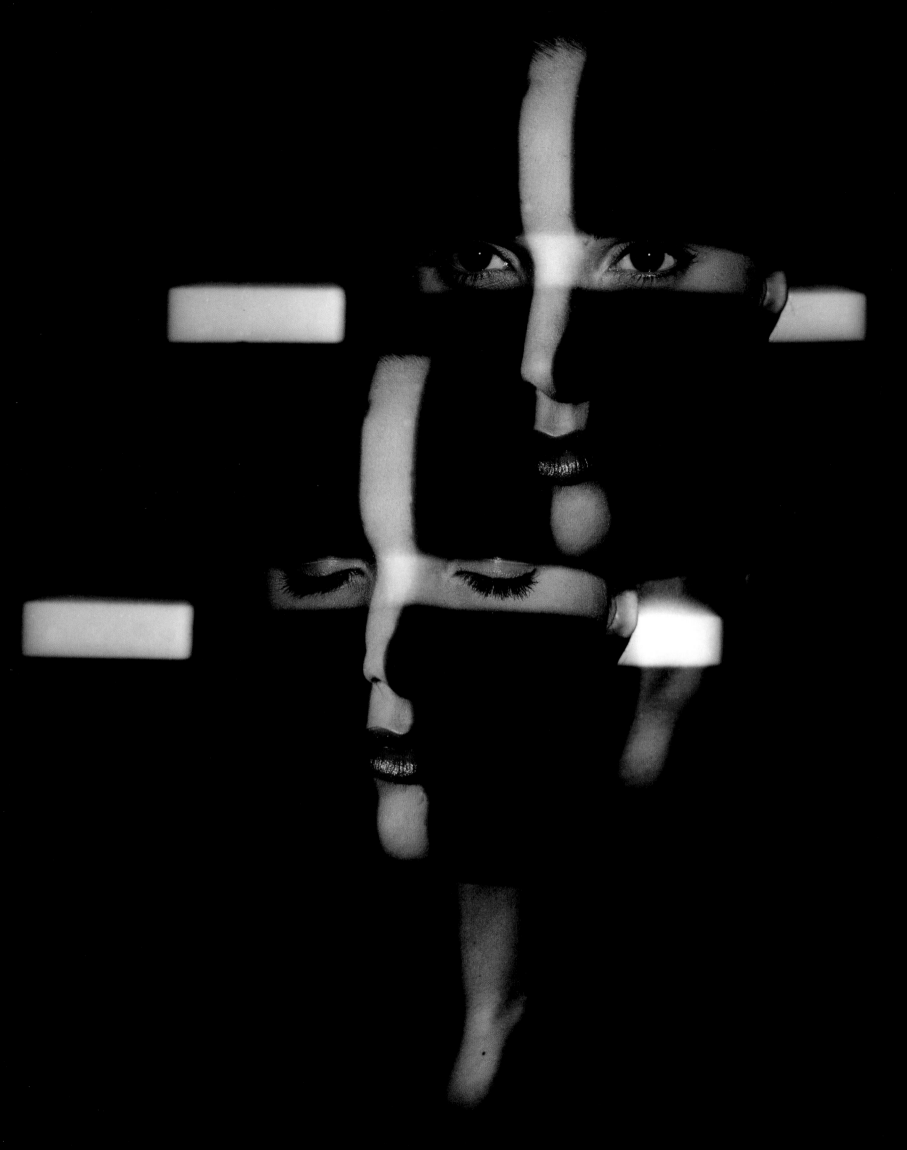

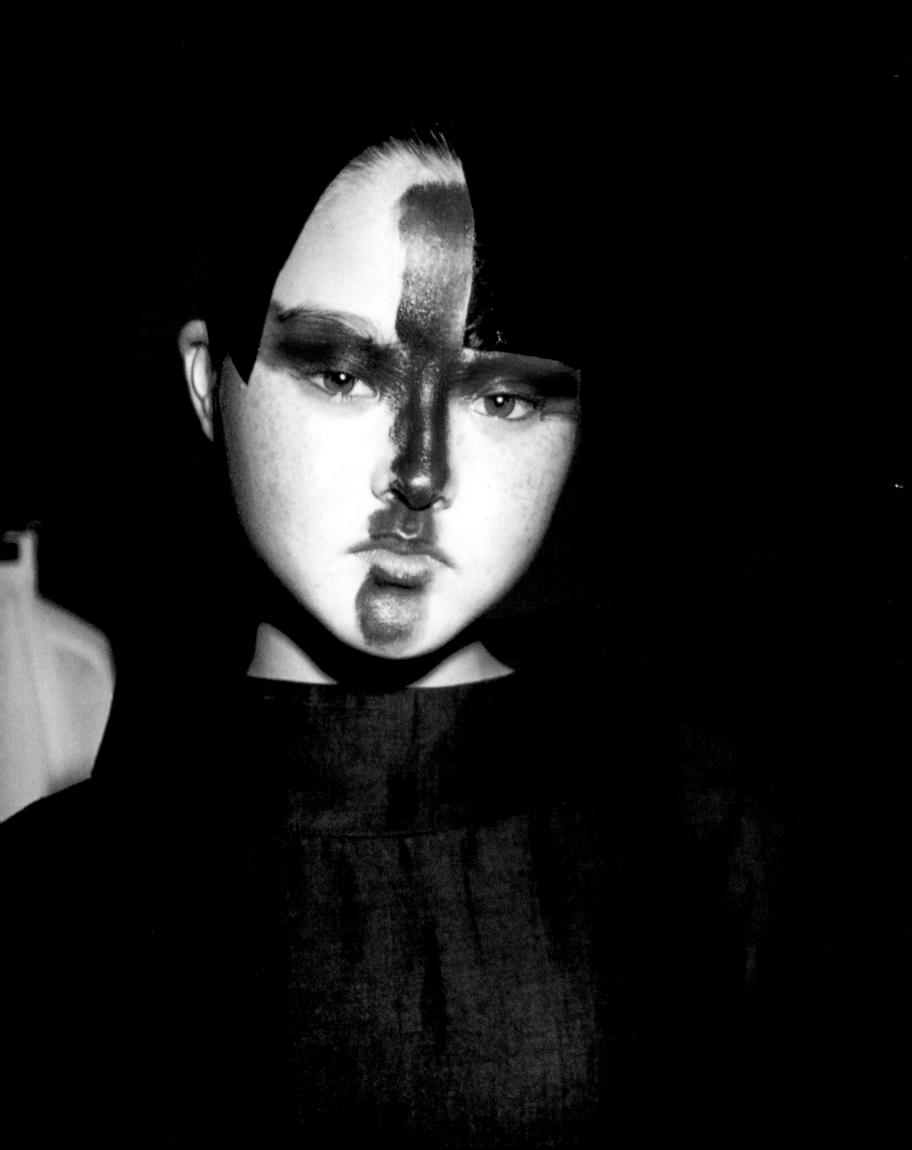

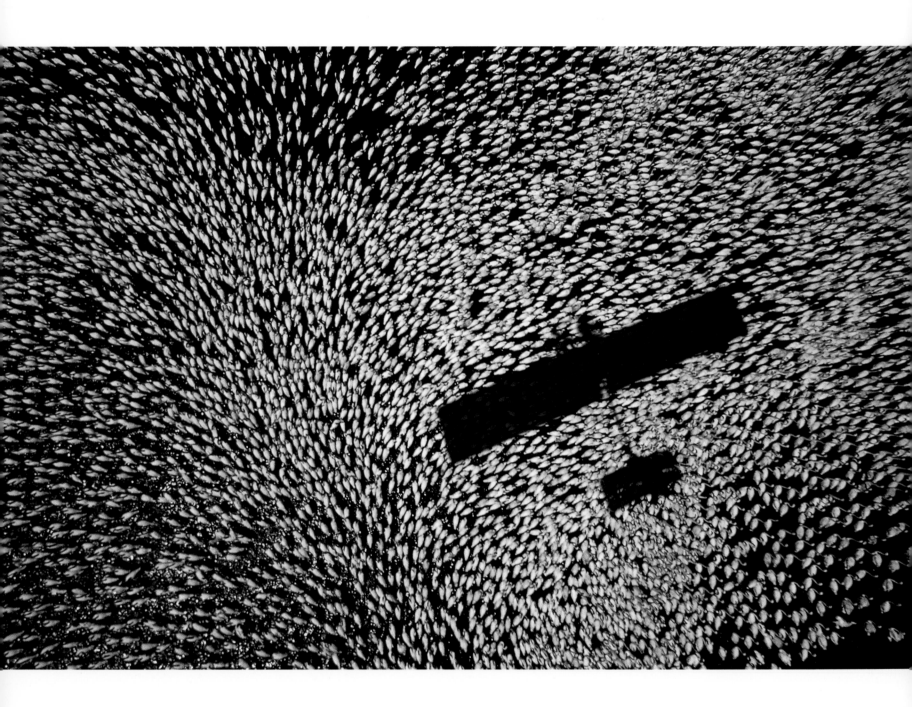

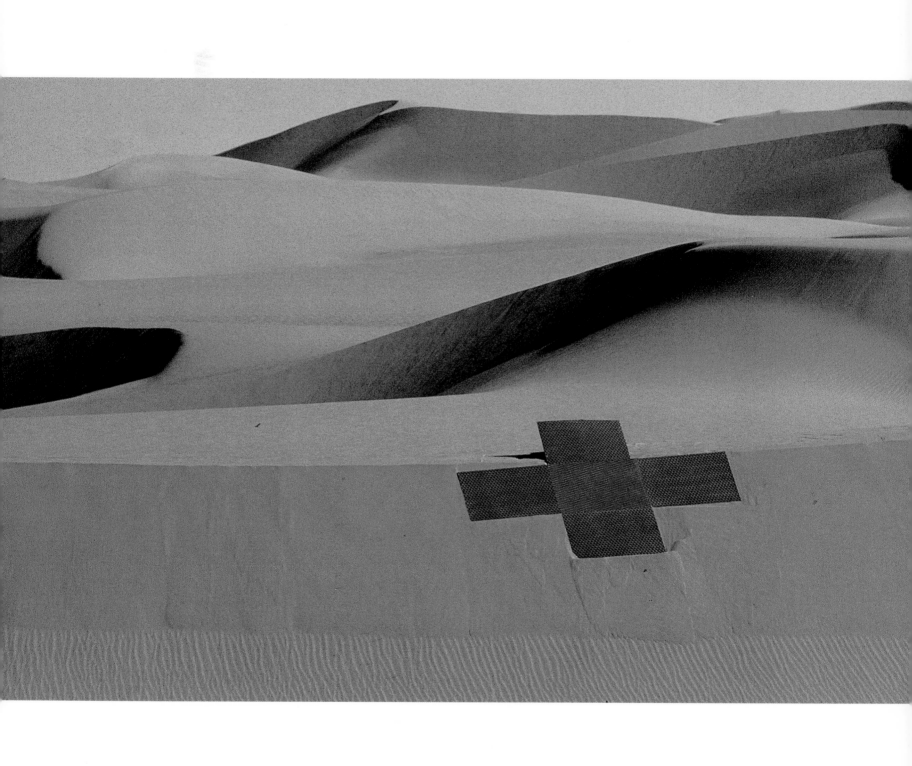

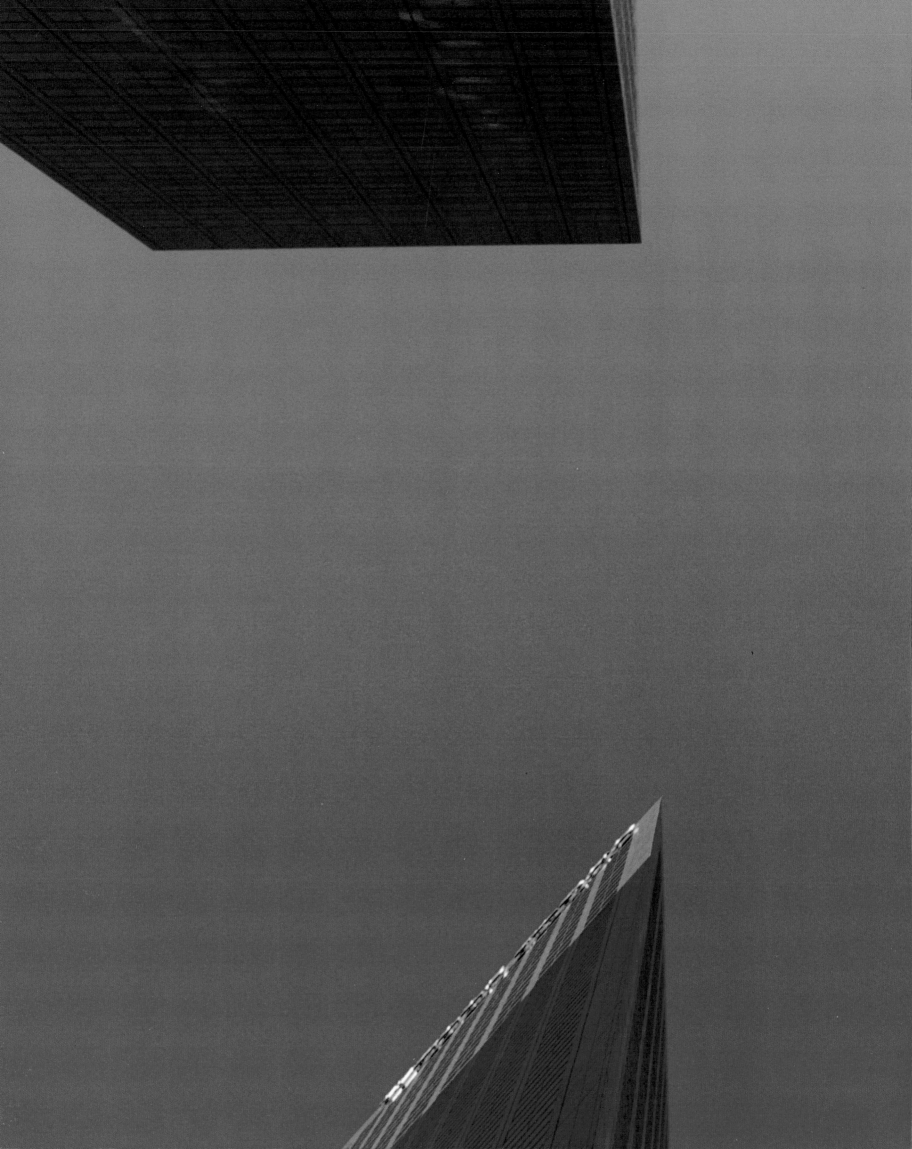

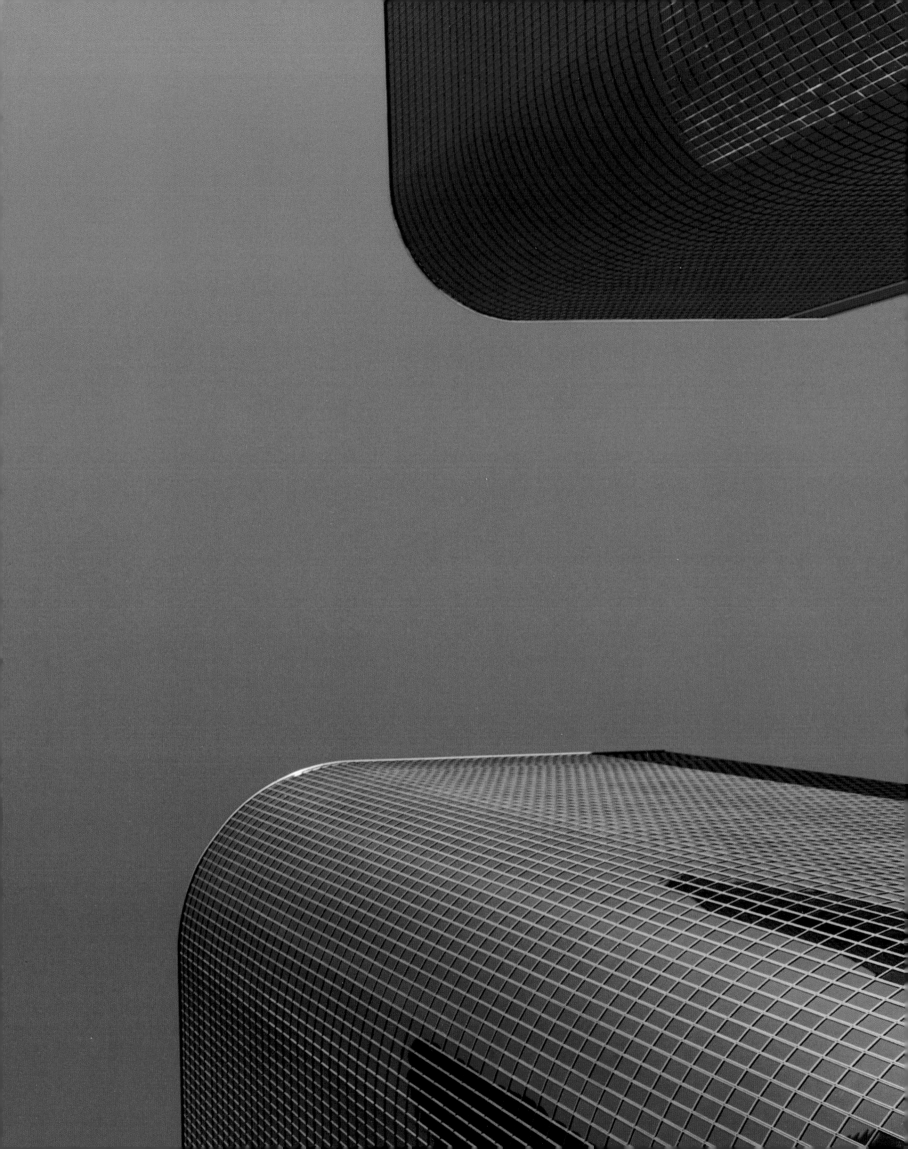

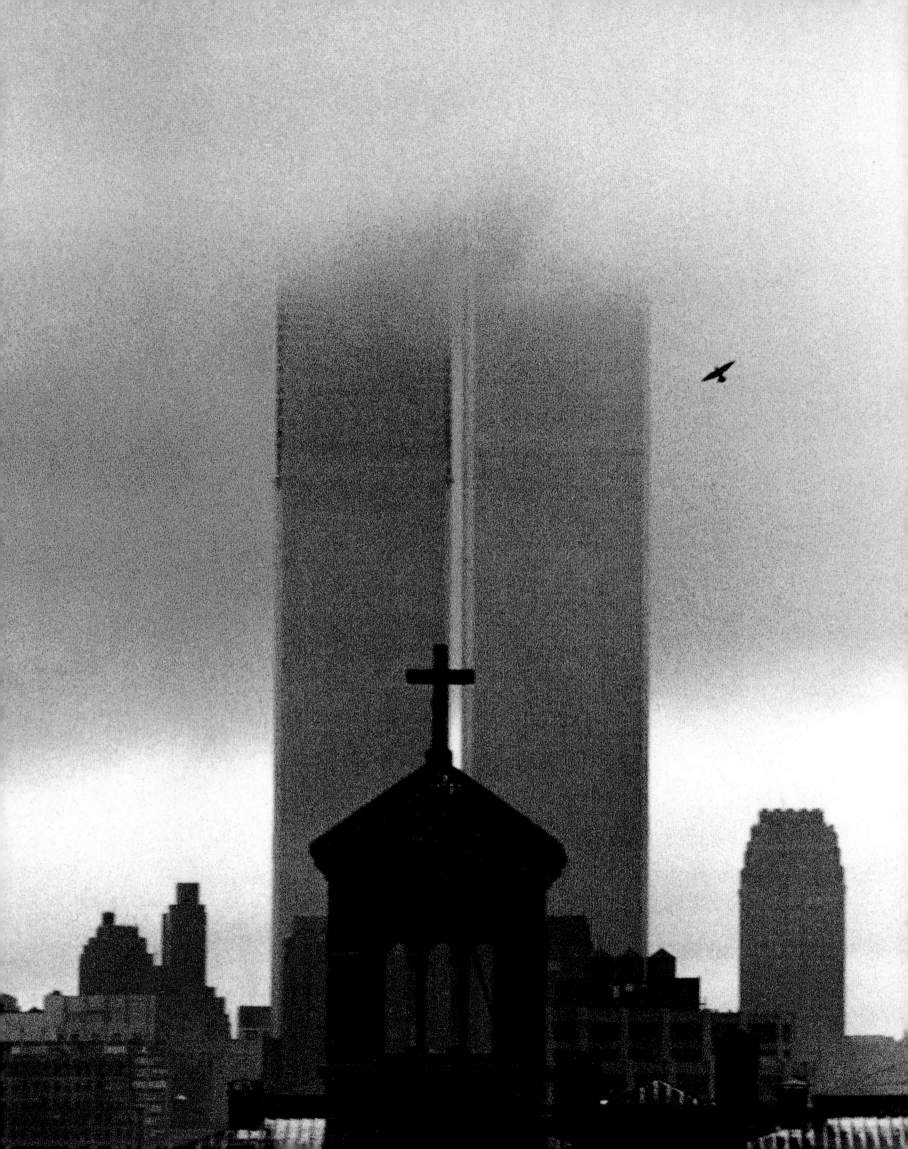

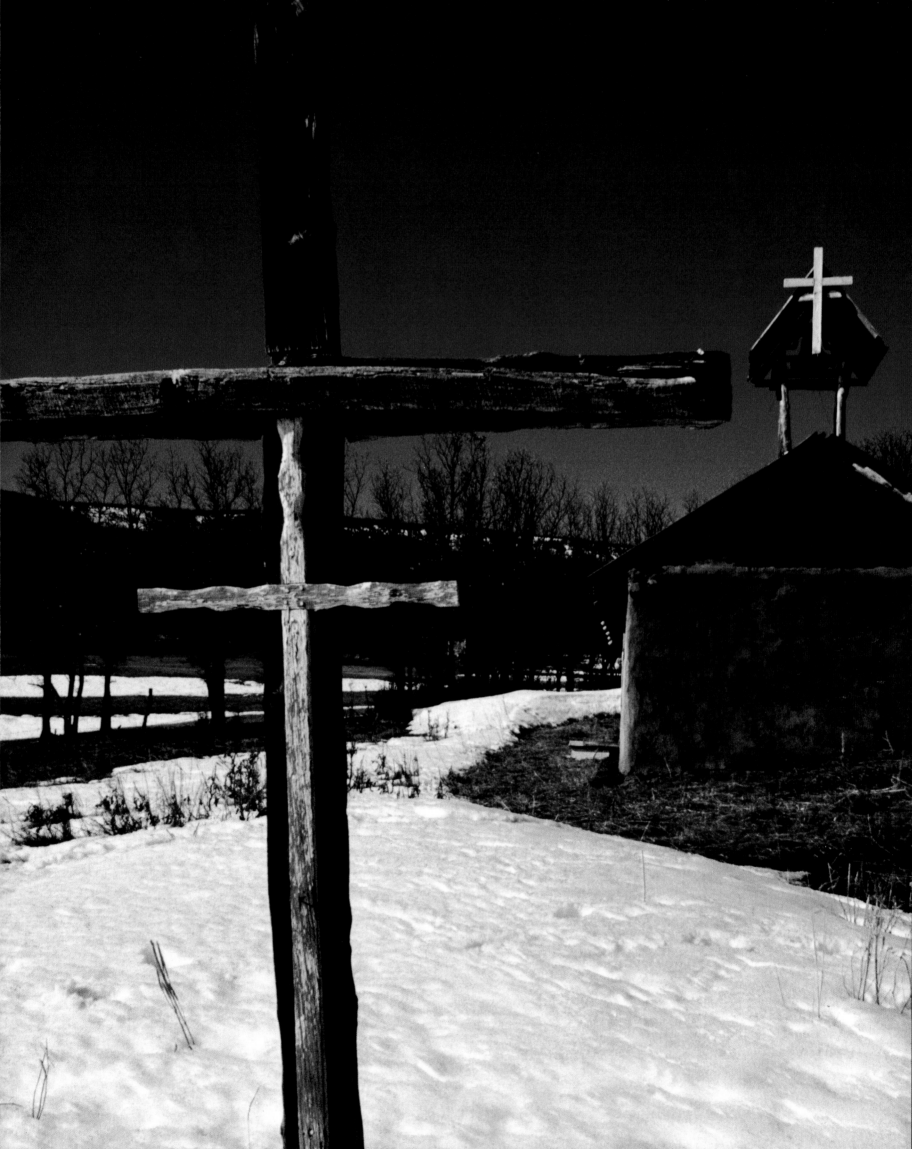

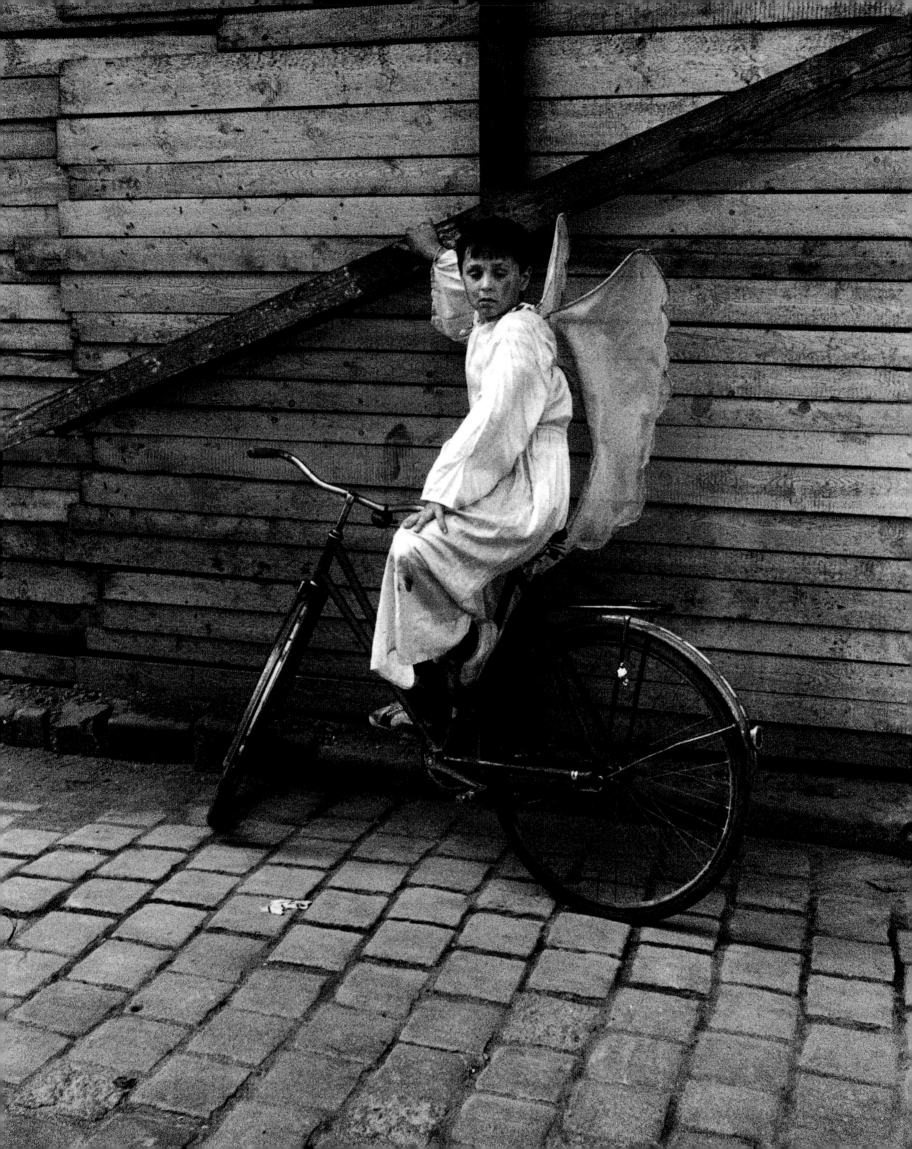

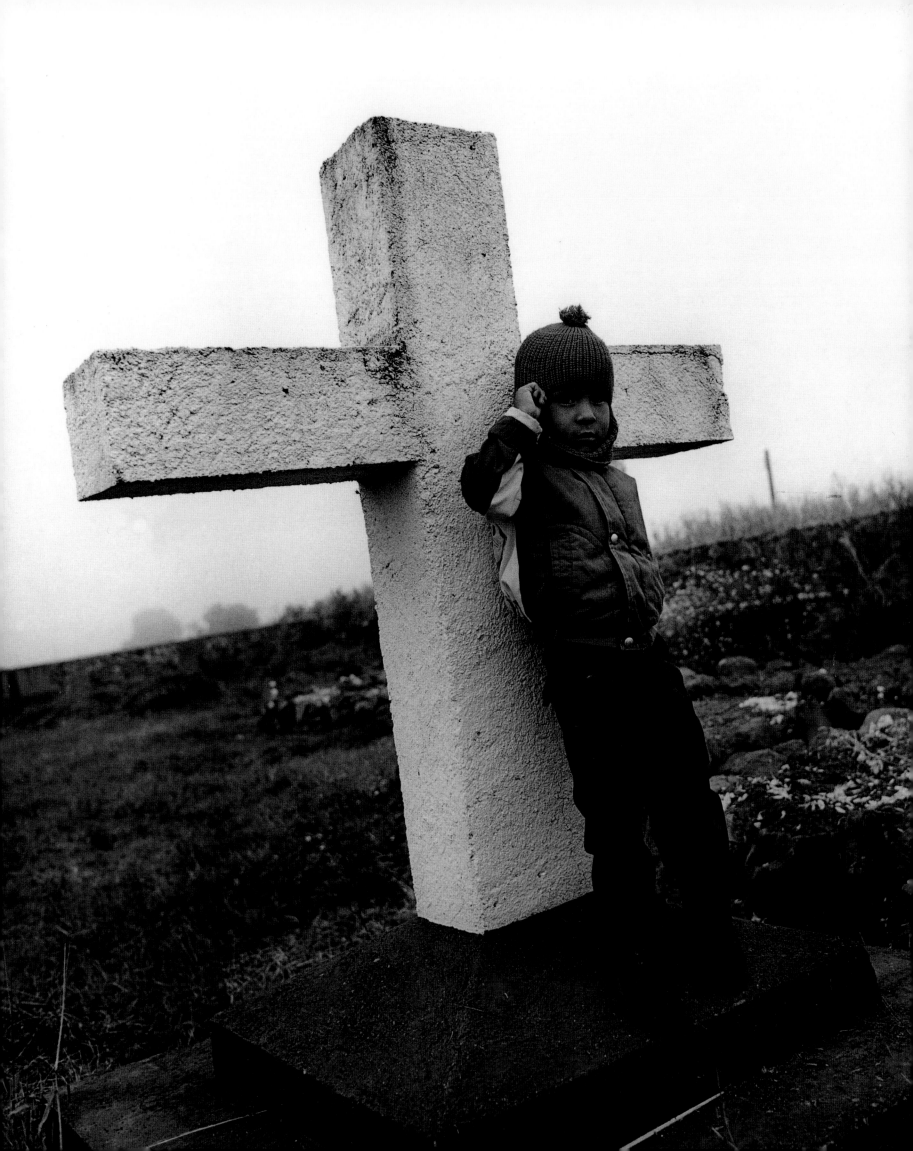

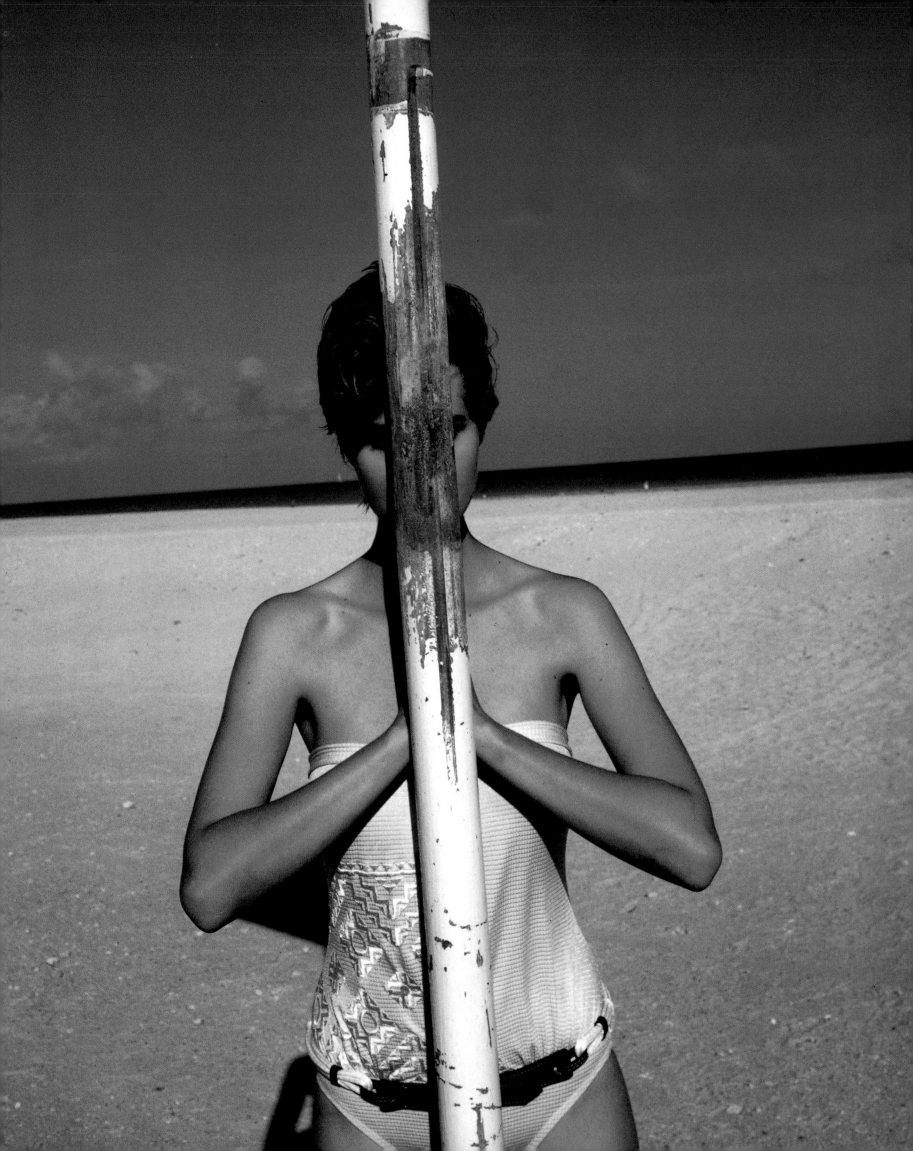

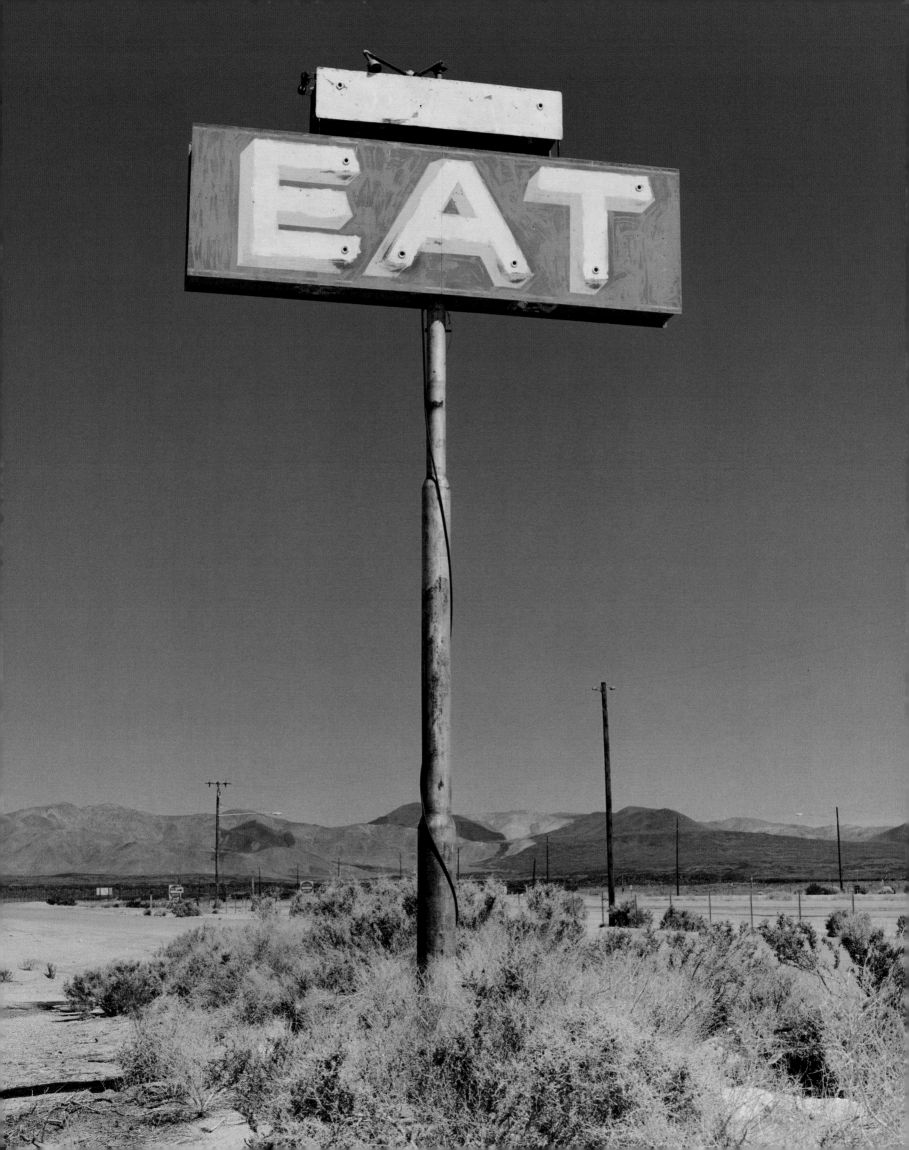

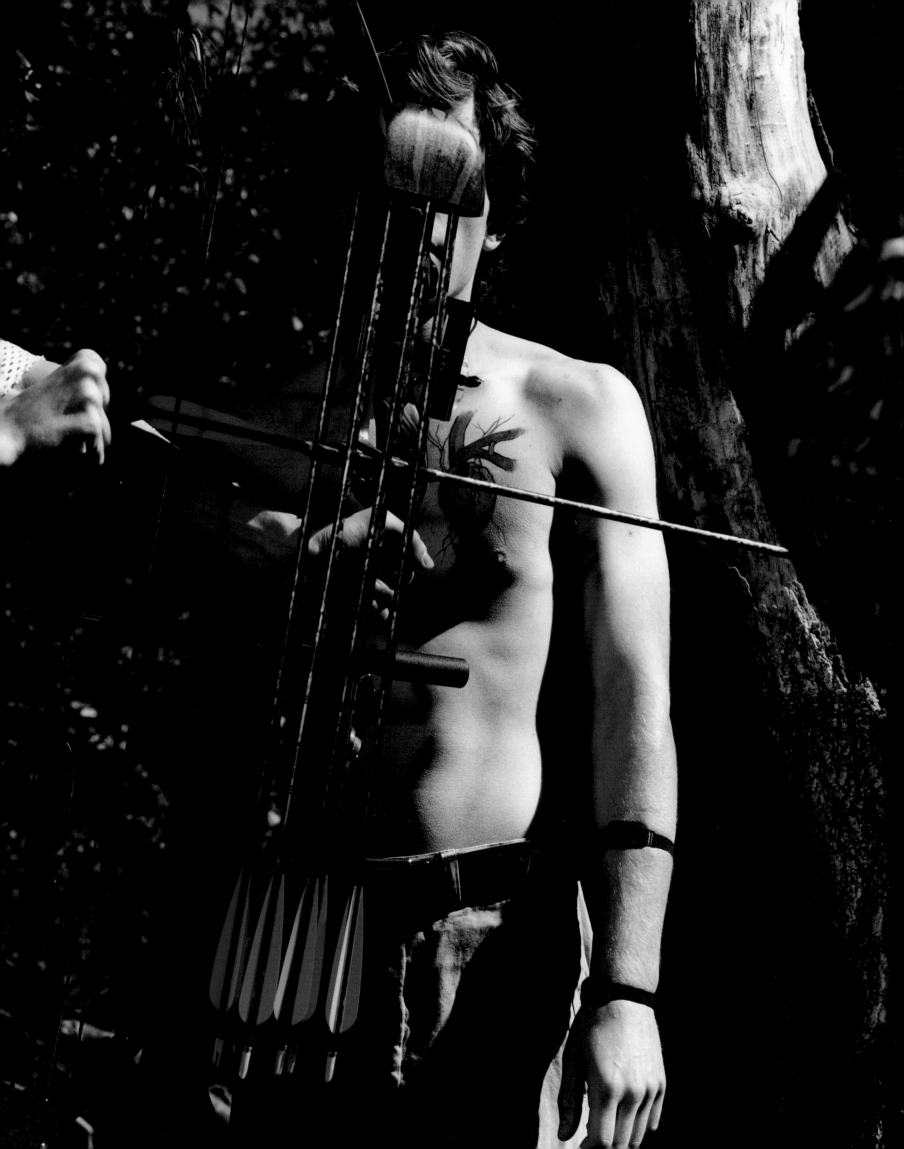

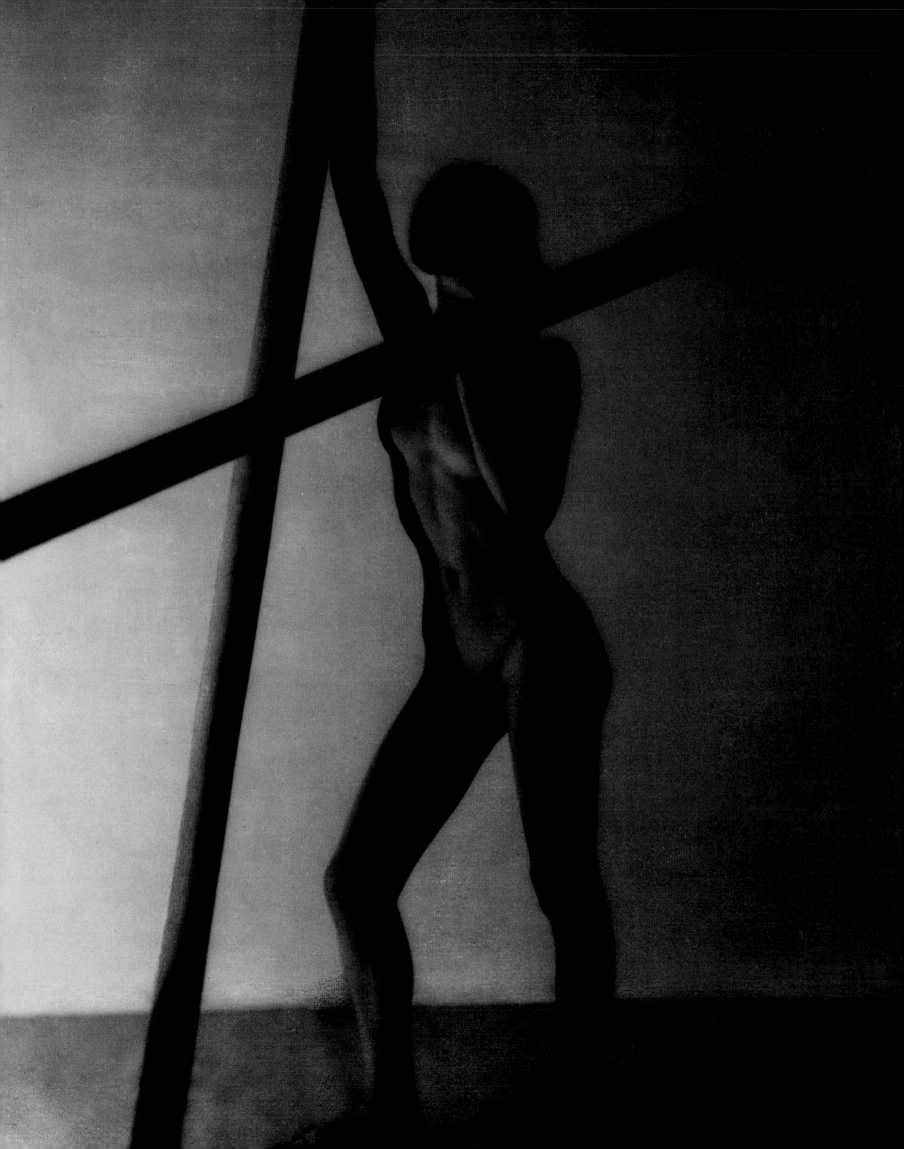

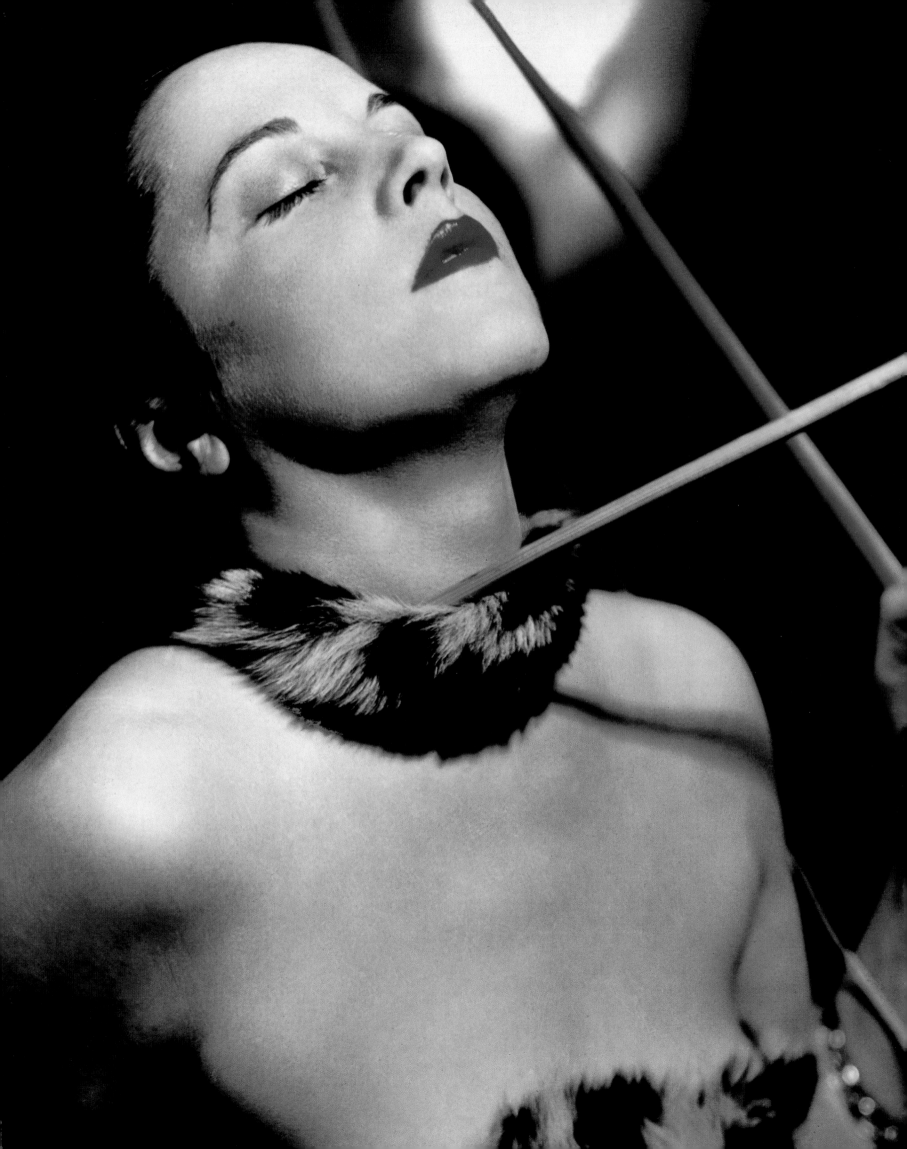

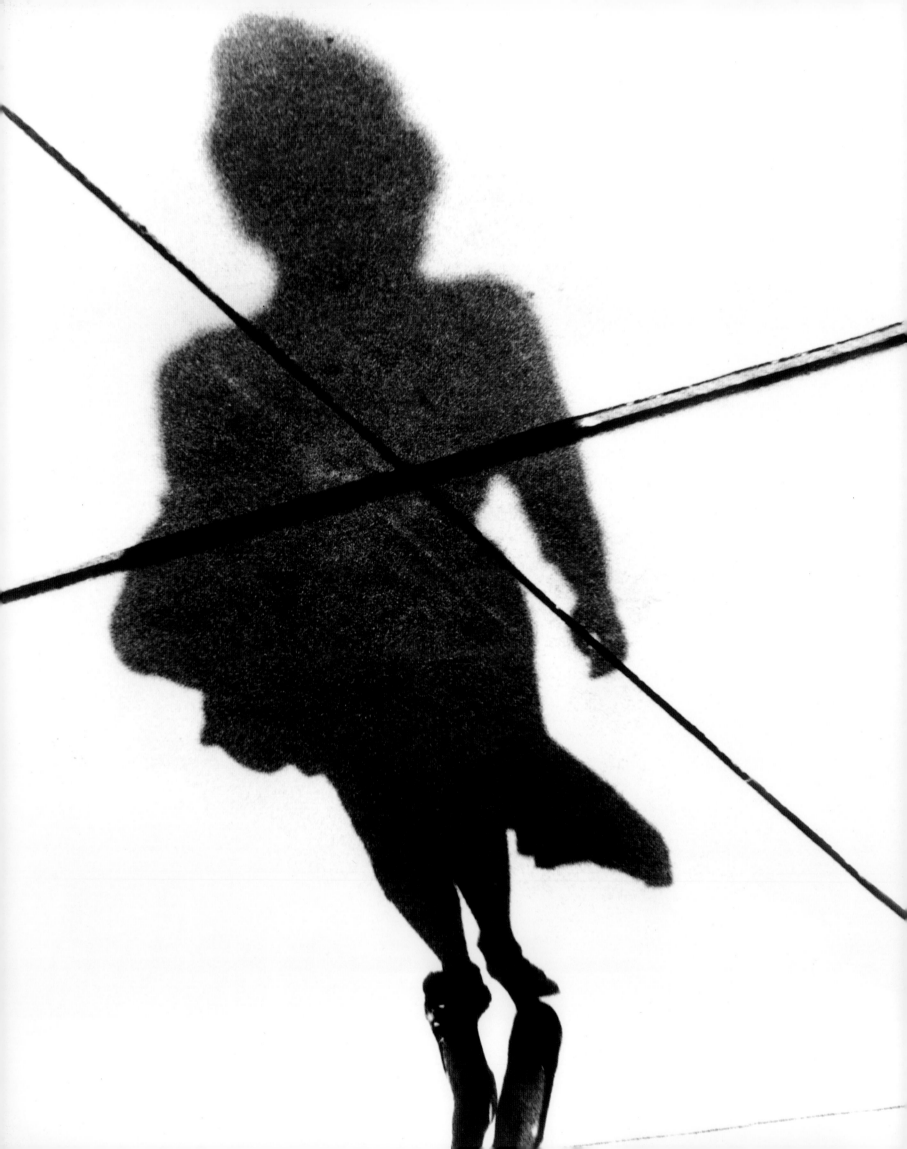

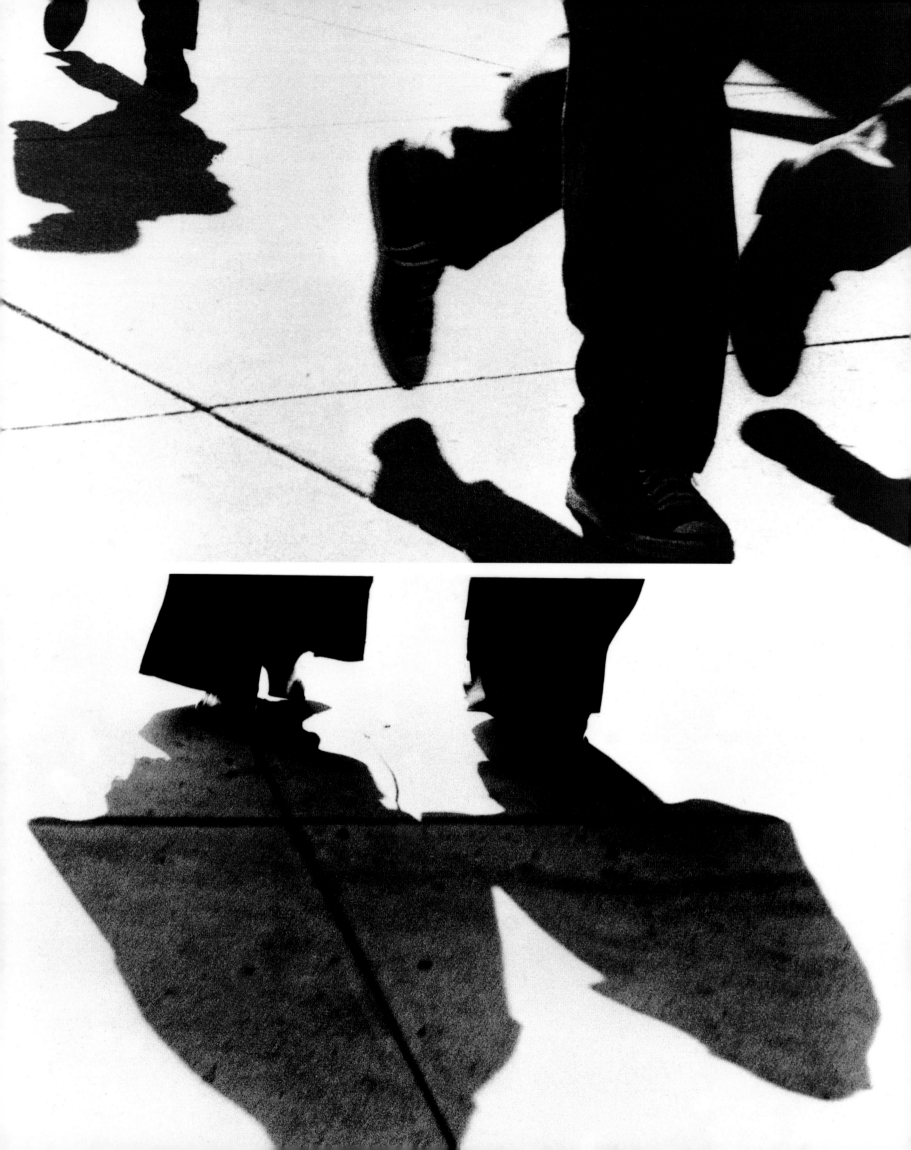

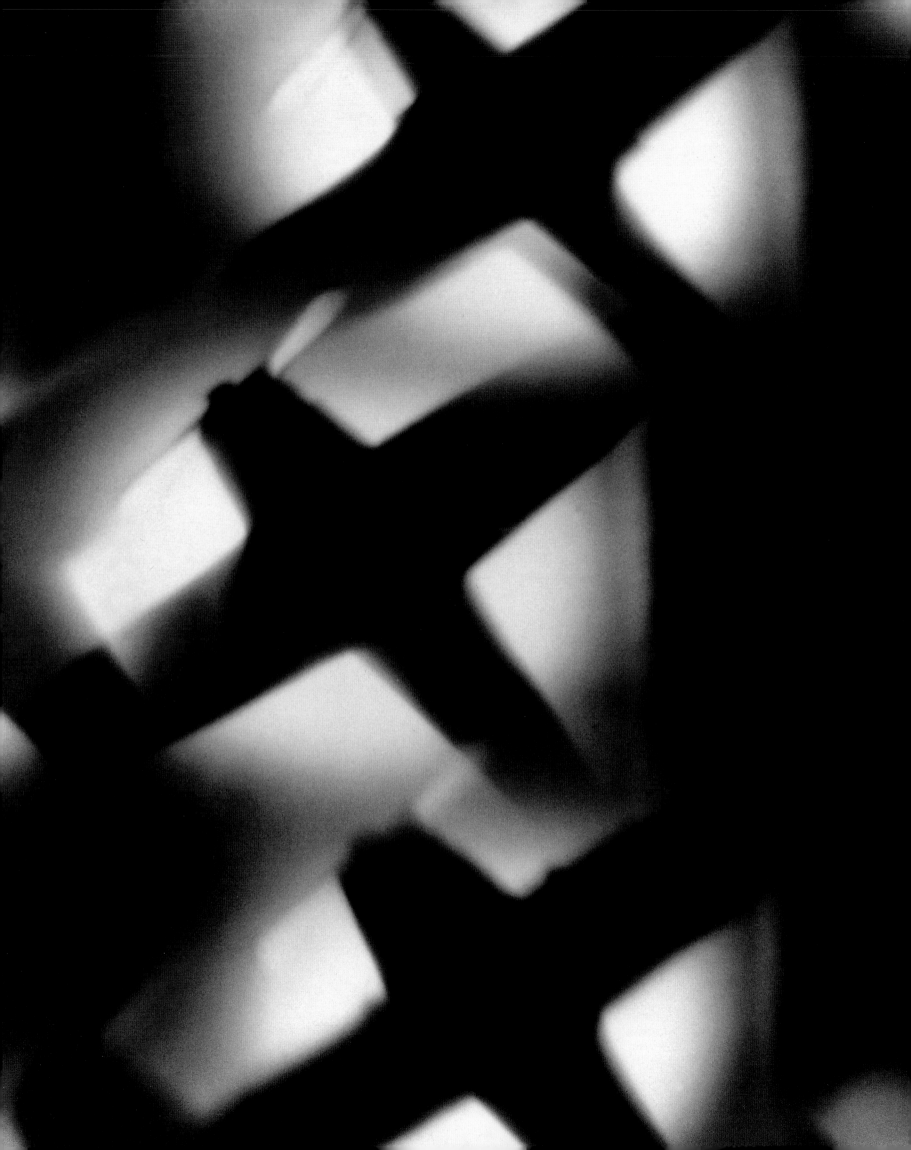

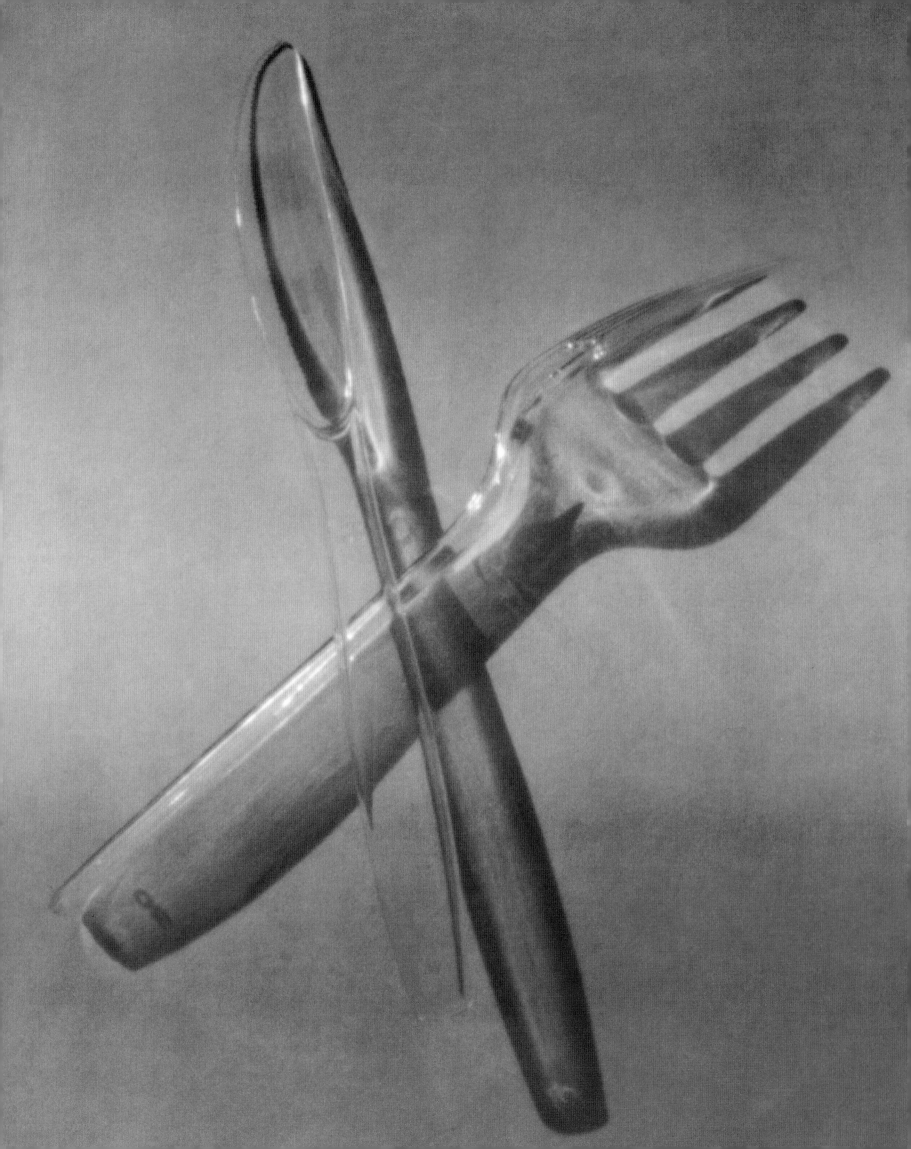

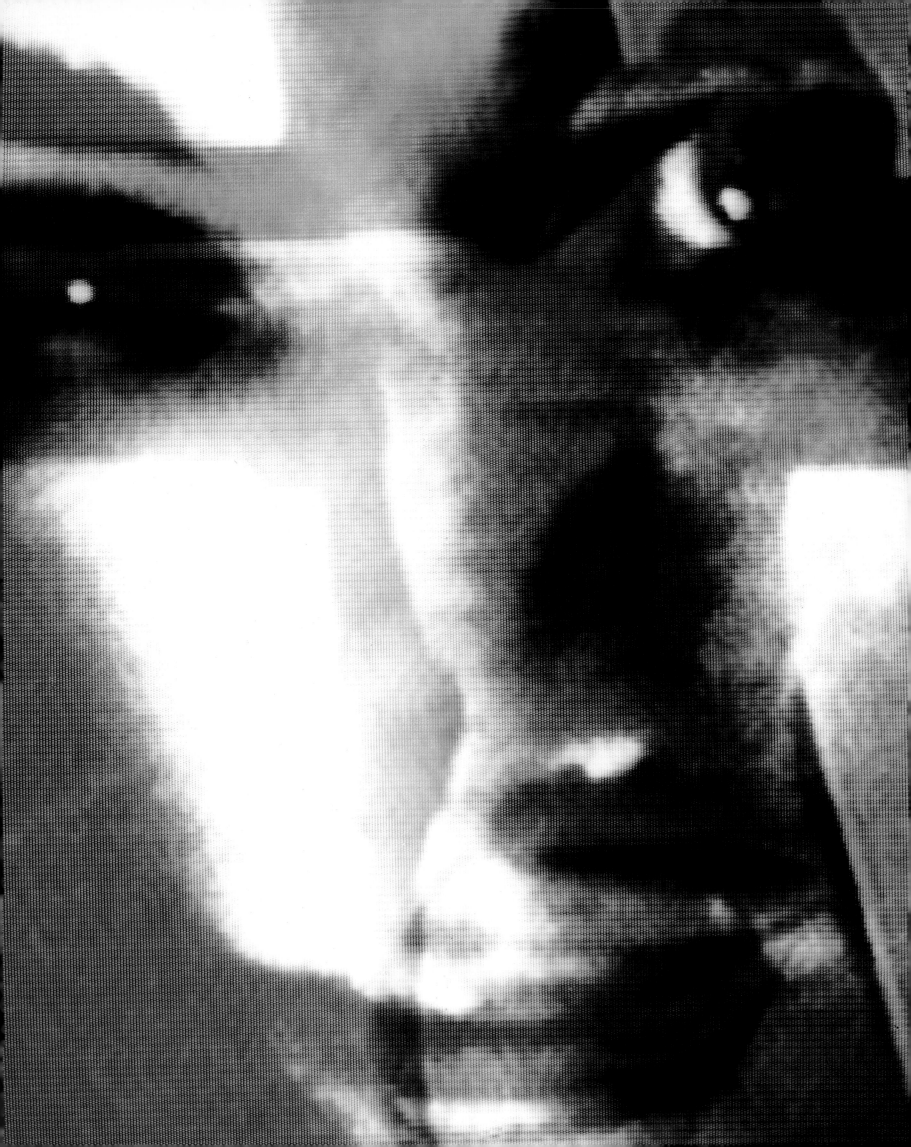

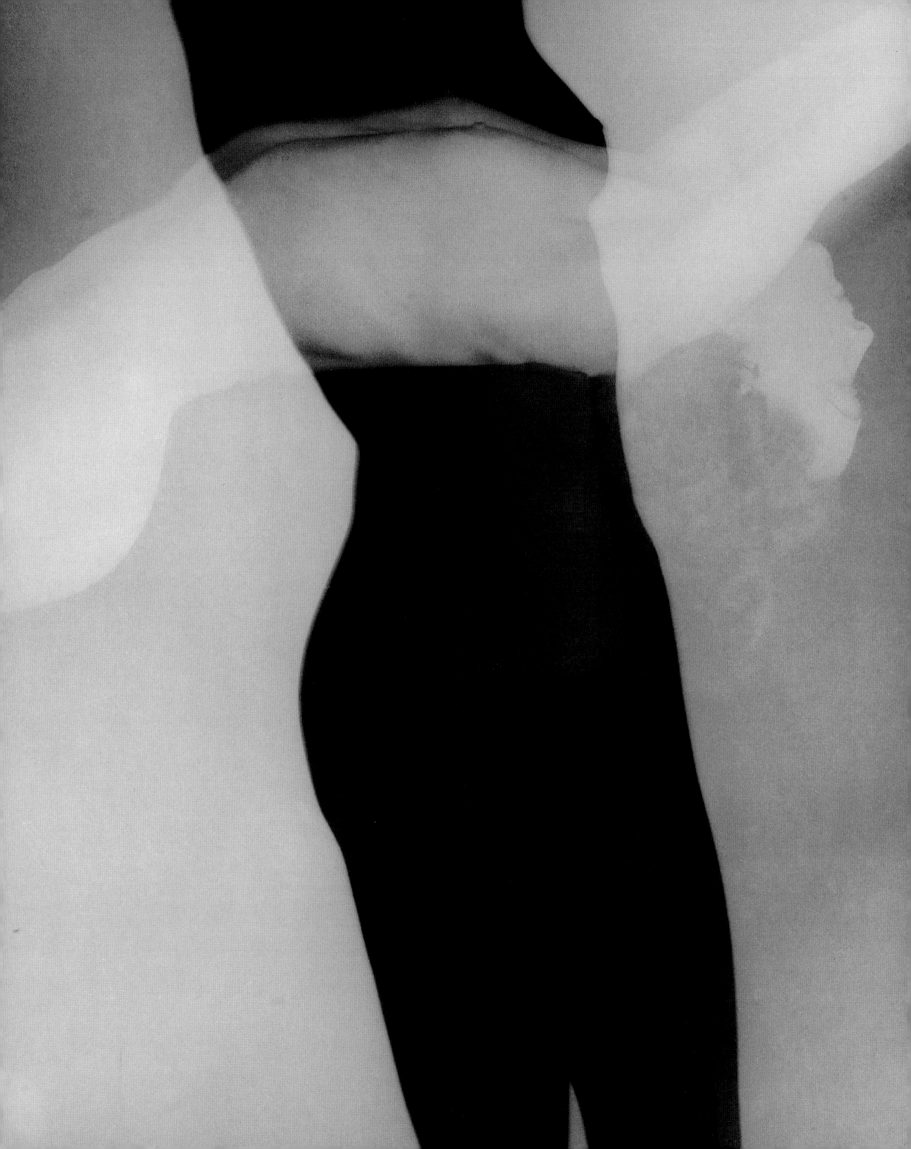

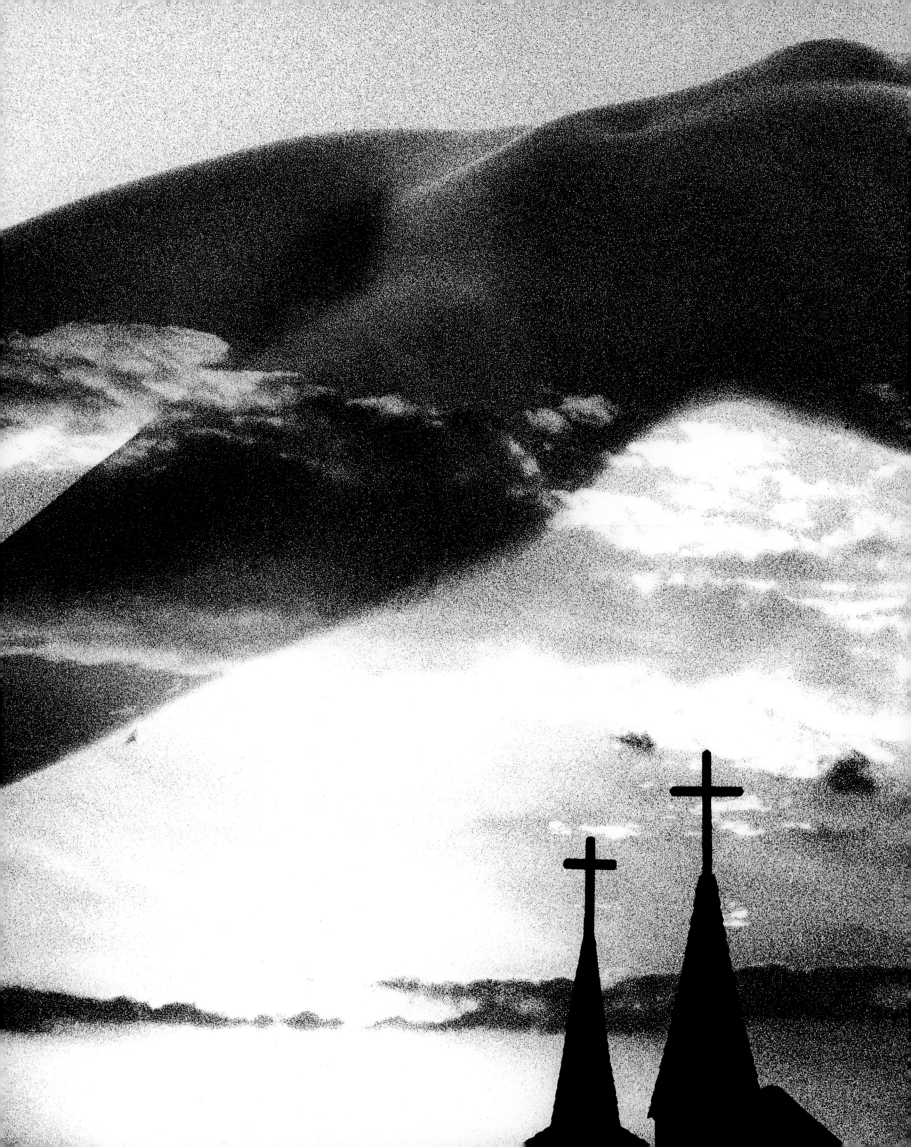

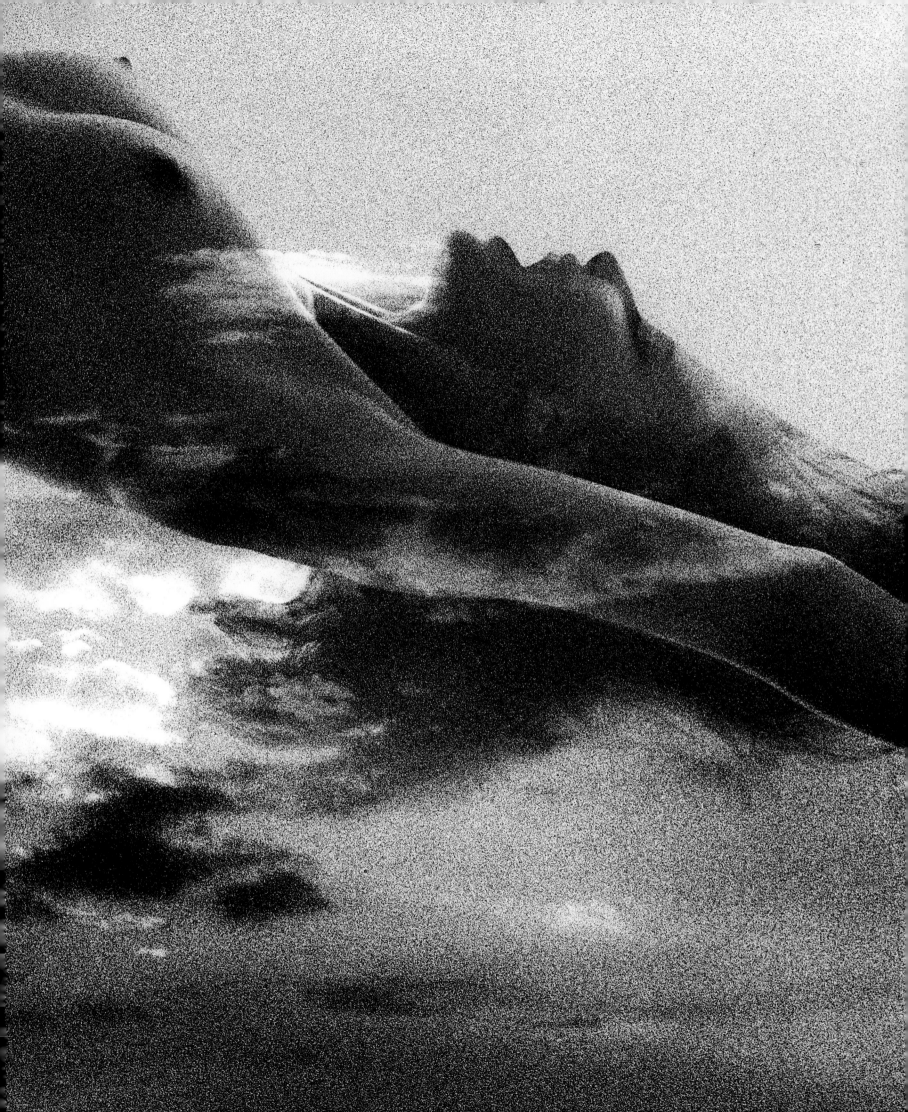

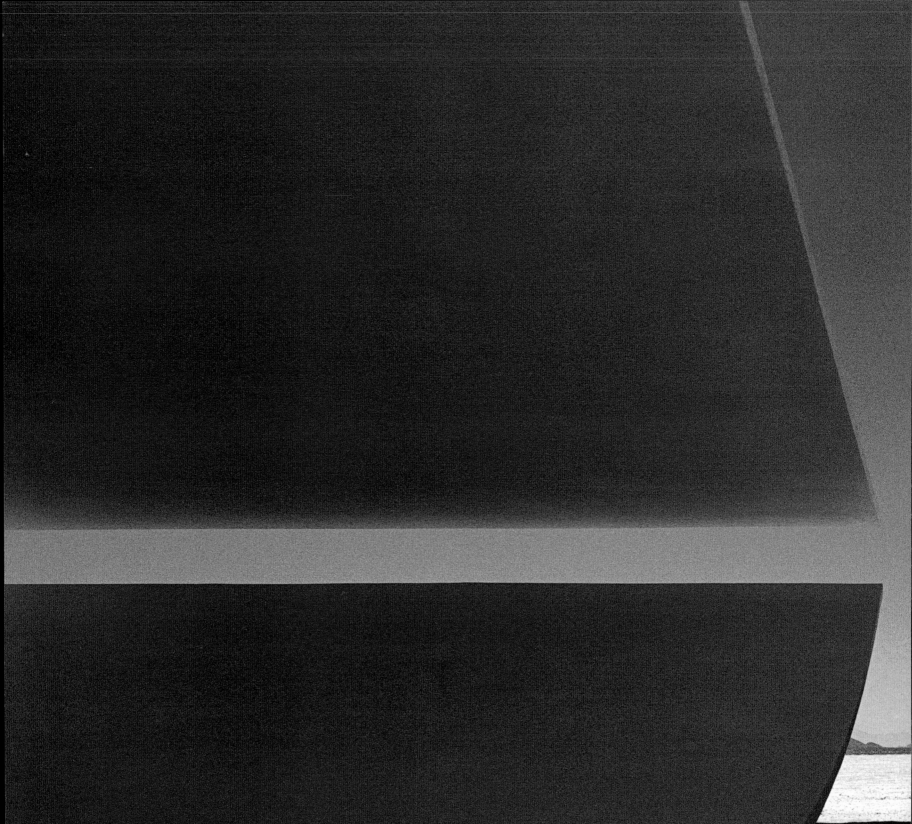

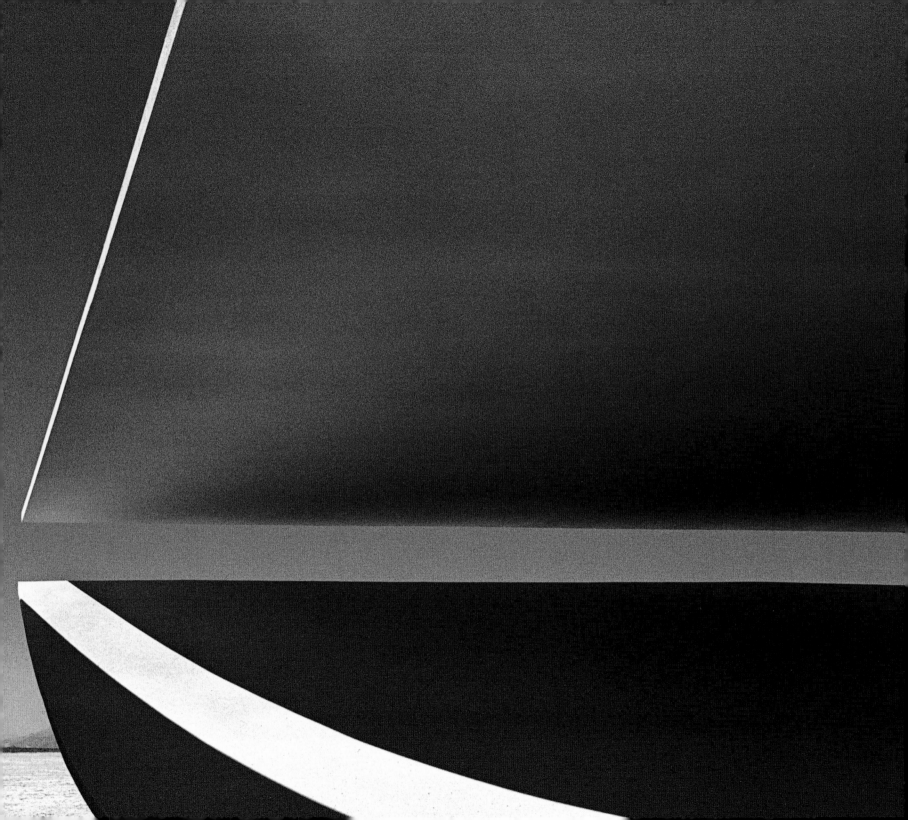

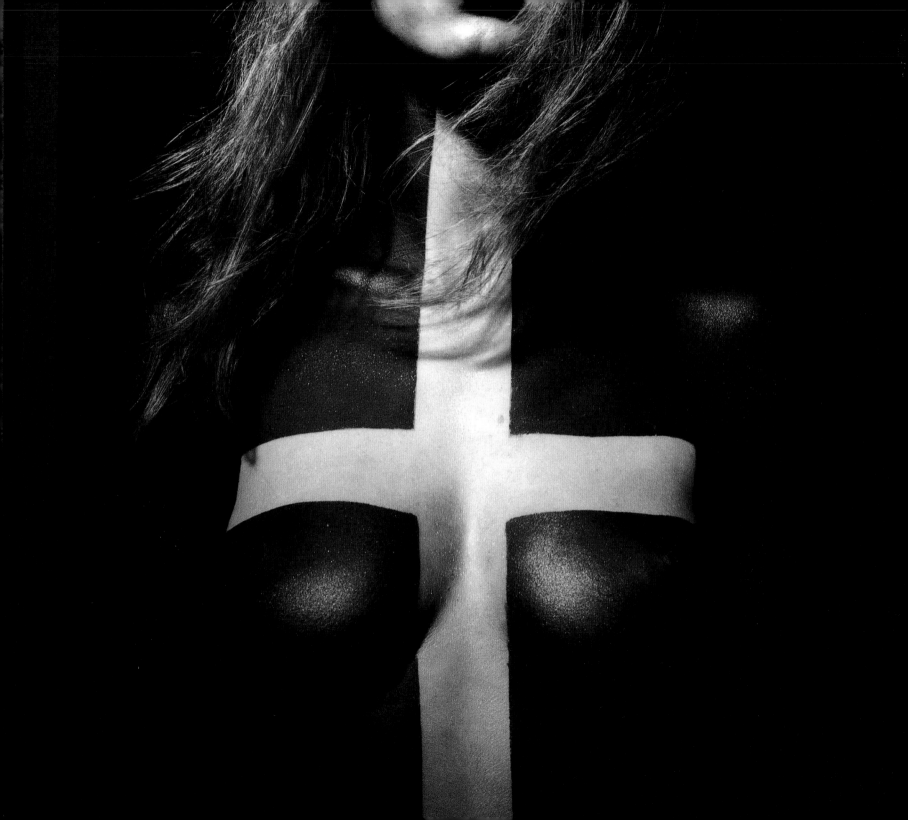

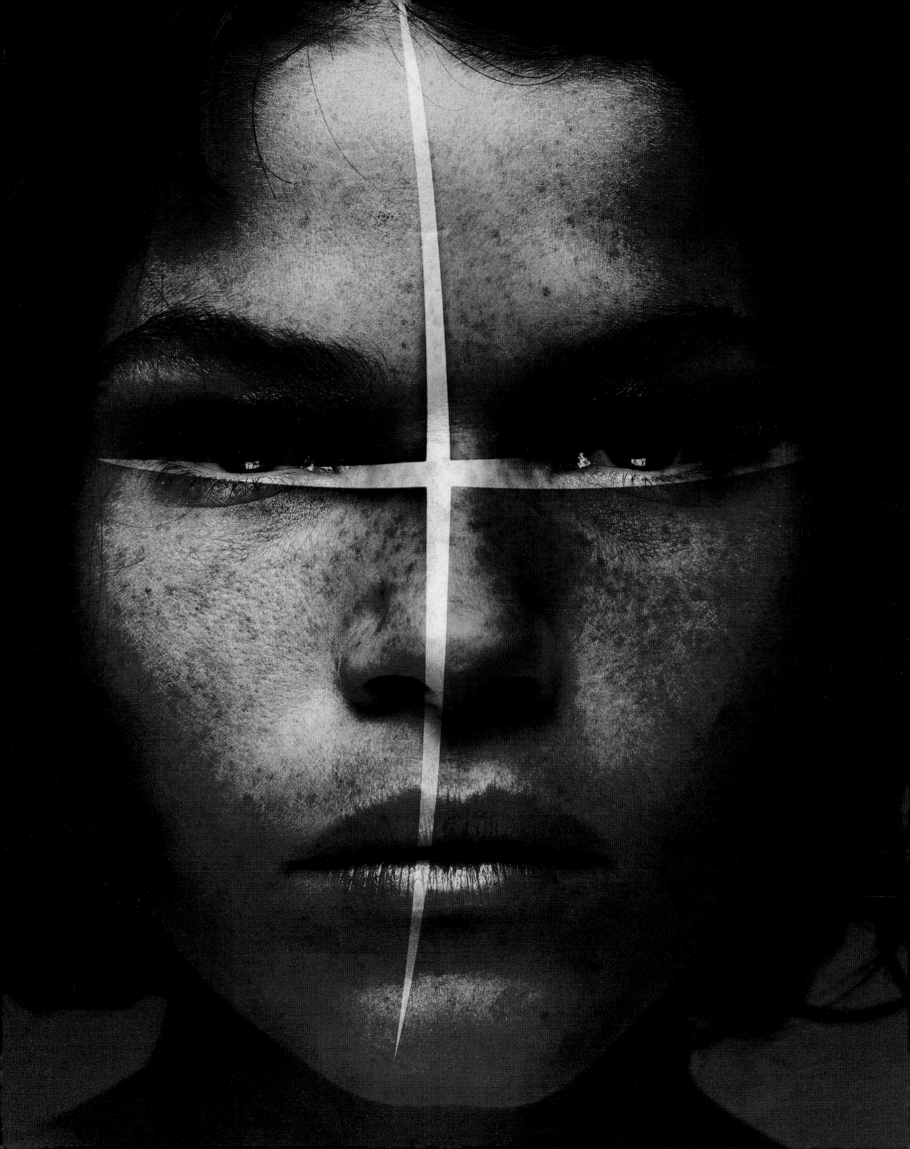

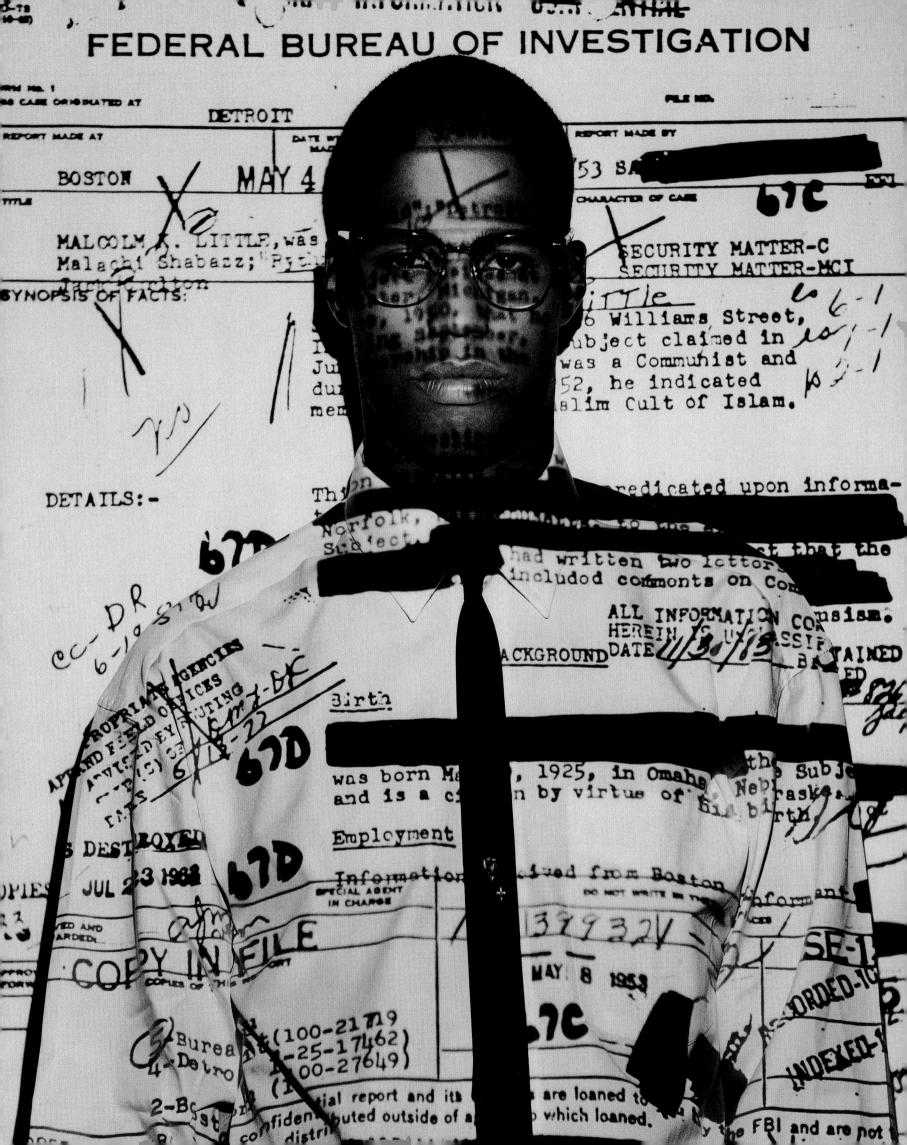

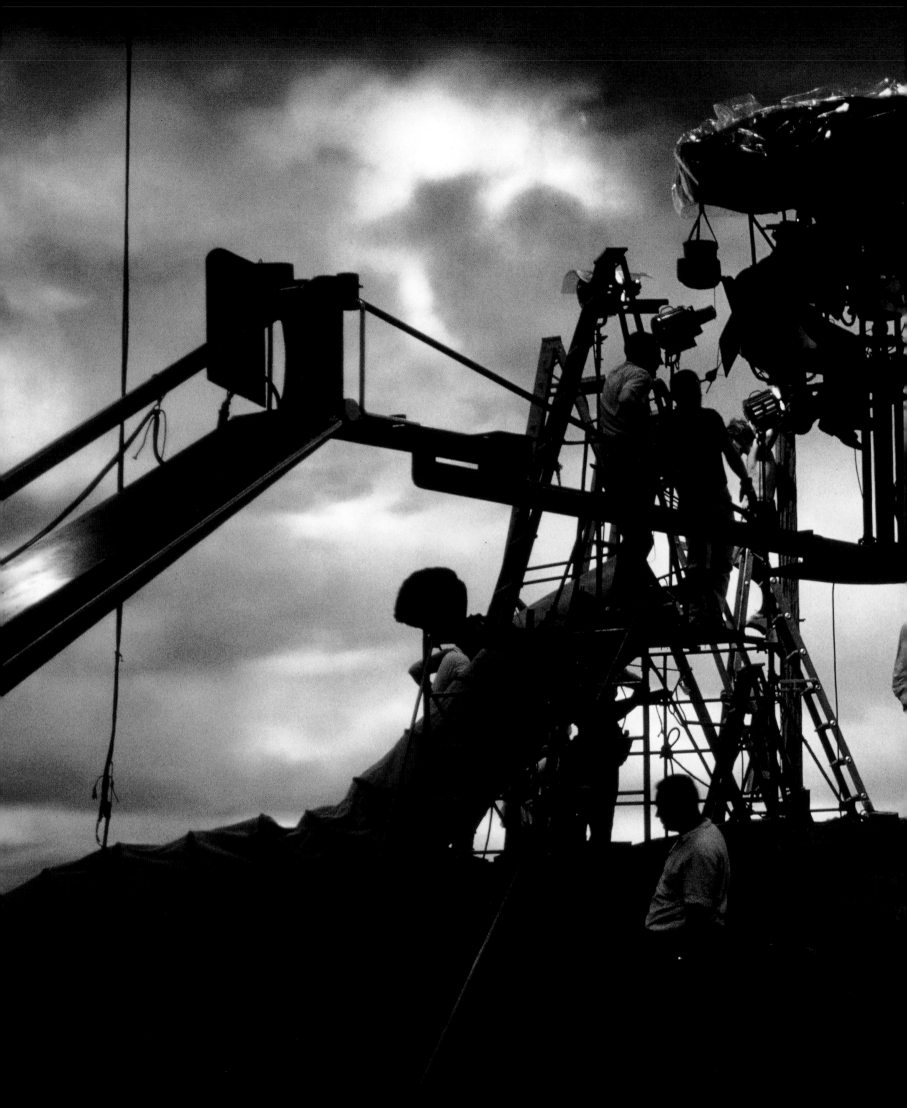

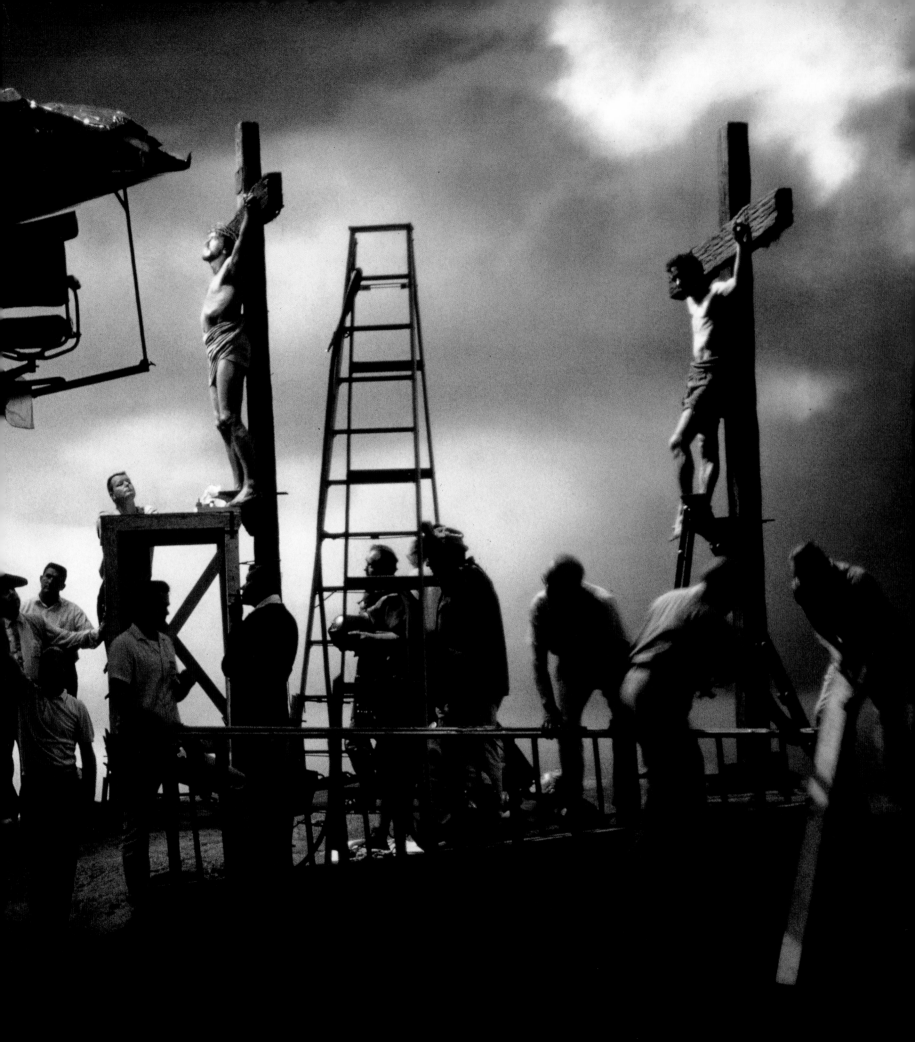

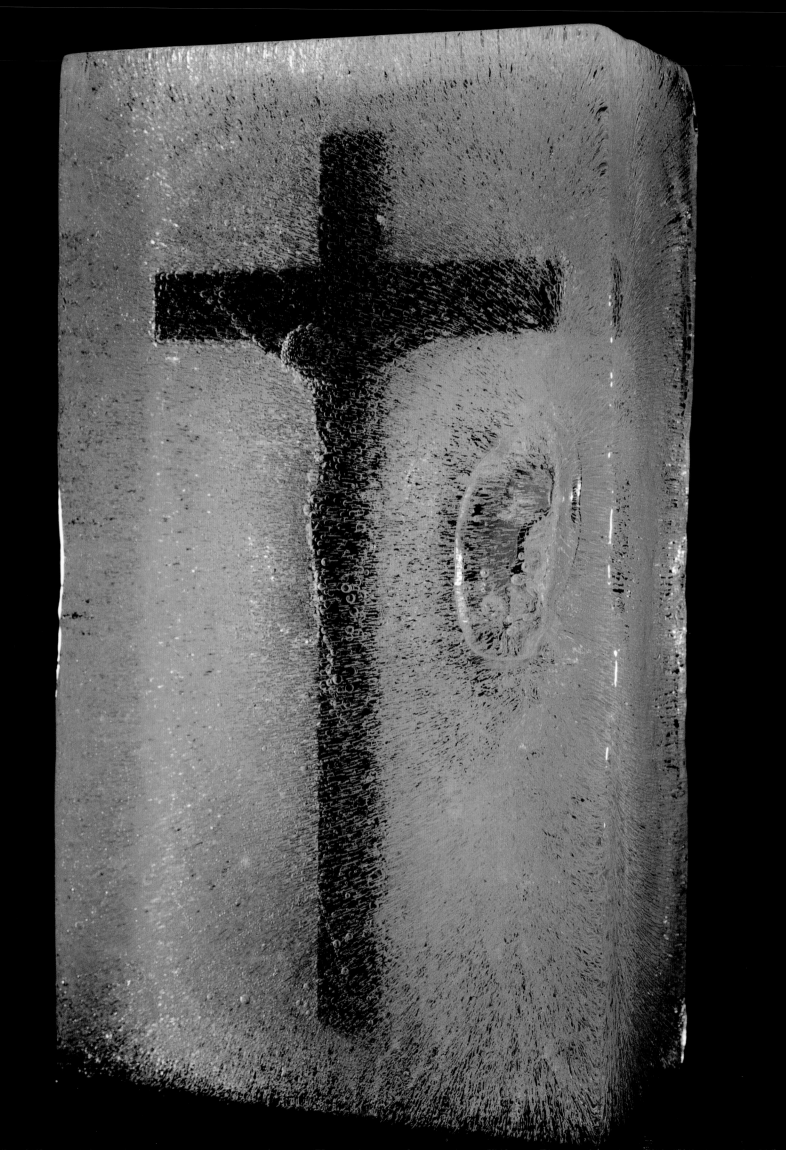

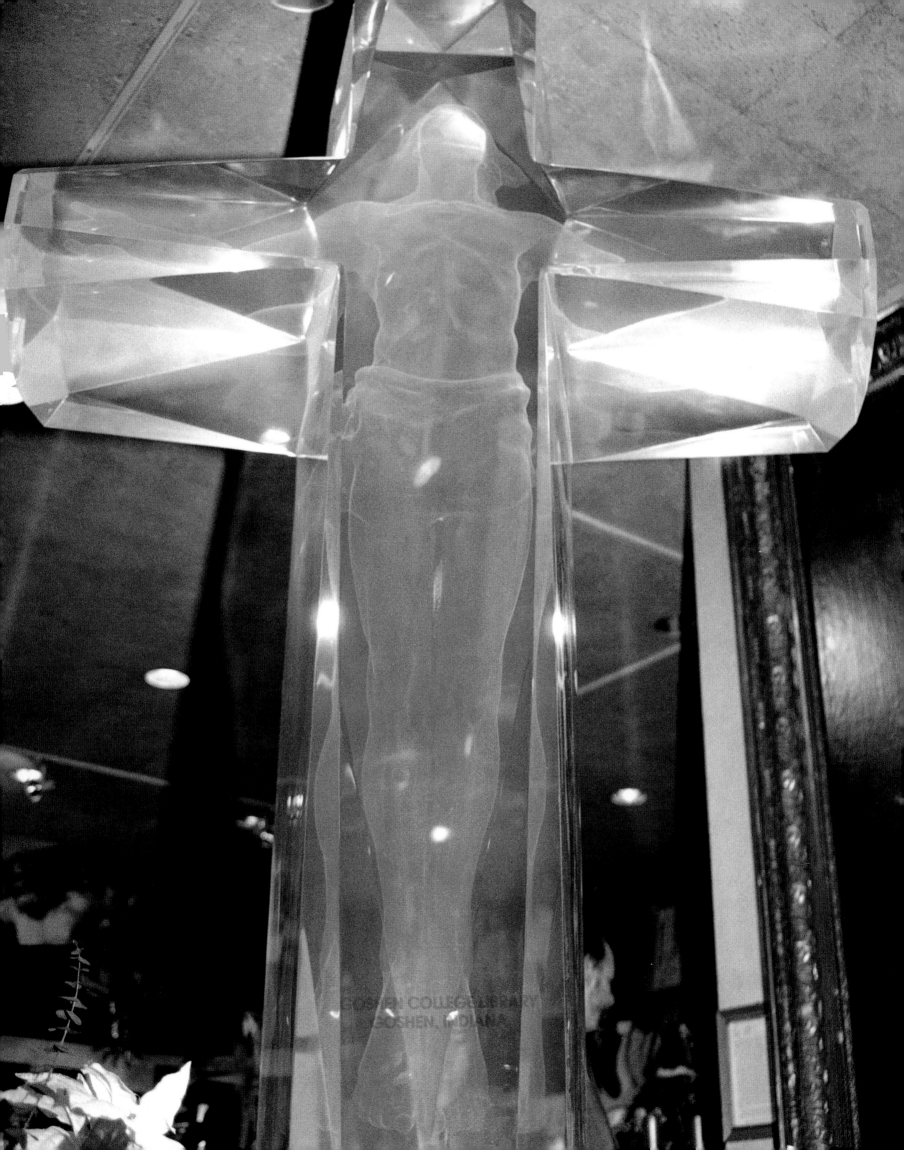

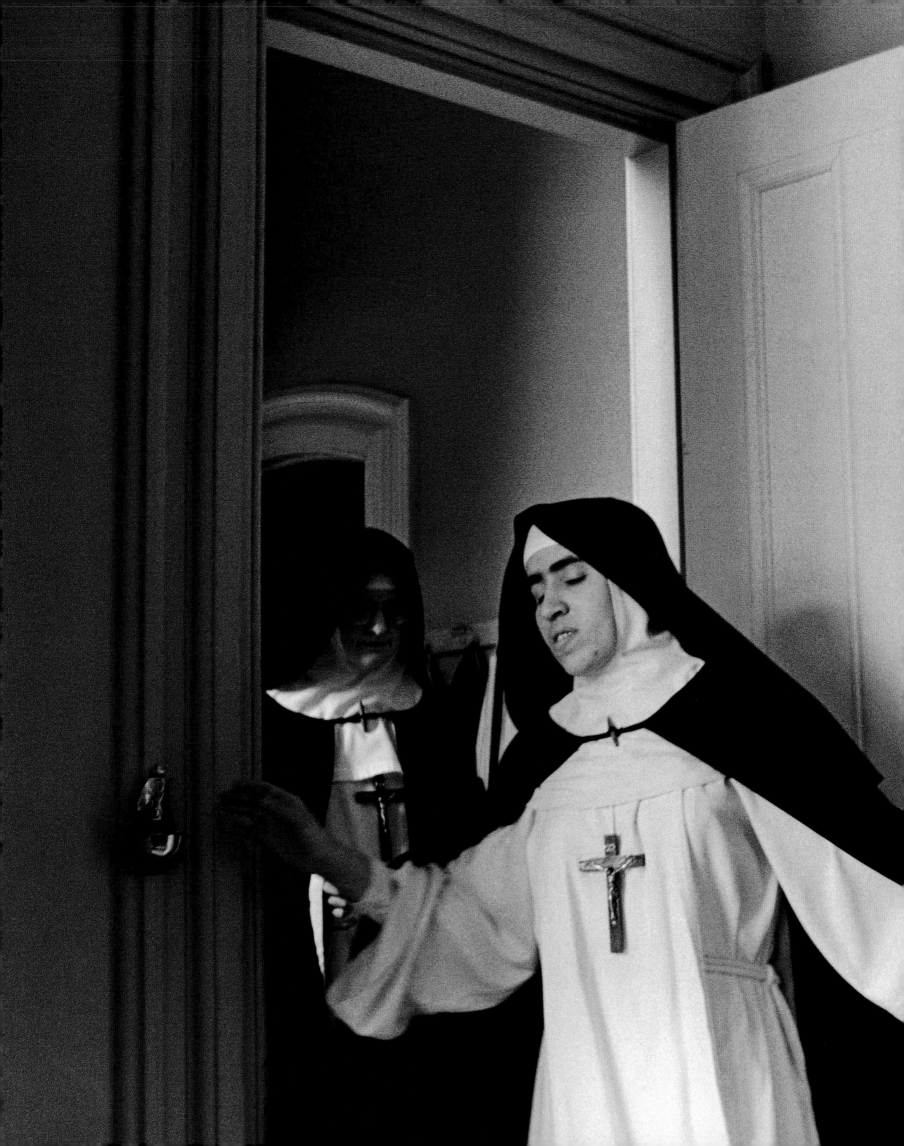

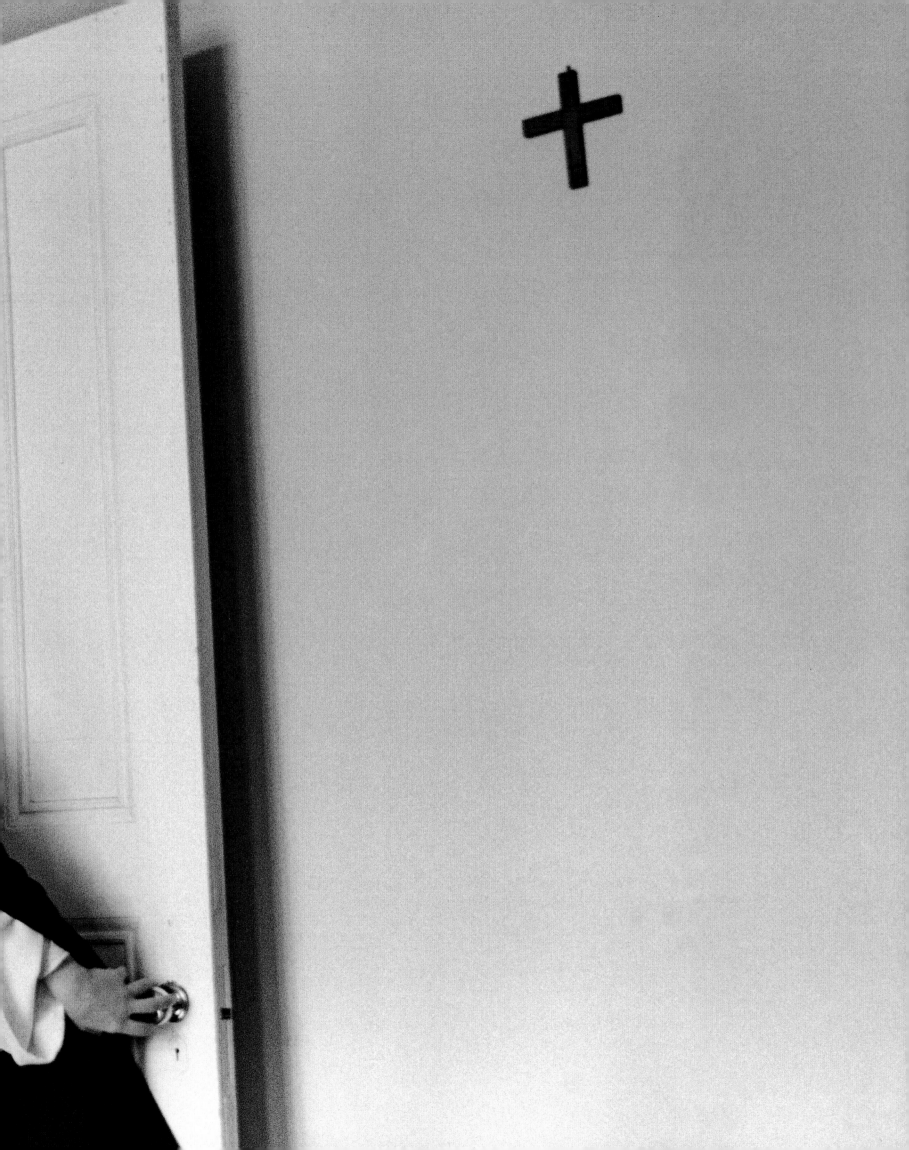

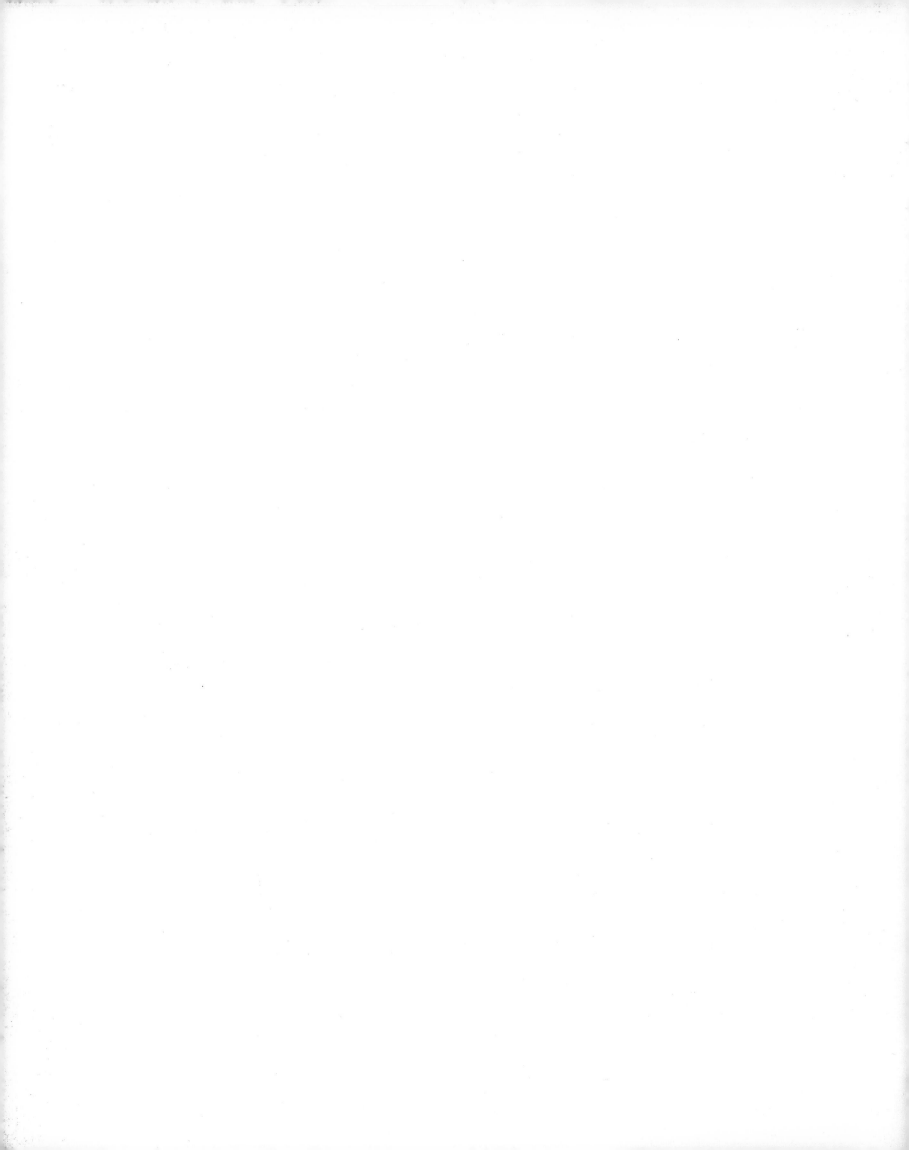

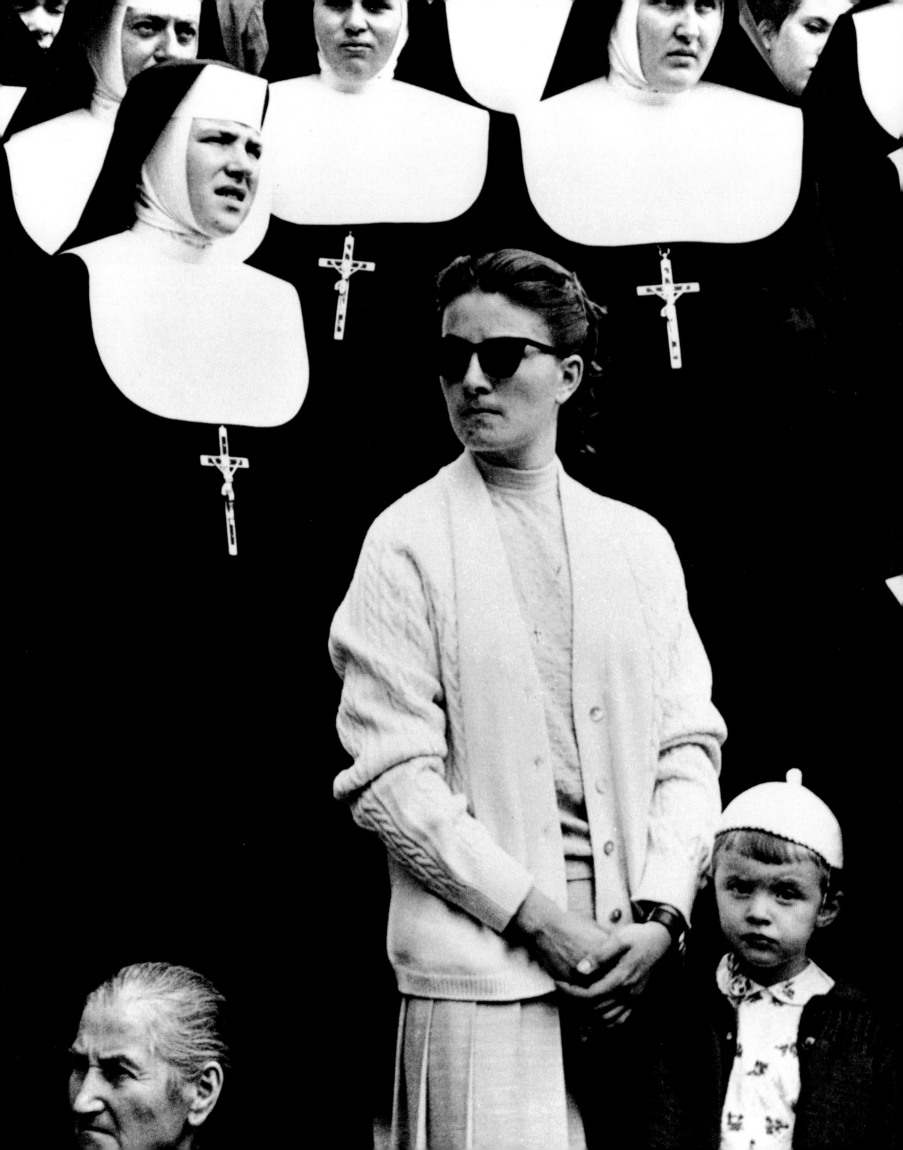

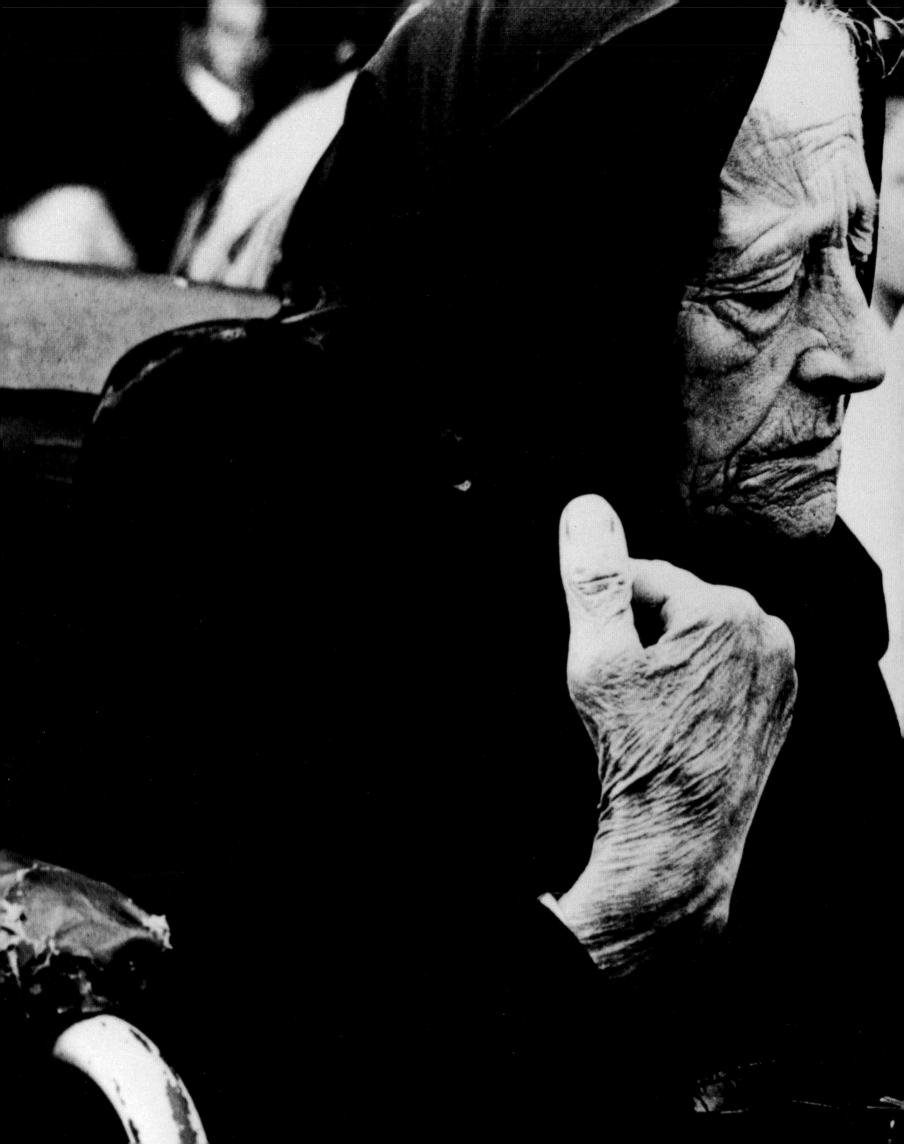

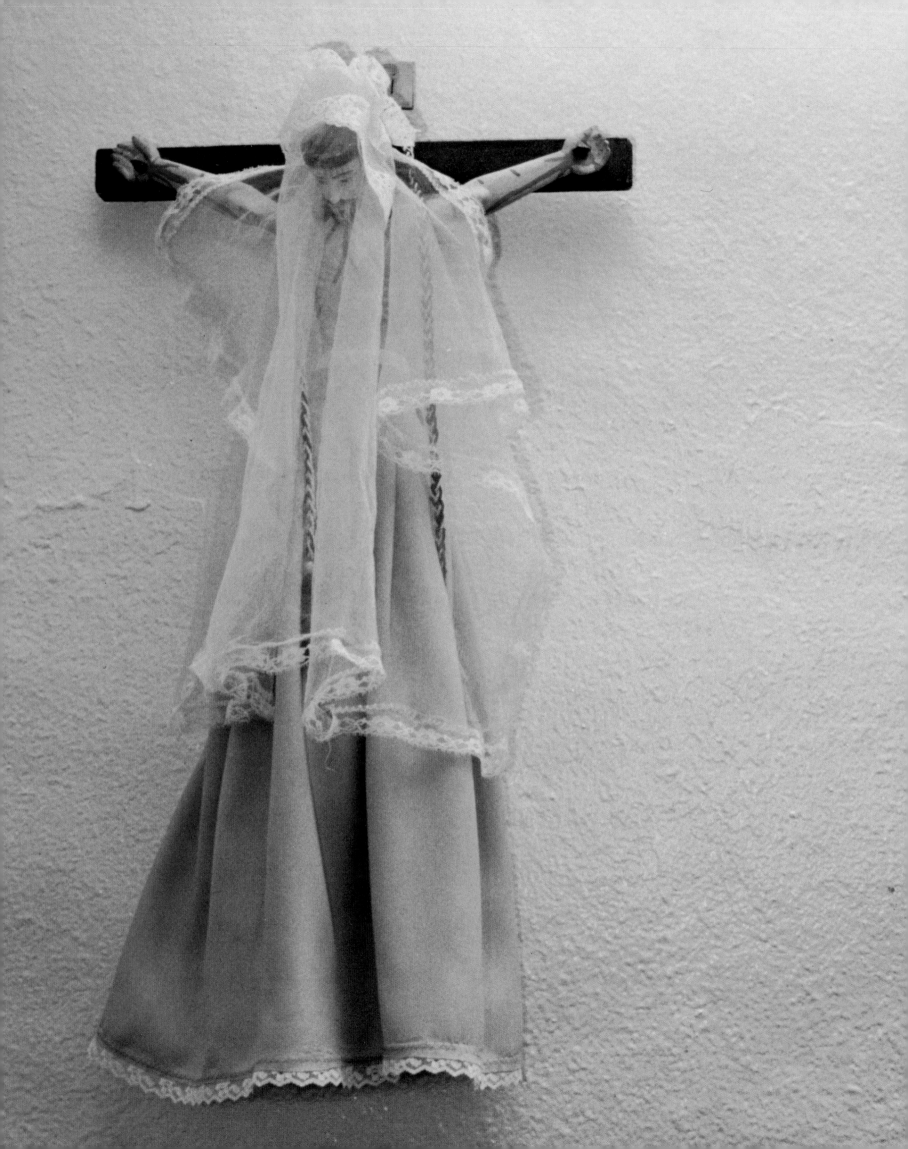

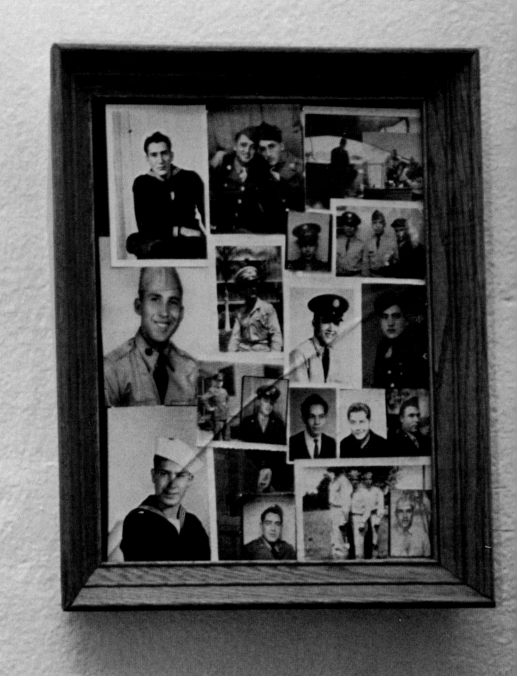

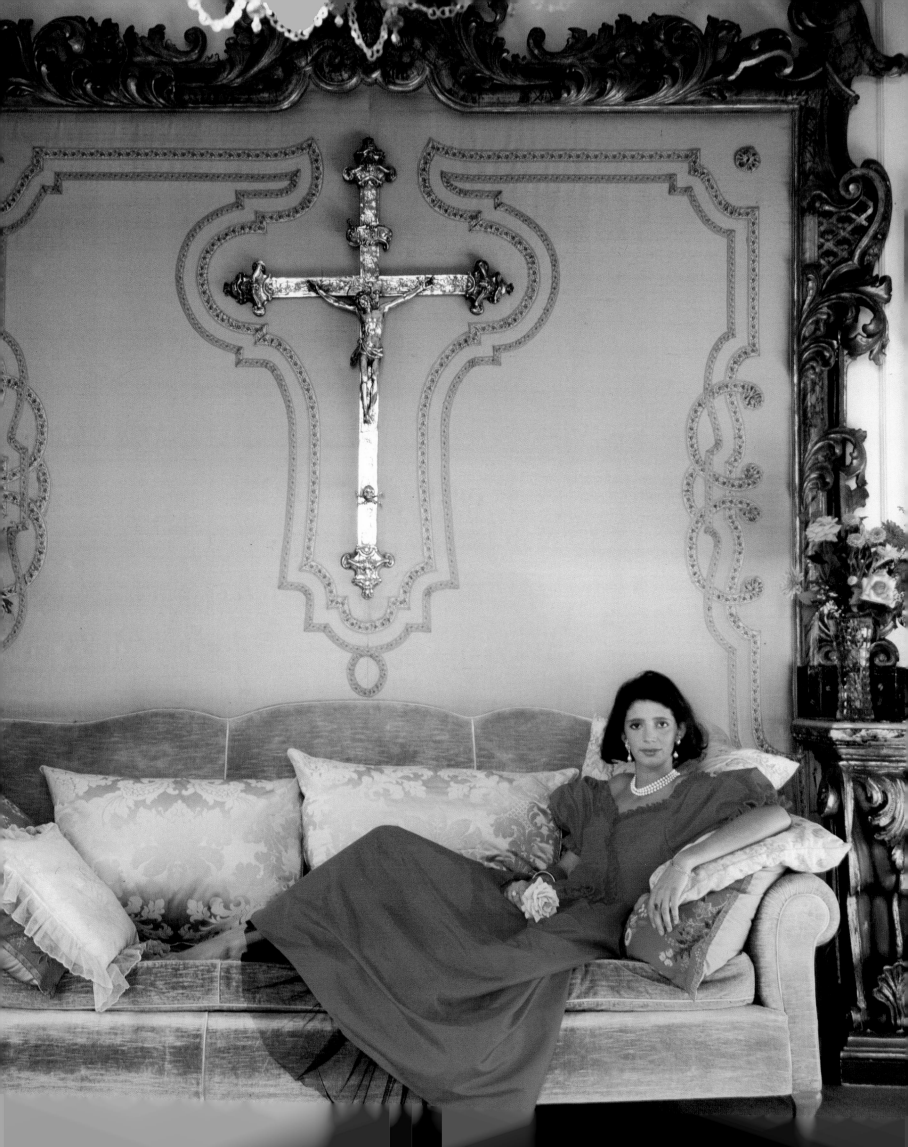

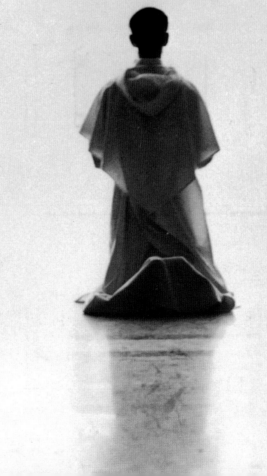

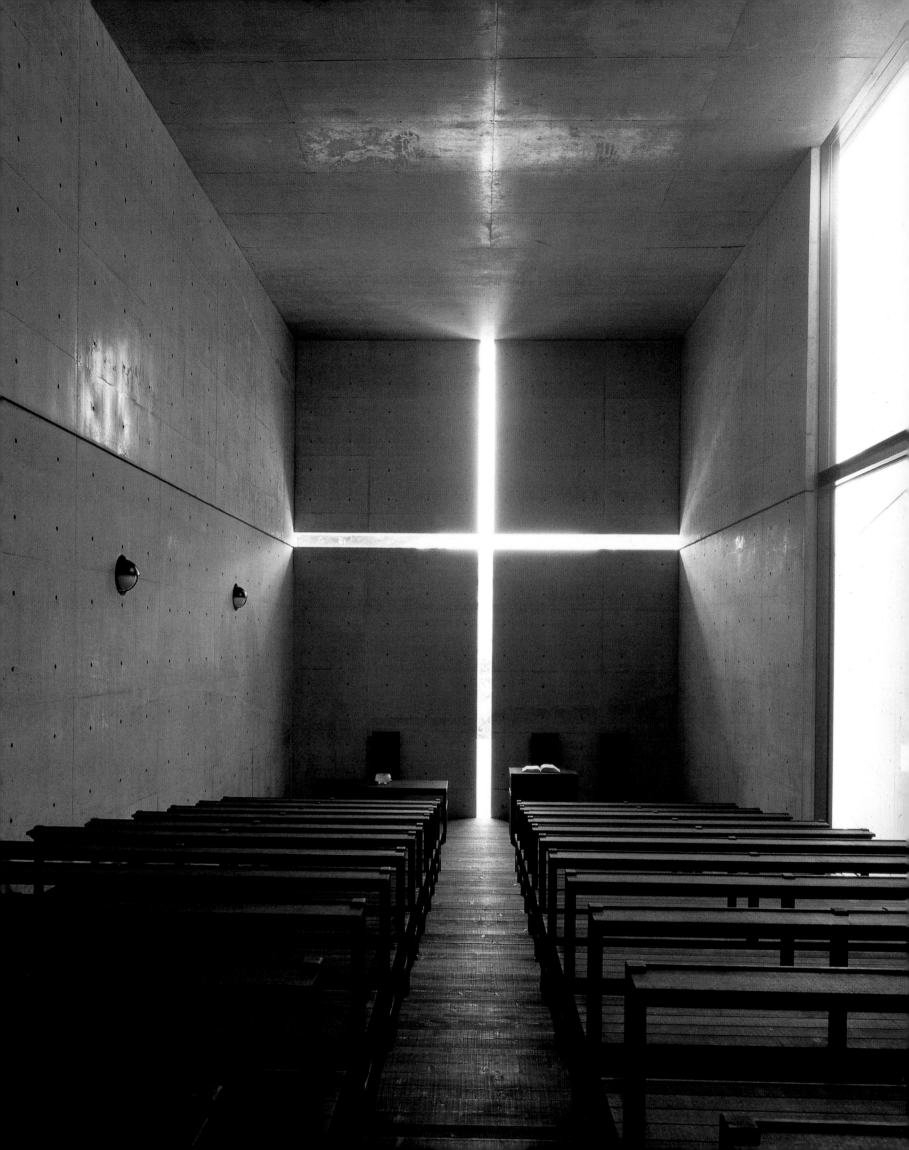

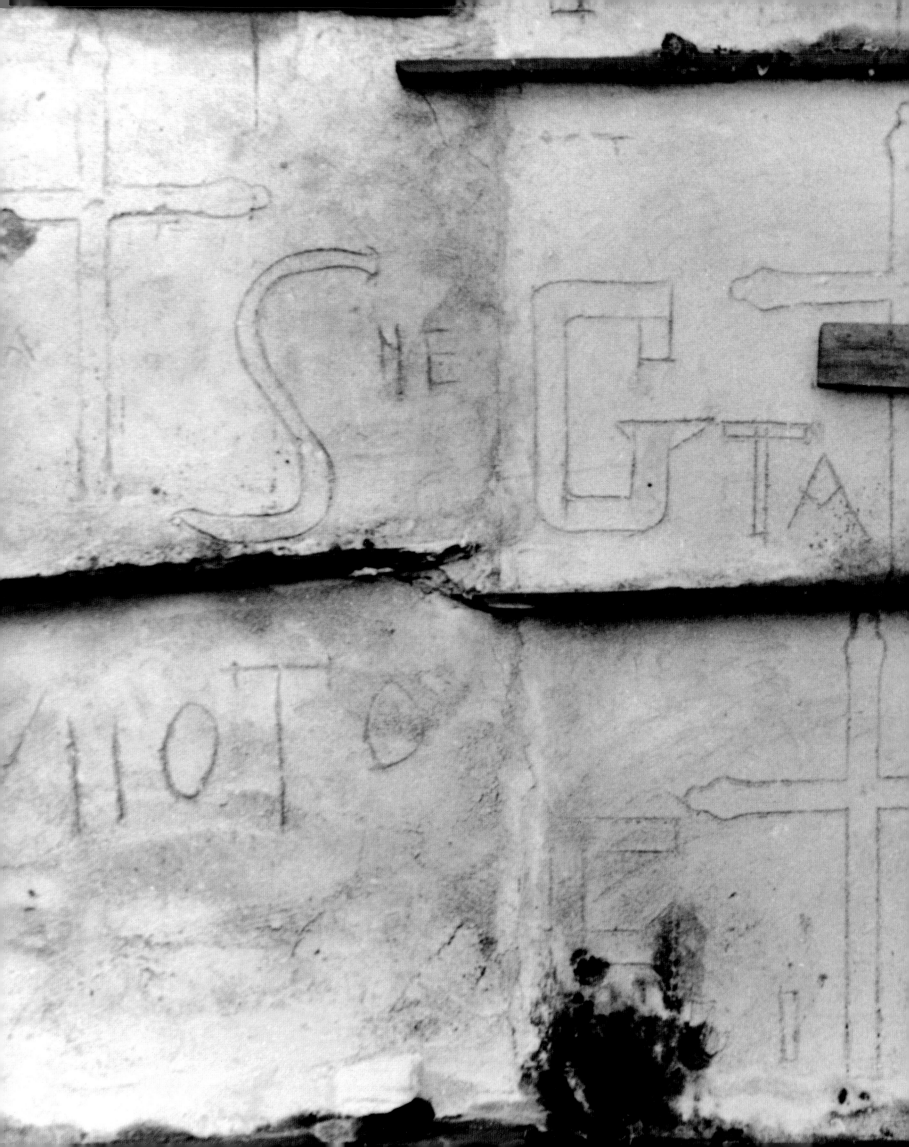

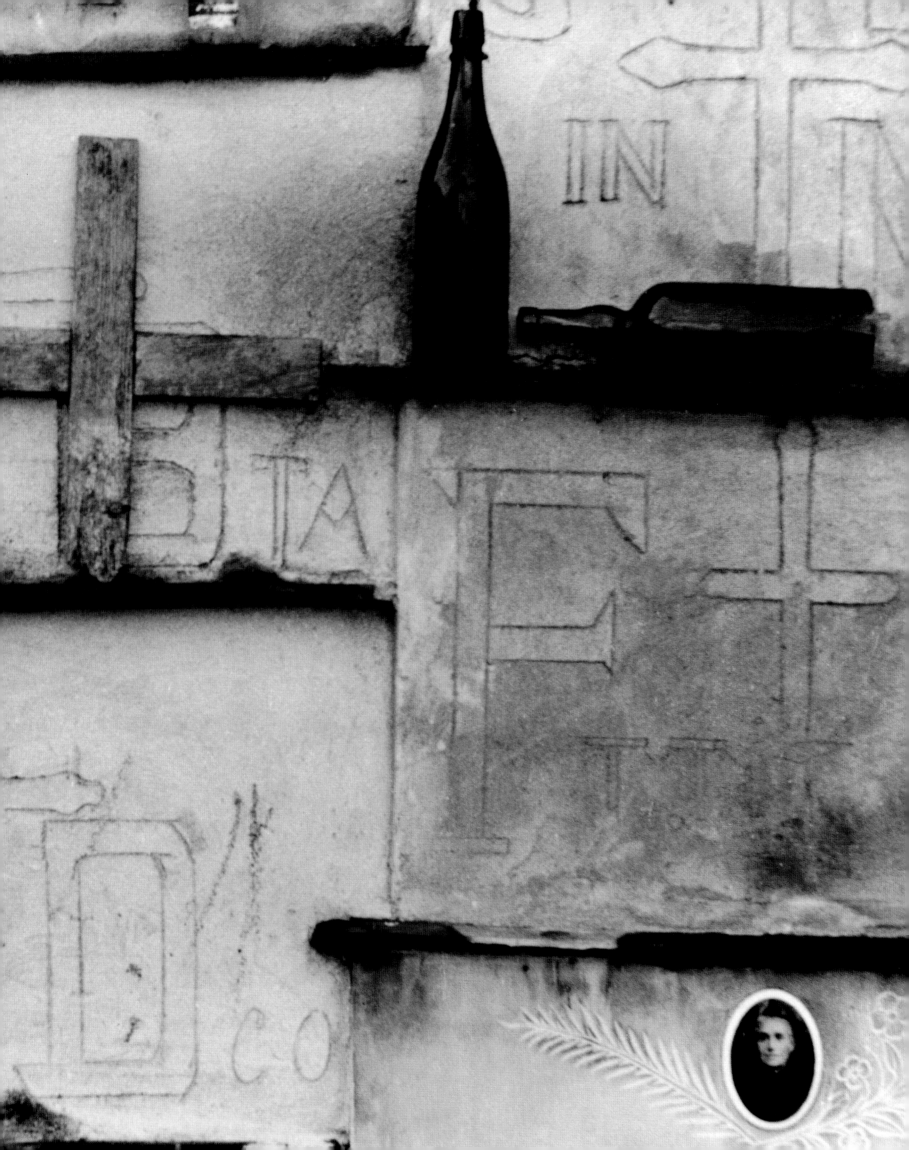

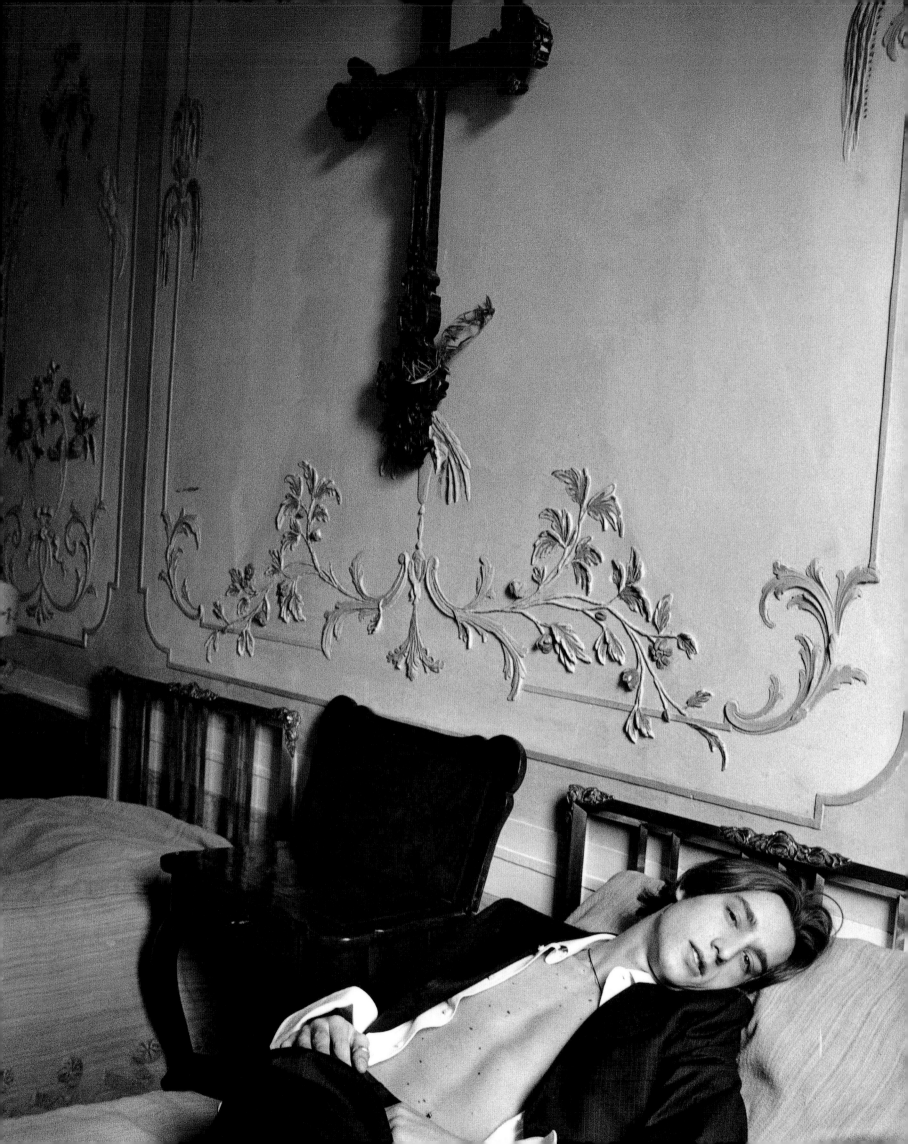

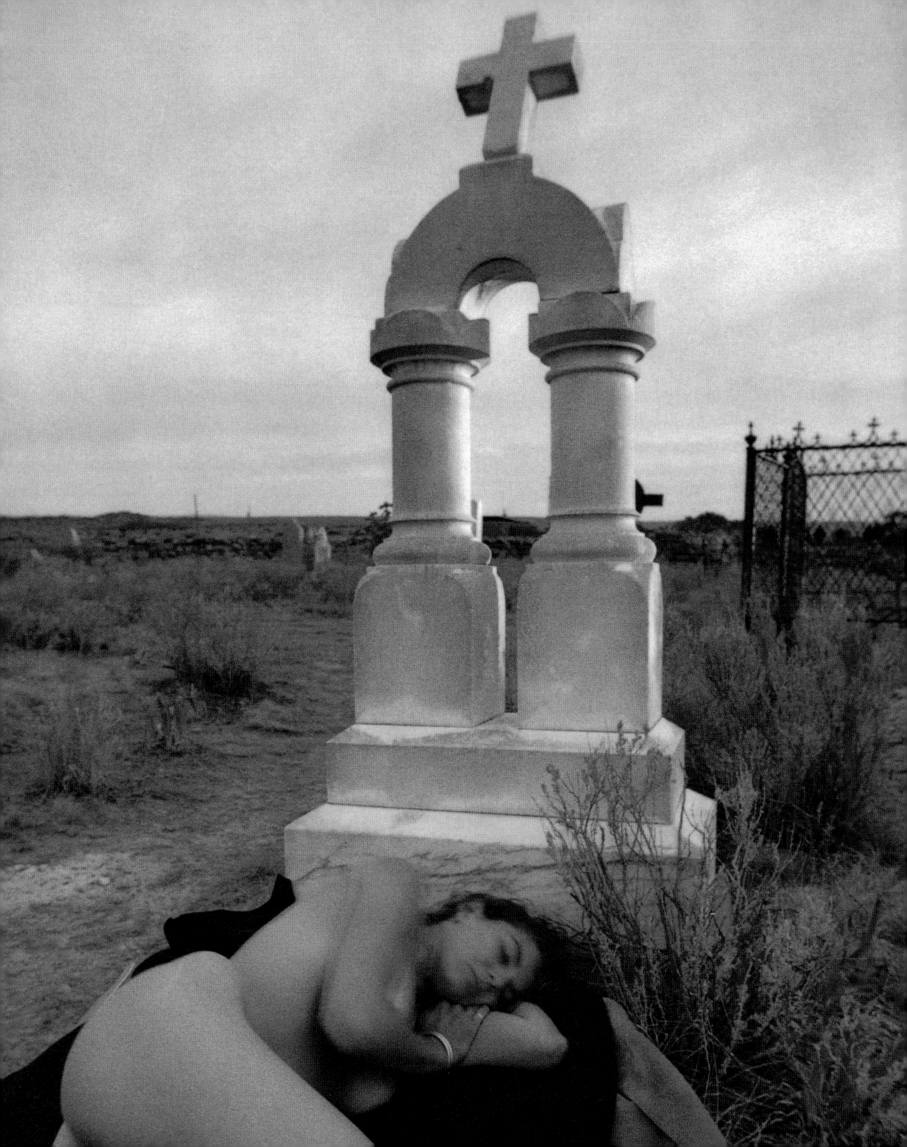

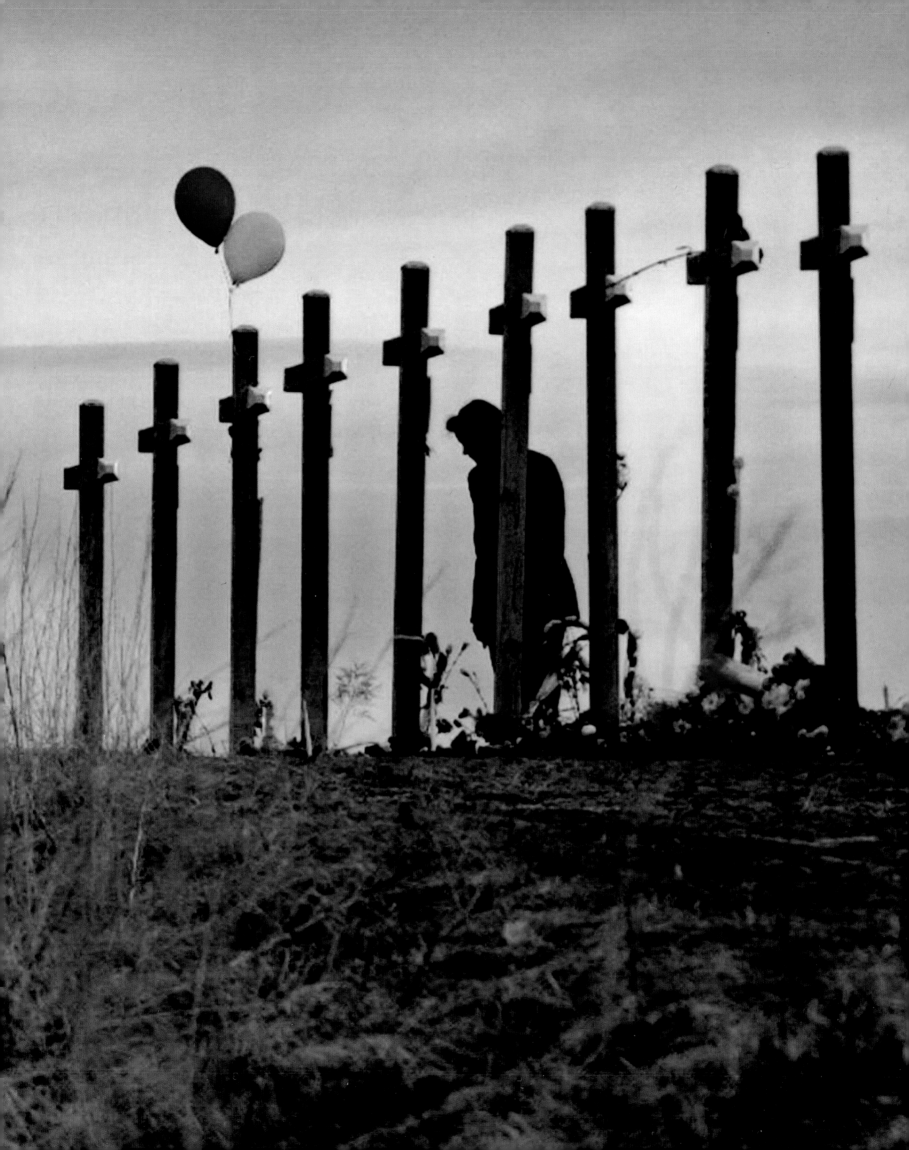

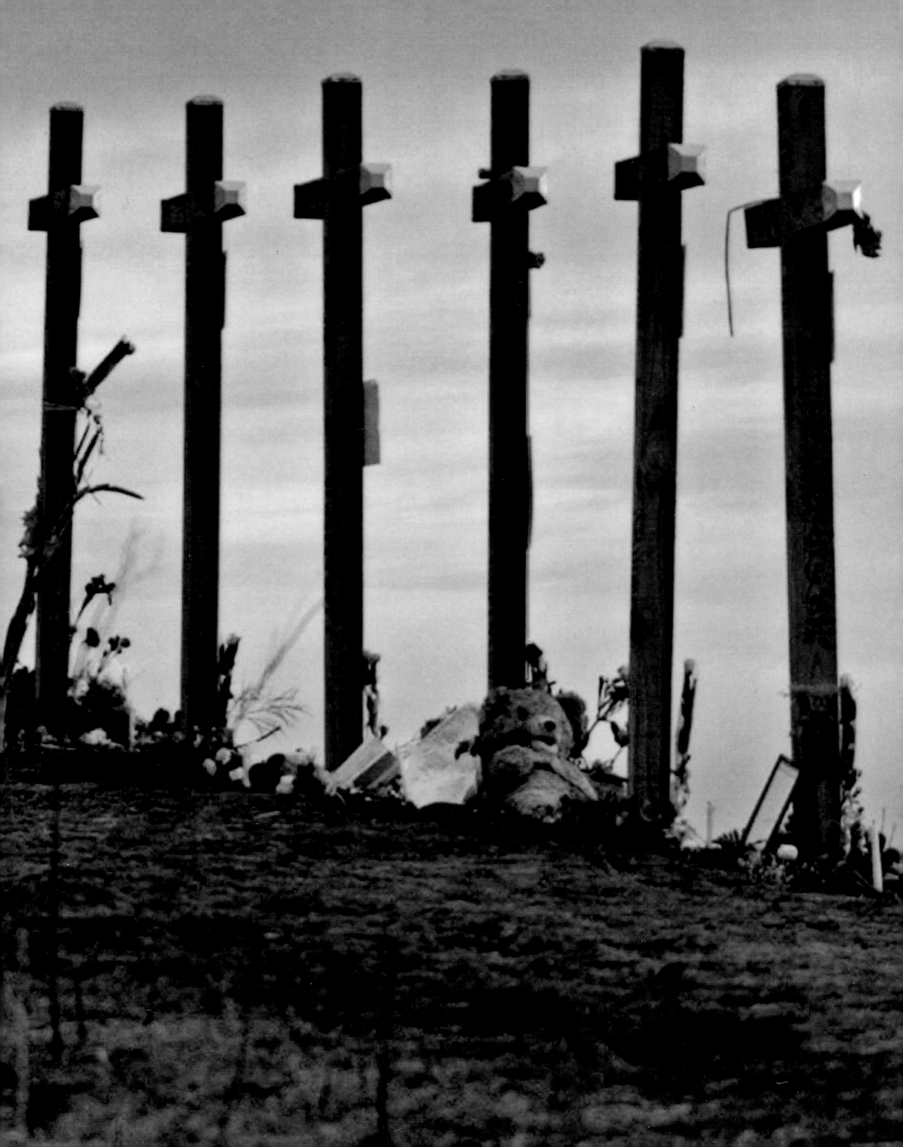

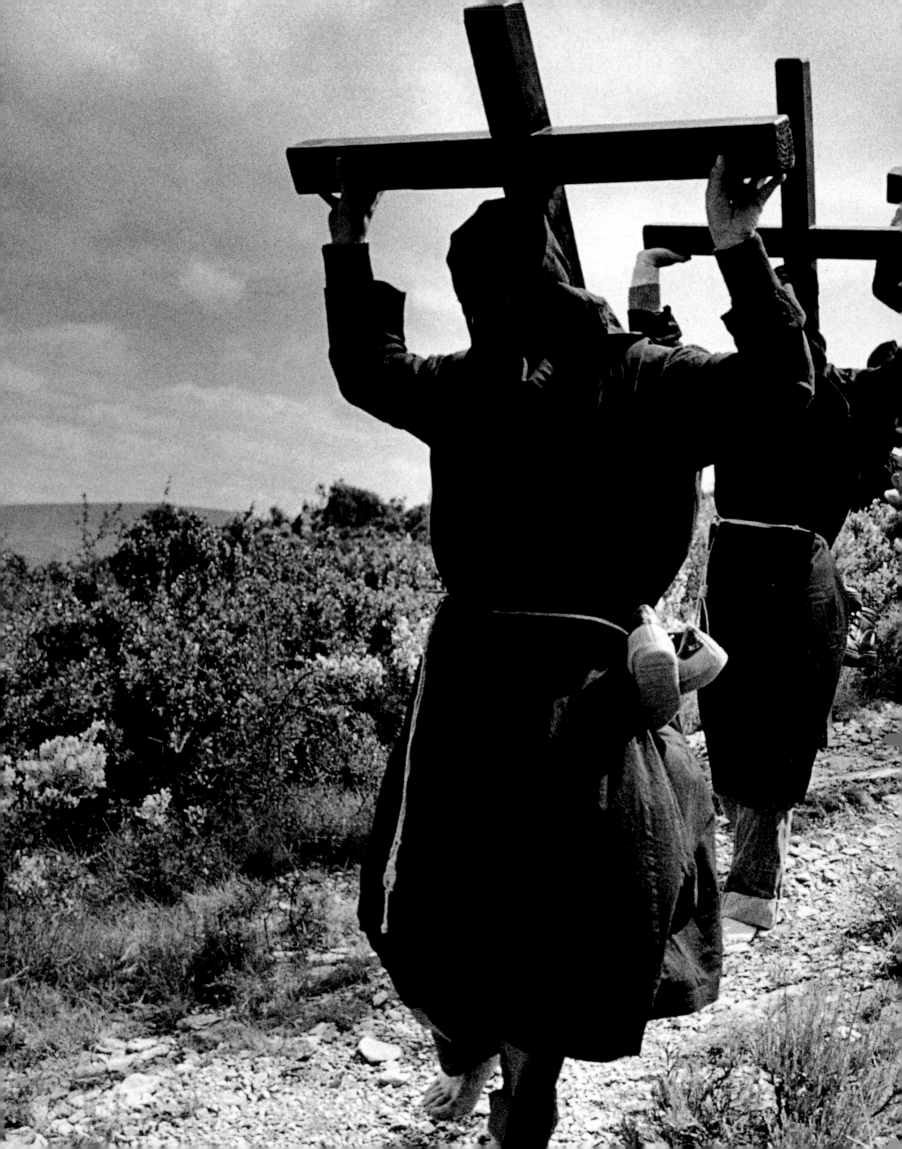

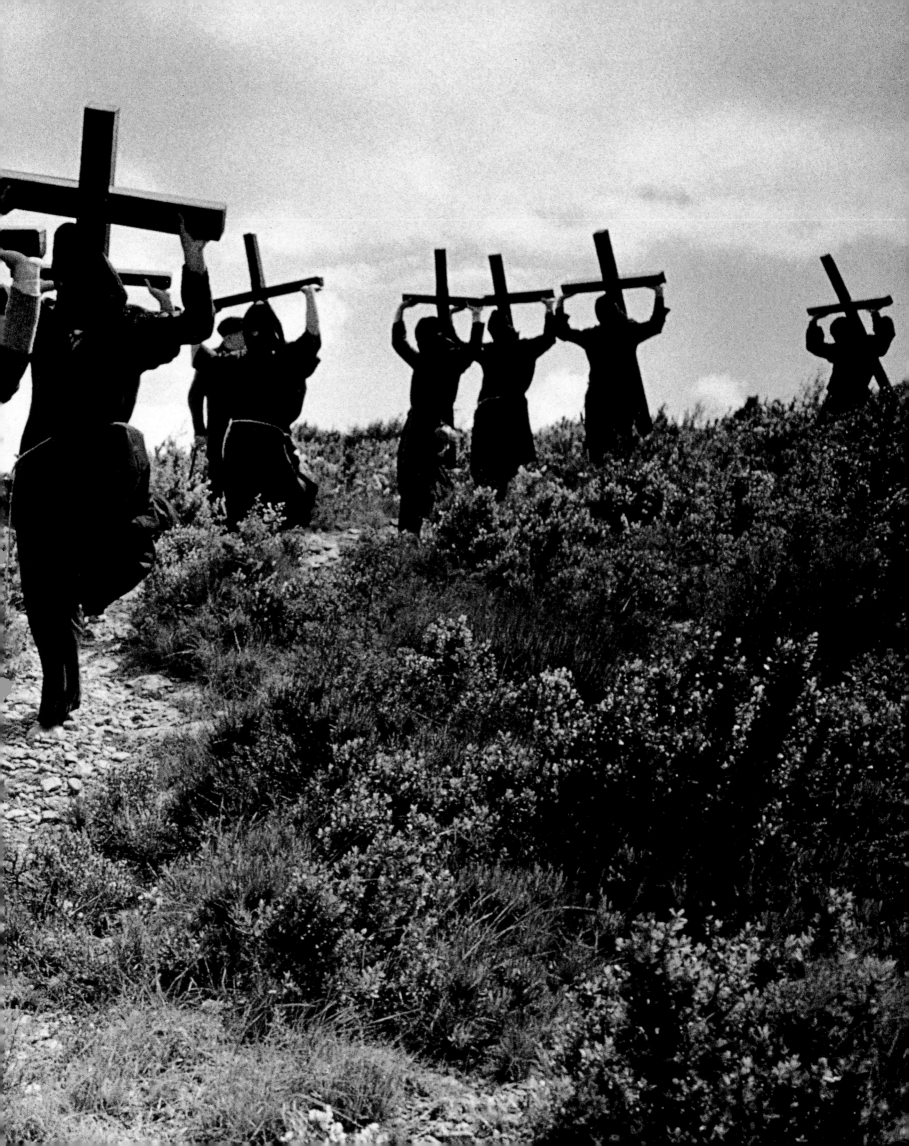

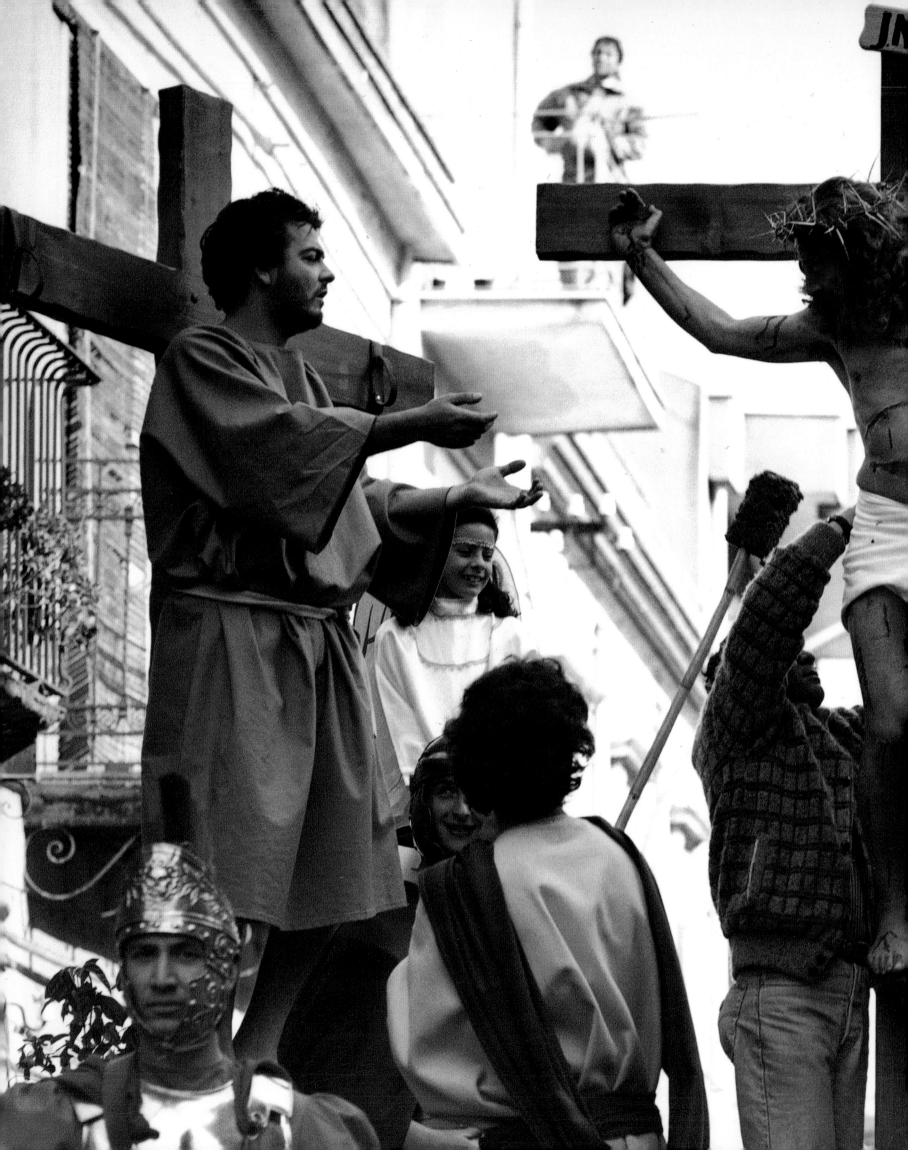

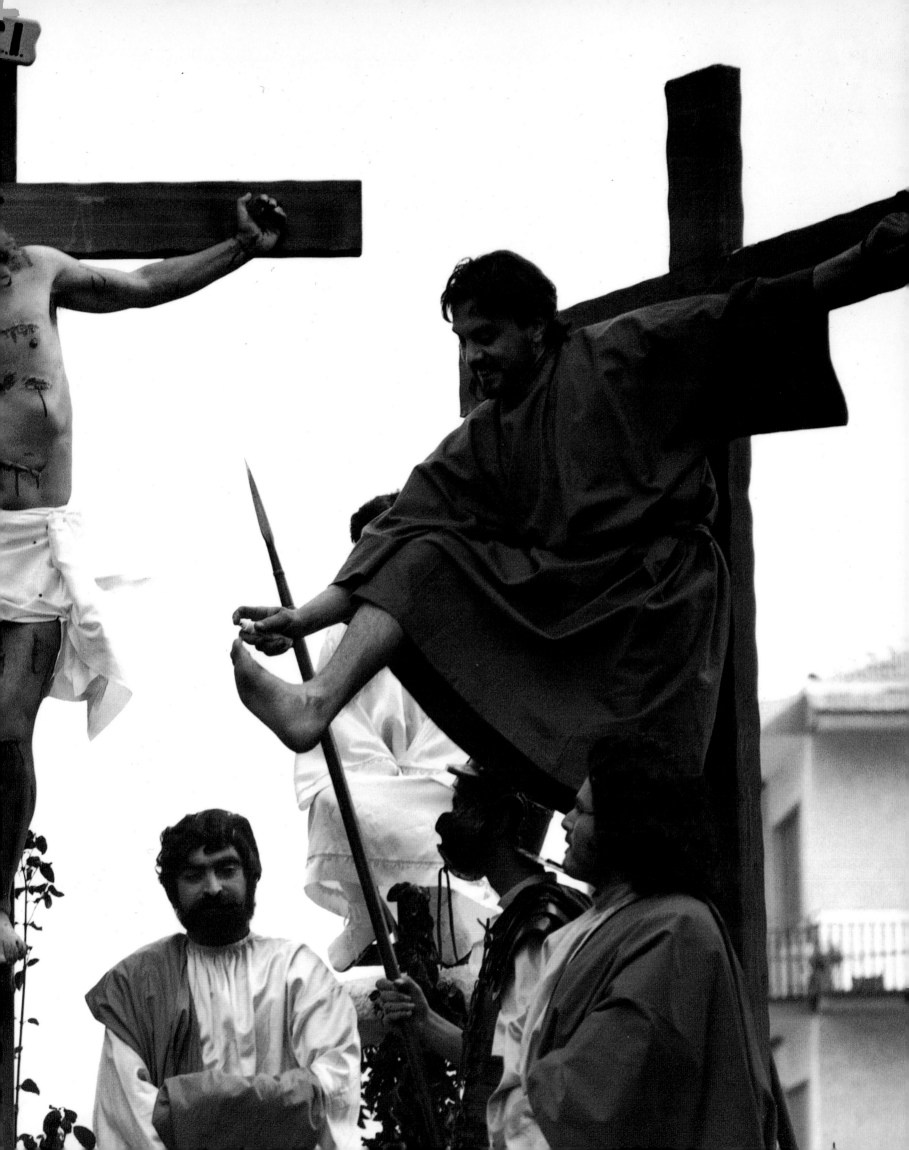

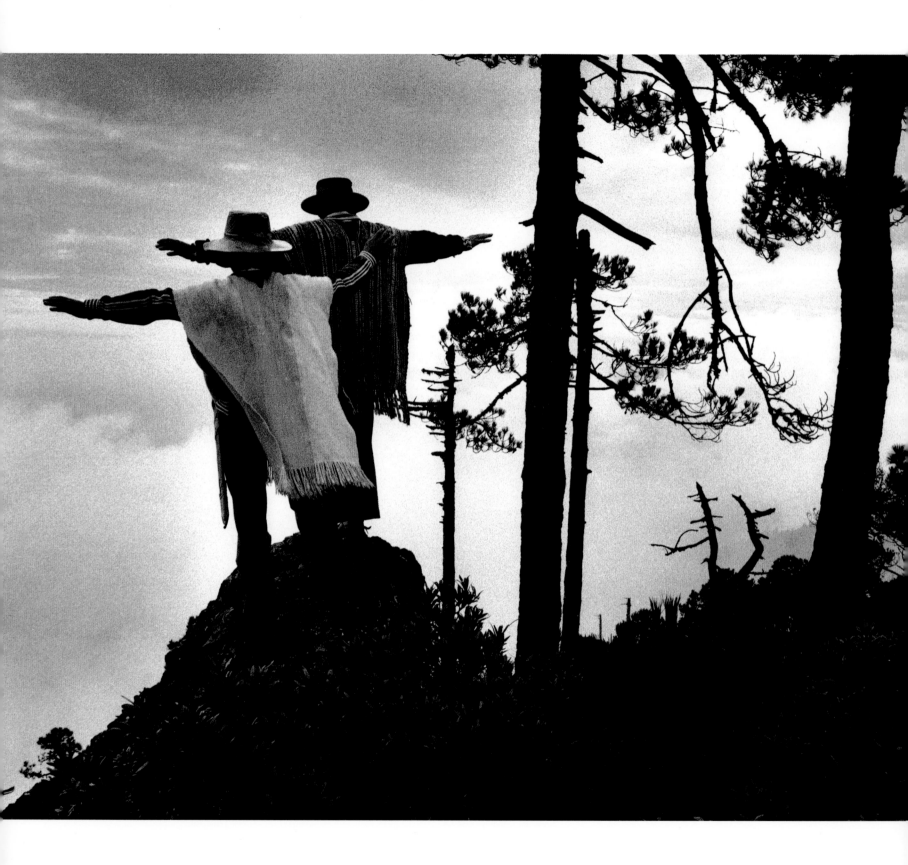

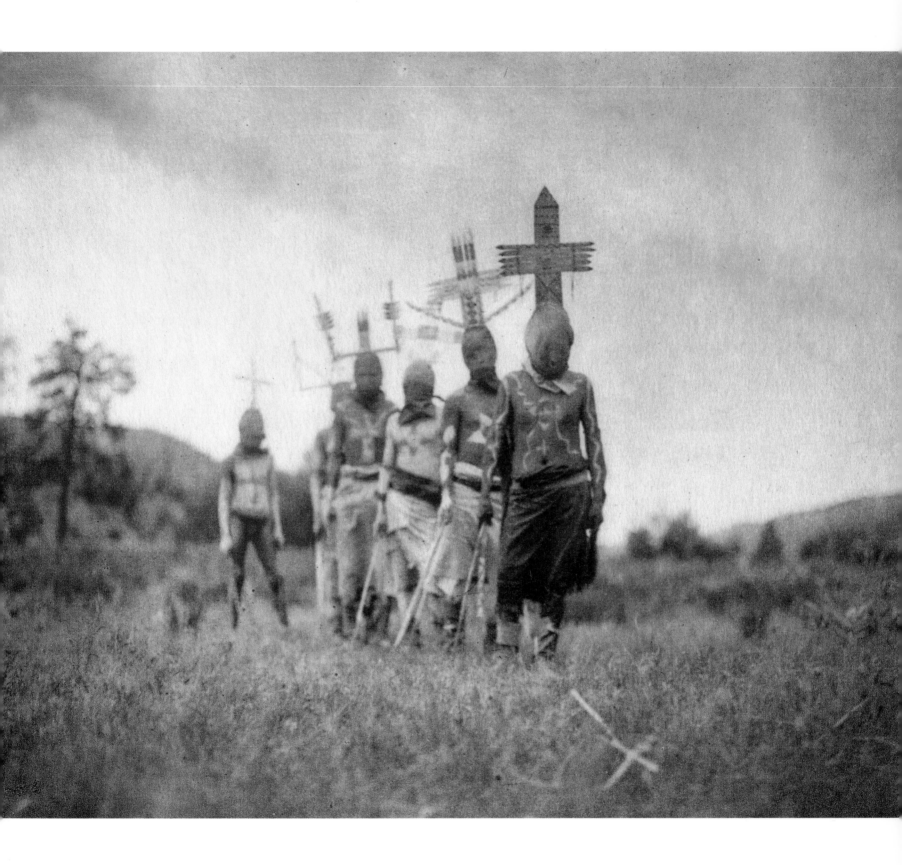

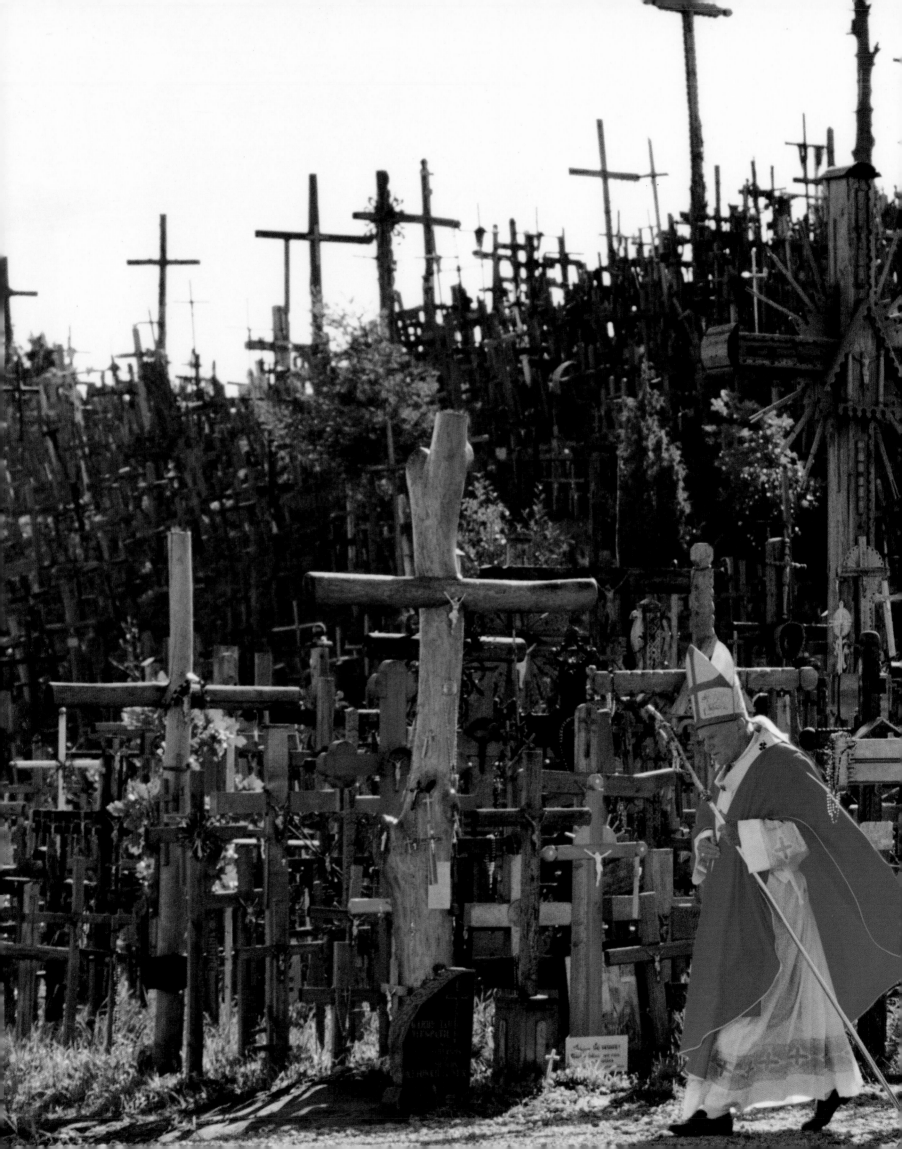

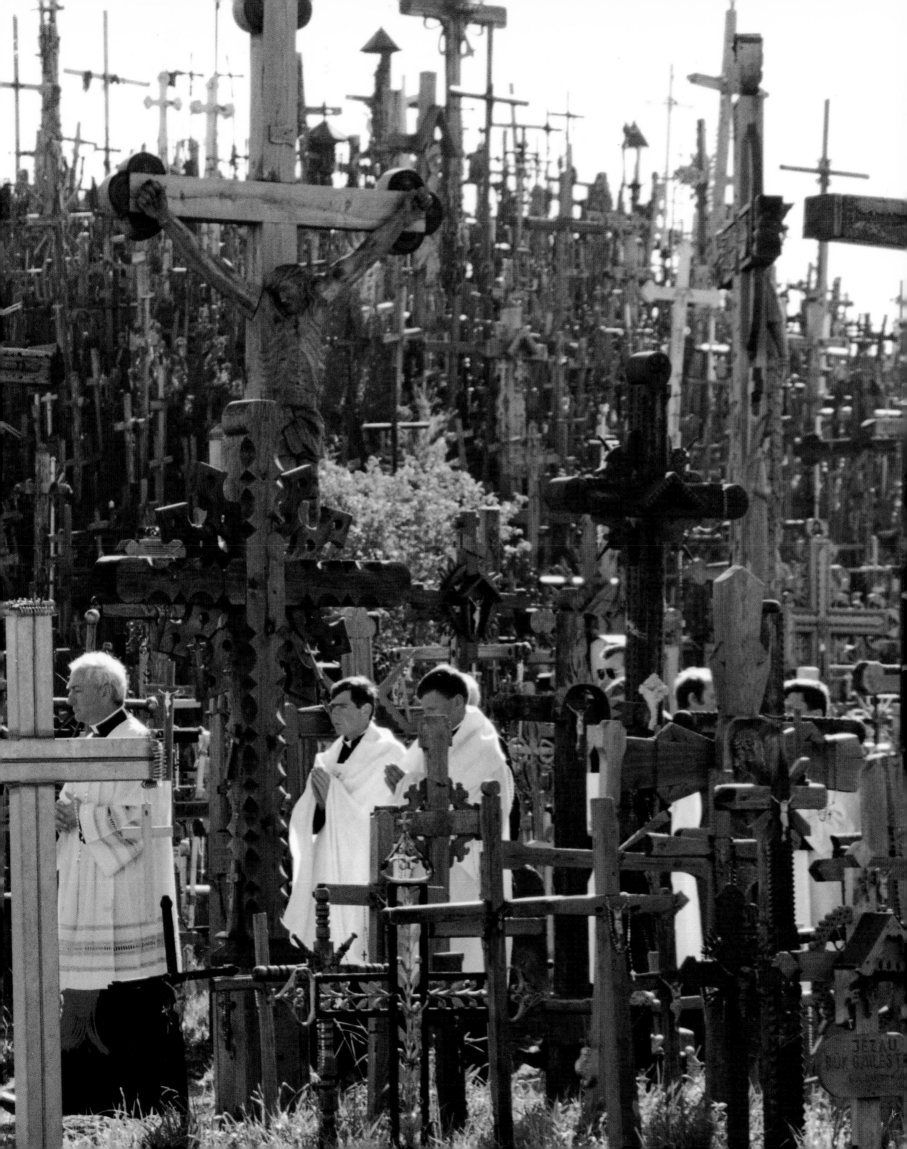

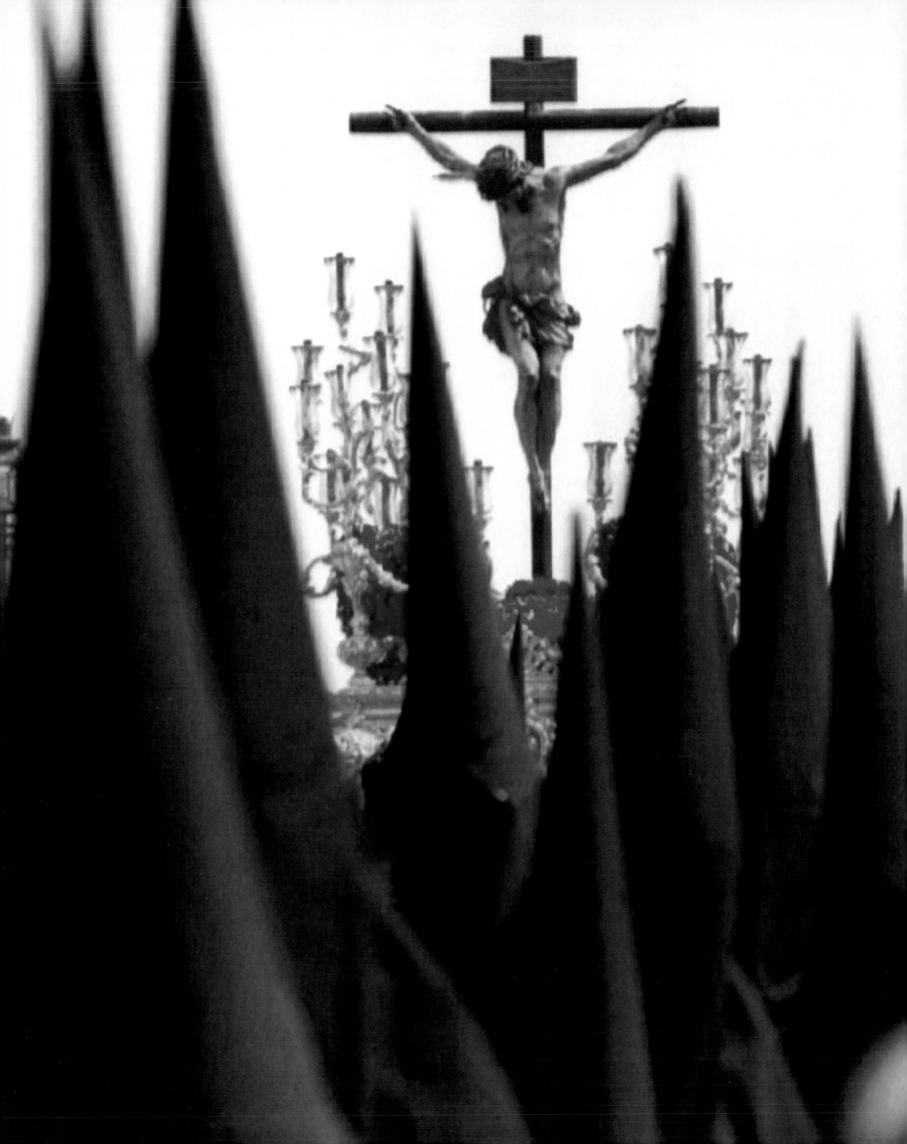

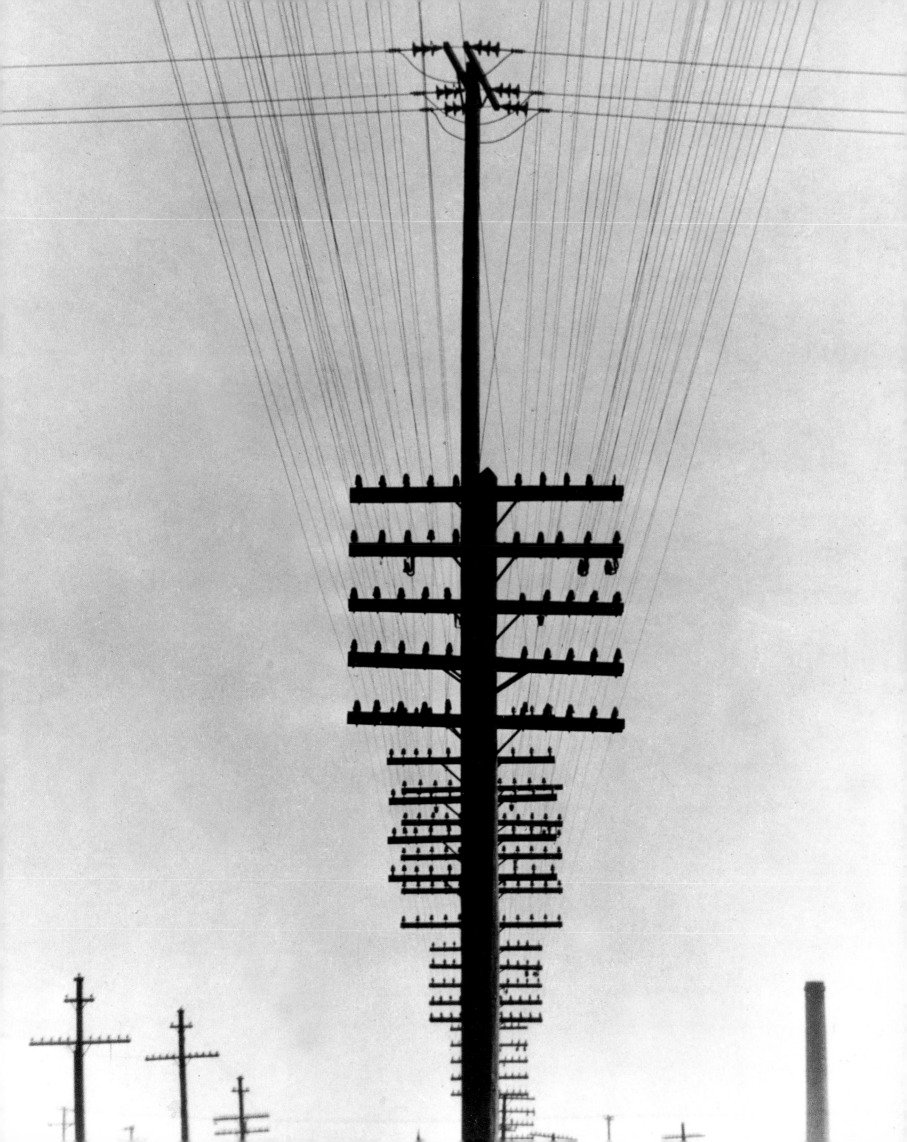

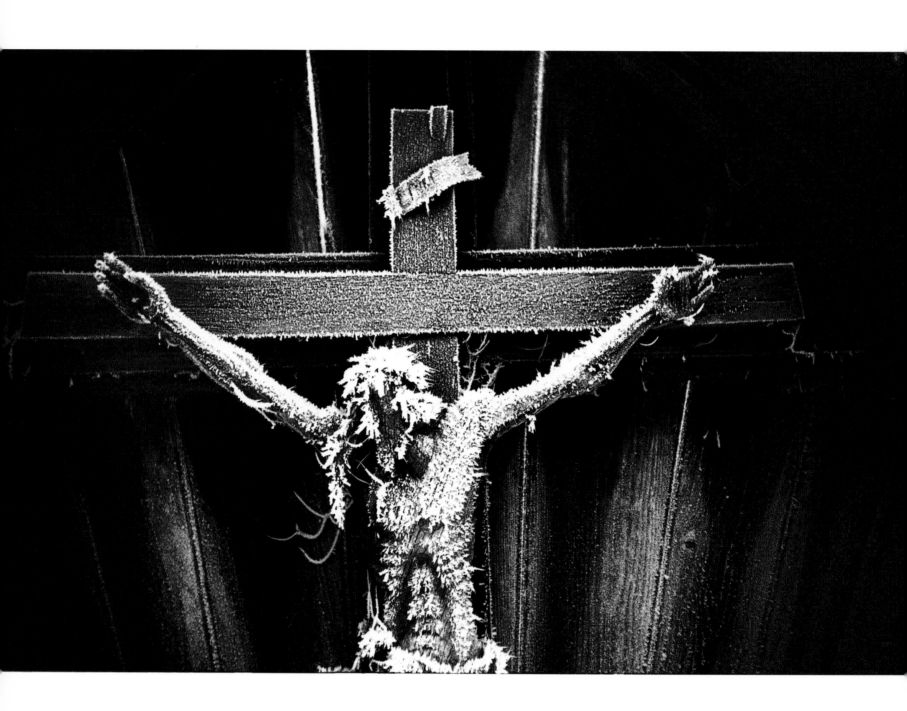

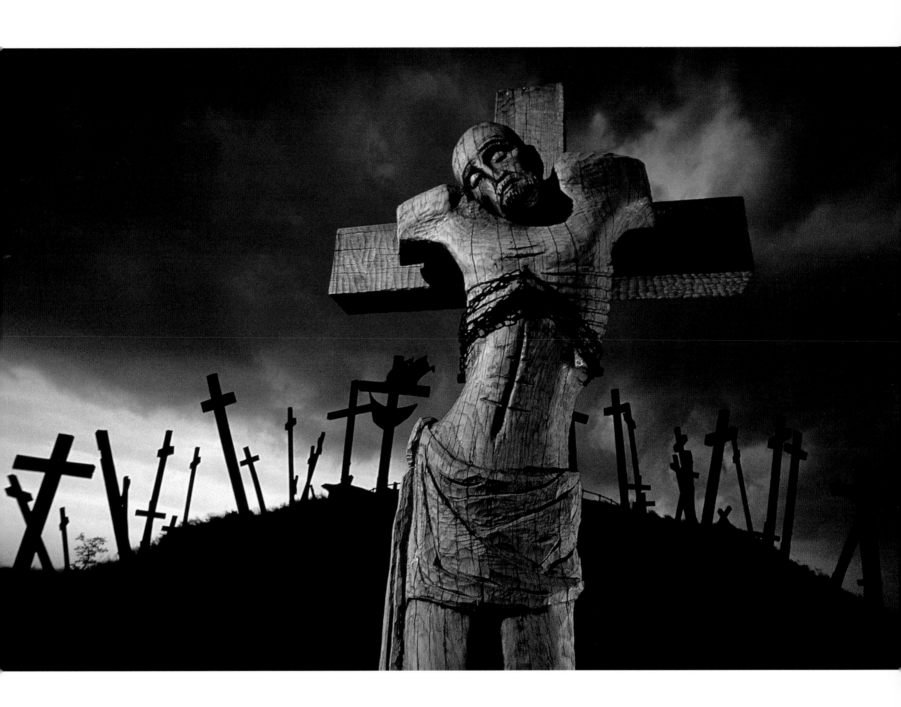

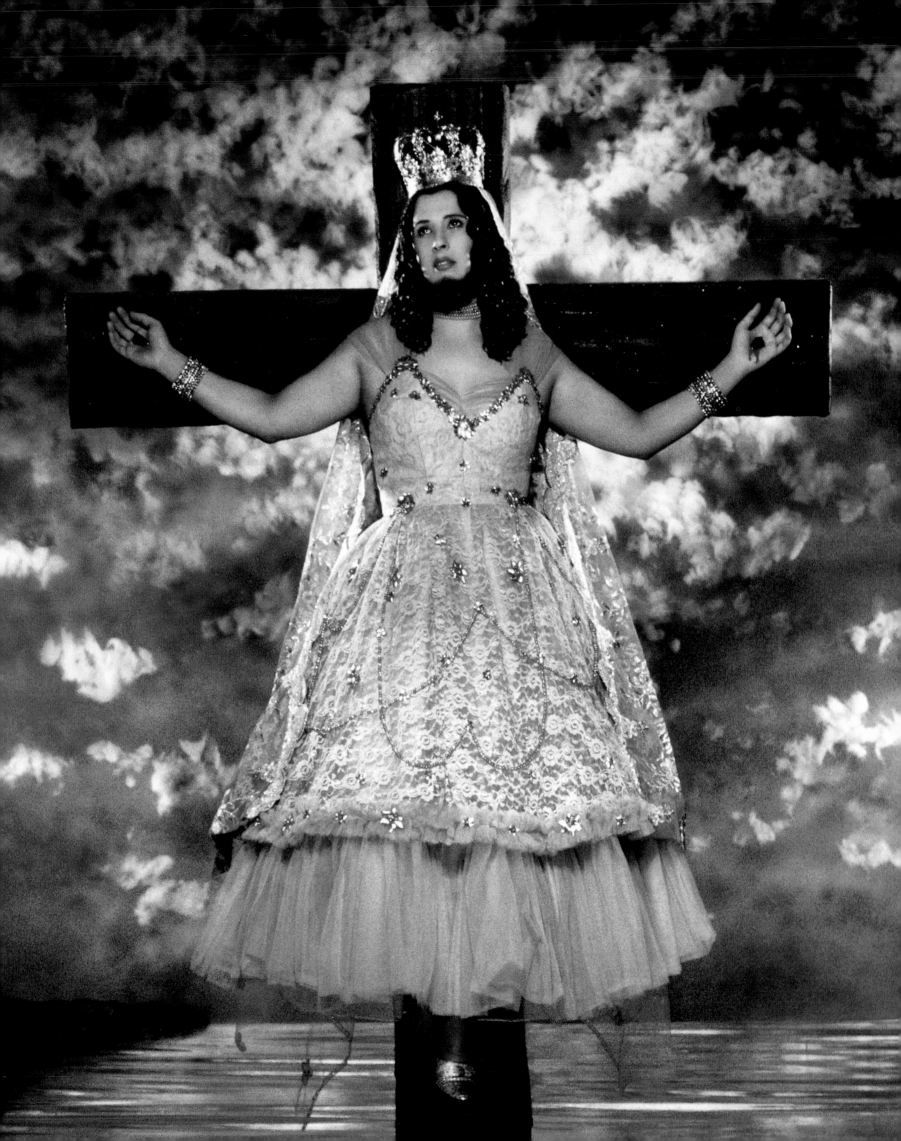

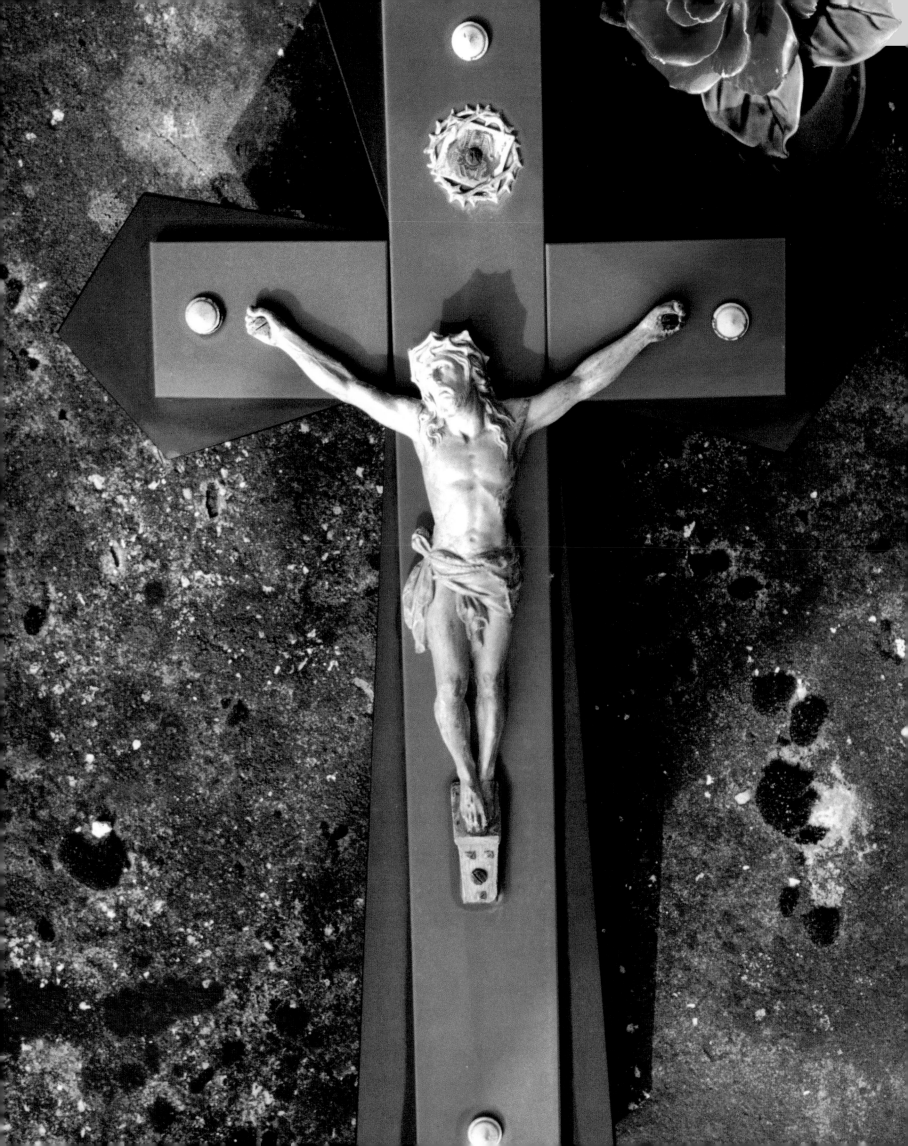

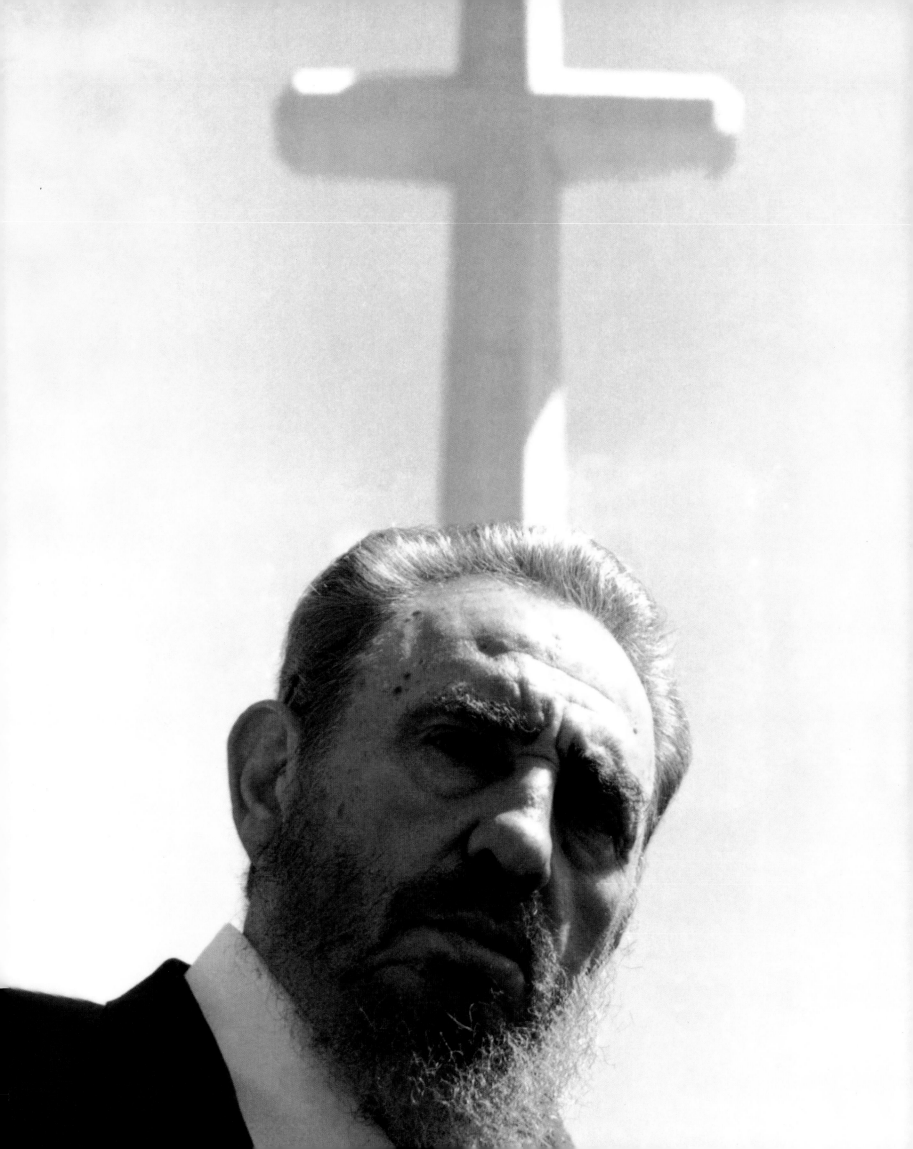

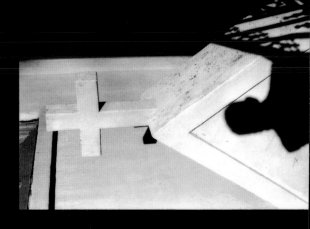

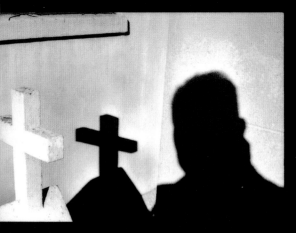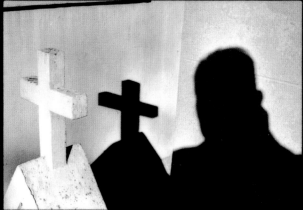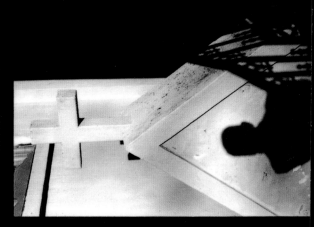

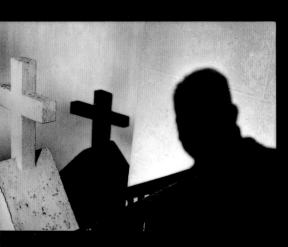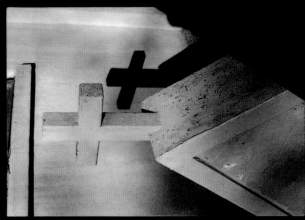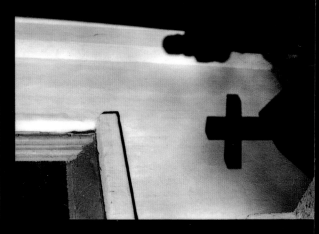

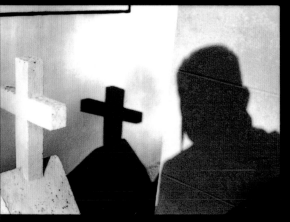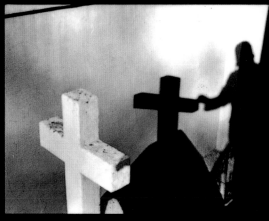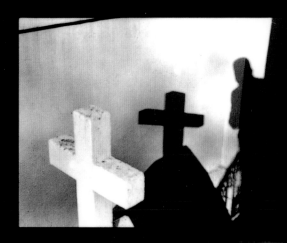

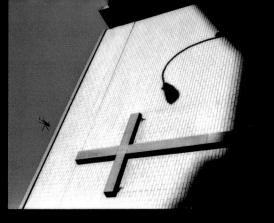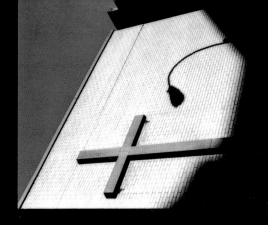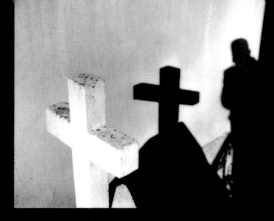

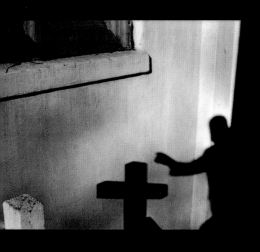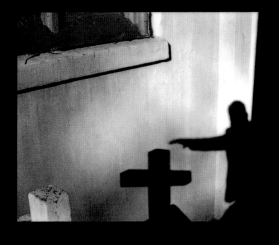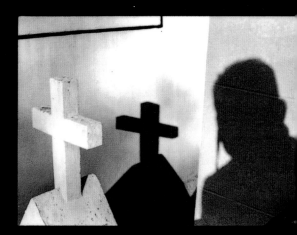

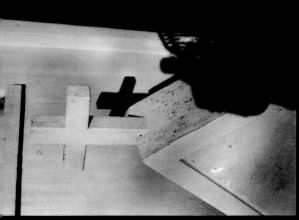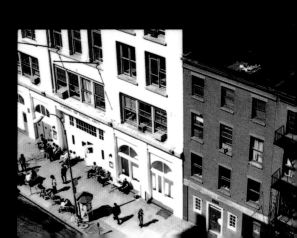

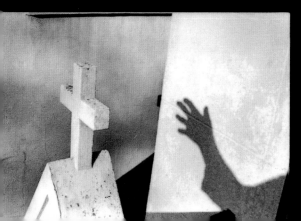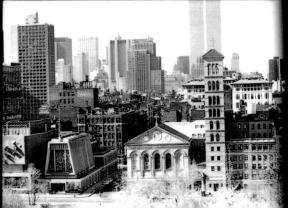

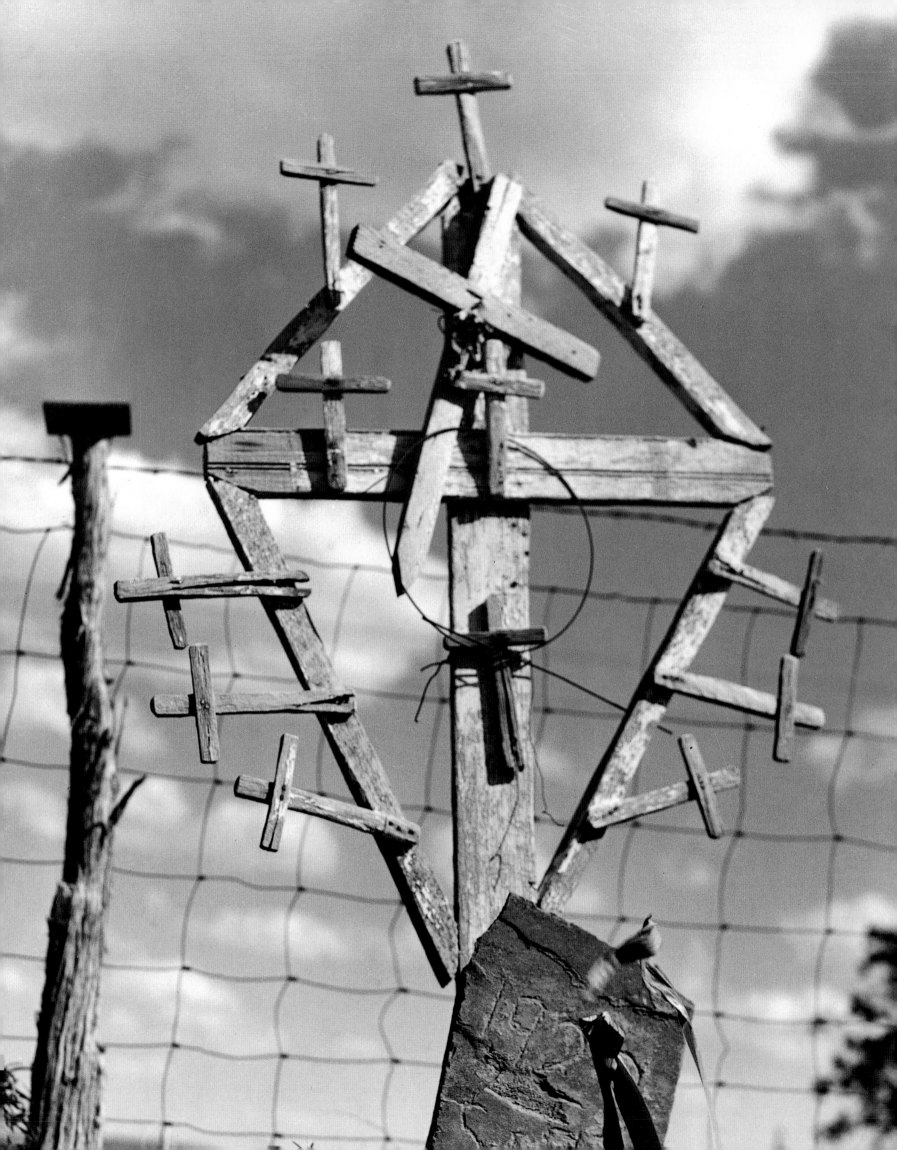

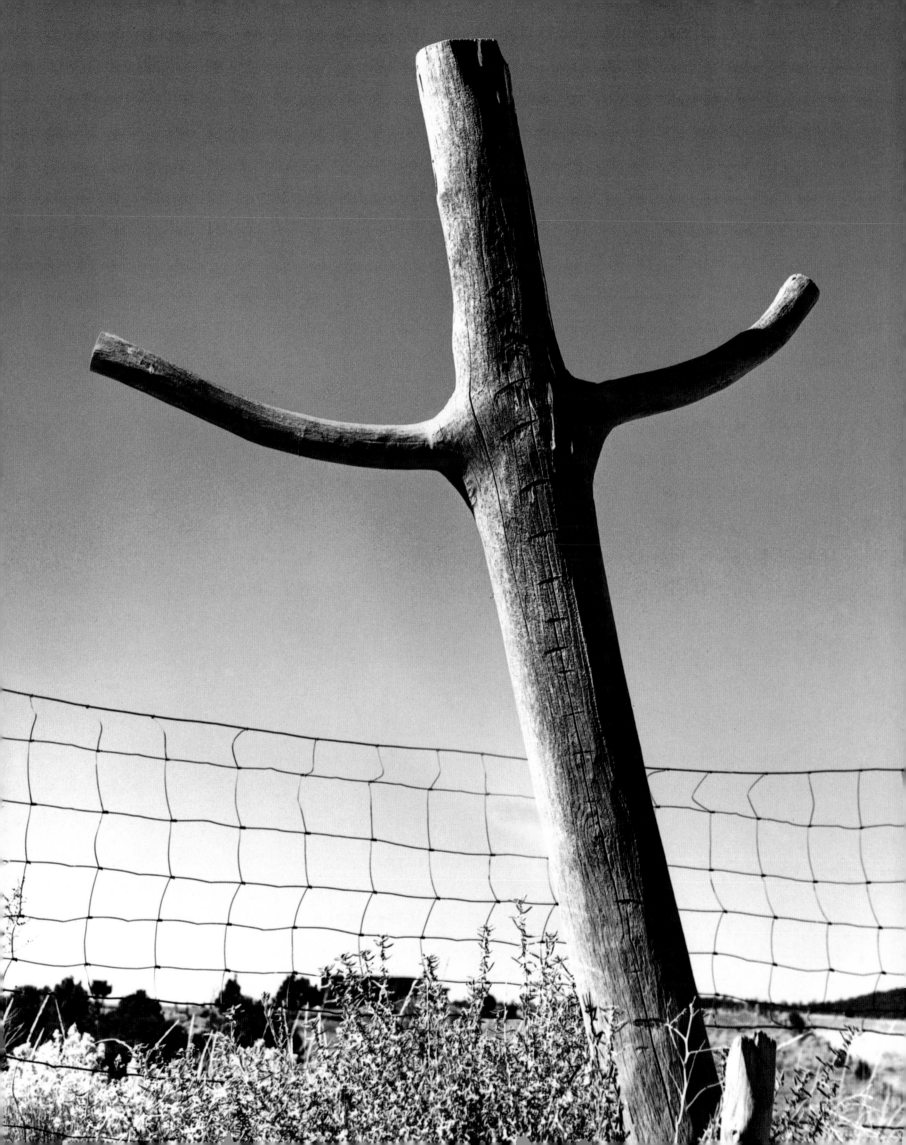

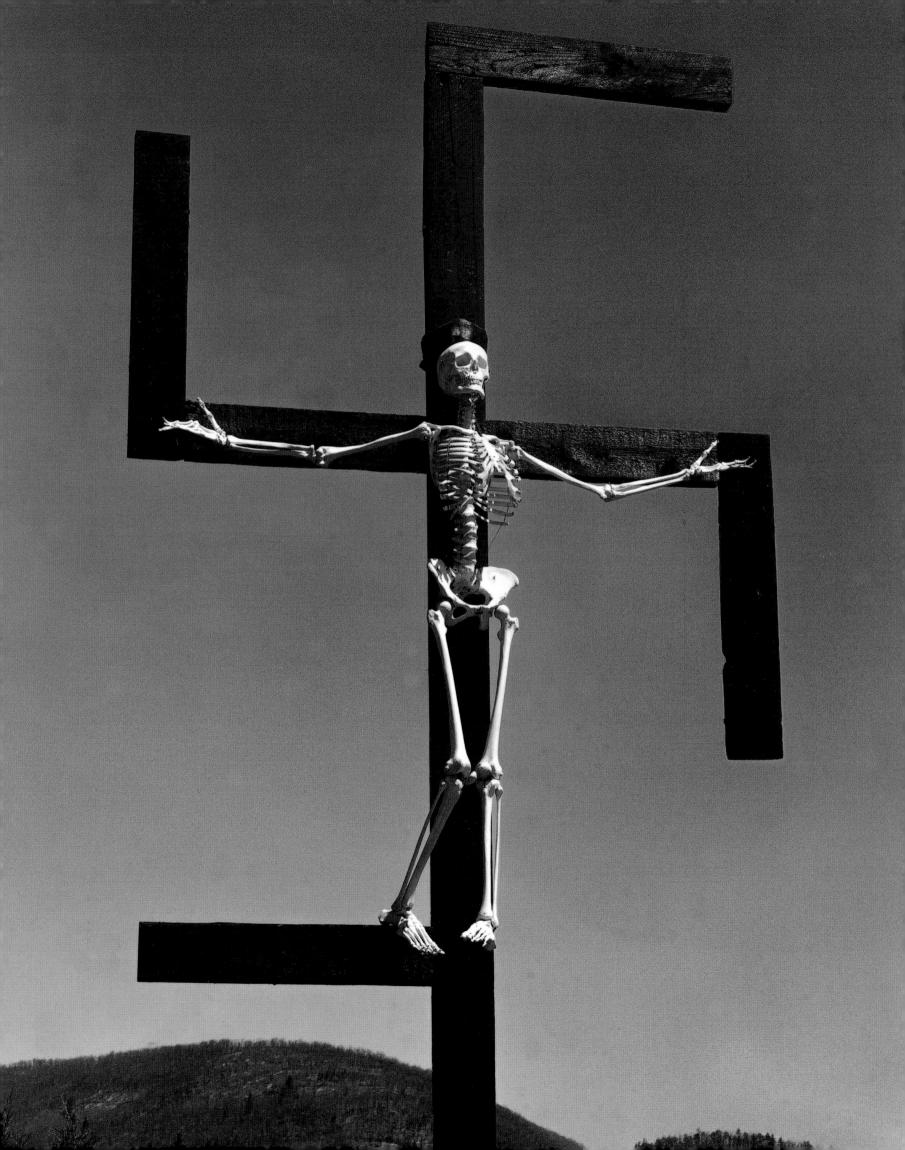

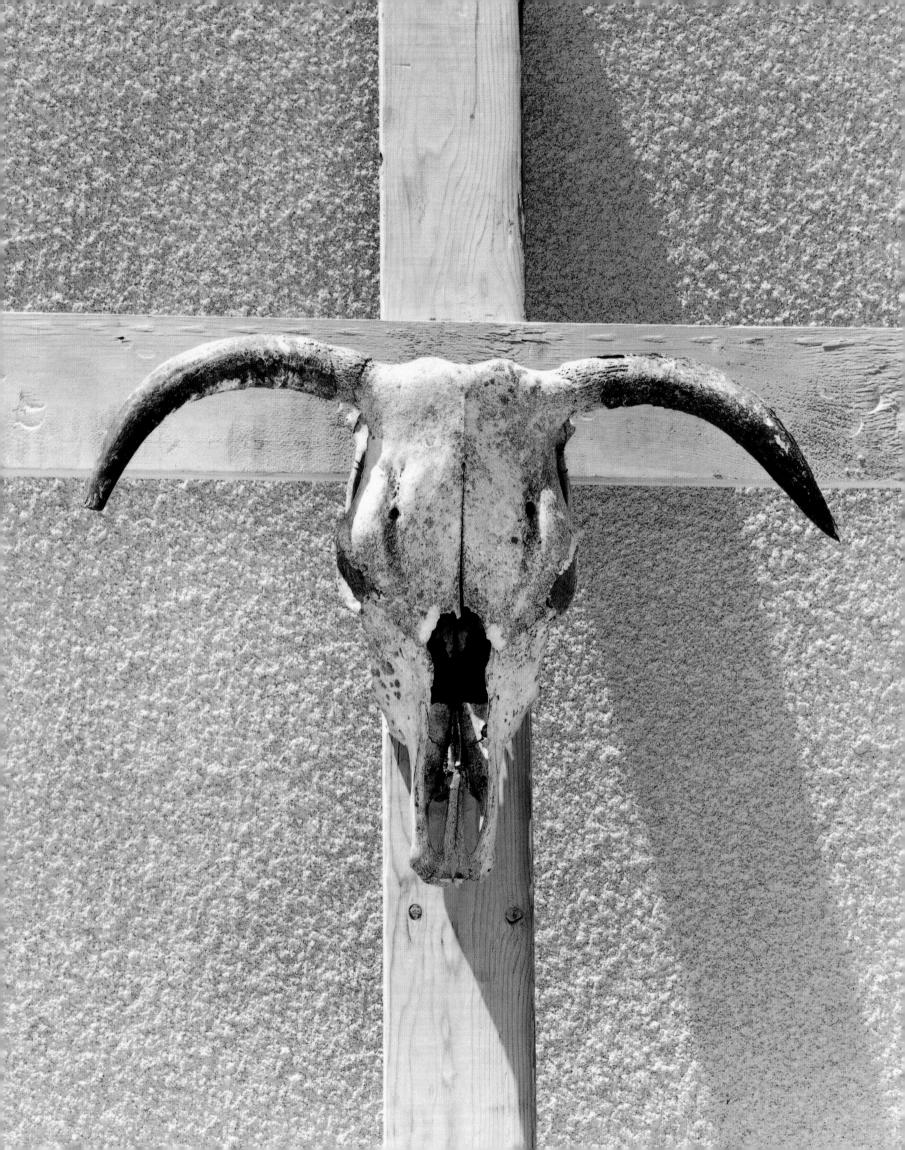

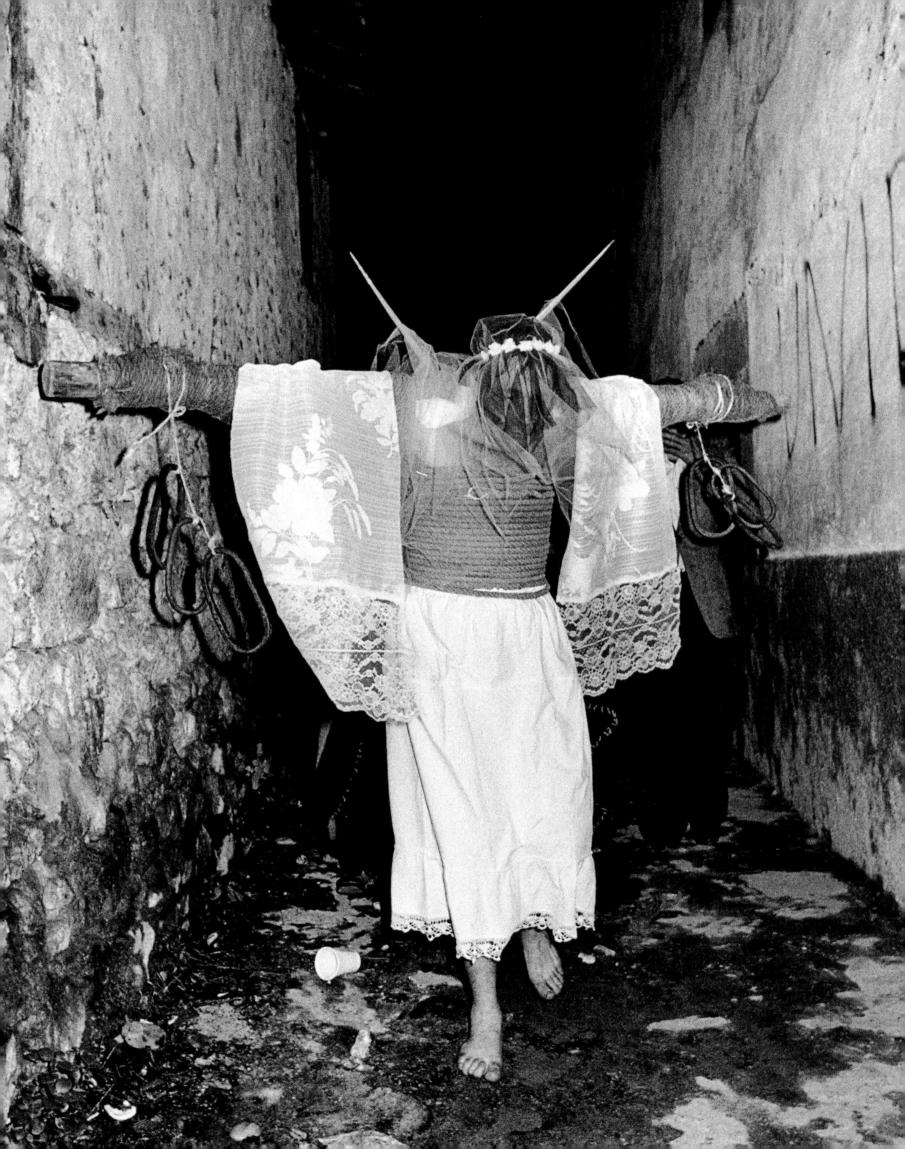

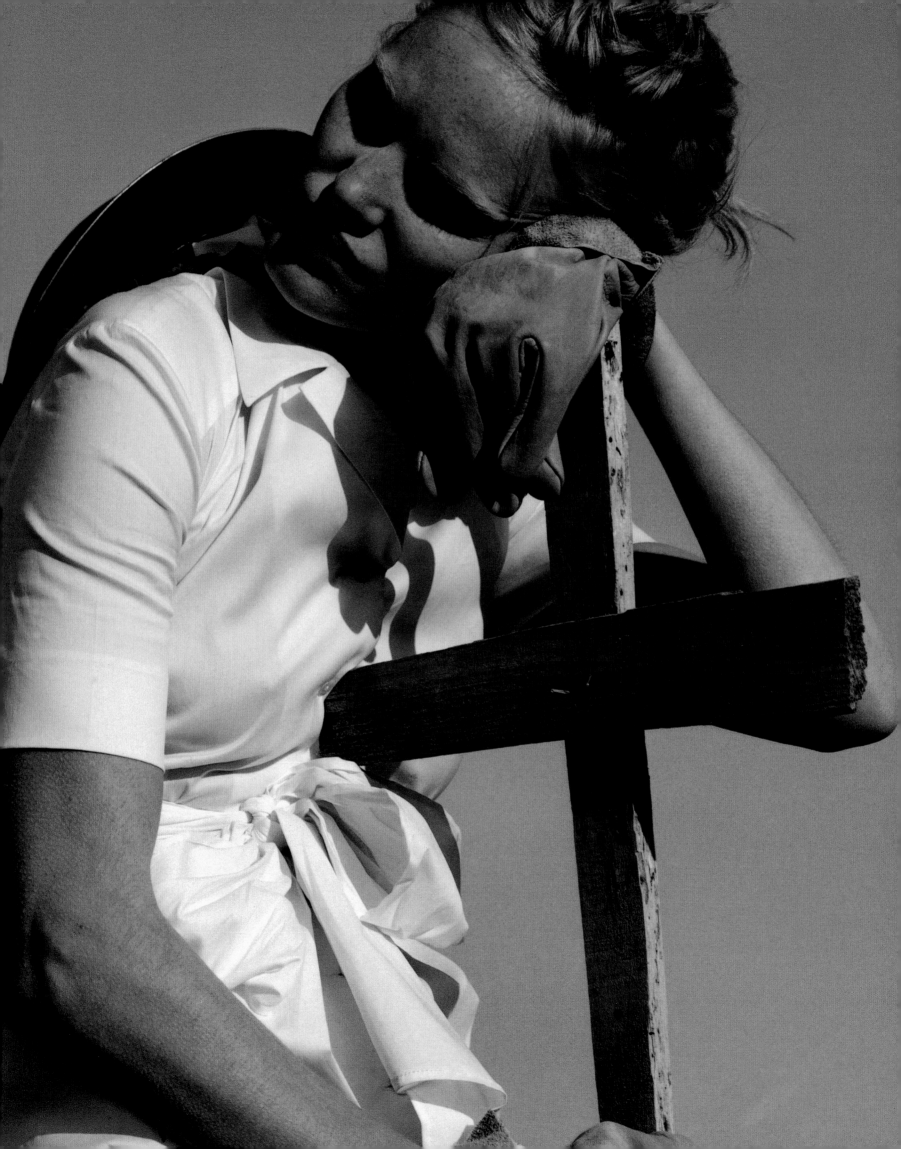

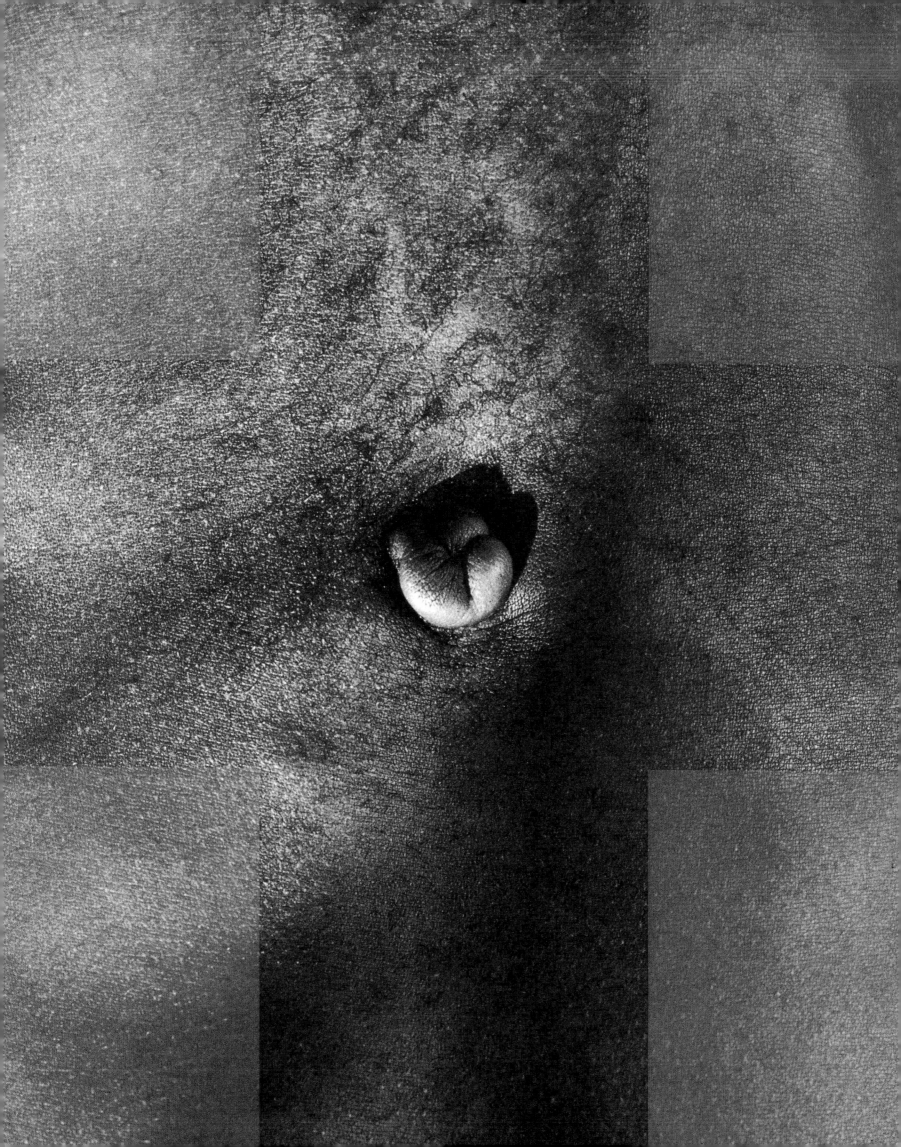

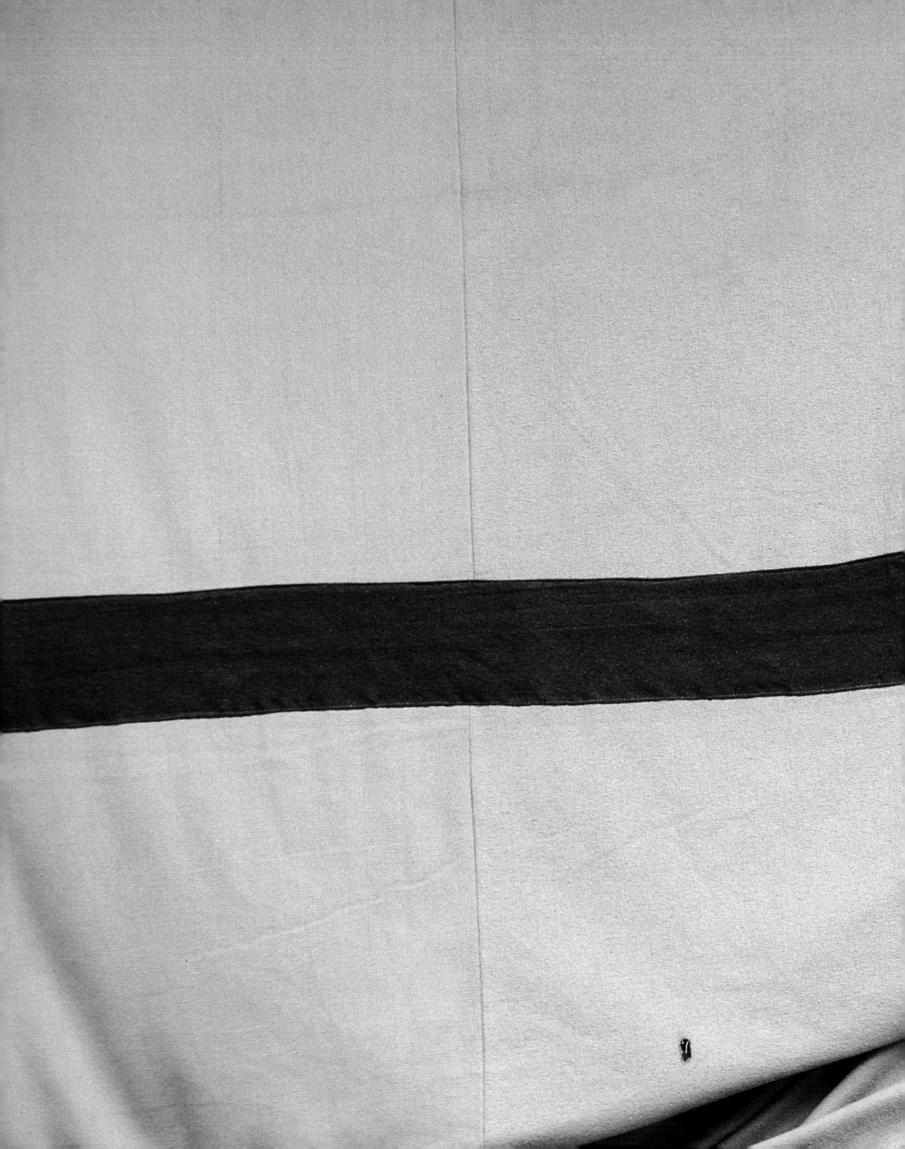

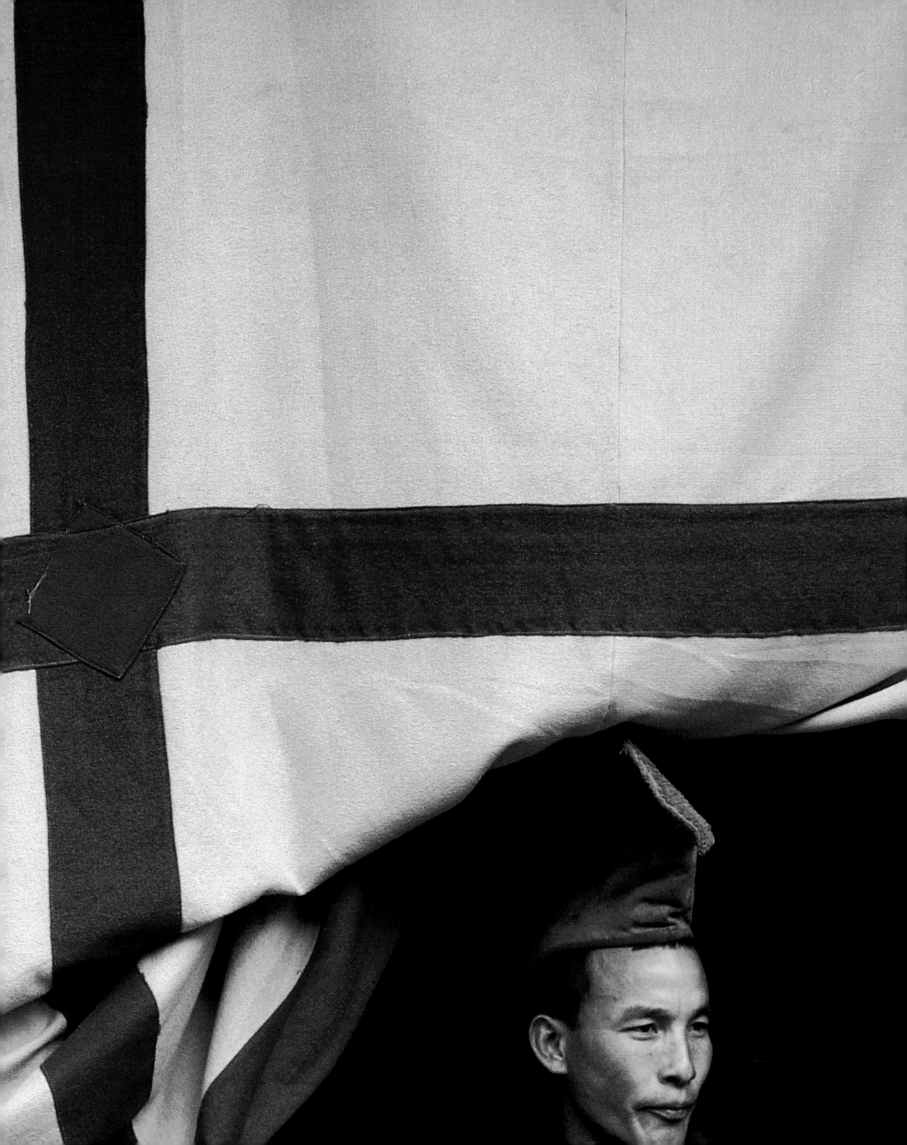

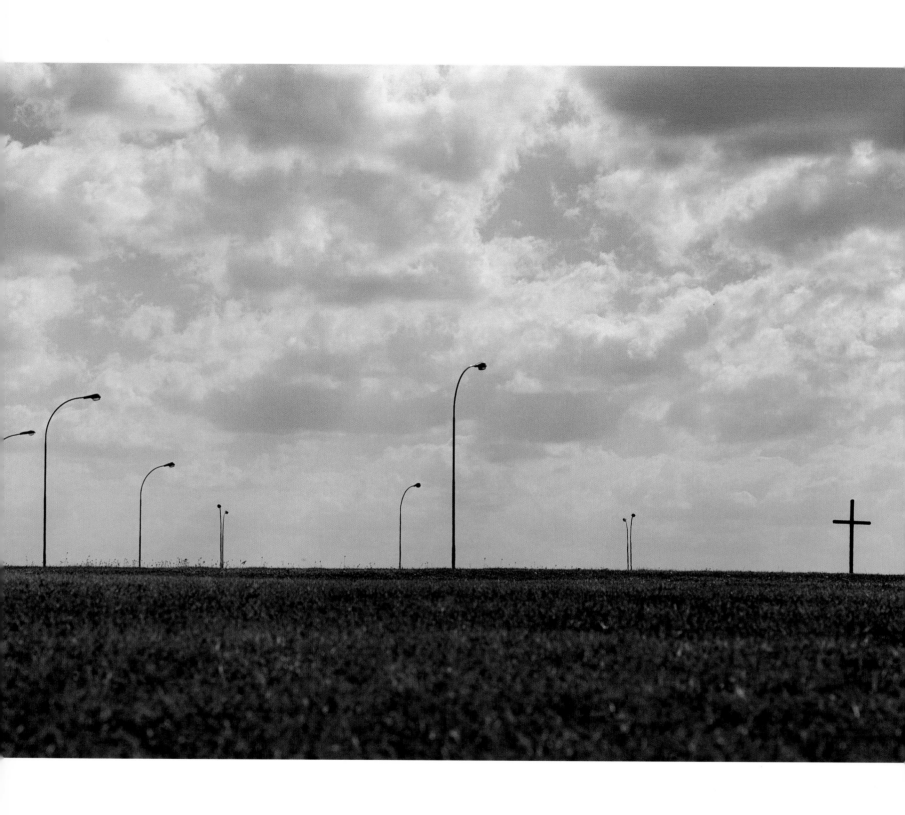

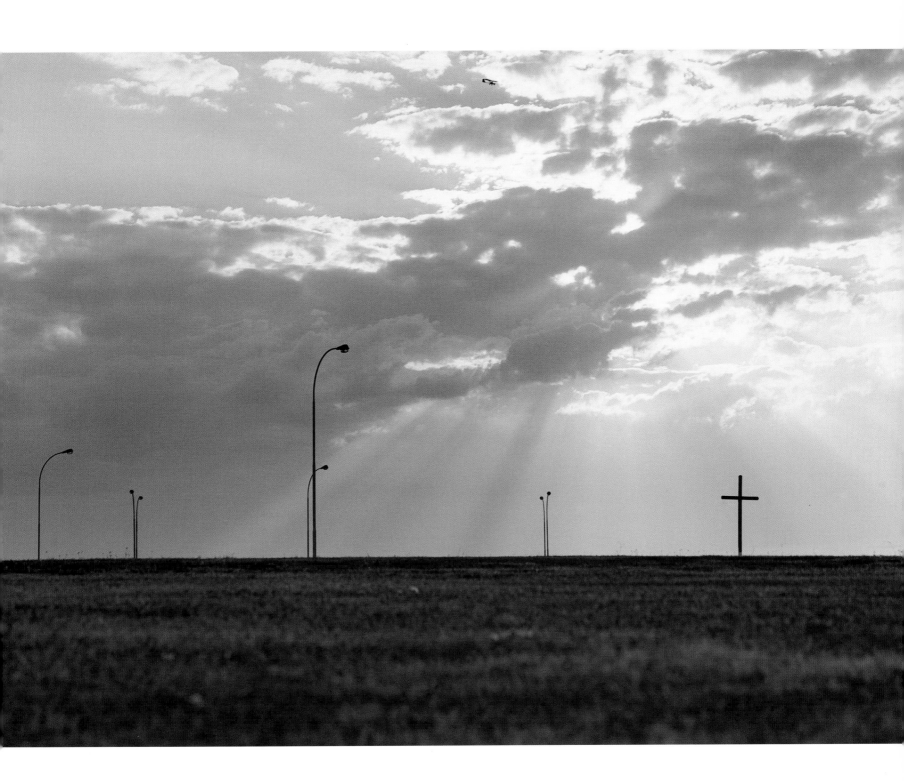

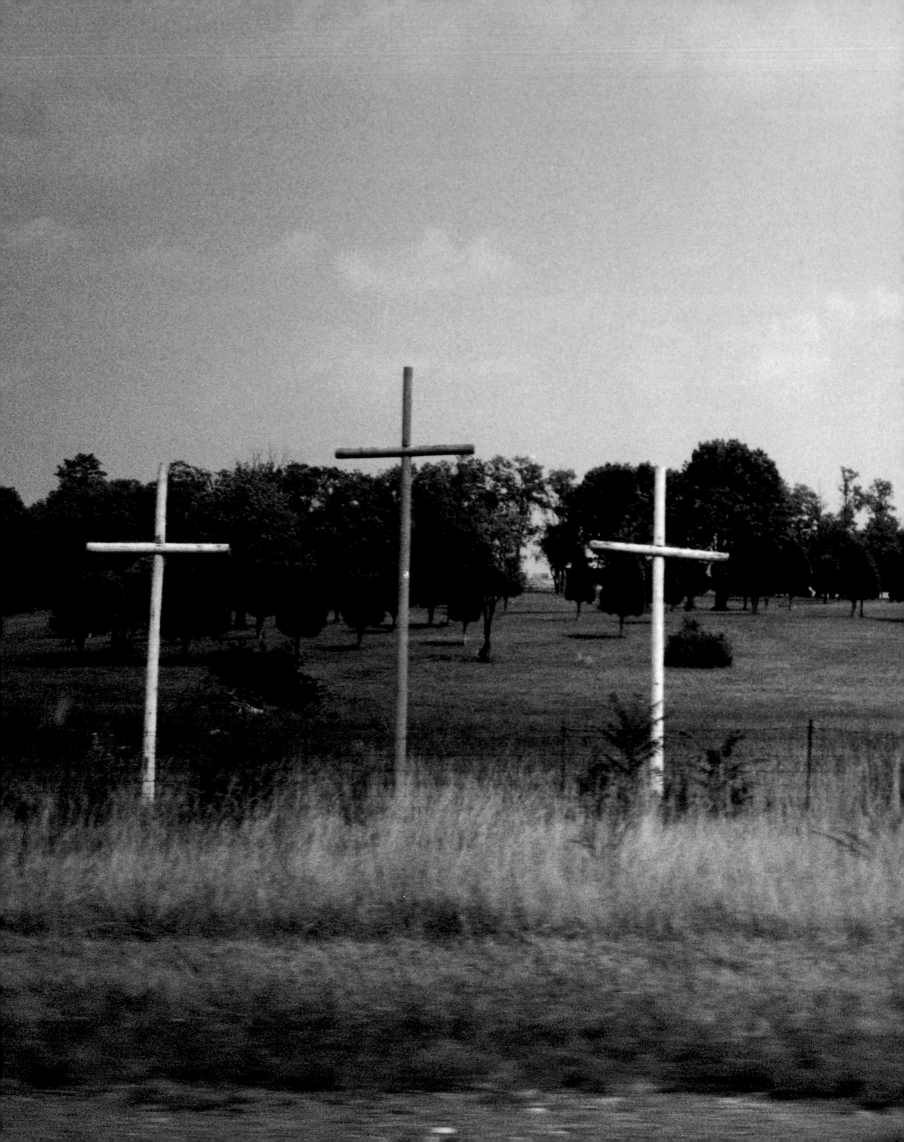

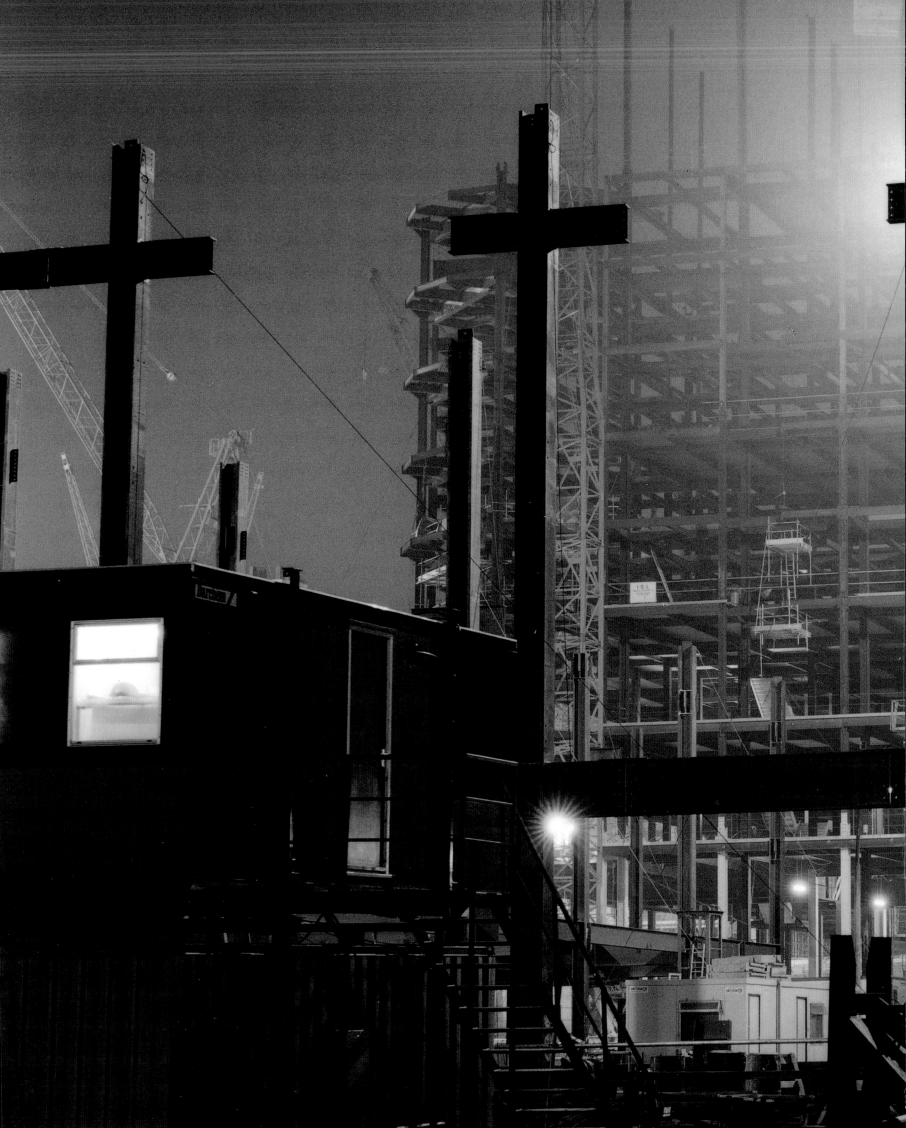

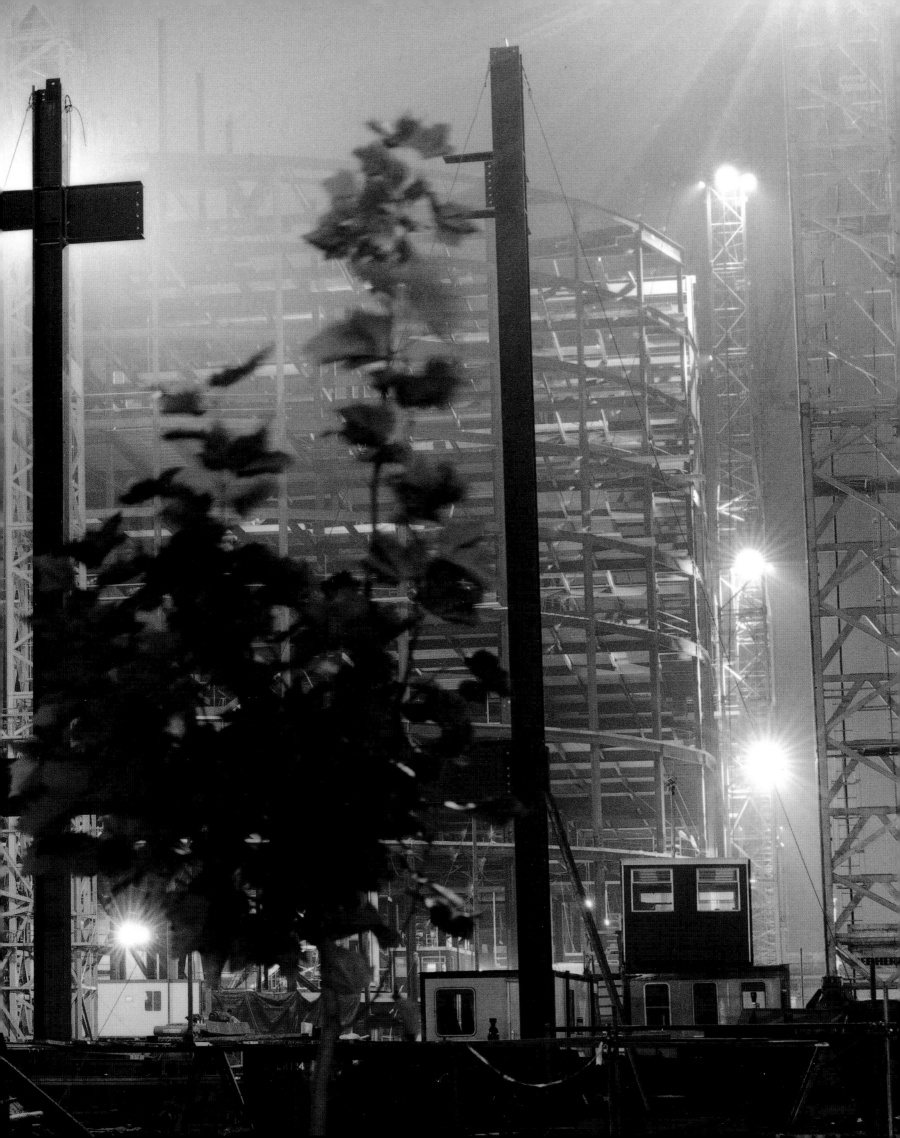

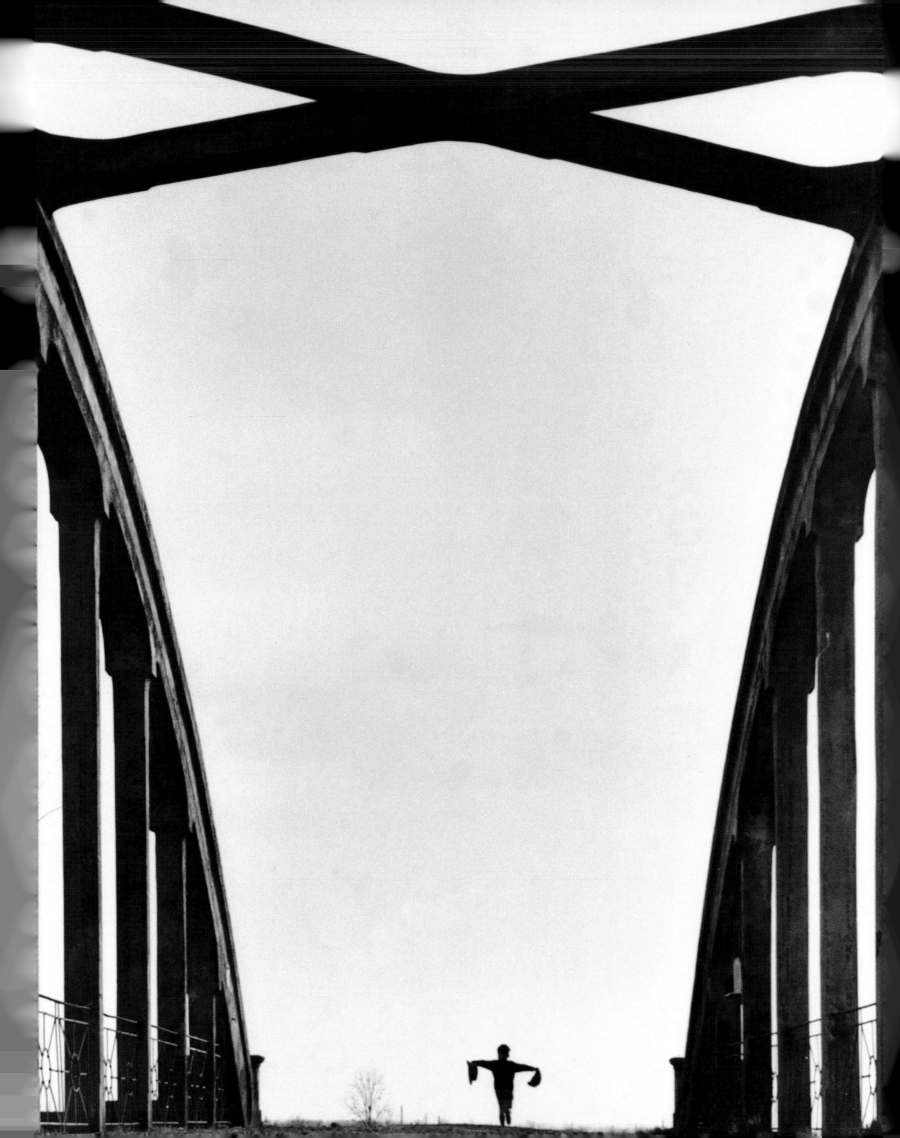

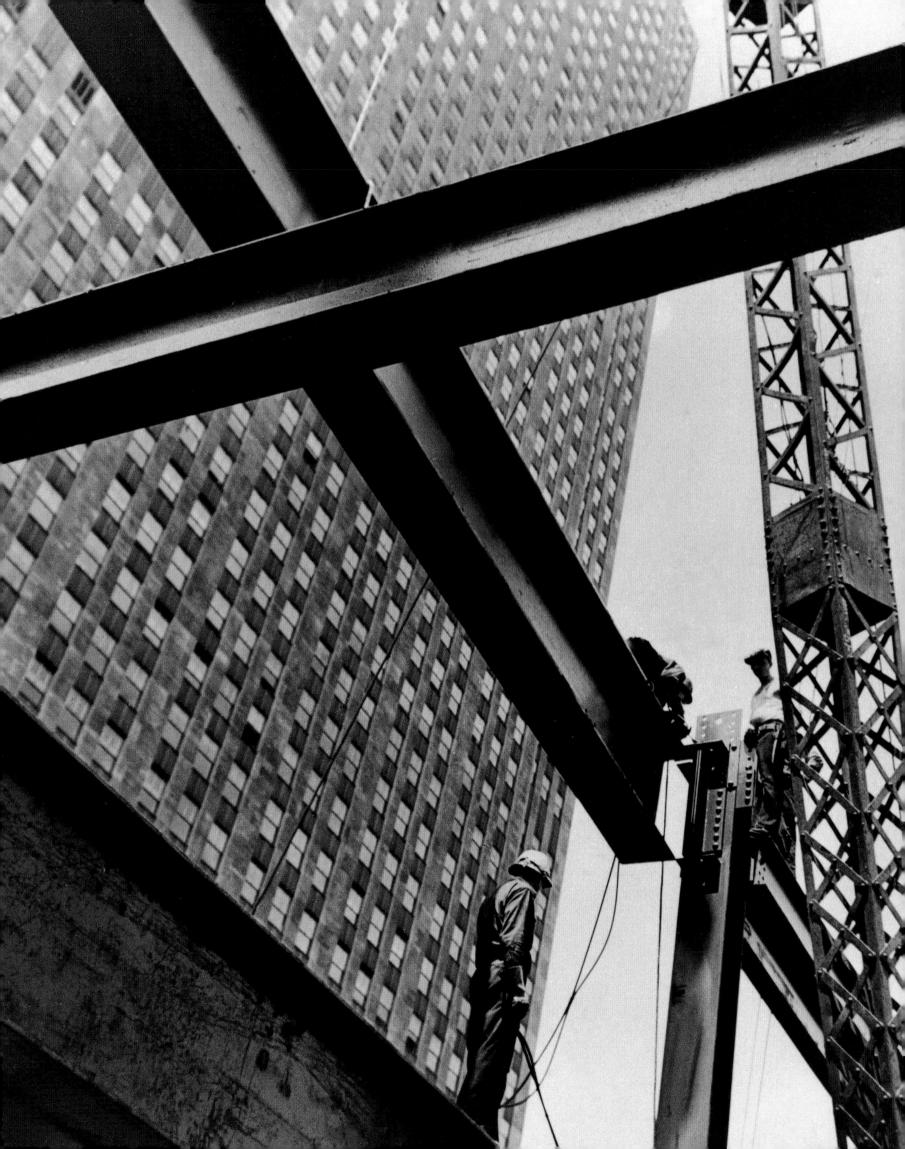

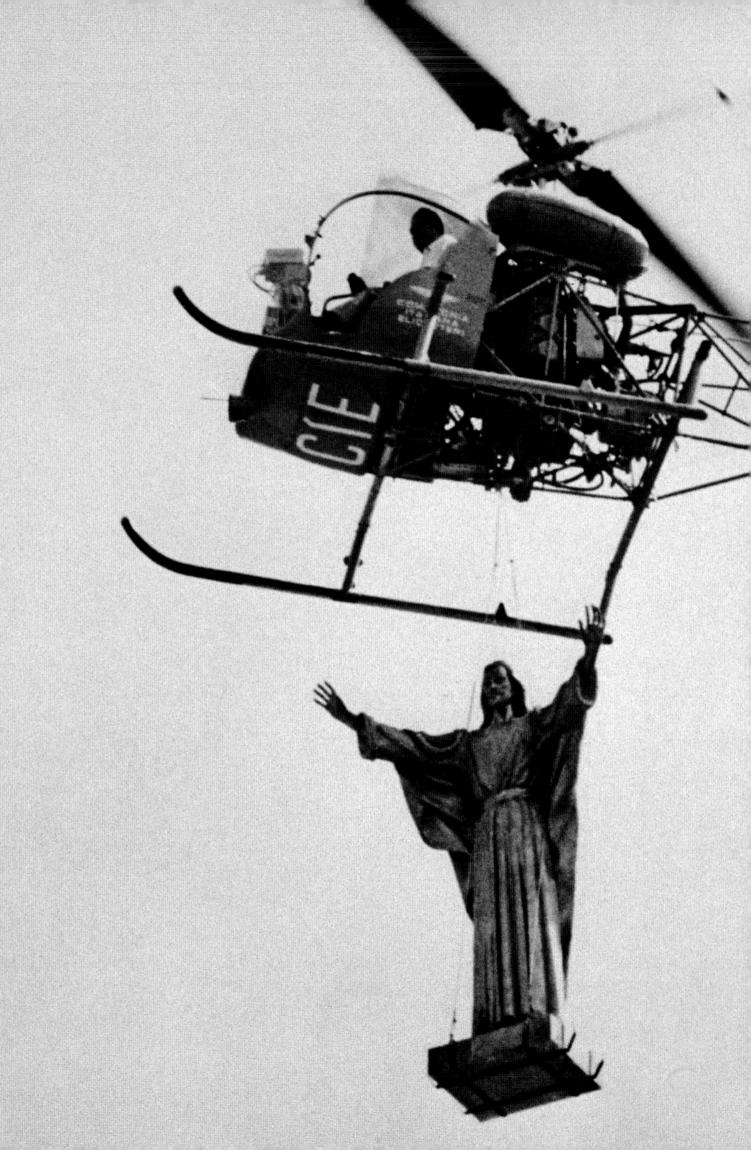

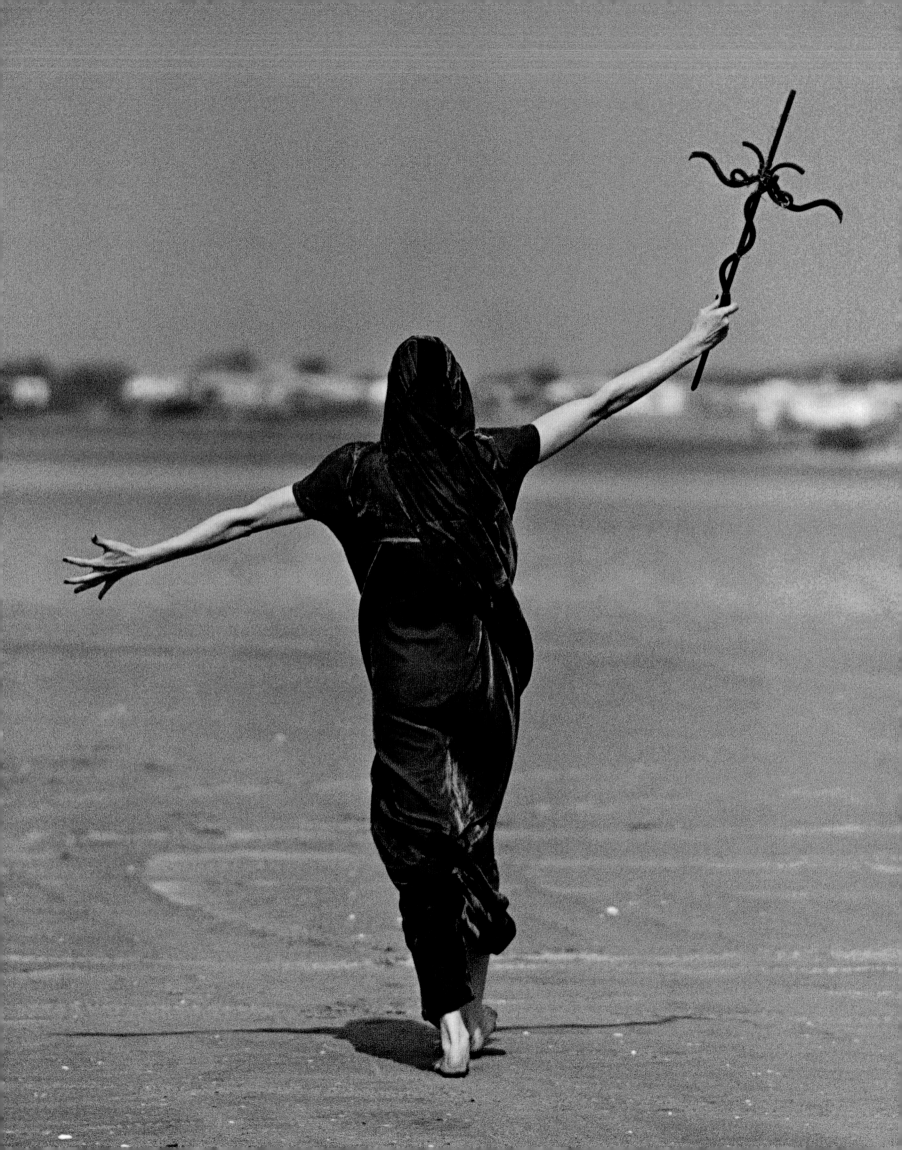

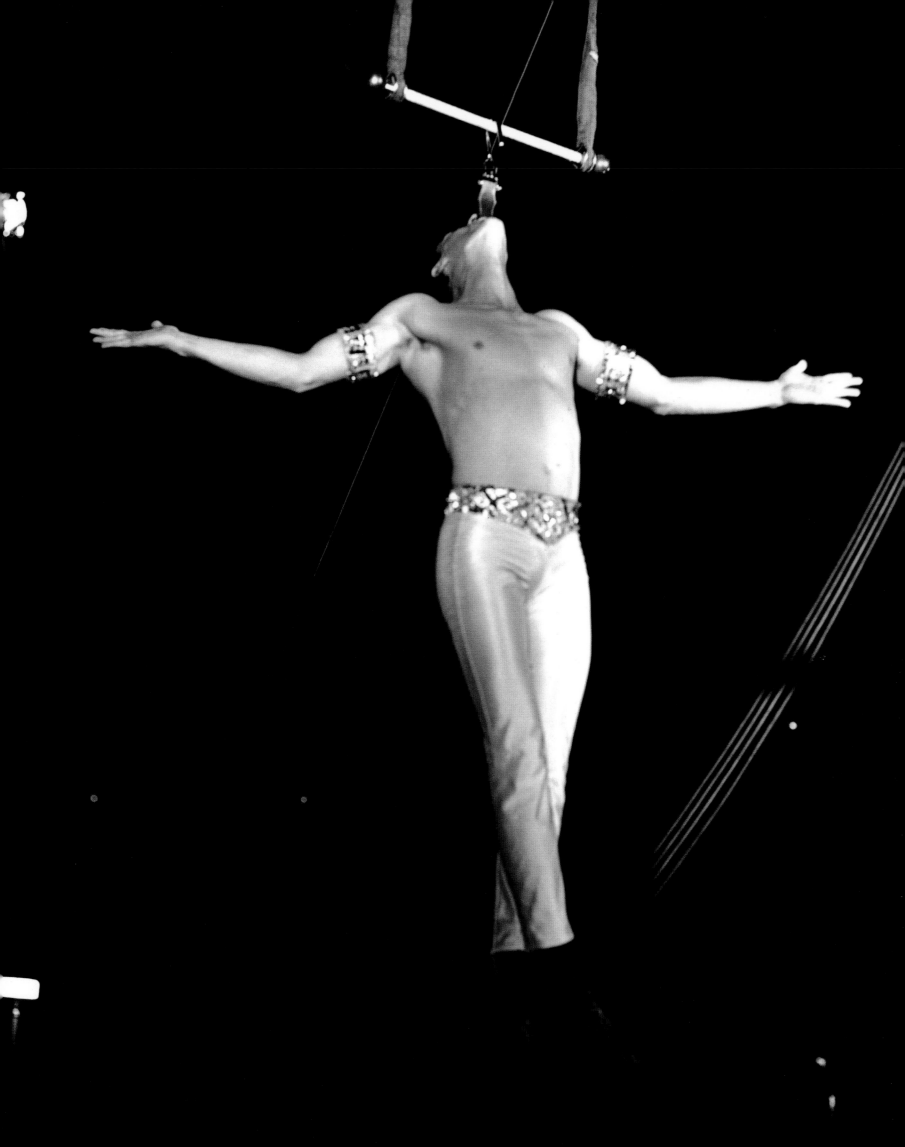

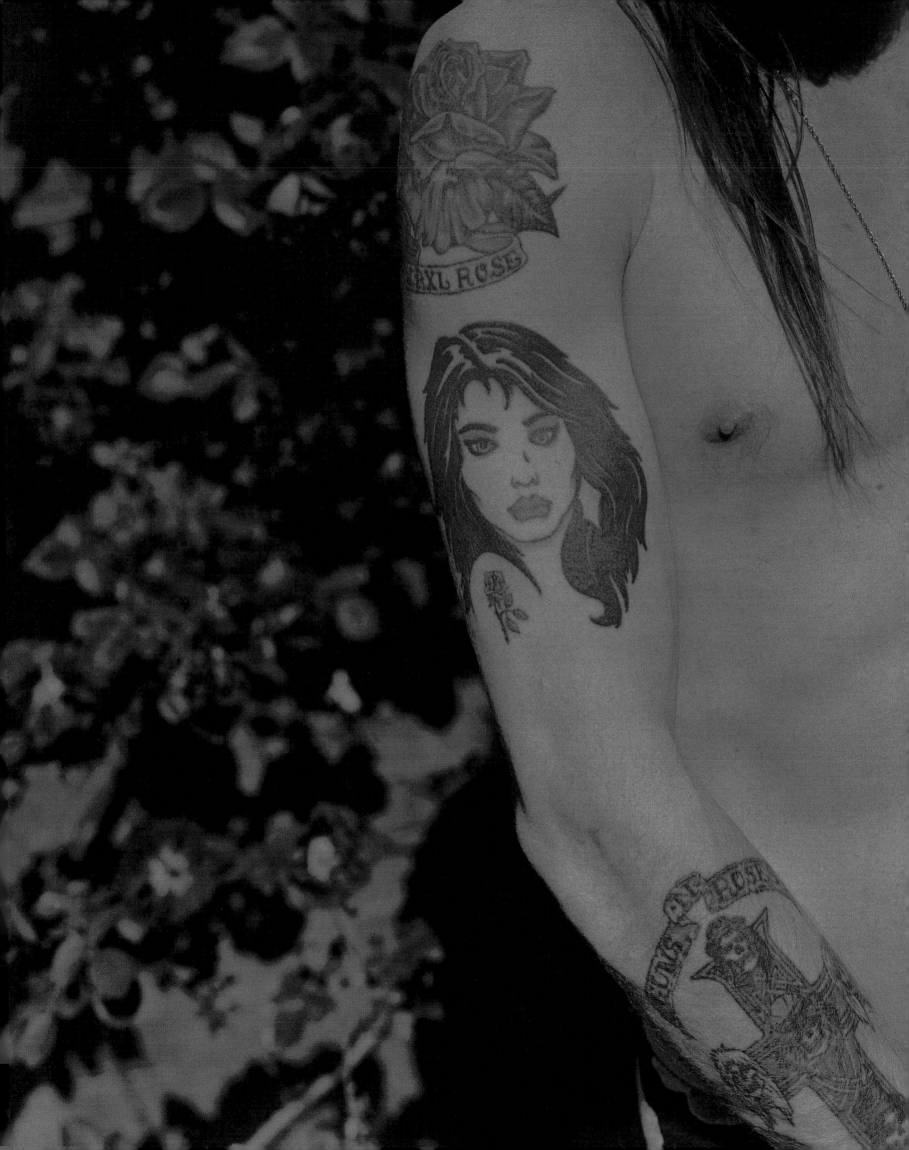

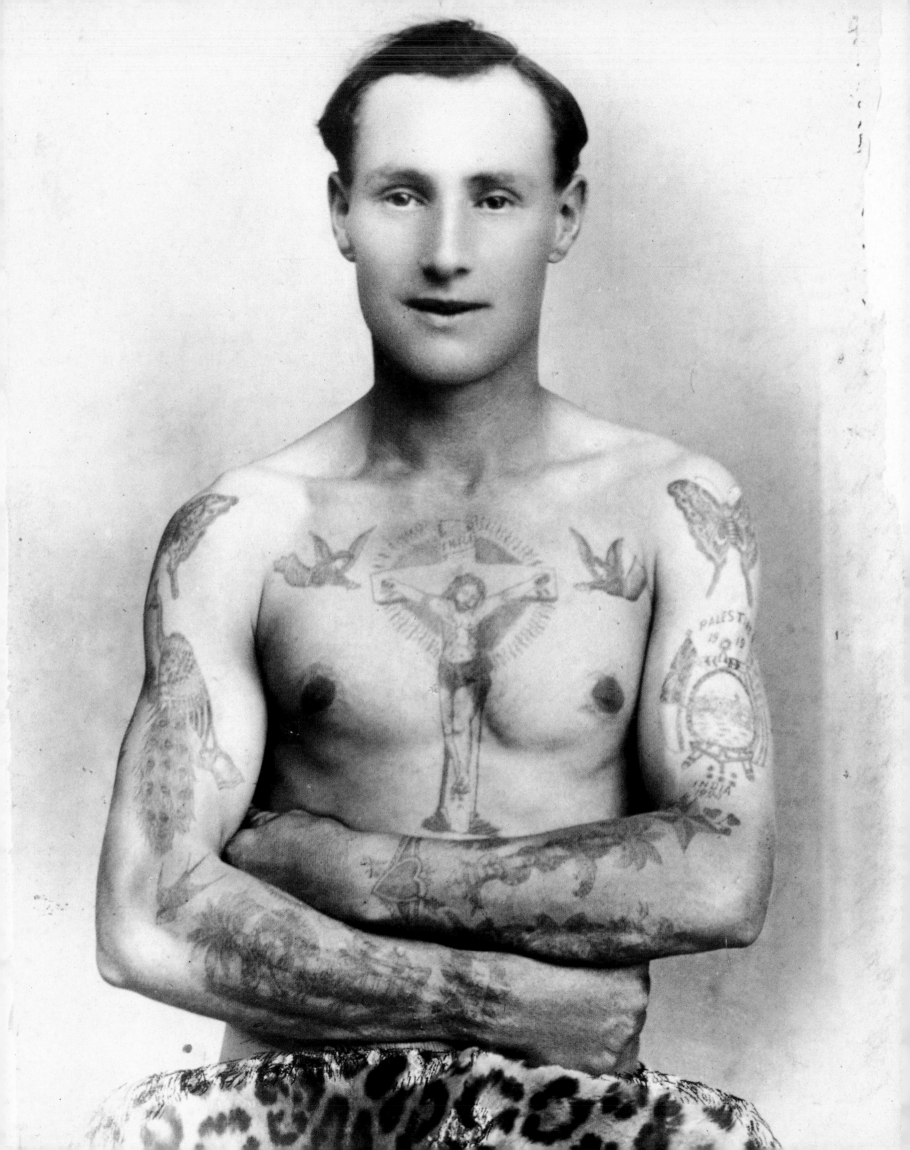

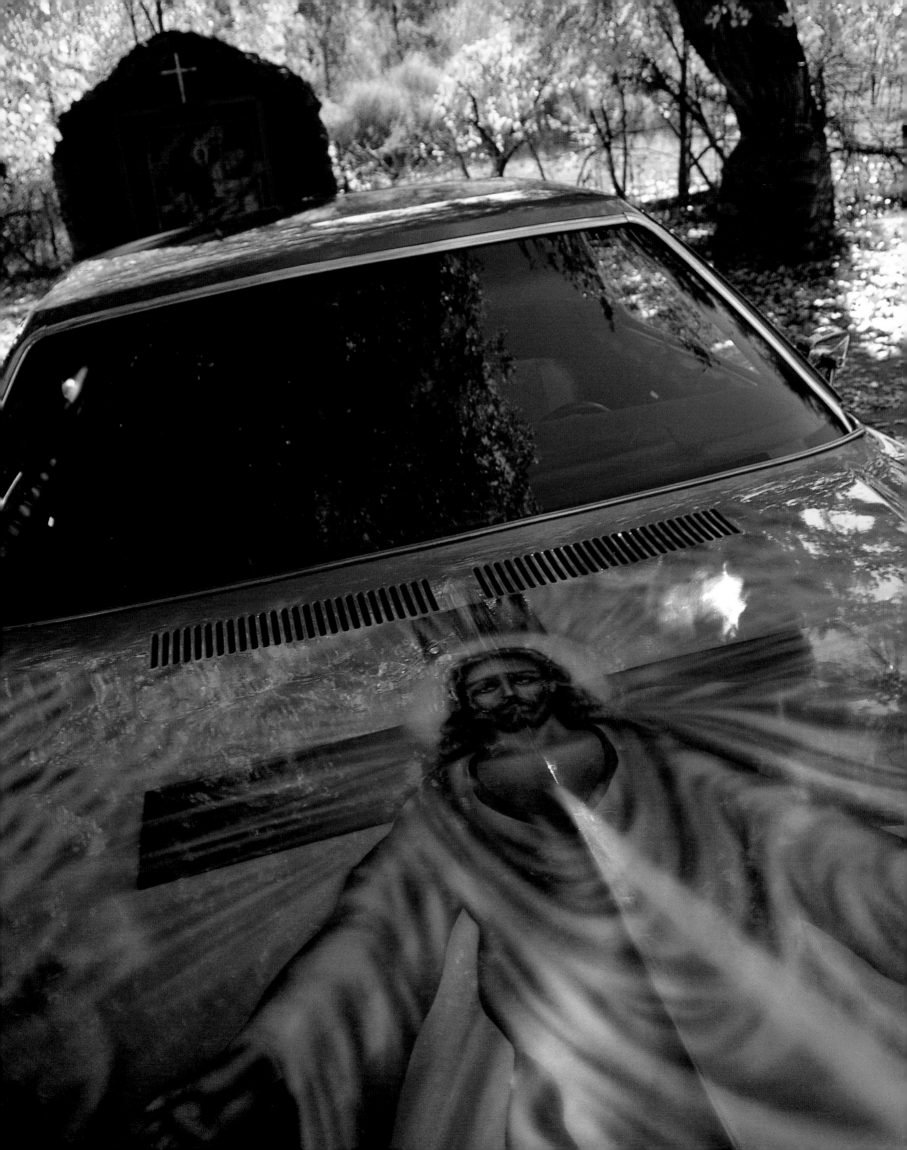

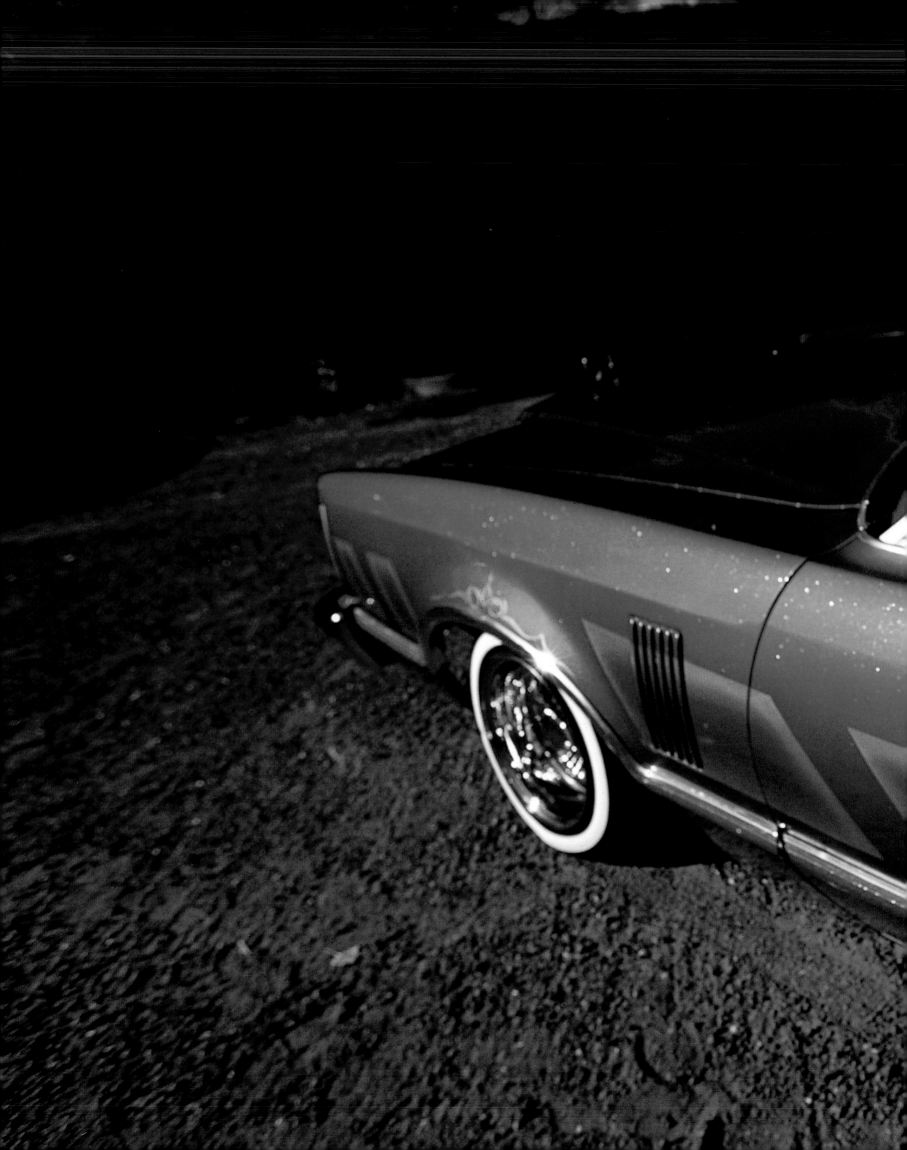

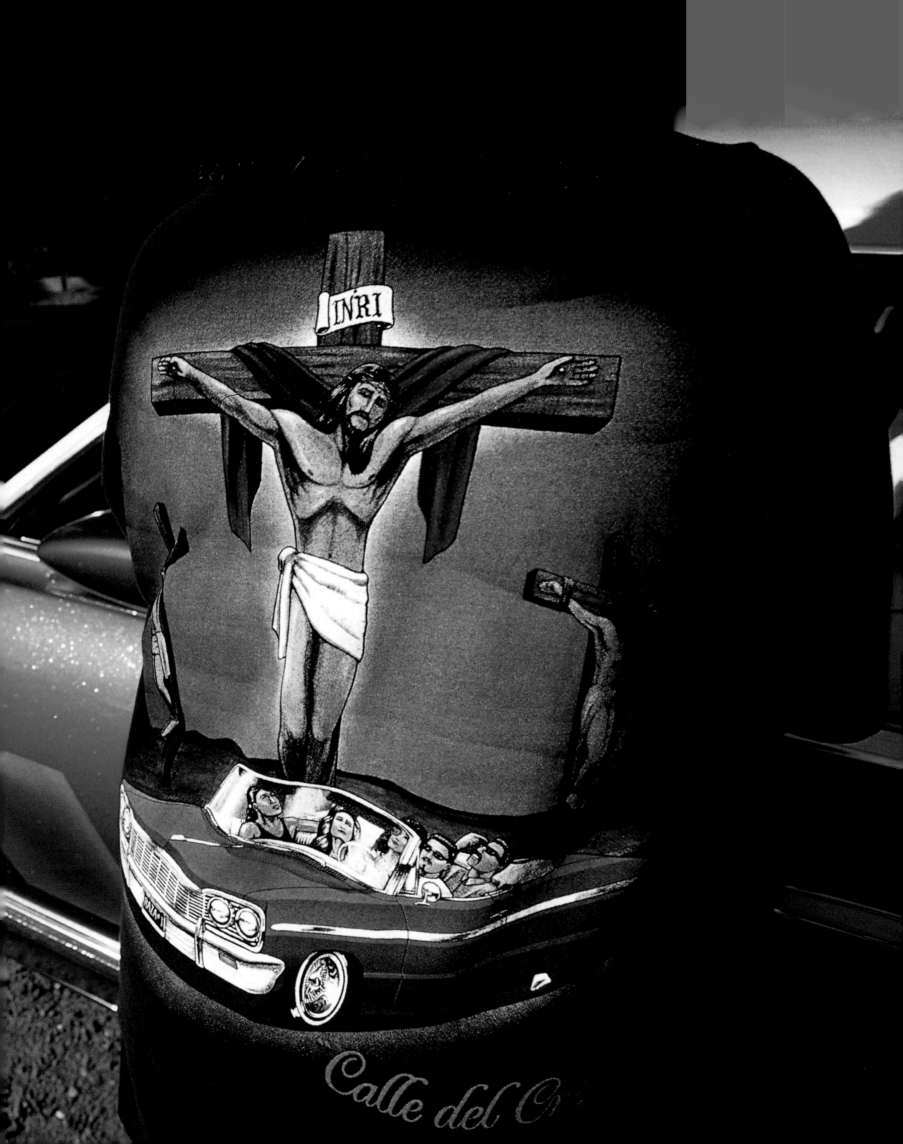

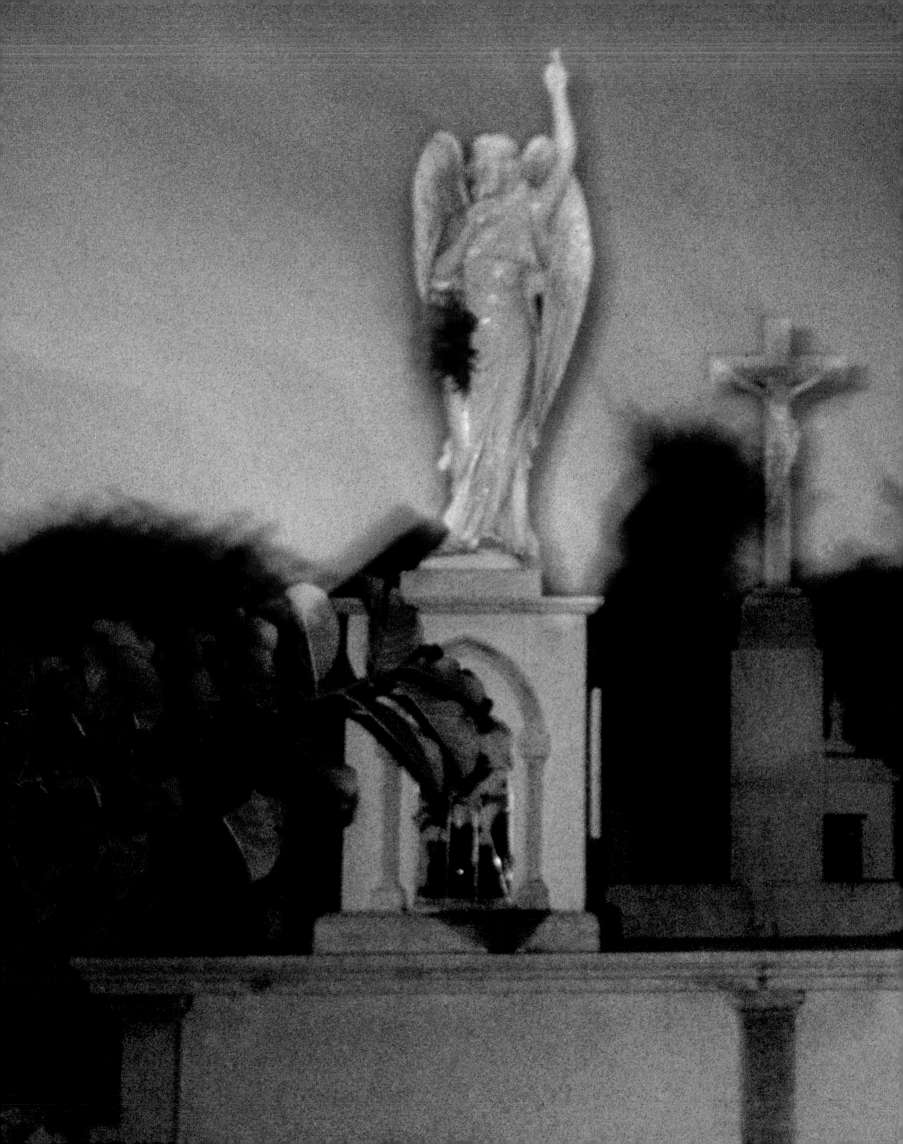

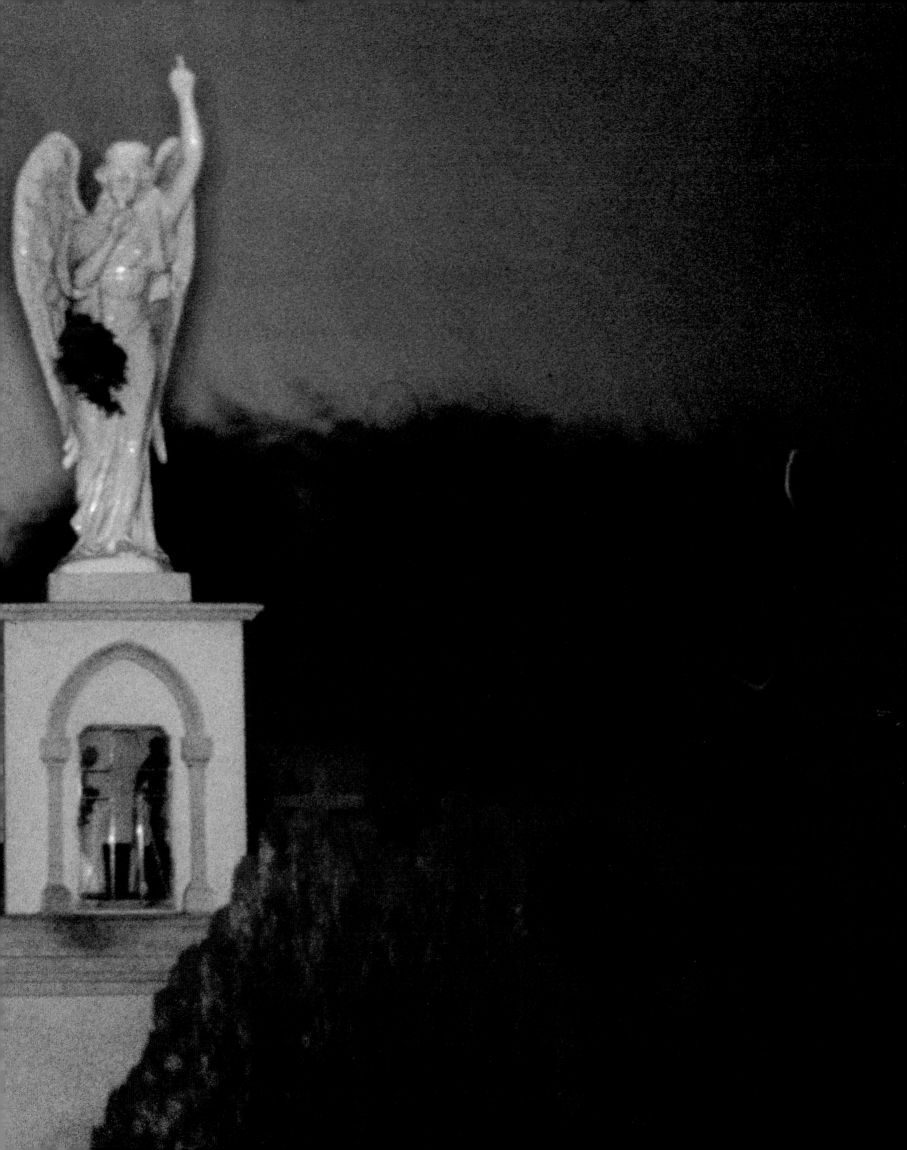

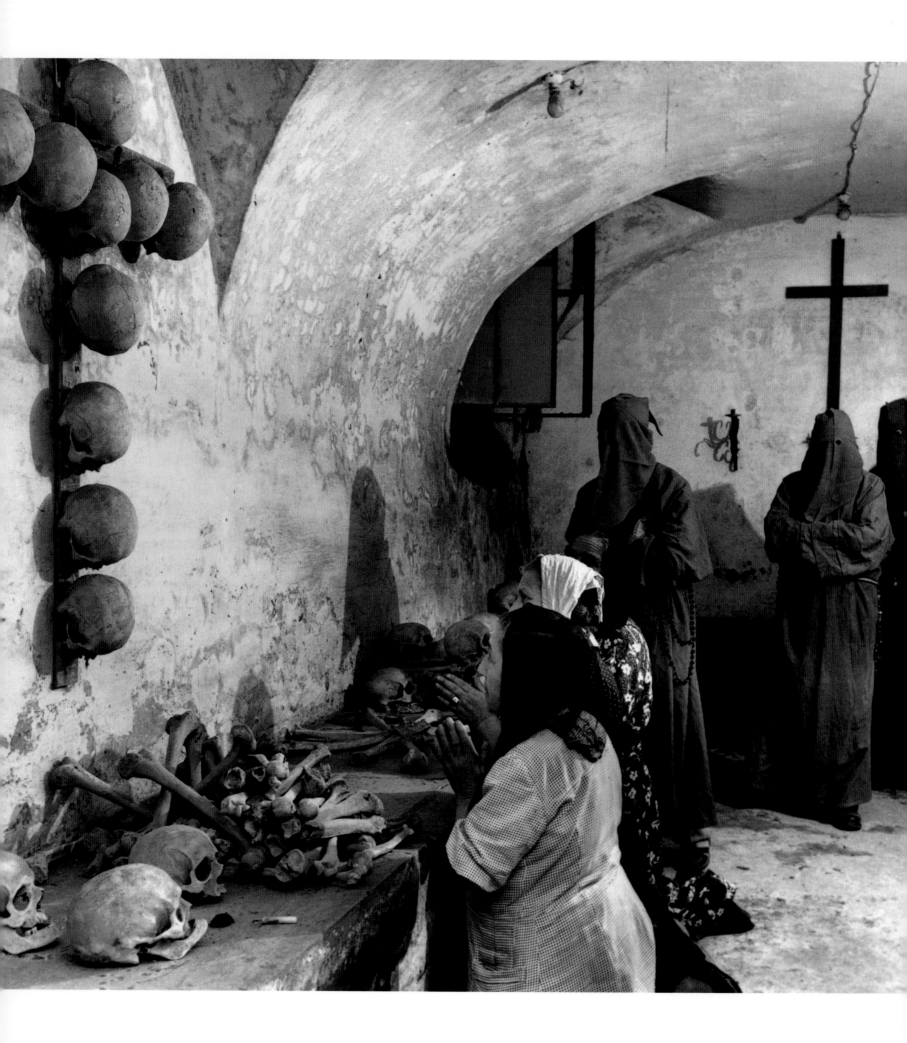

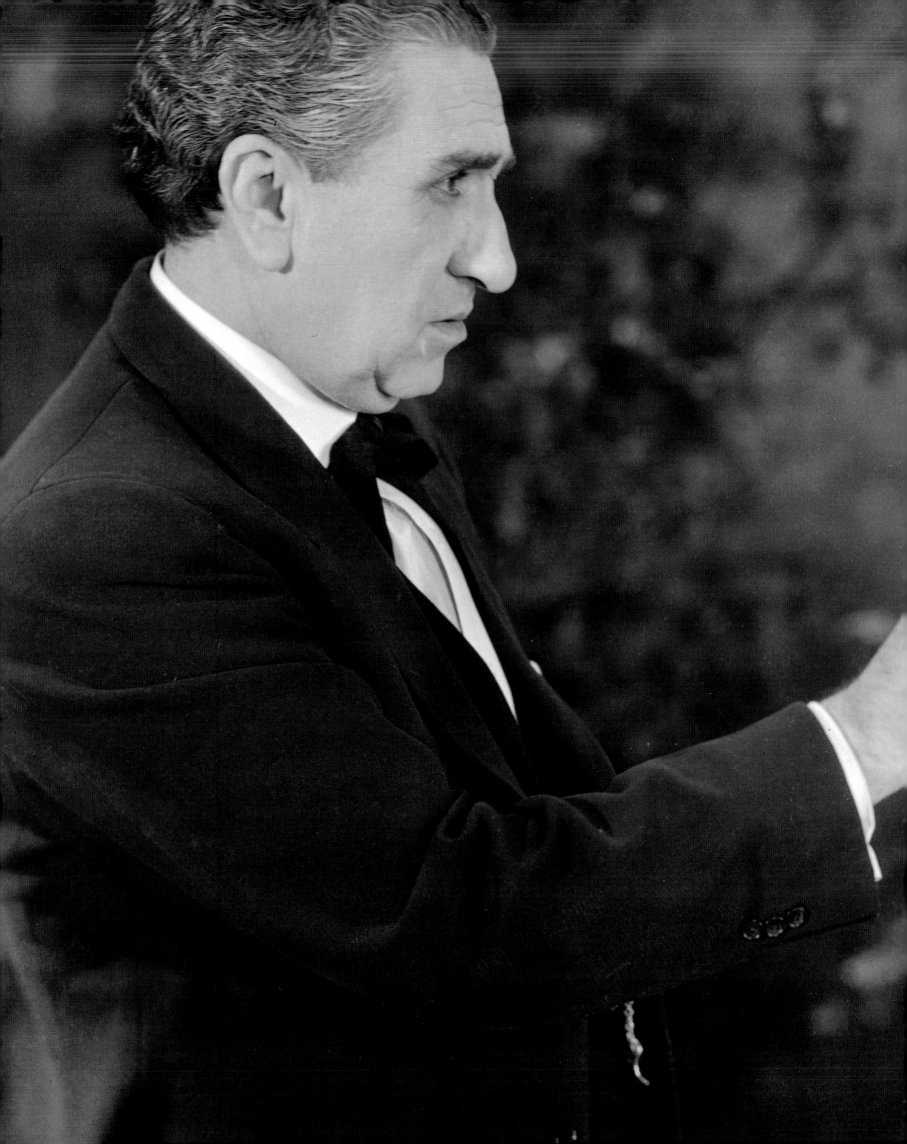

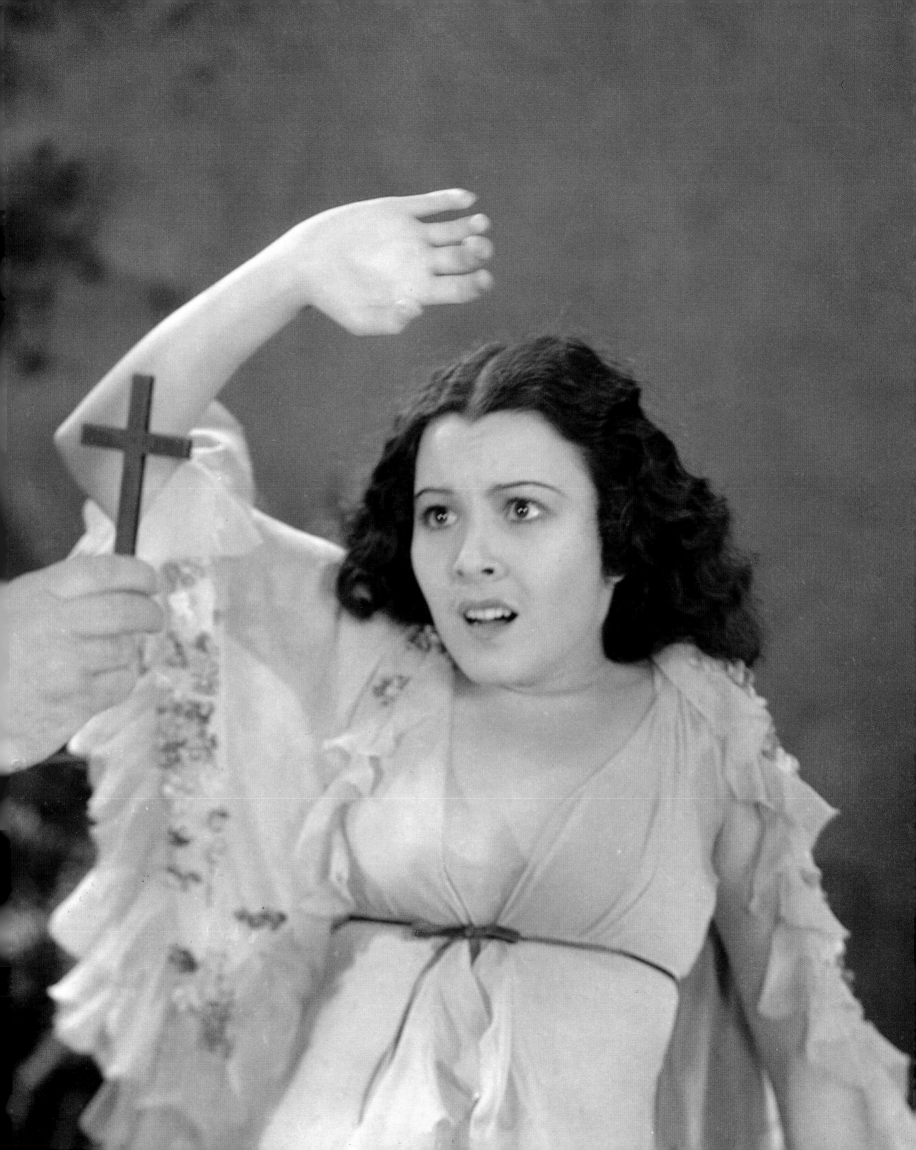

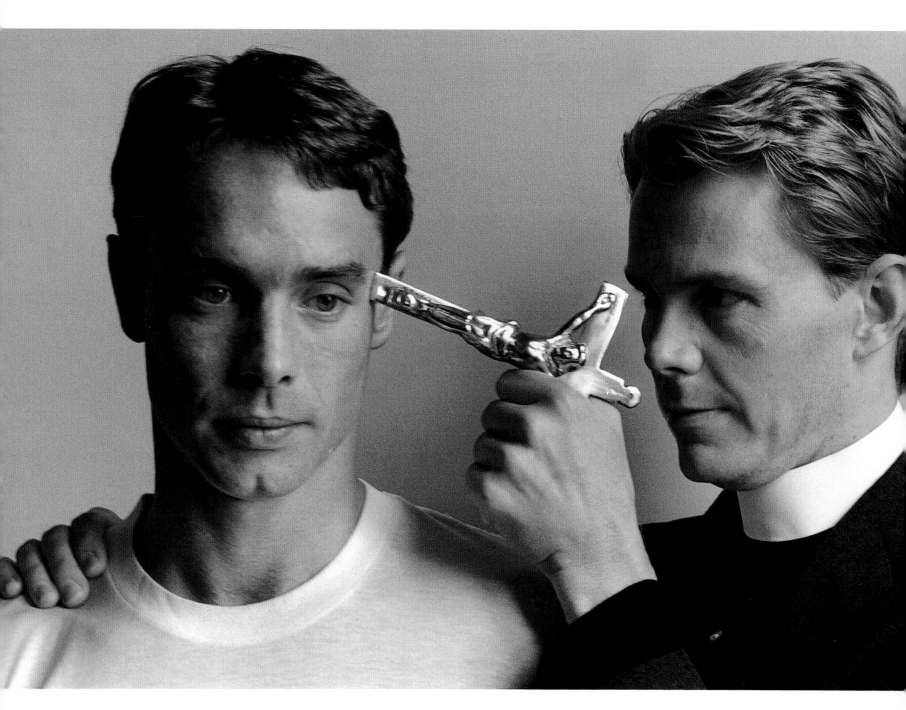

SALVATION

SALVATION

No American citizen has the right to impose his private morality on any other American citizen, which is exactly the political agenda of some organized religions today.

Millions of ~~women~~ men have been victims of these churches intrusion into their most private and painful decision, whether to have or not have an abortion.

Millions of gays and lesbians have been victims of these churches ~~and~~ assaults on gay rights legislation, which would simply protect them from housing and job discrimination, rights assumed by all heterosexual citizens.

If one does not have the freedom to make his most intimate choices without fear, one does not have any freedom at all.

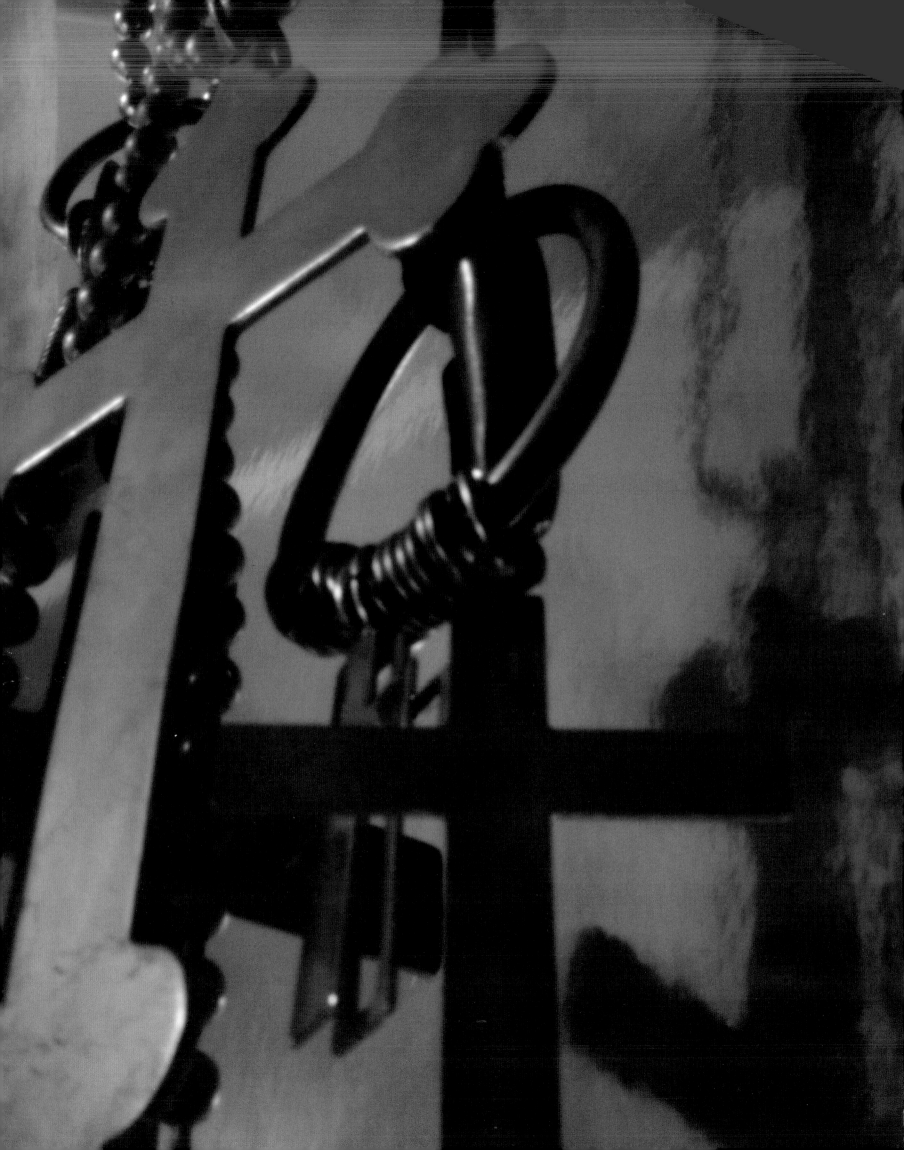

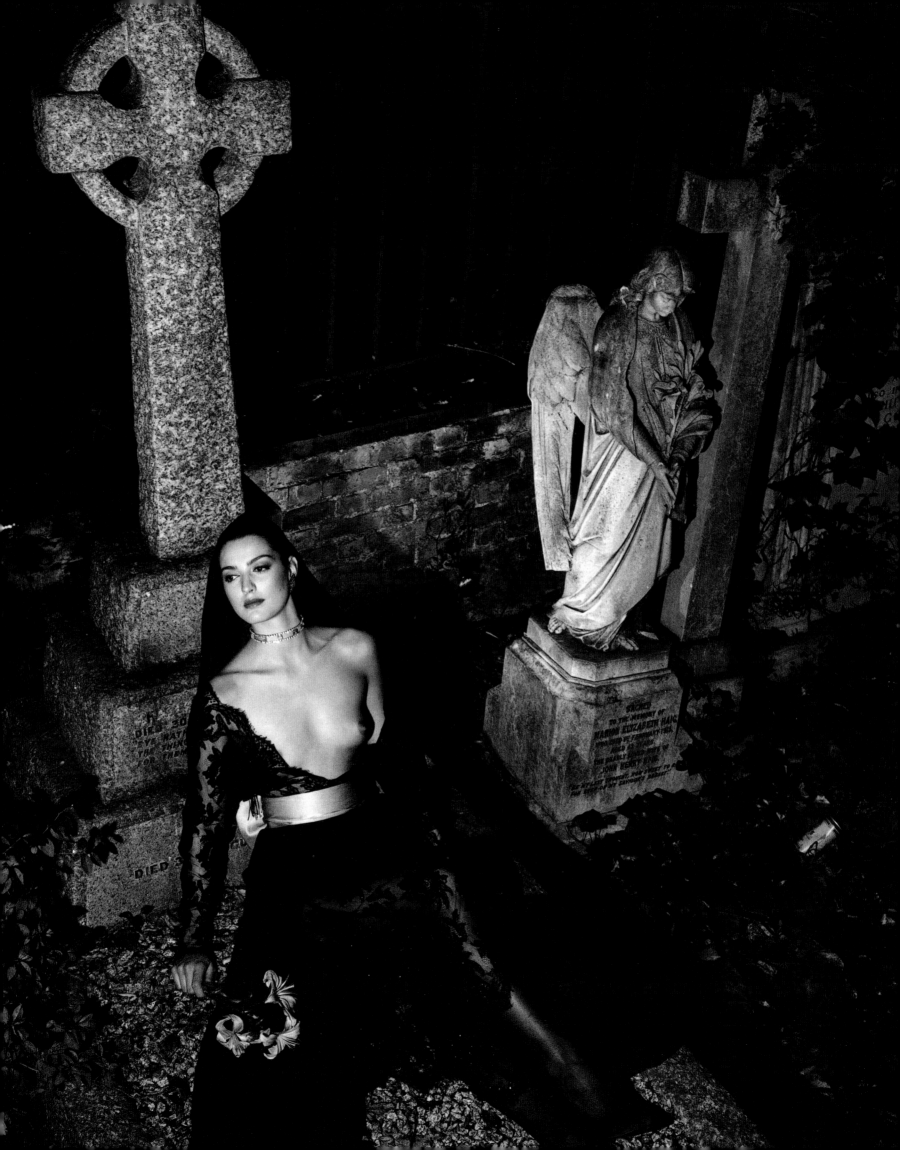

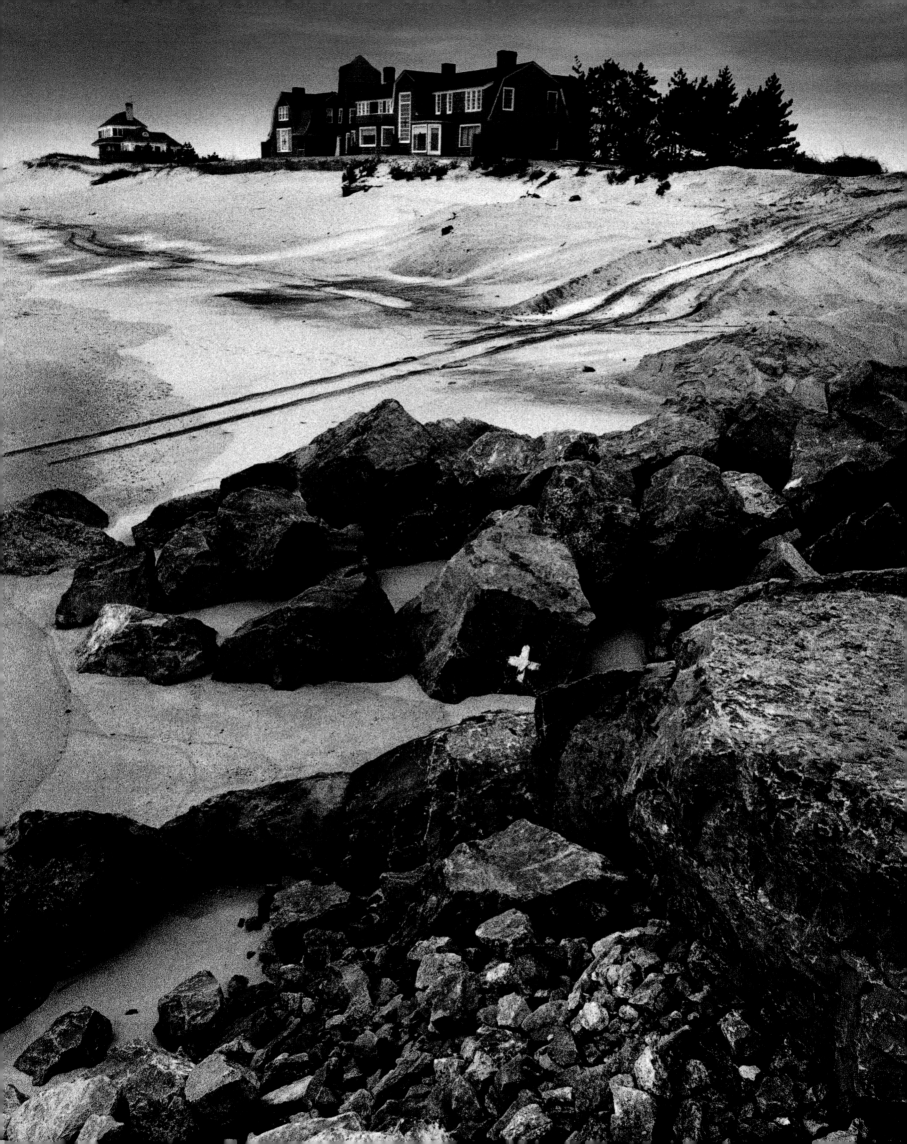

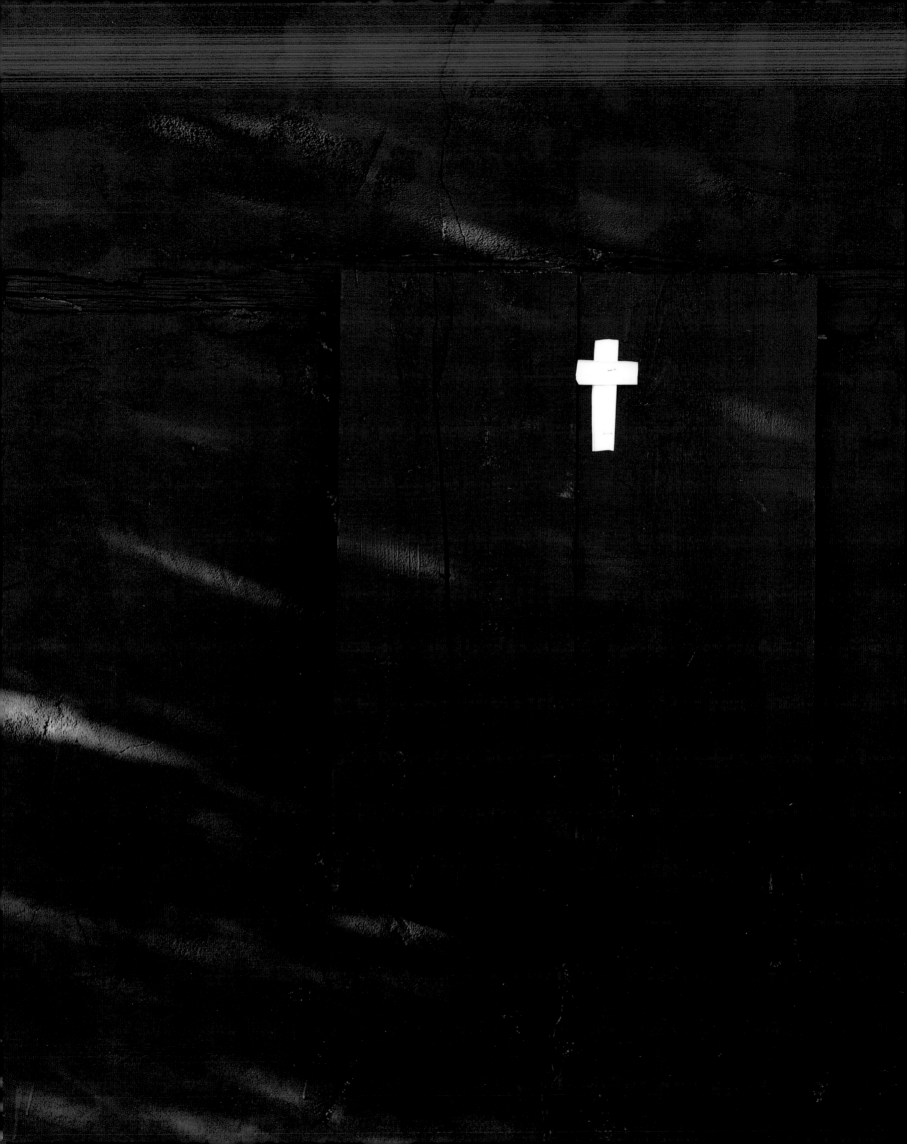

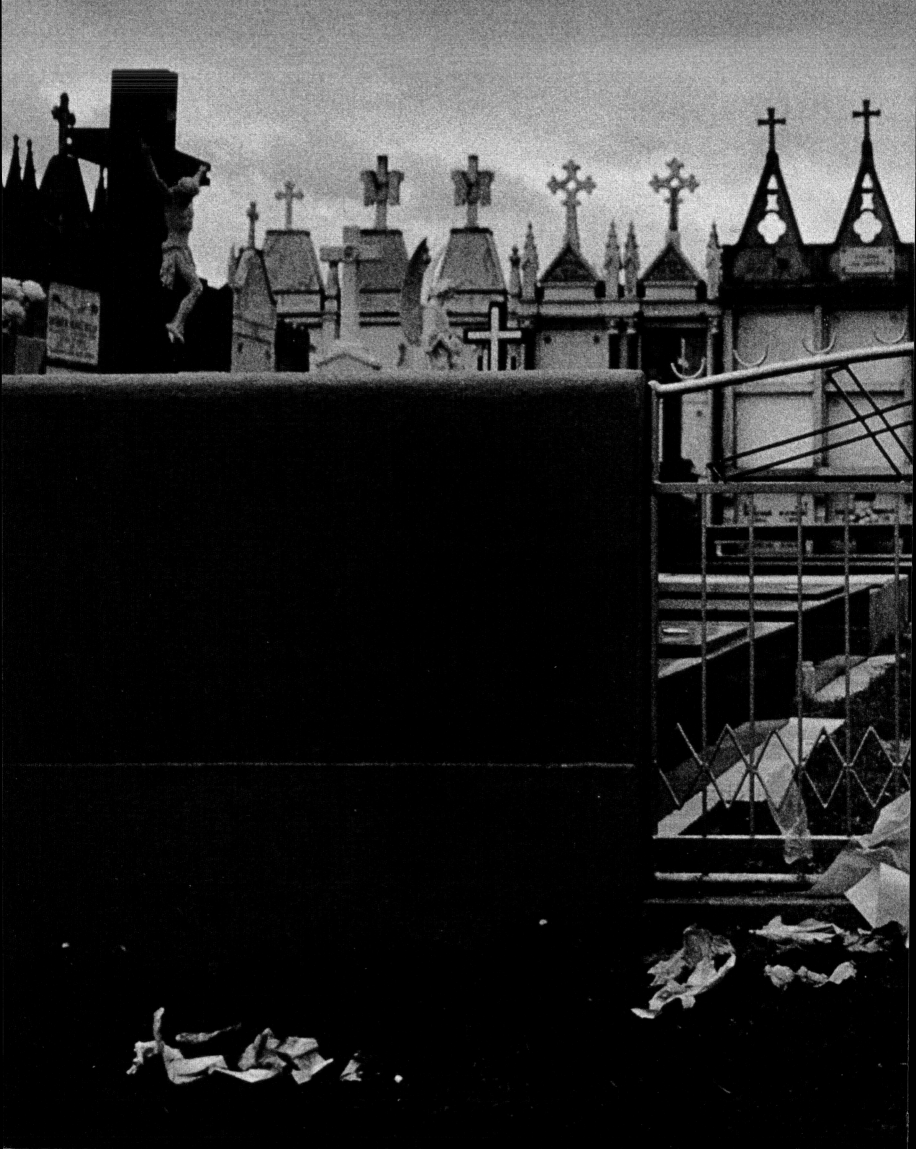

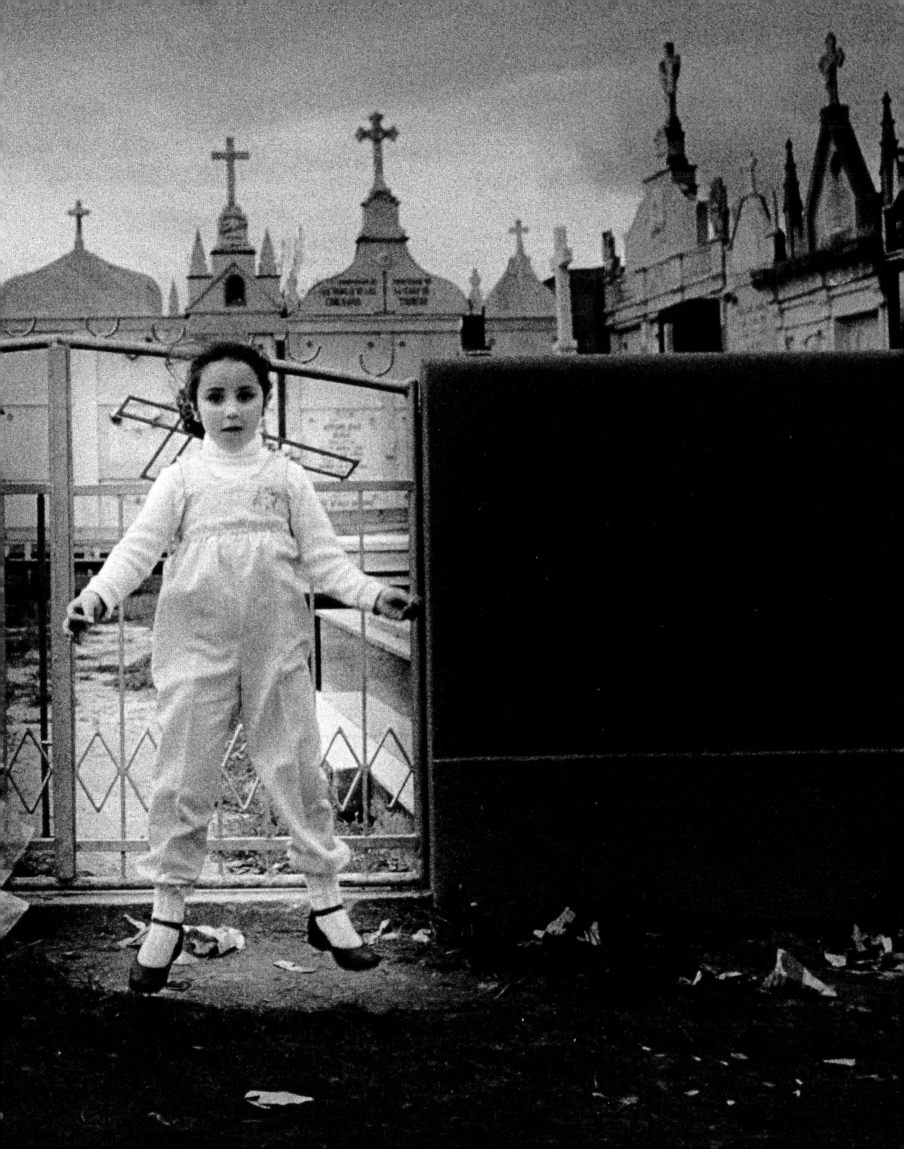

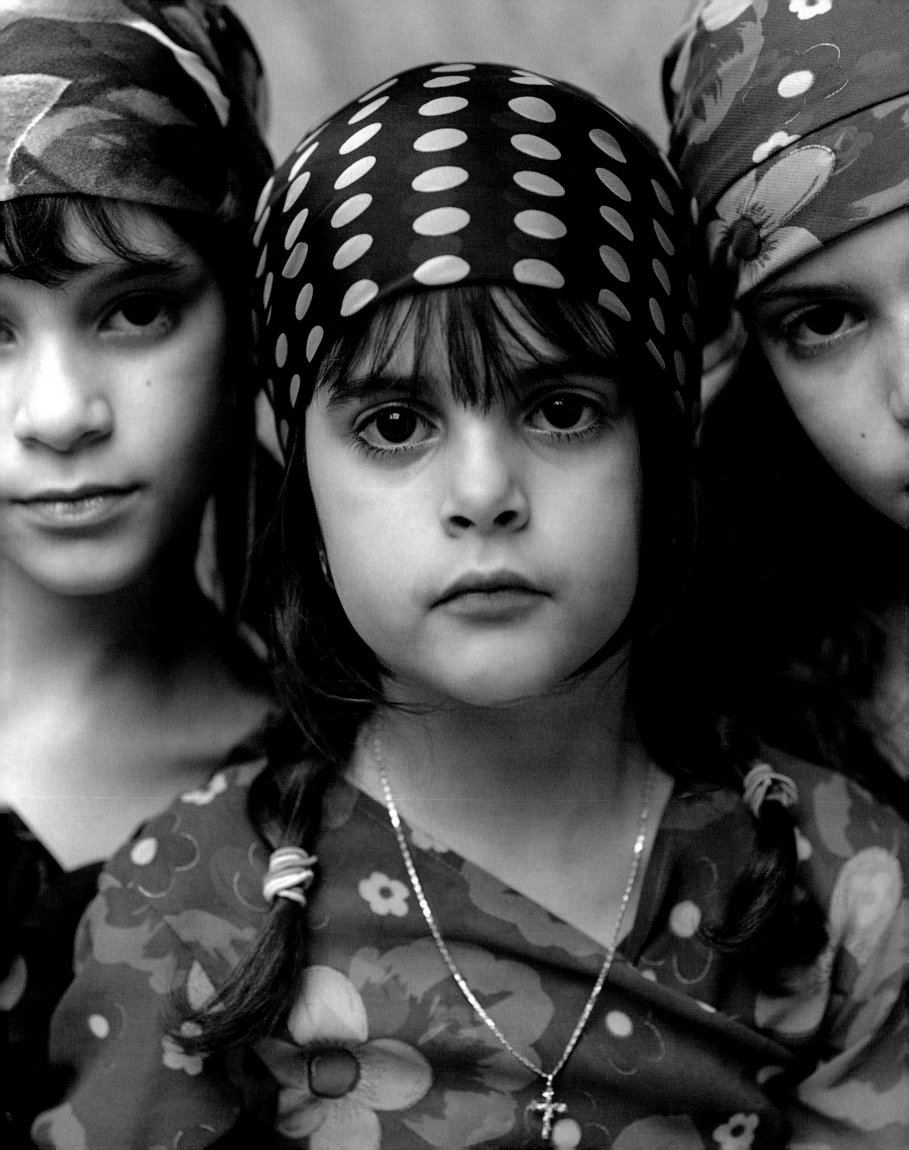

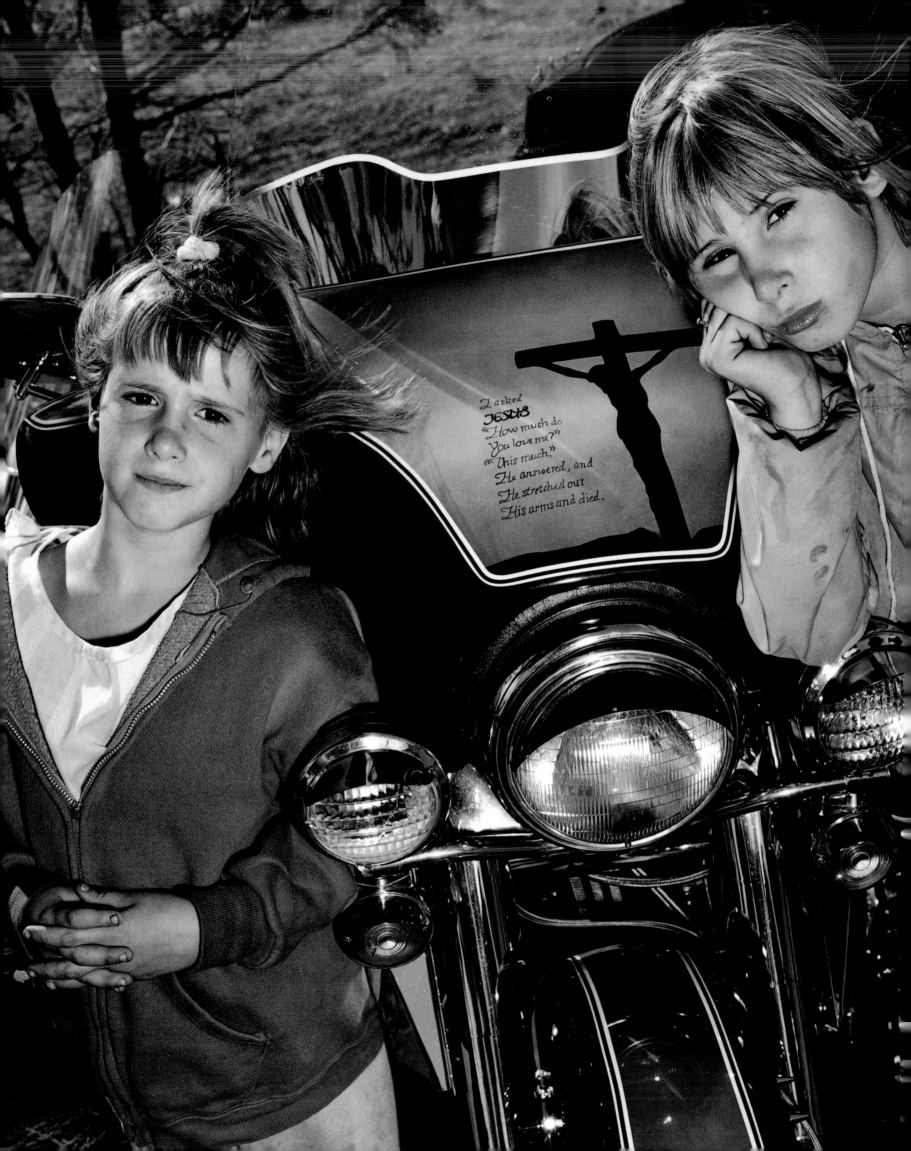

I asked **JESUS**
*"How much do
You love me?"*
"This much,"
He answered, and
He stretched out
His arms and died.

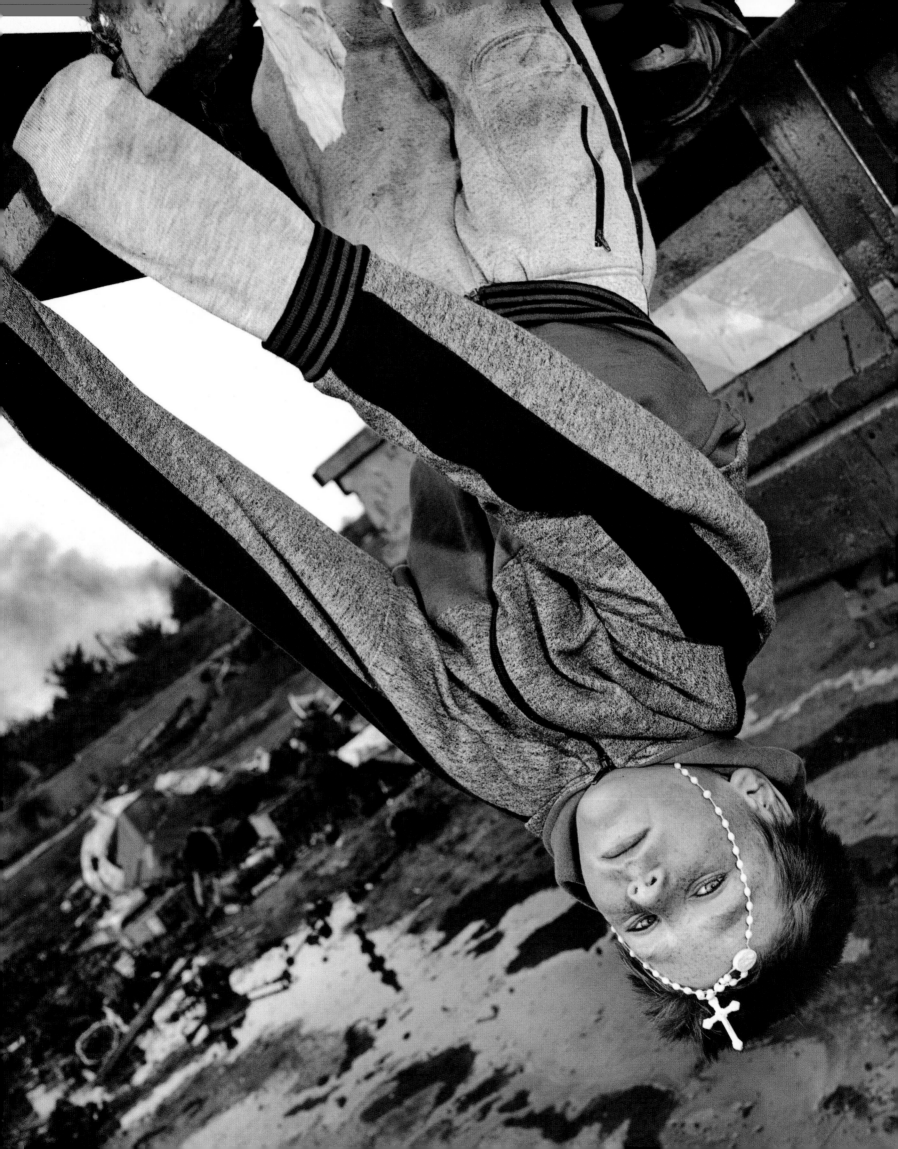

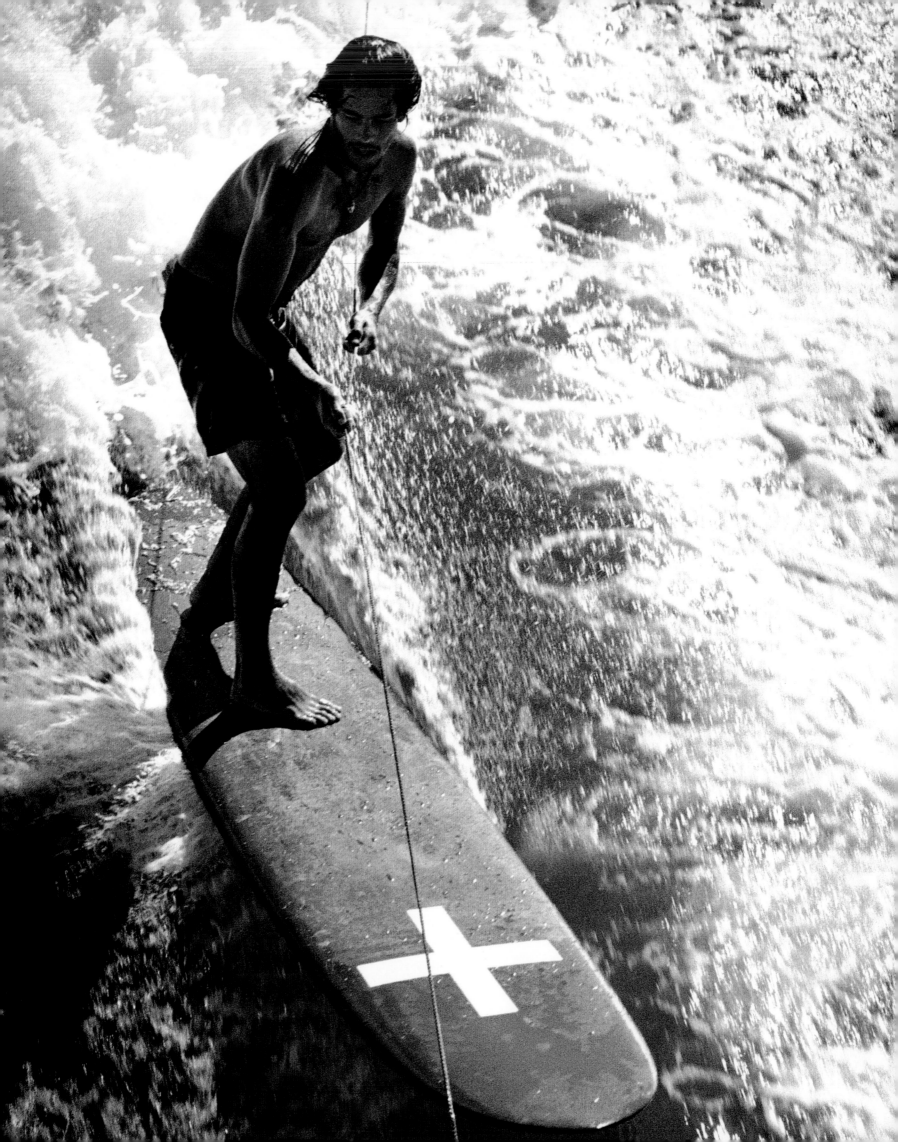

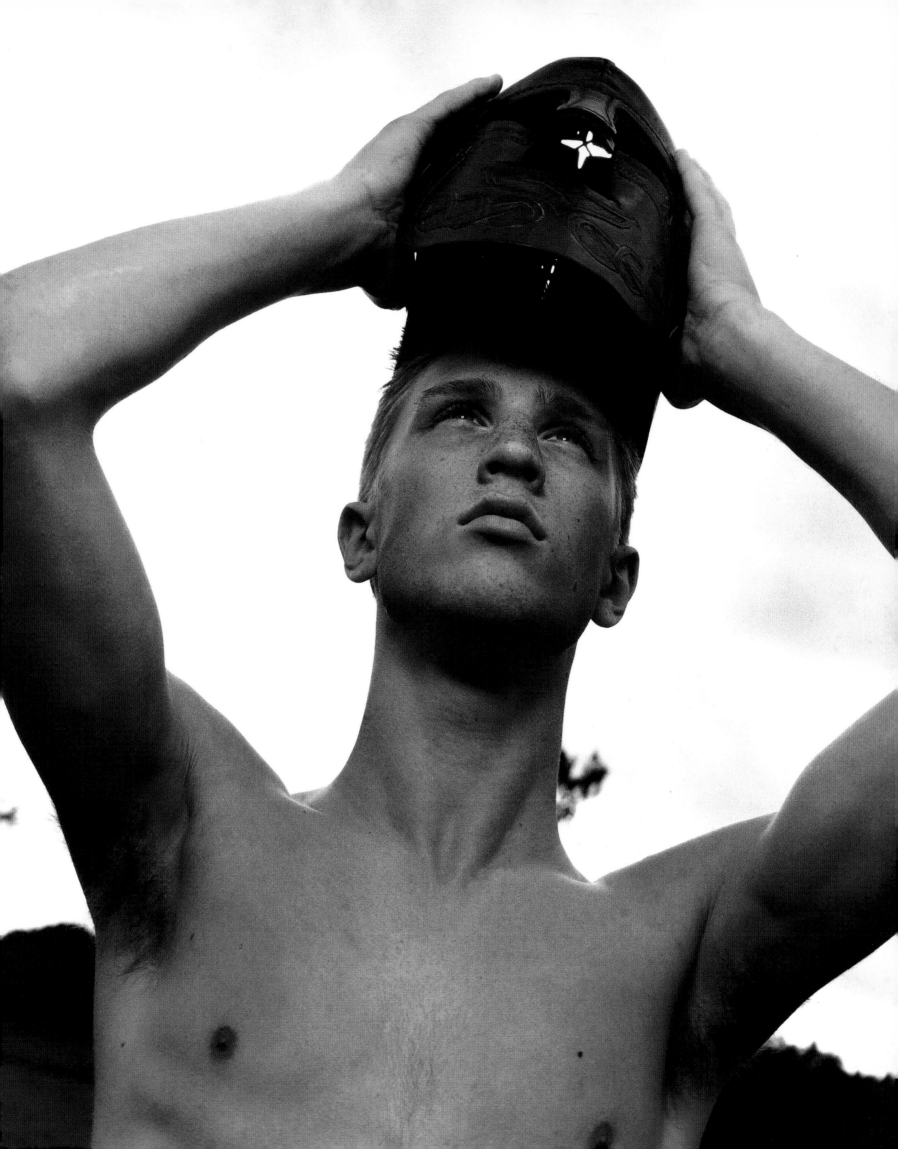

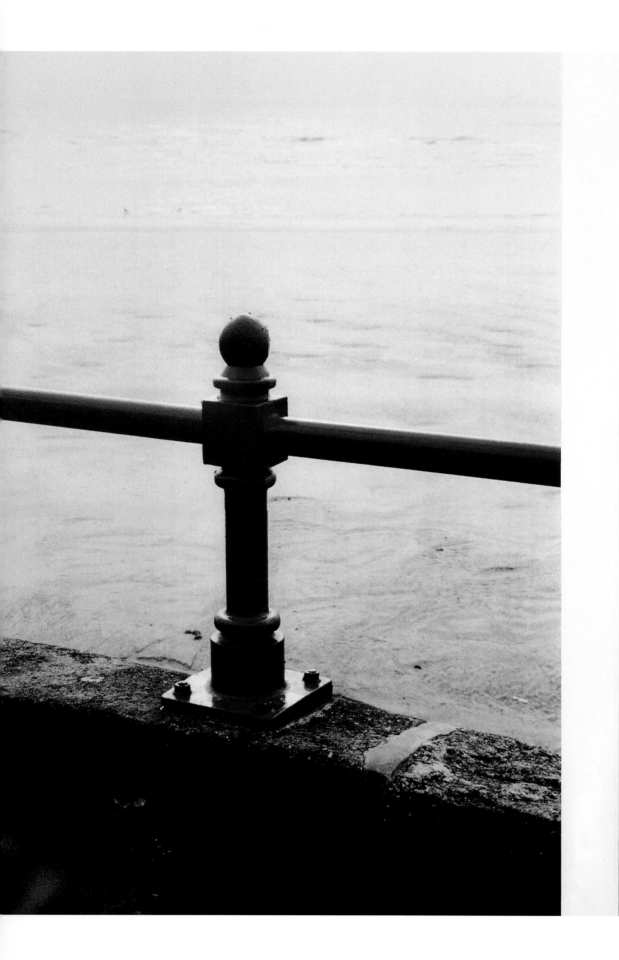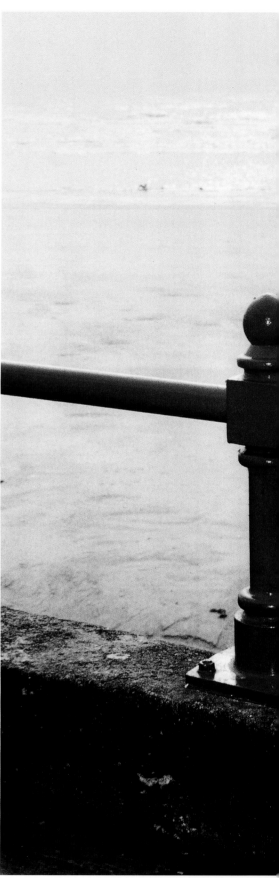

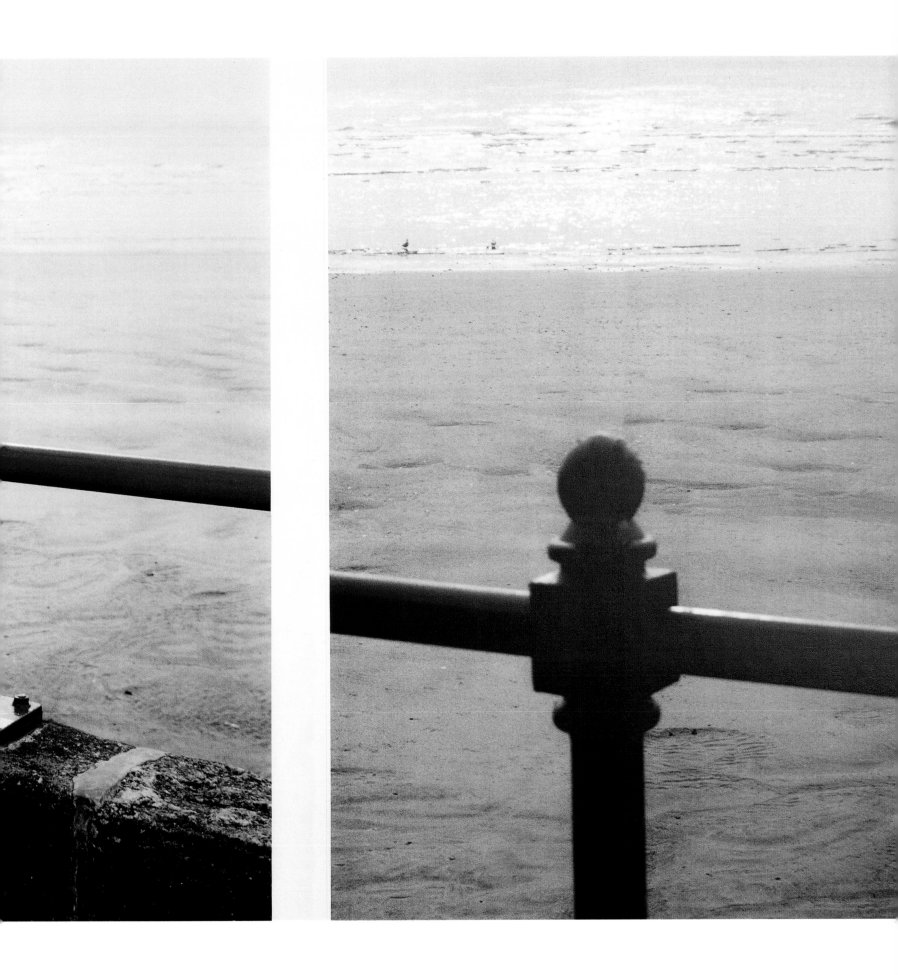

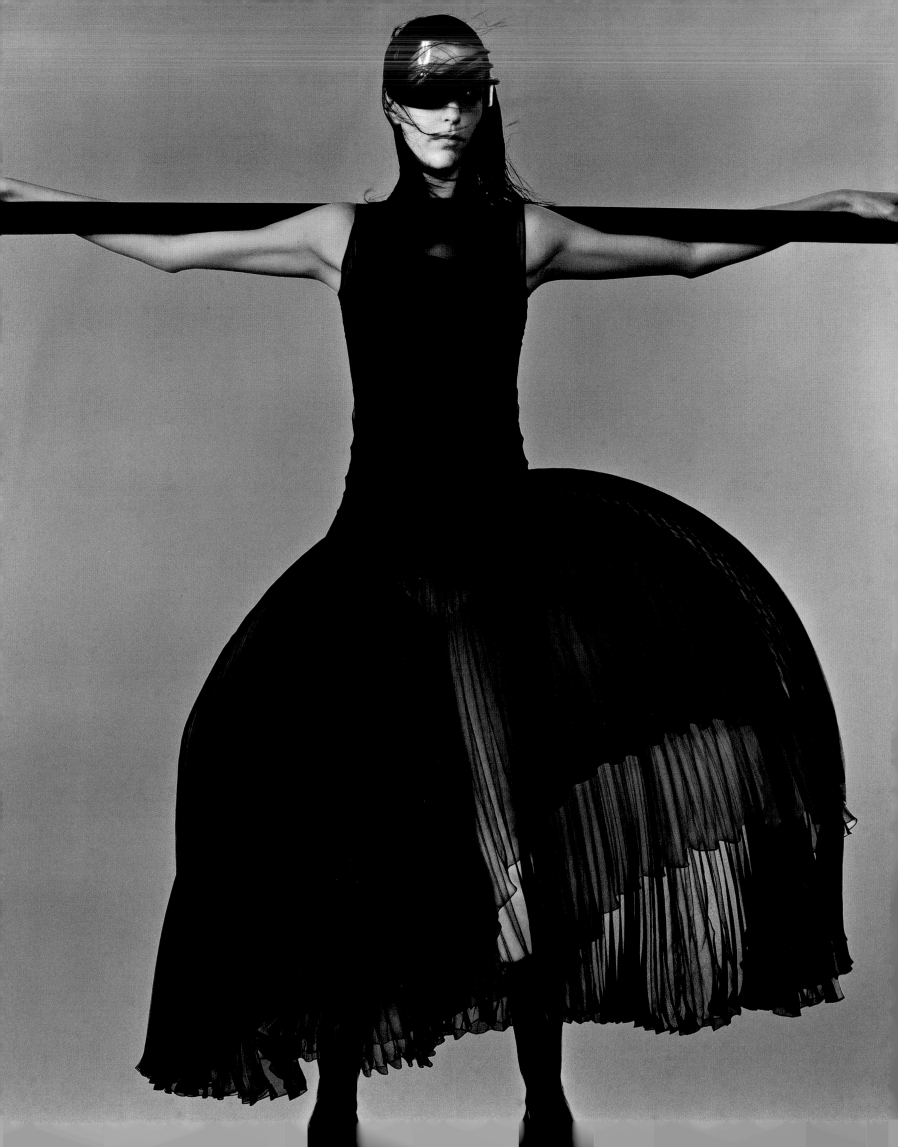

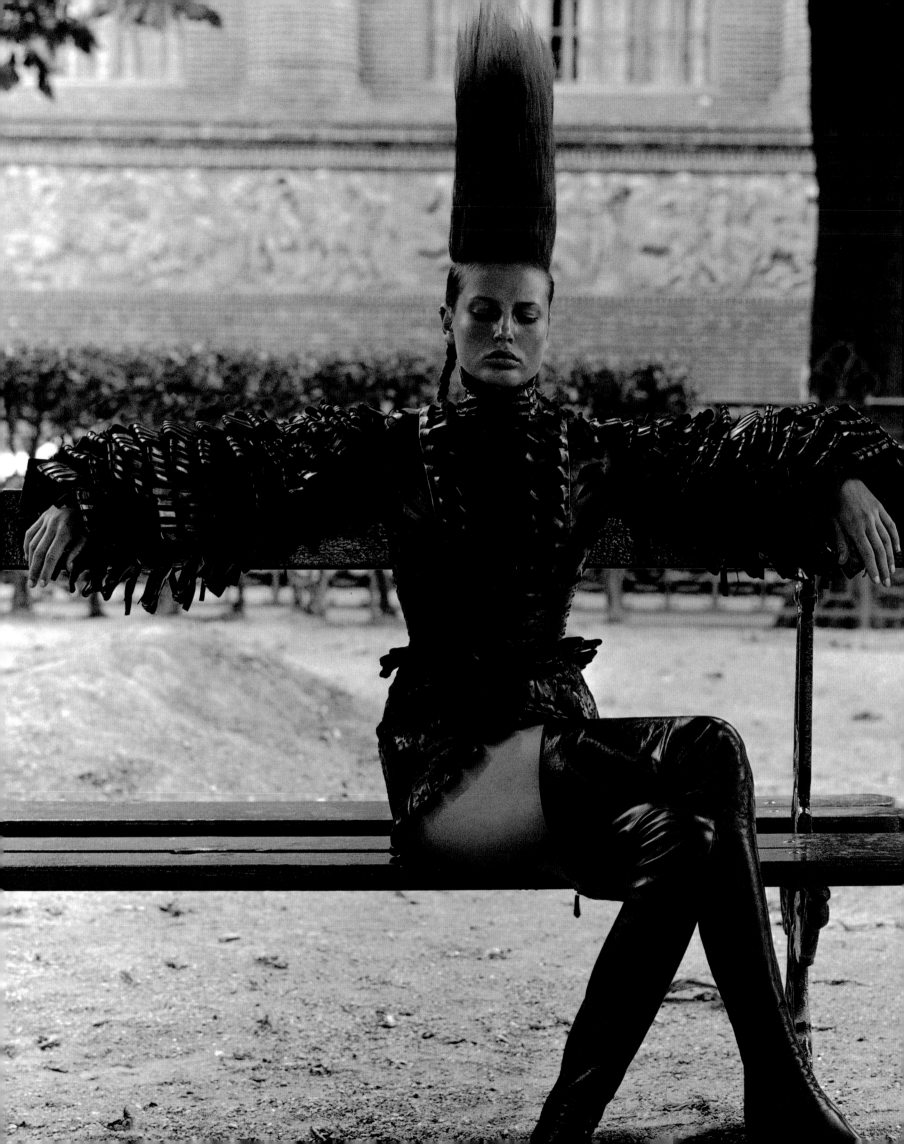

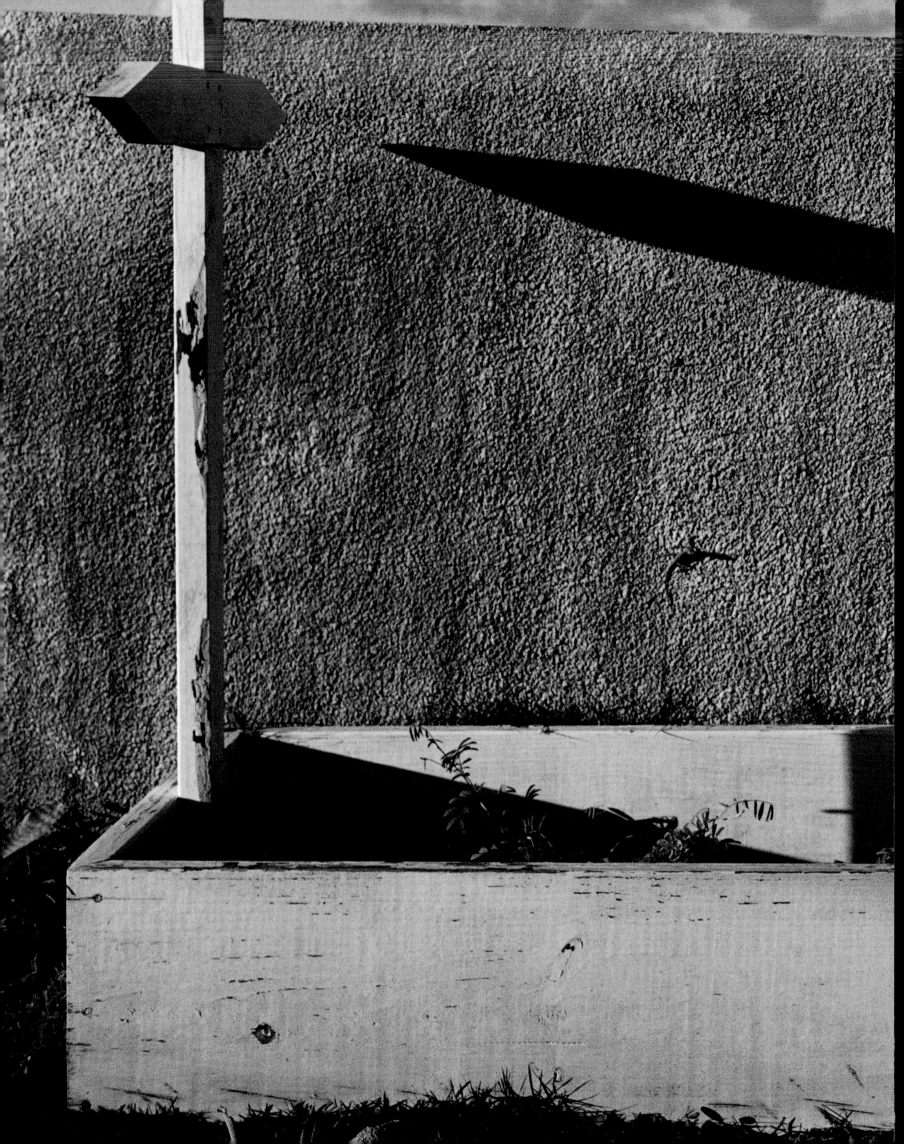

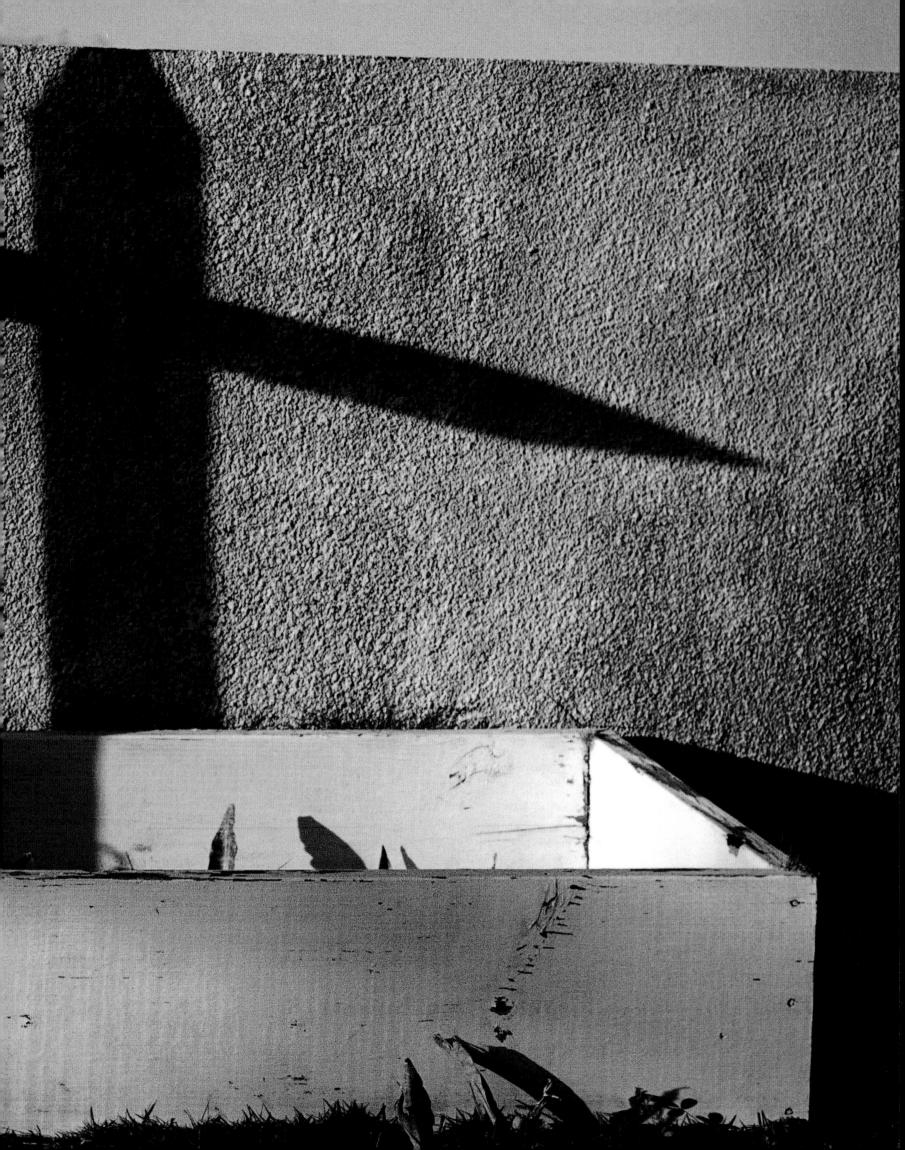

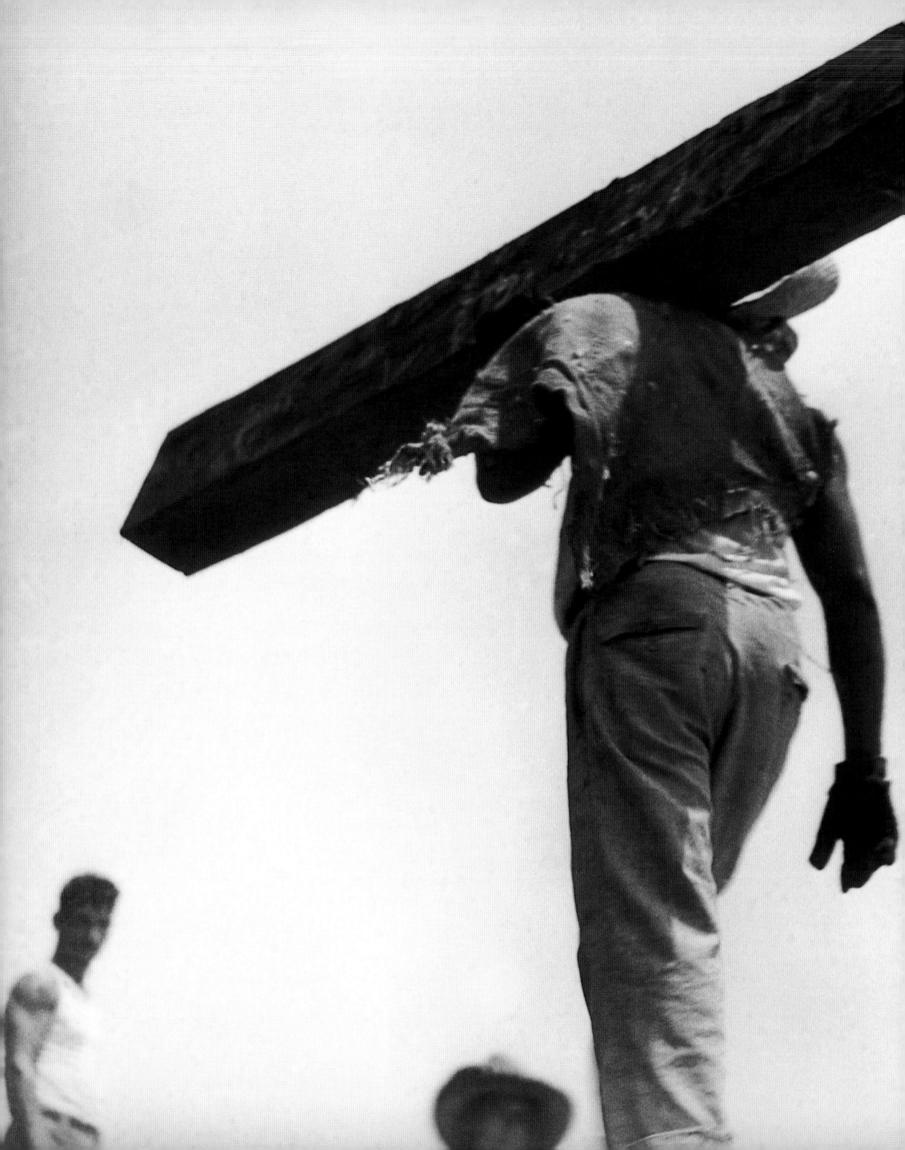

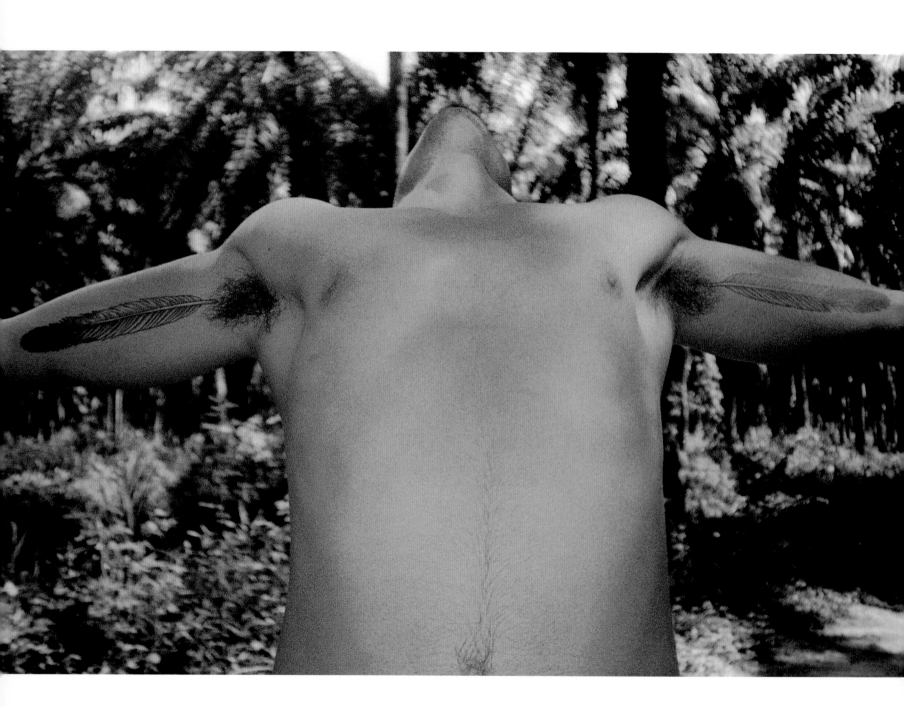

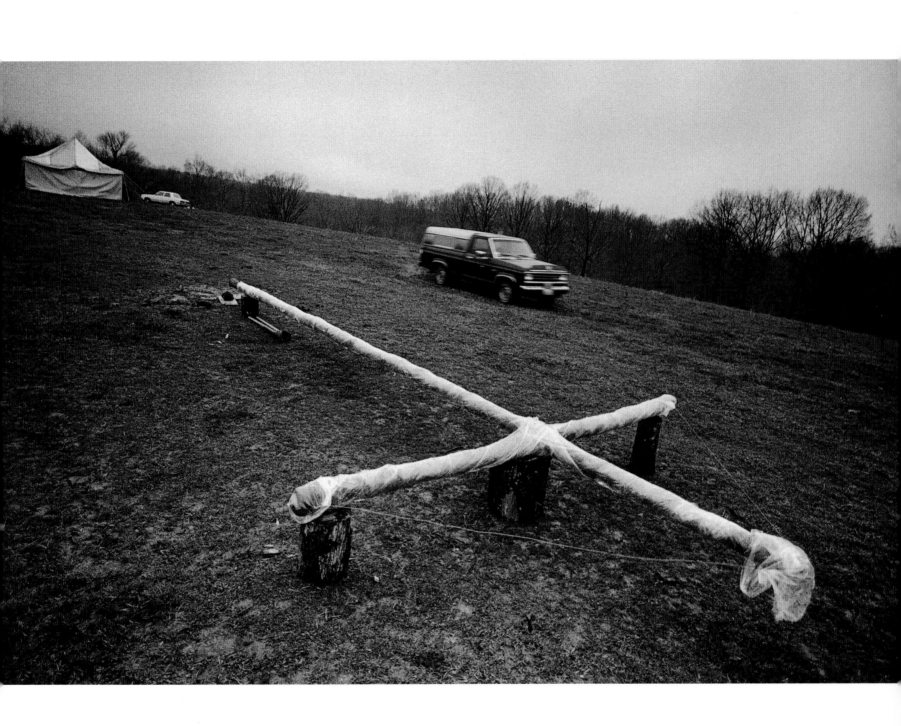

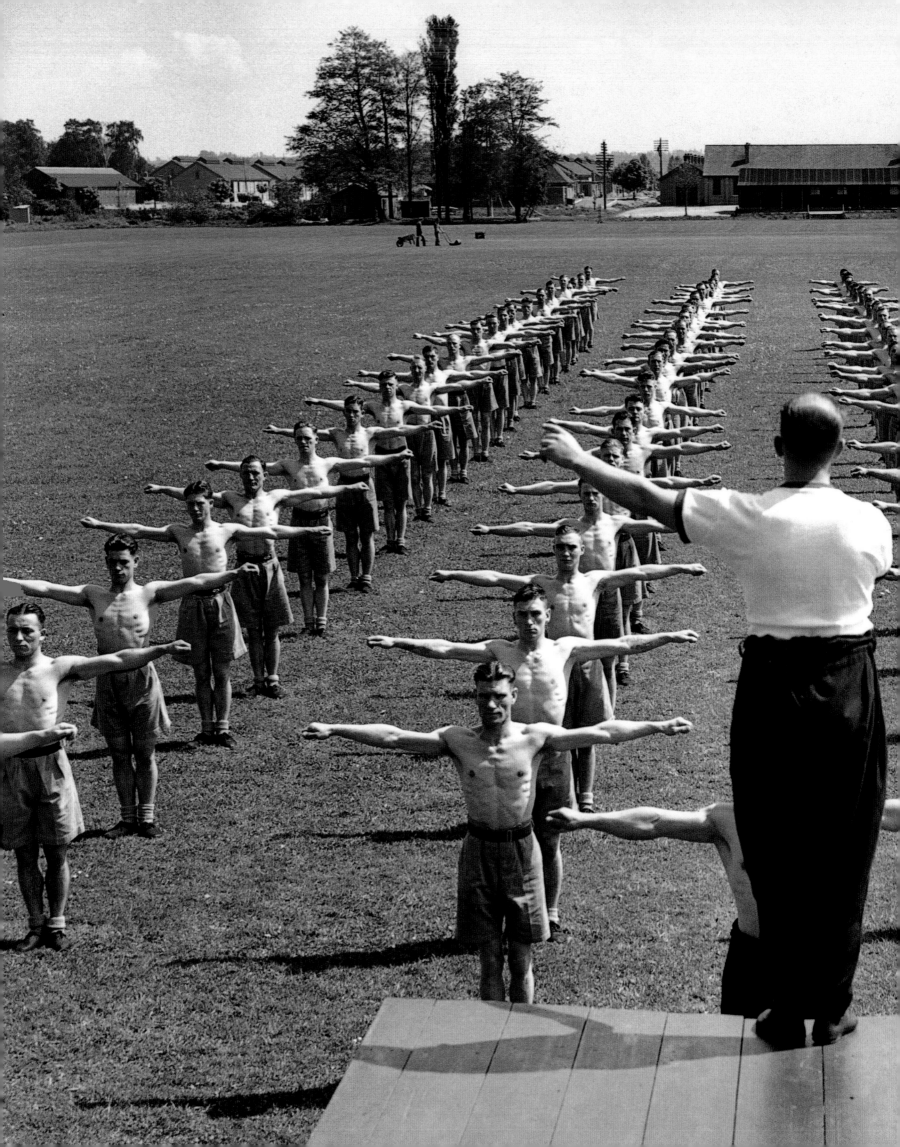

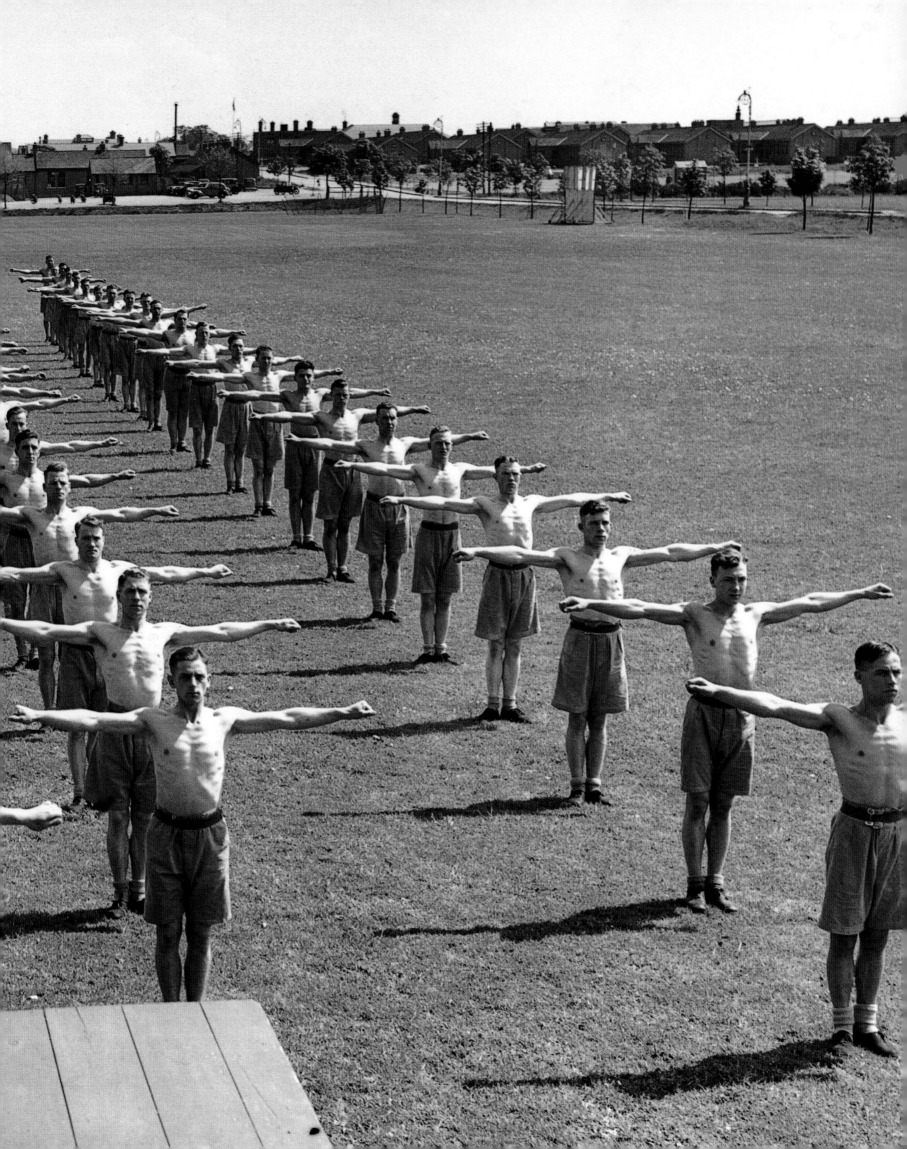

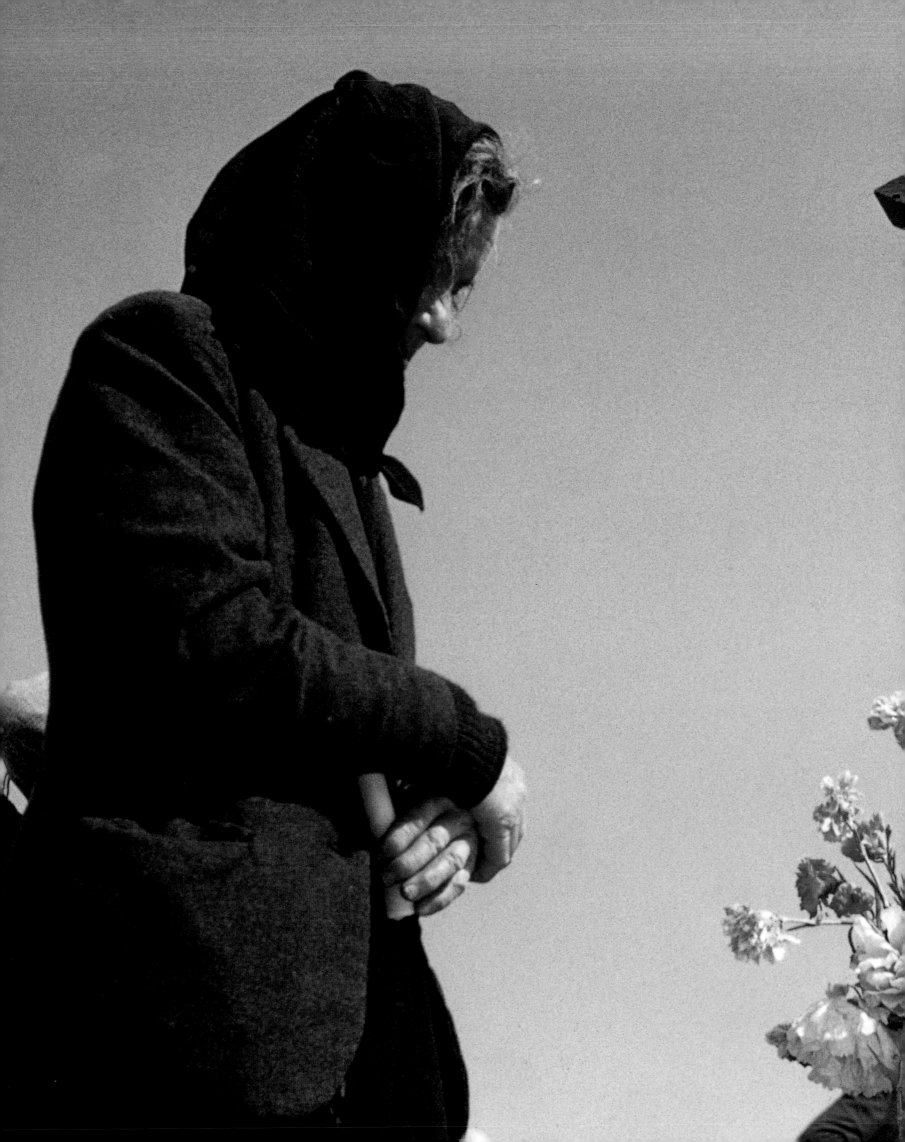

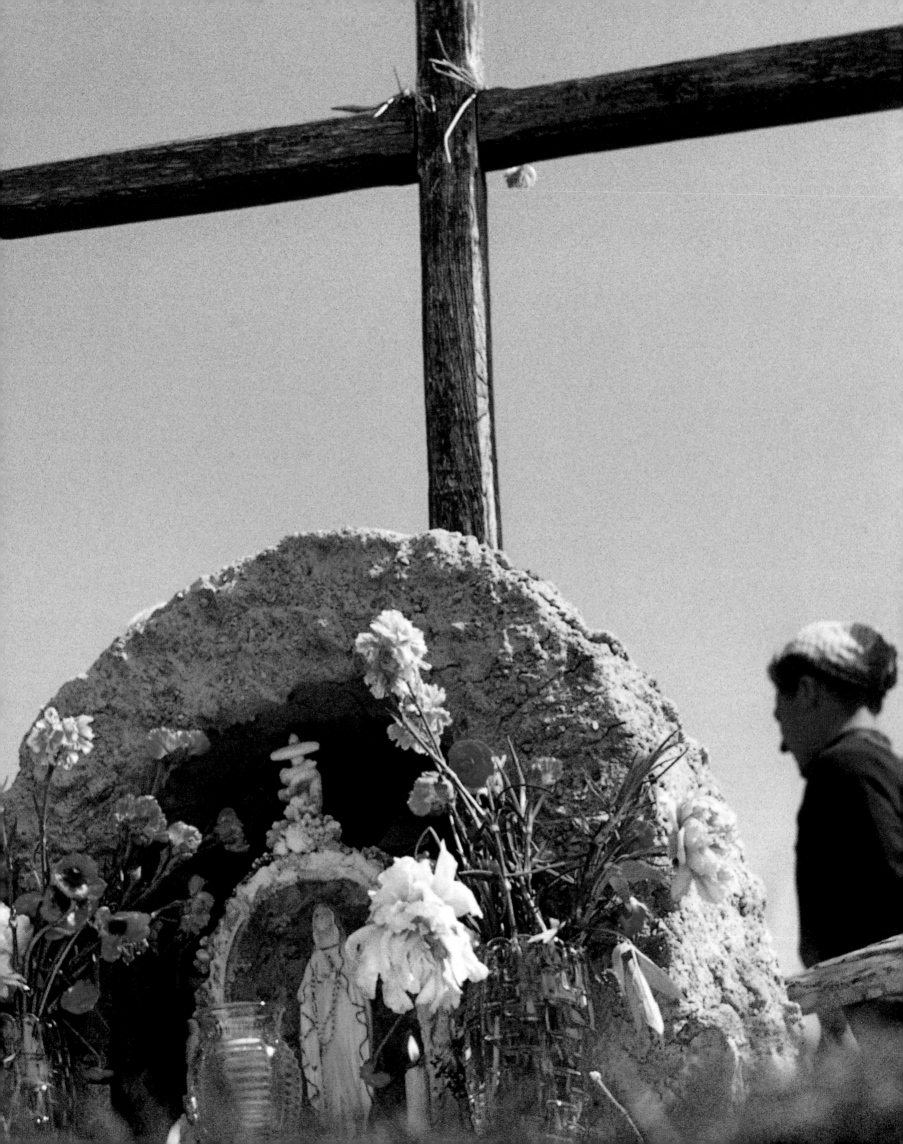

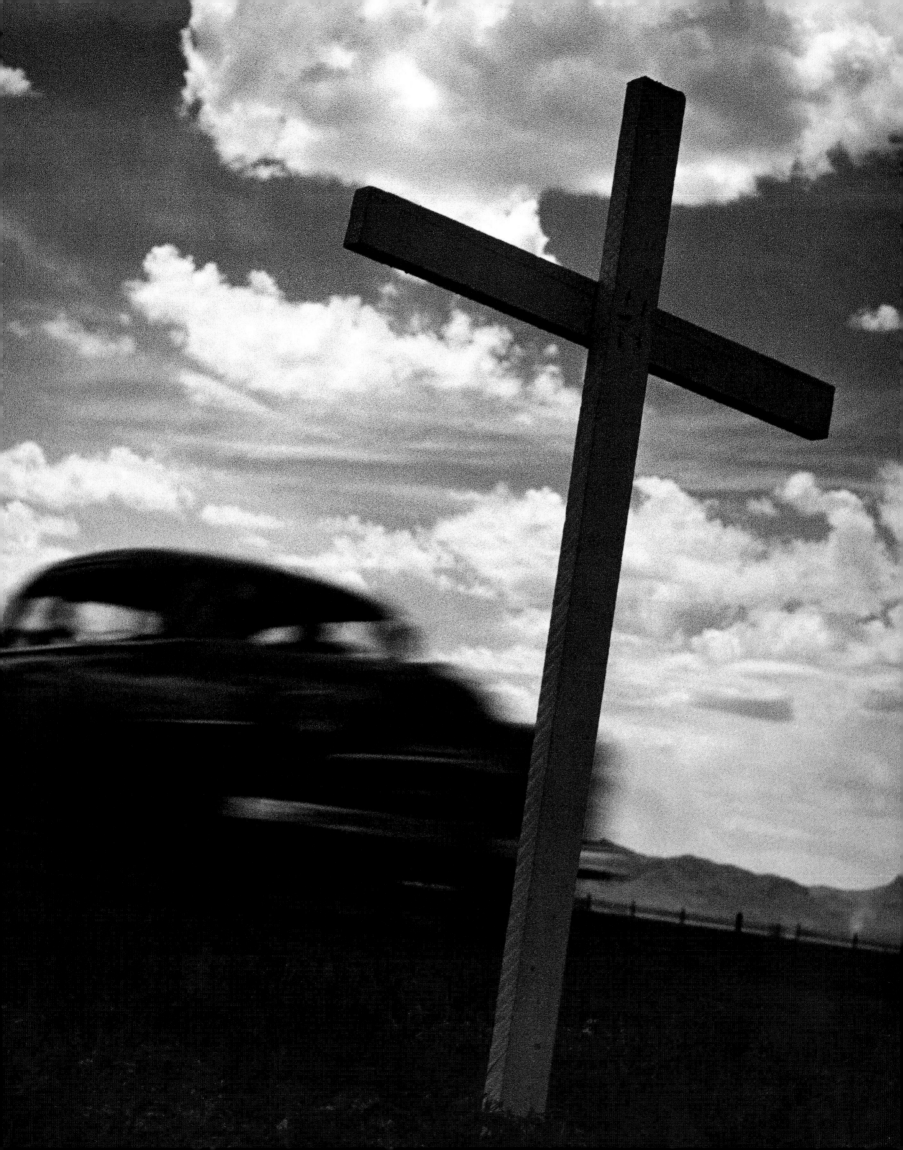

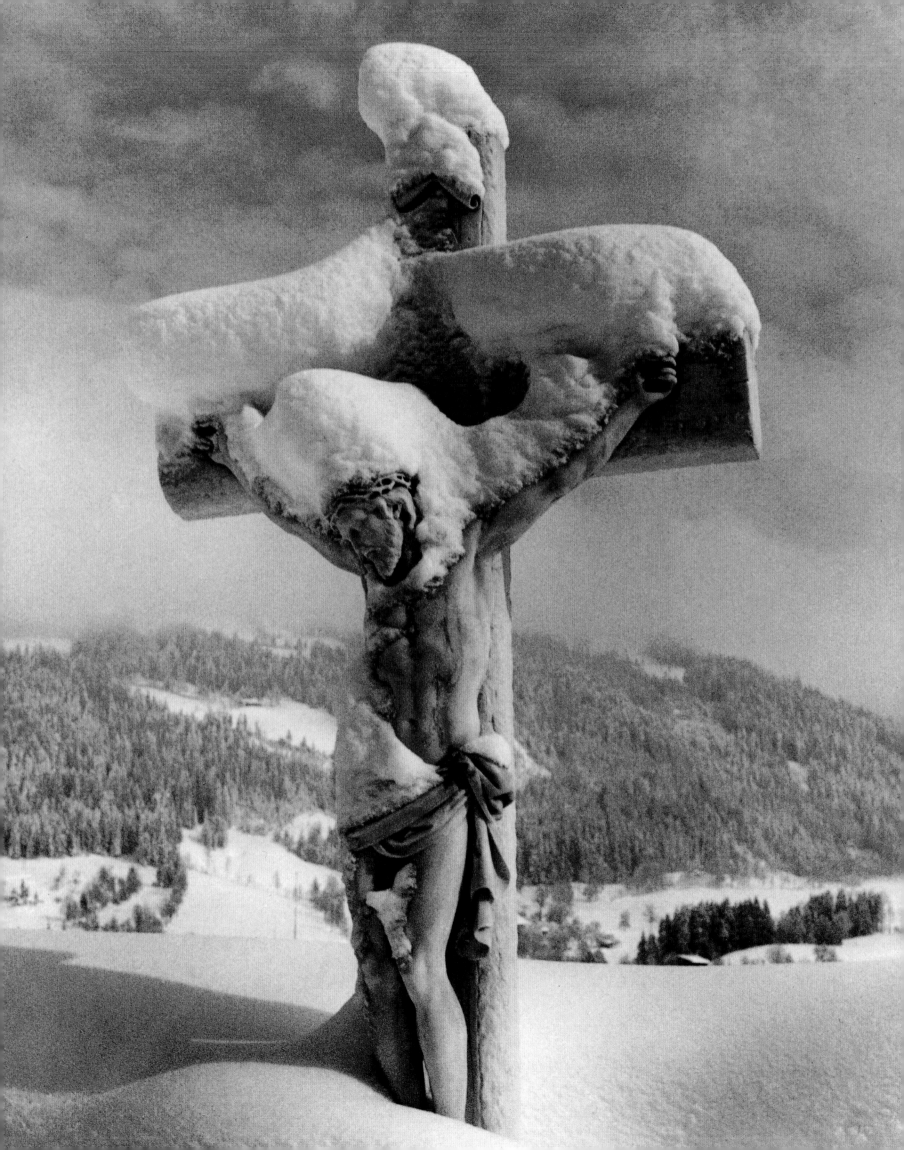

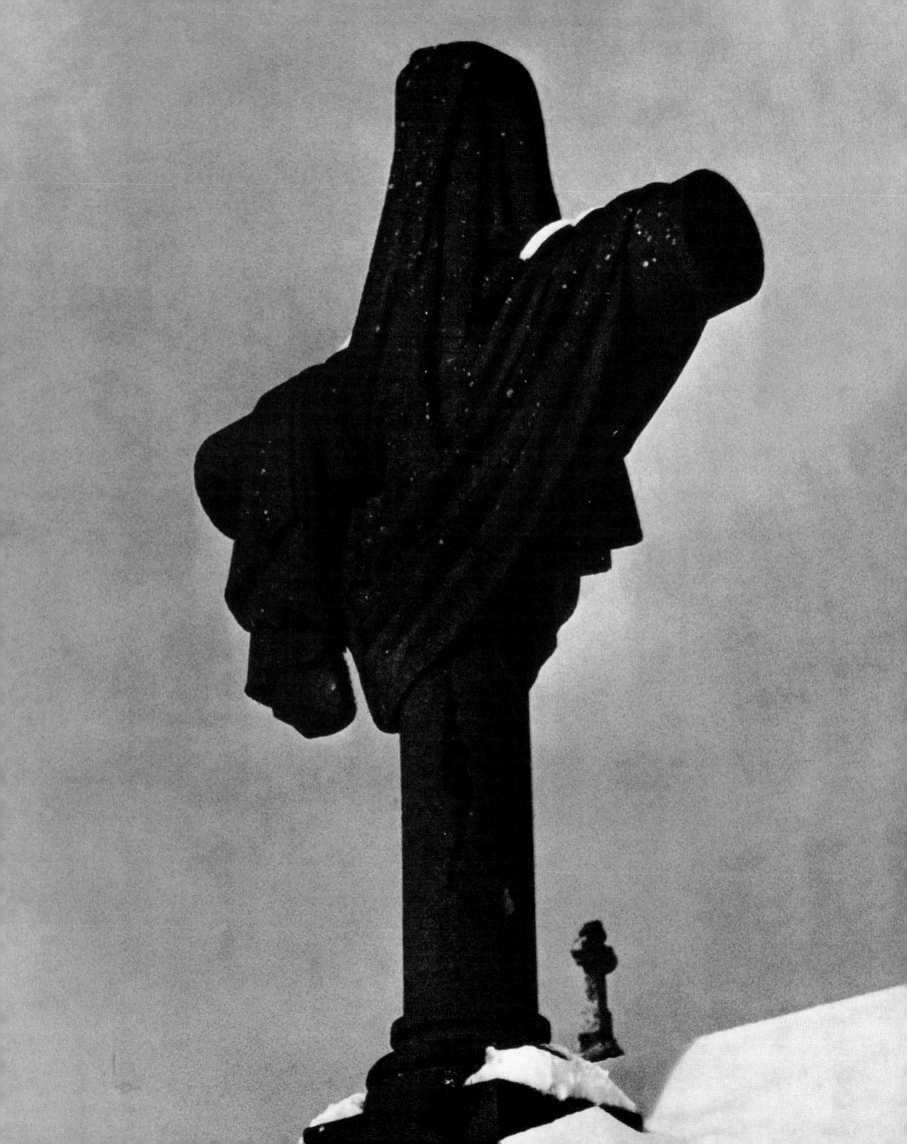

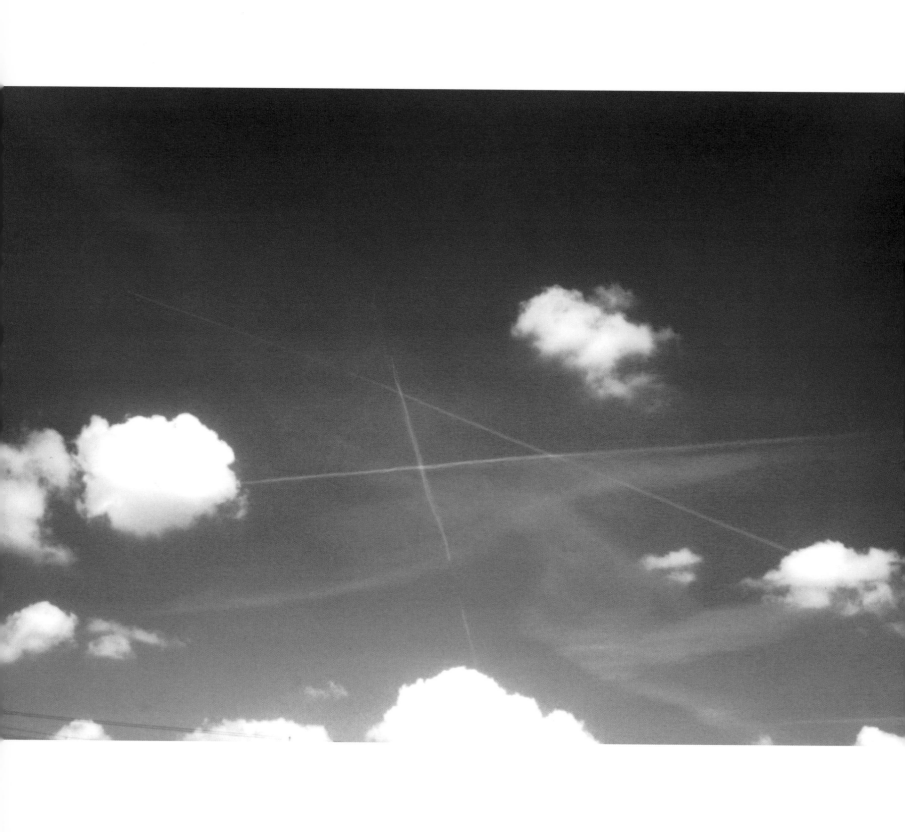

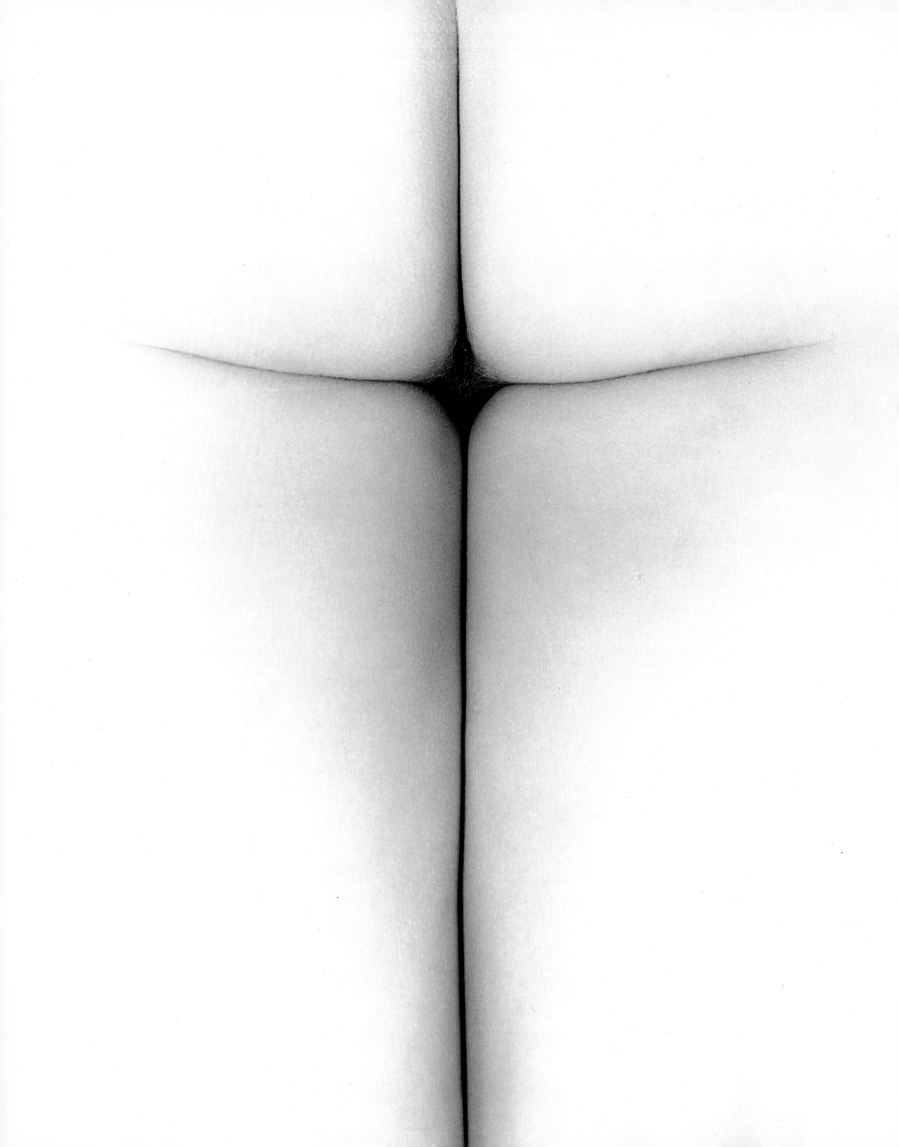

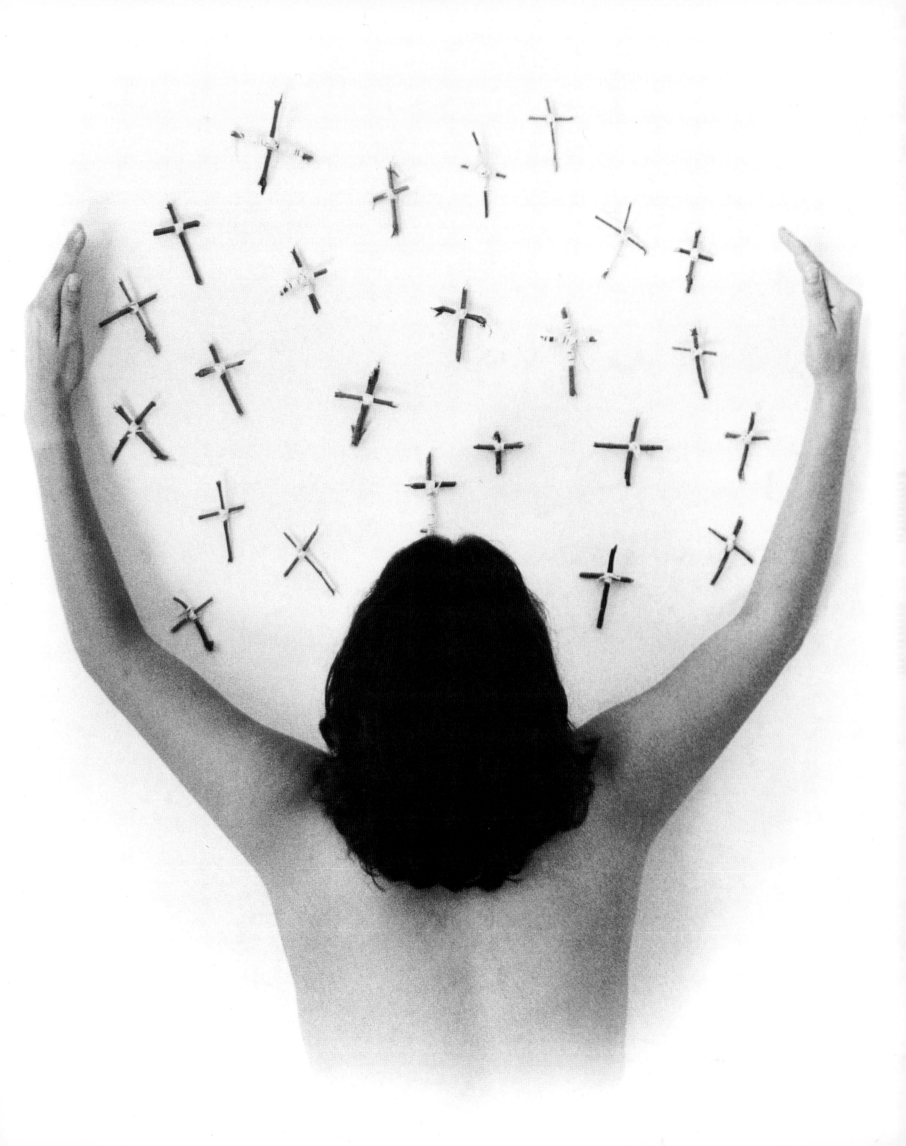

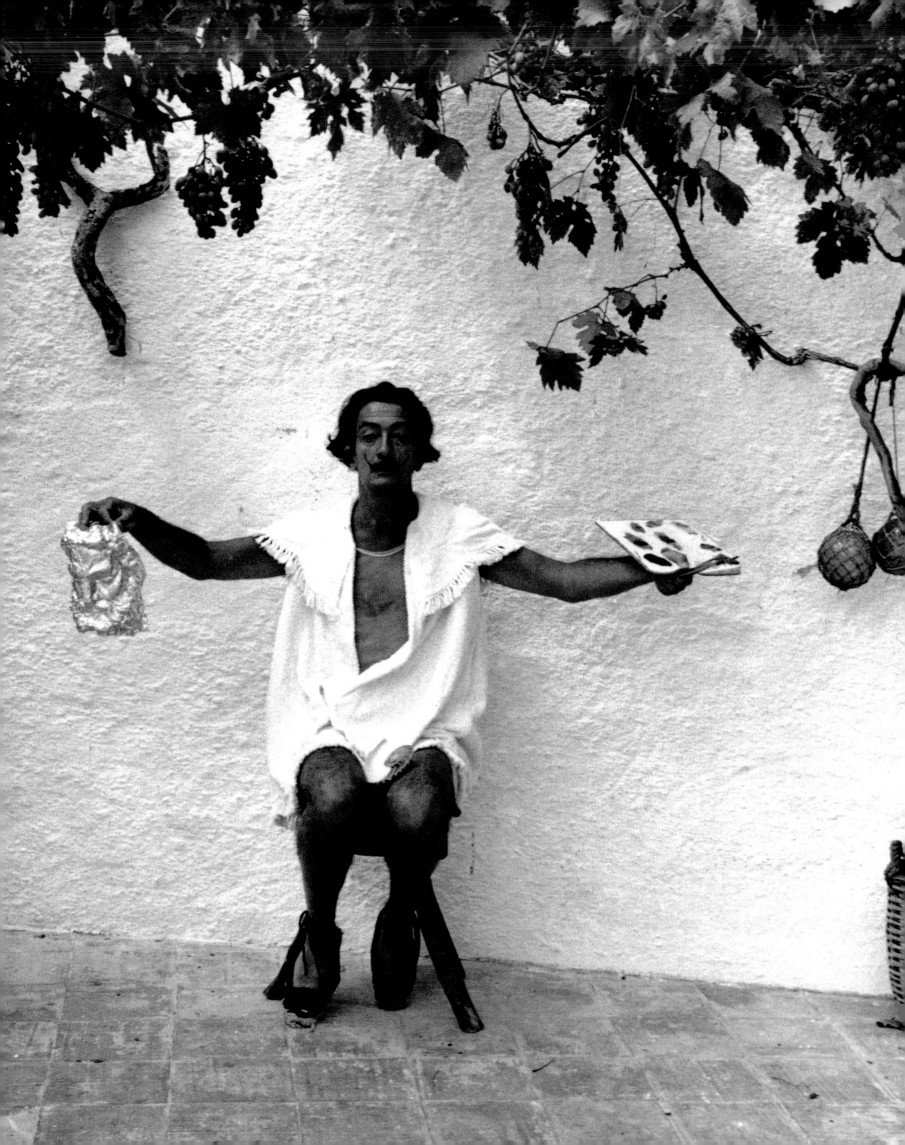

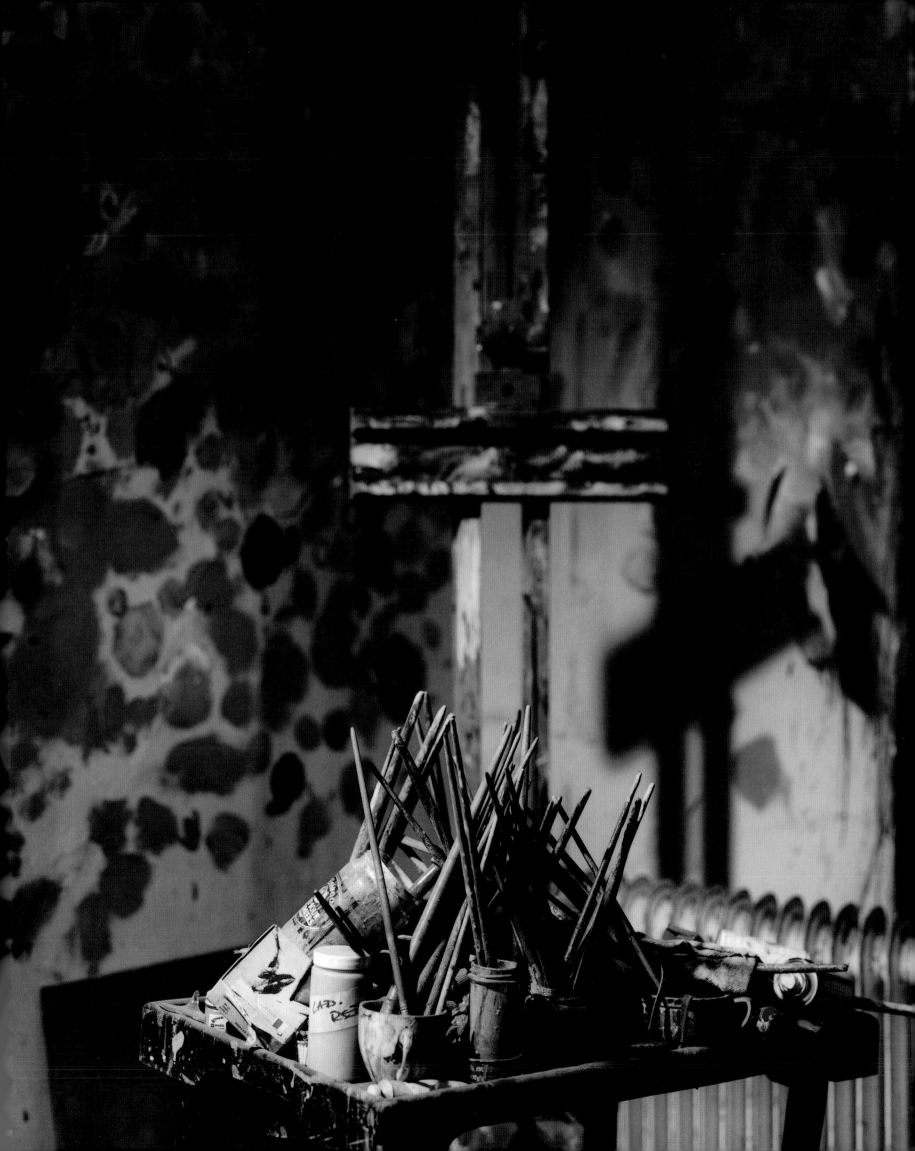

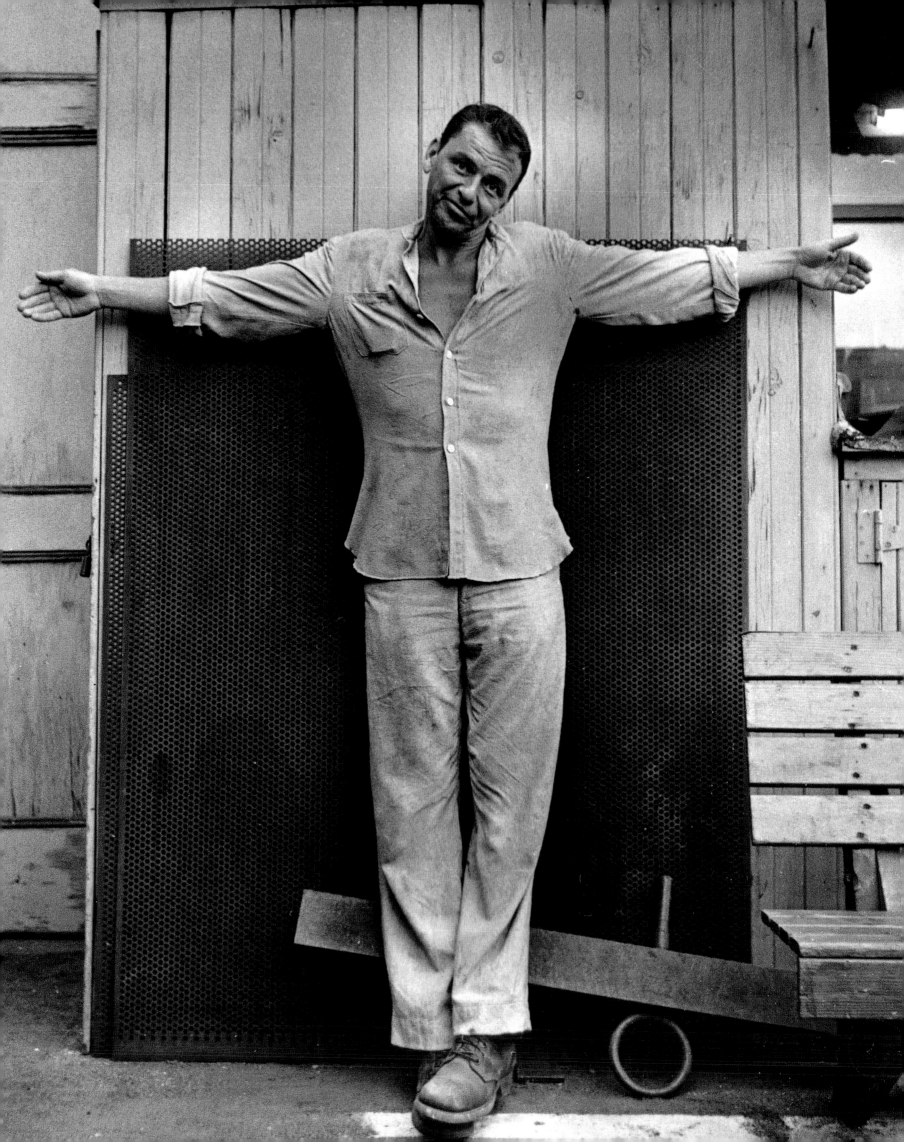

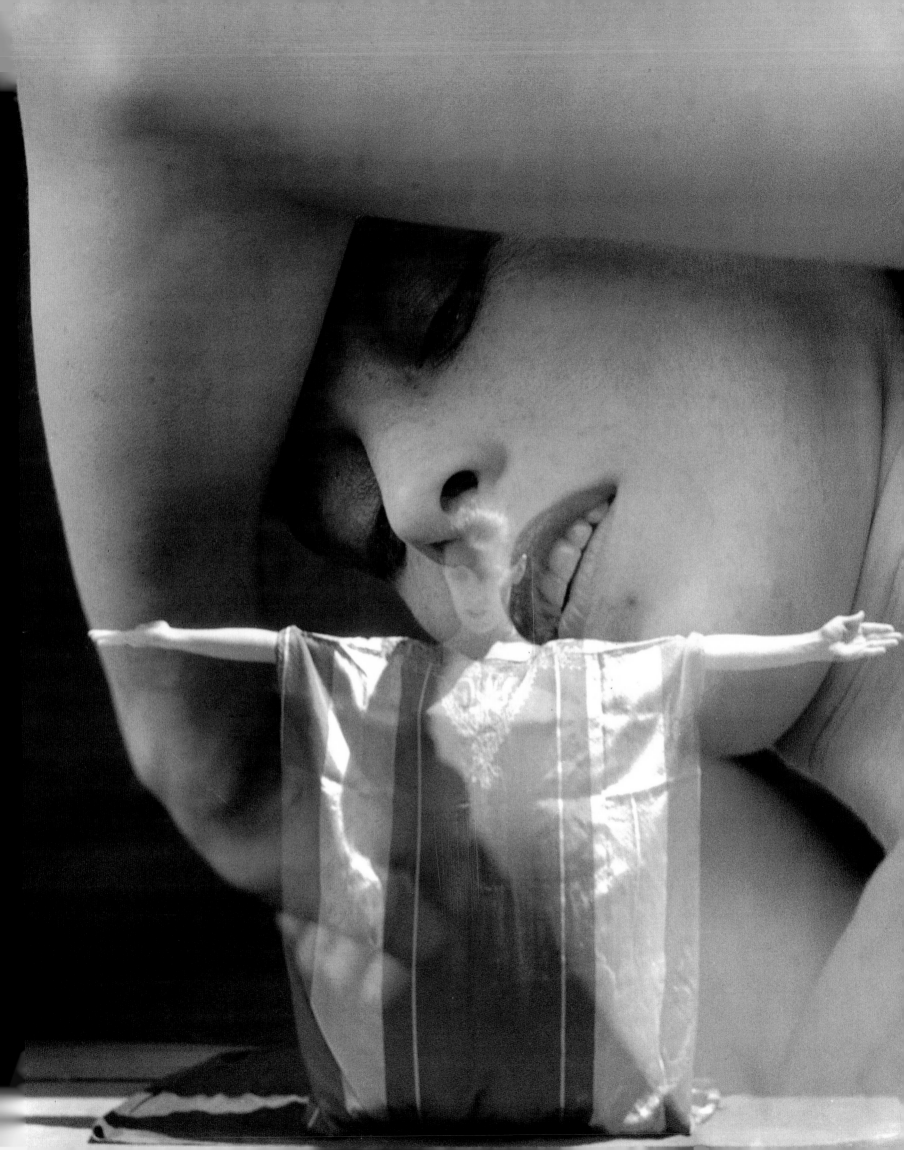

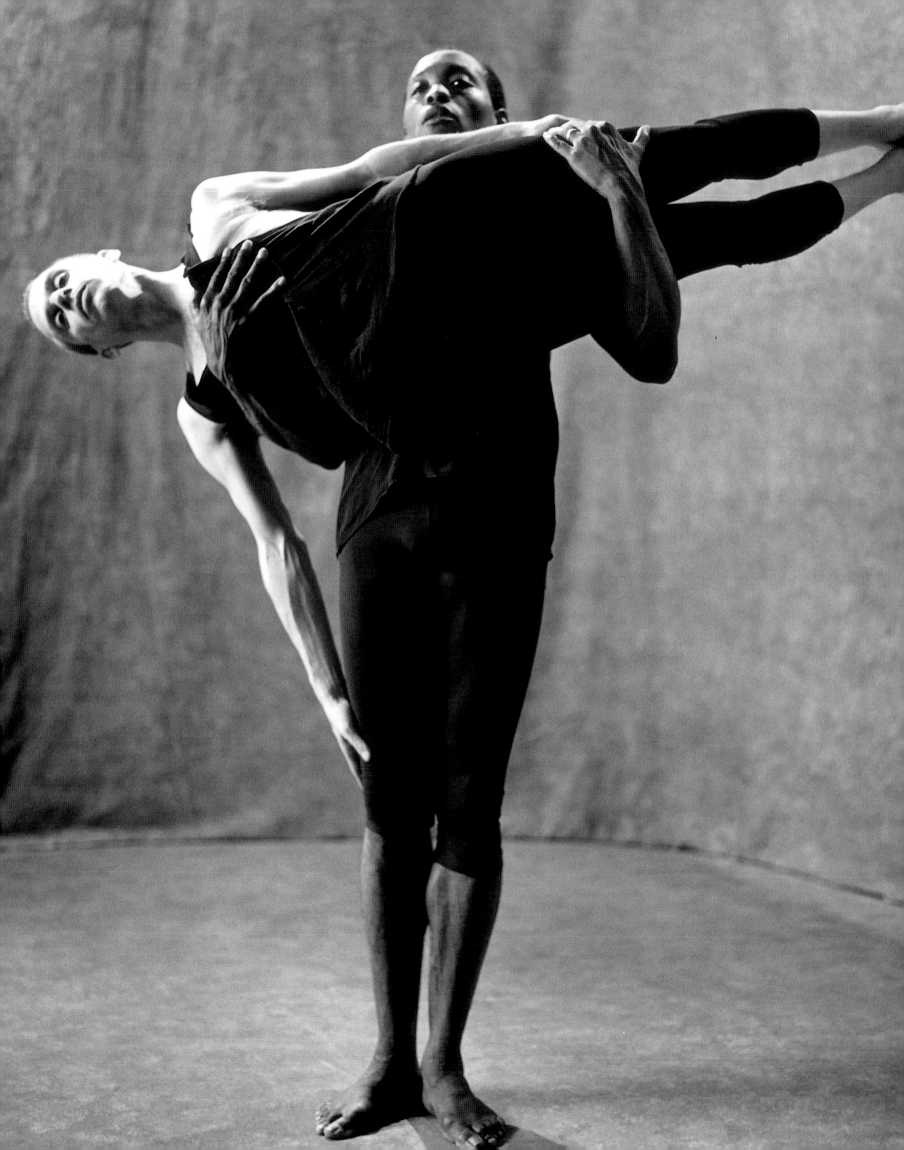

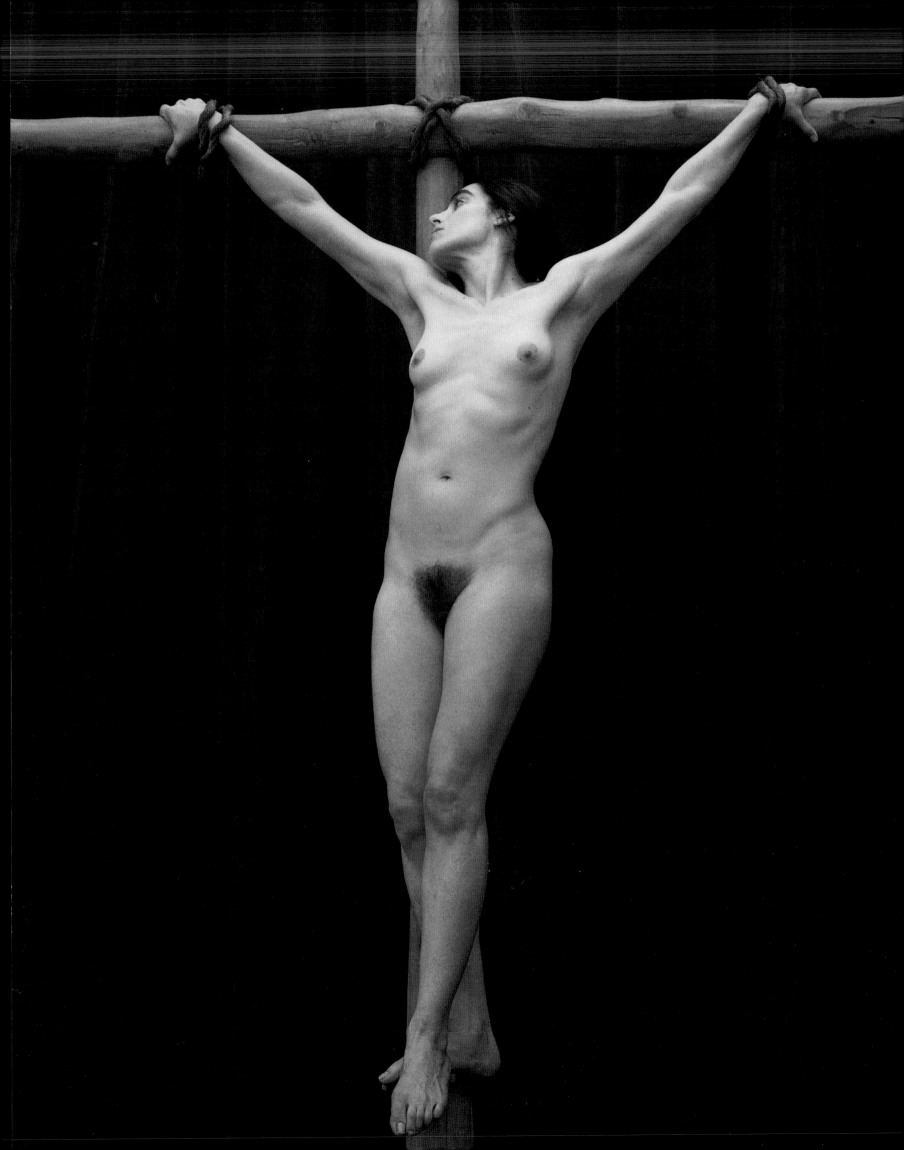

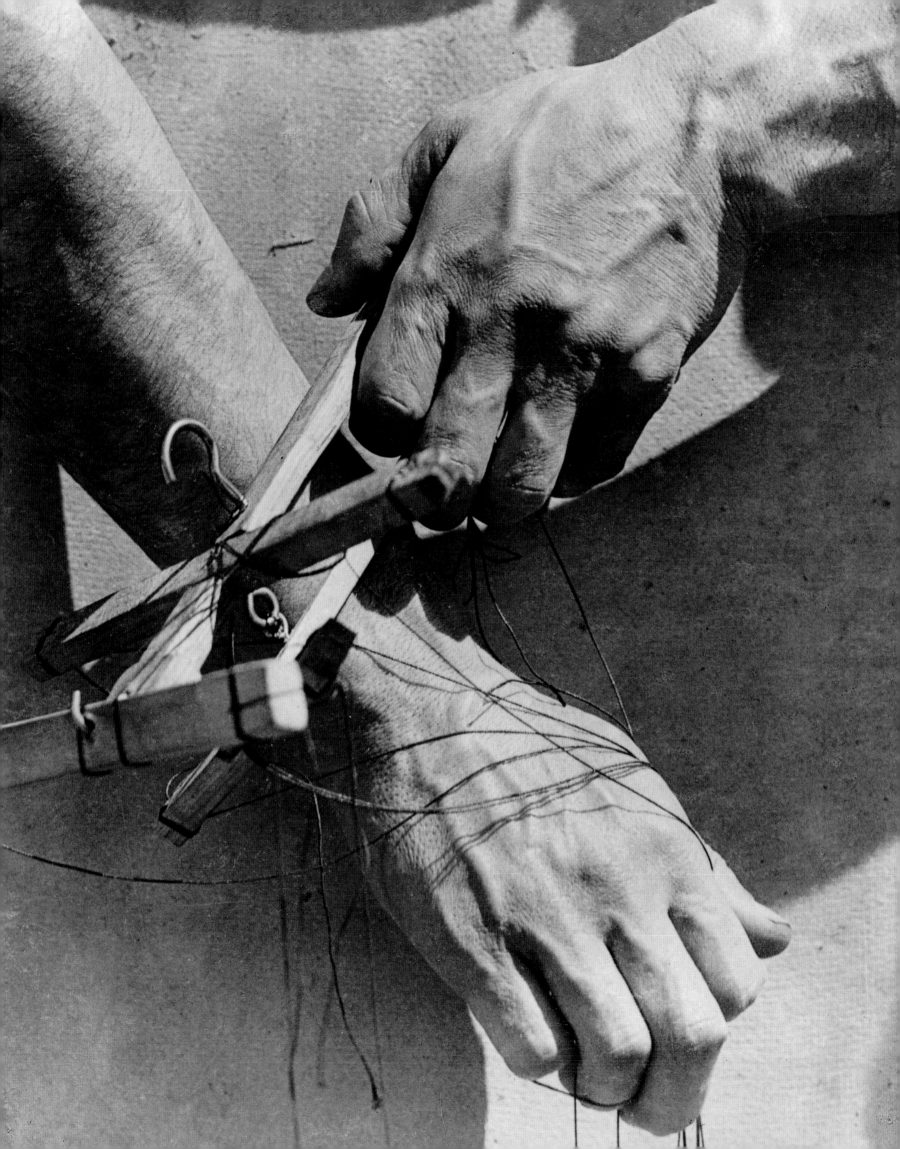

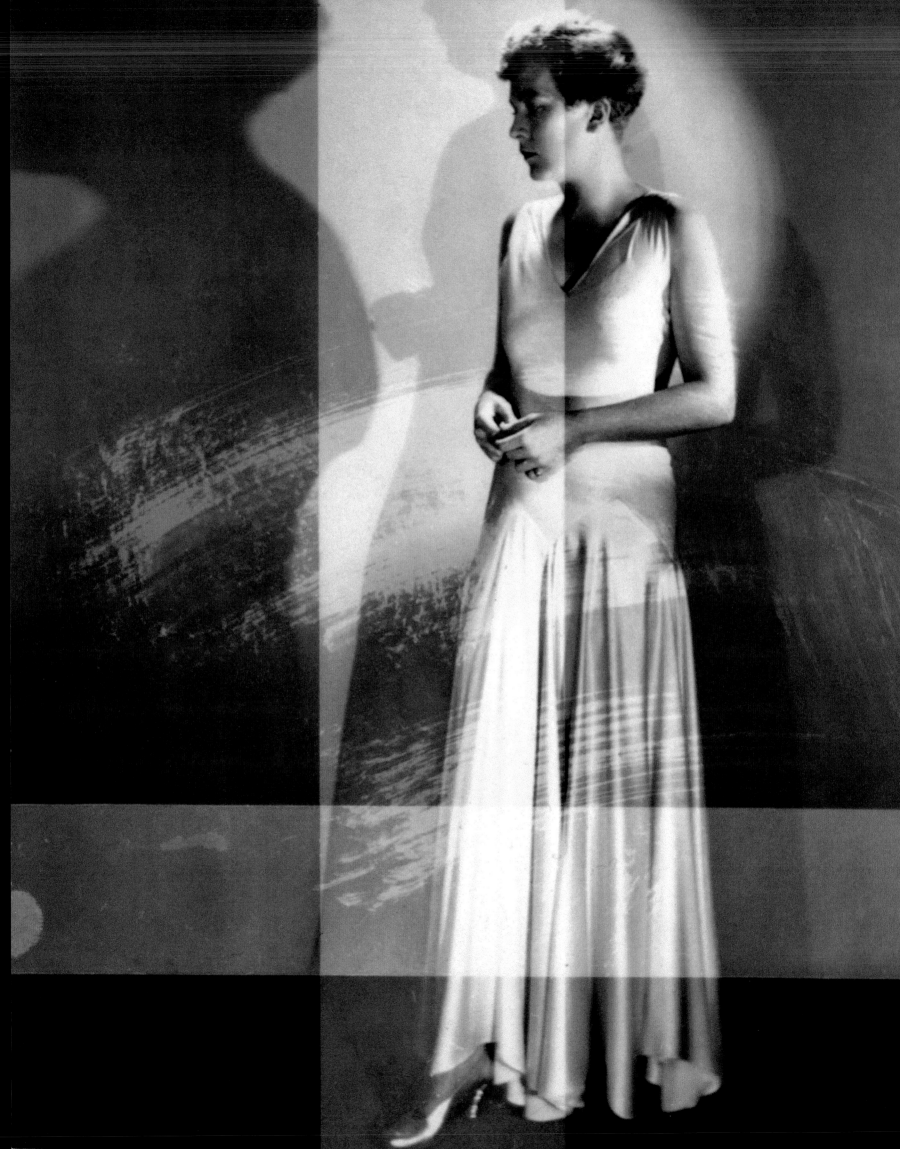

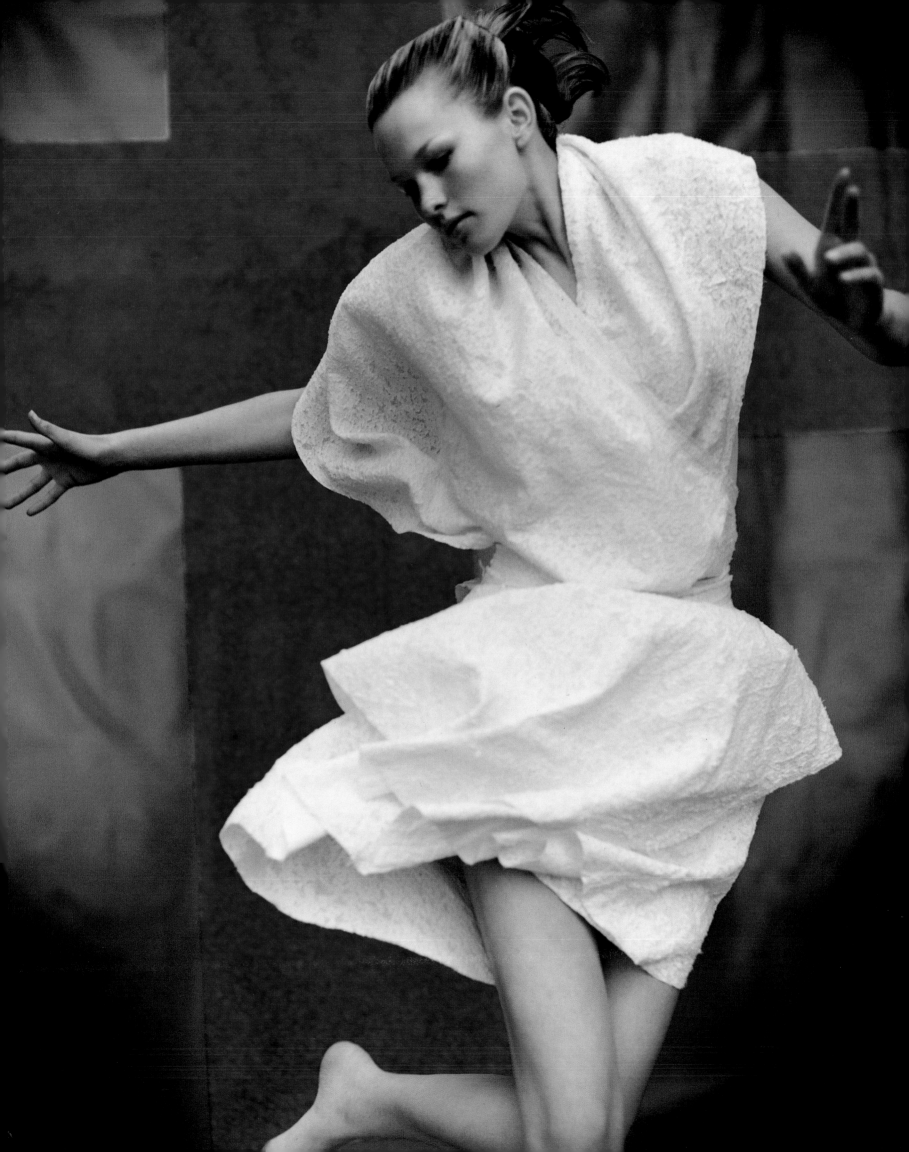

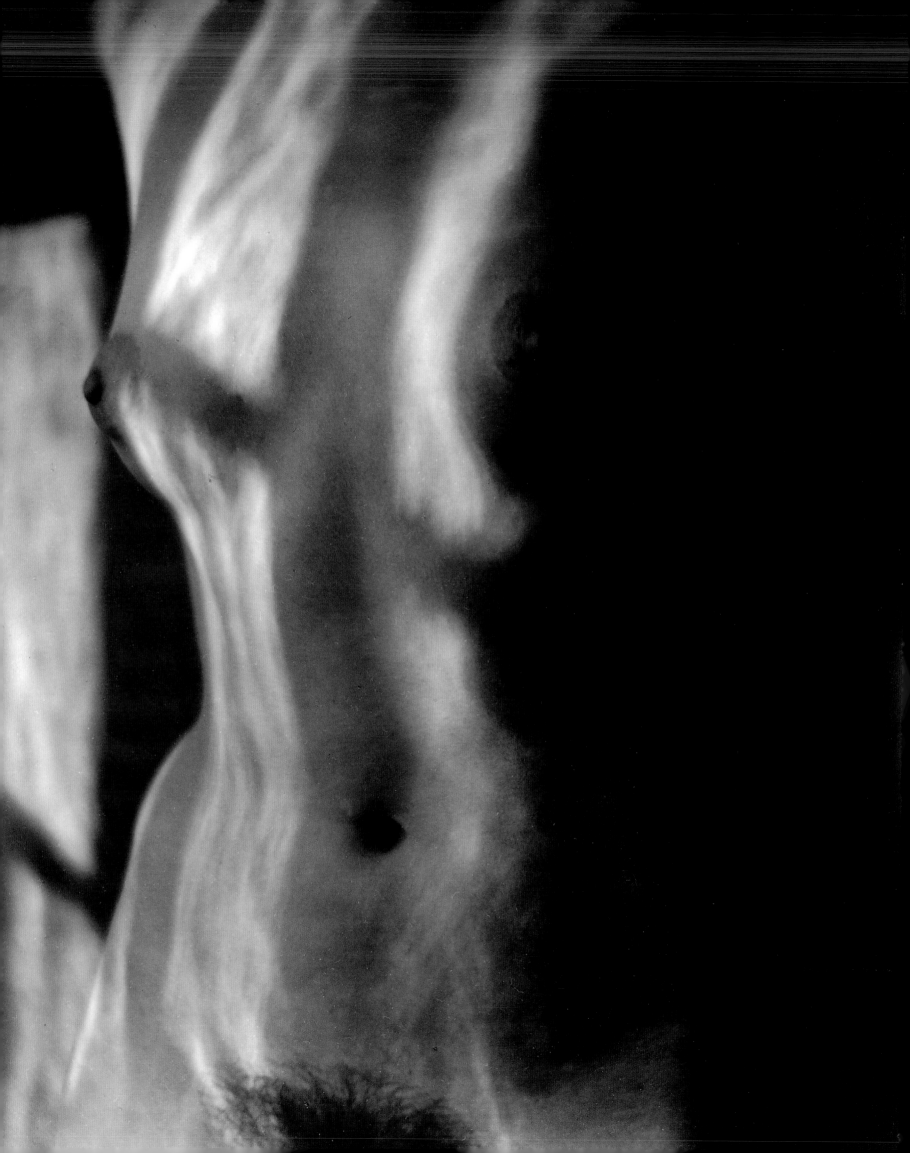

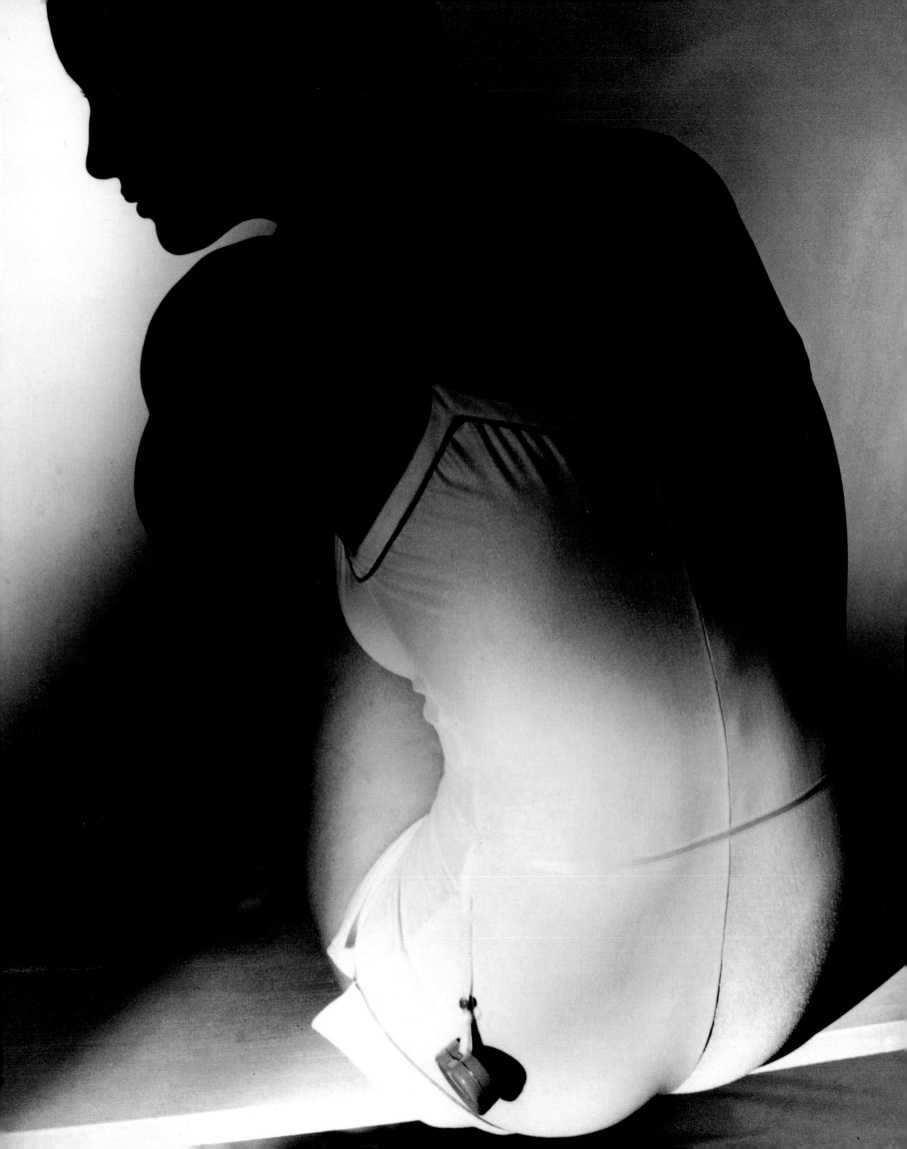

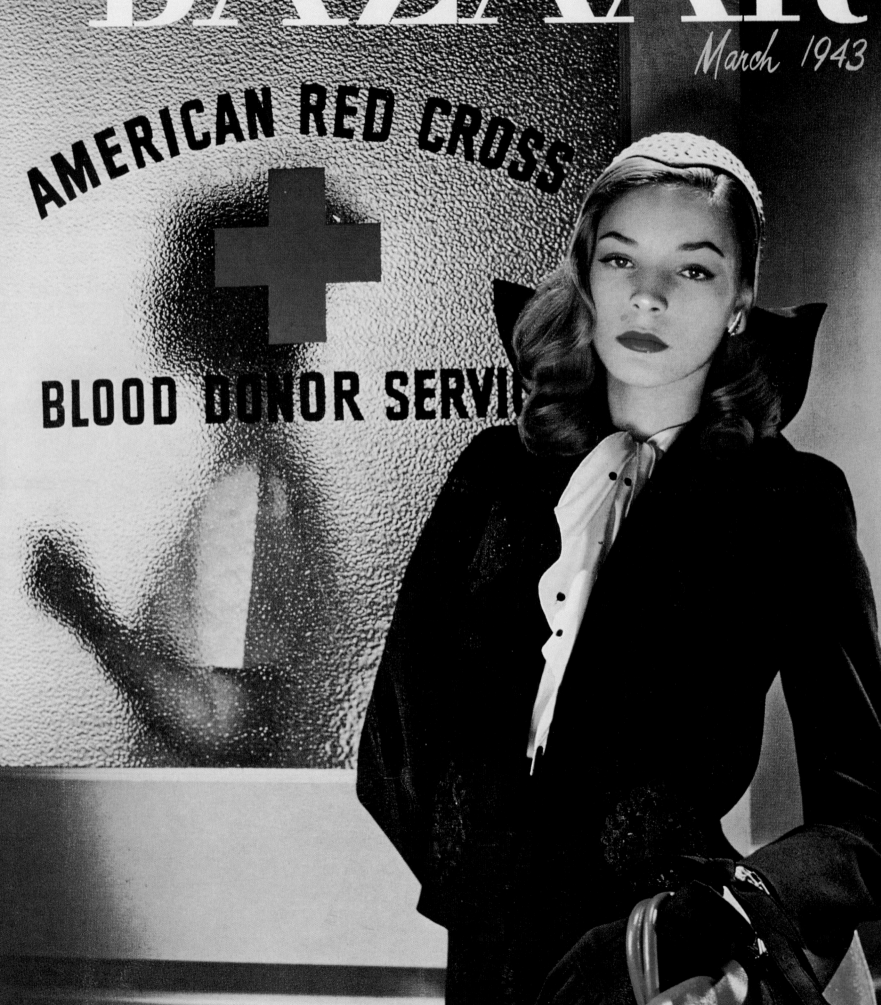

Harper's BAZAAR

March 1943

AMERICAN RED CROSS

BLOOD DONOR SERVI

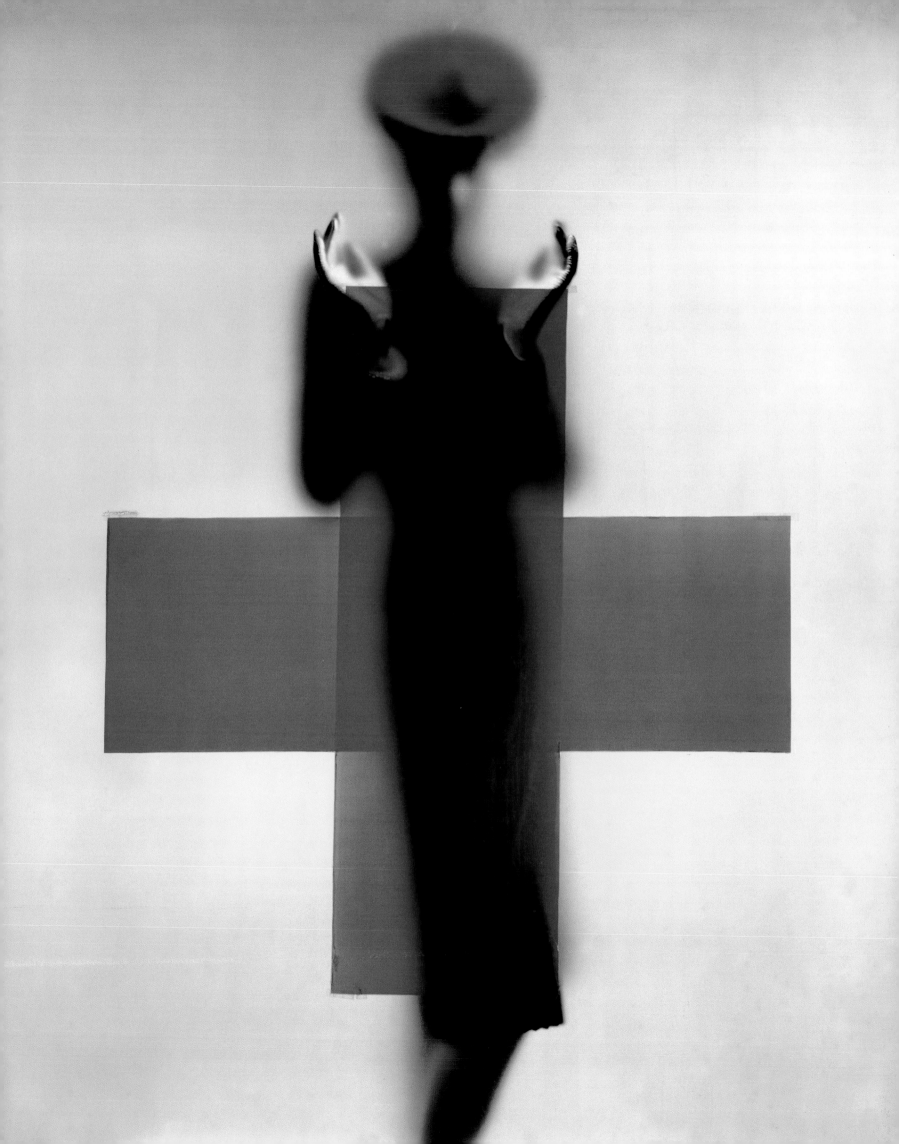

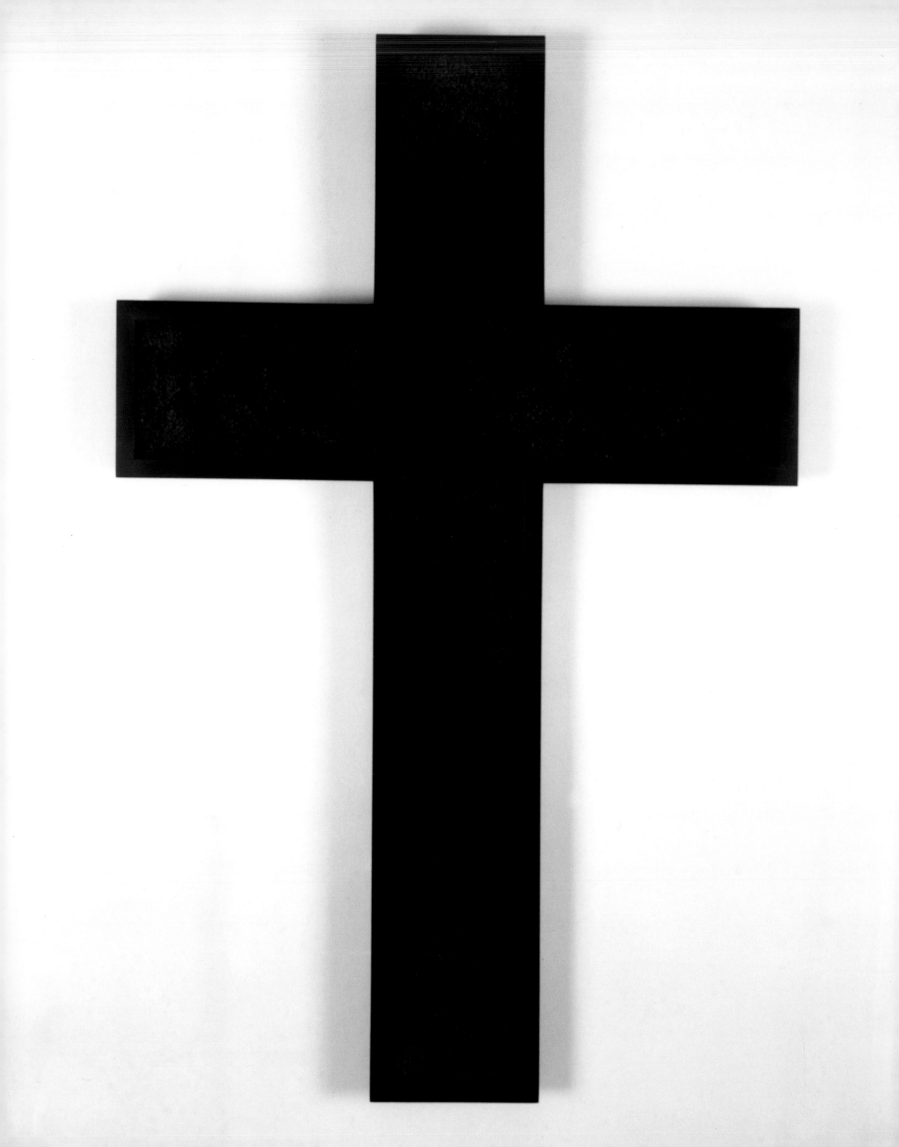

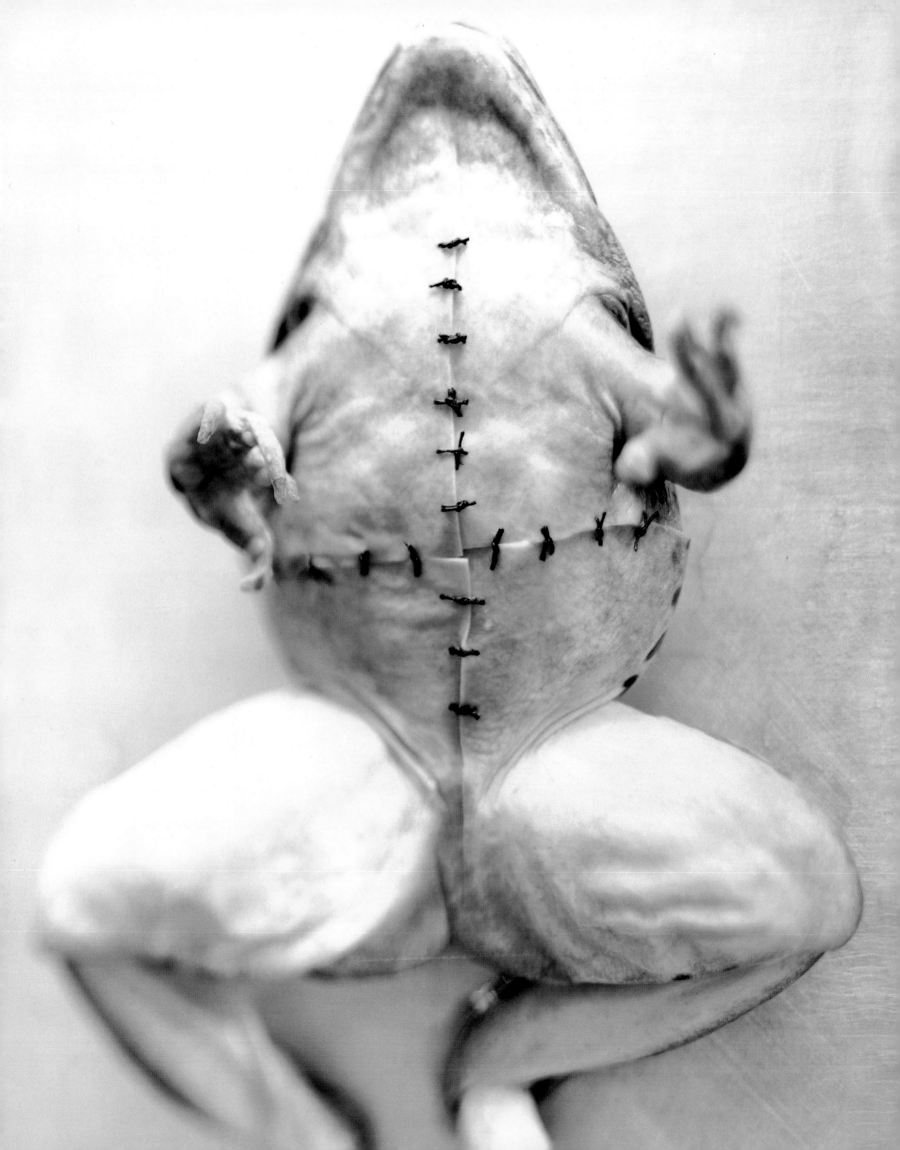

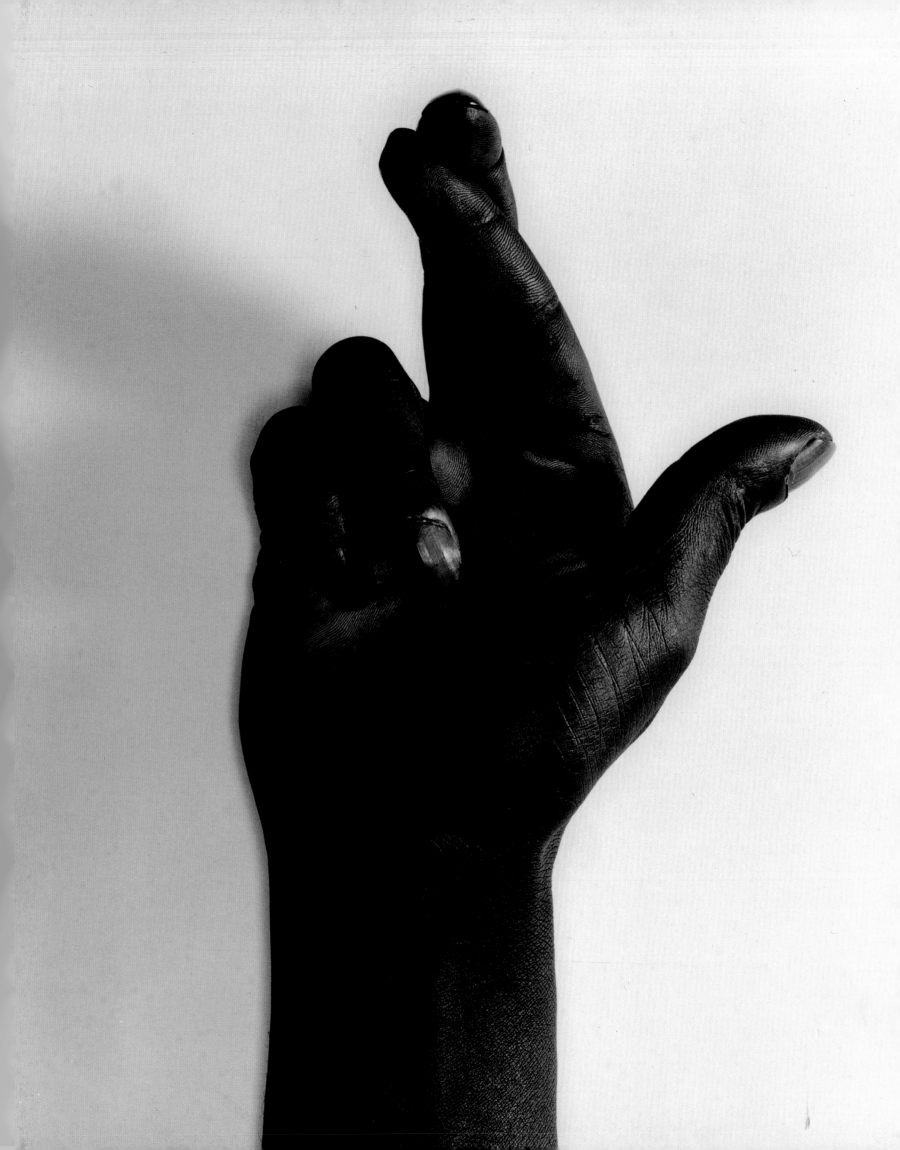

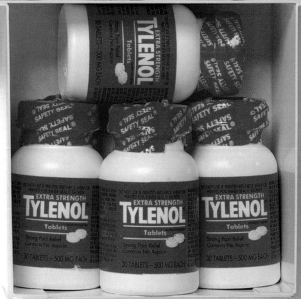

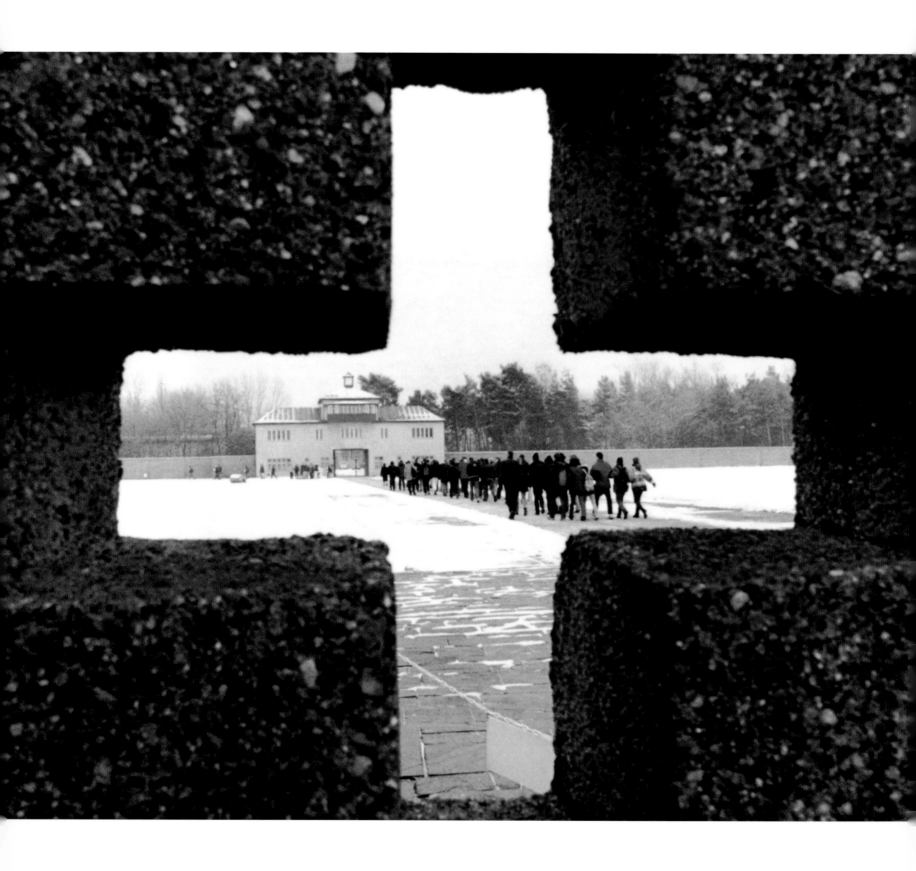

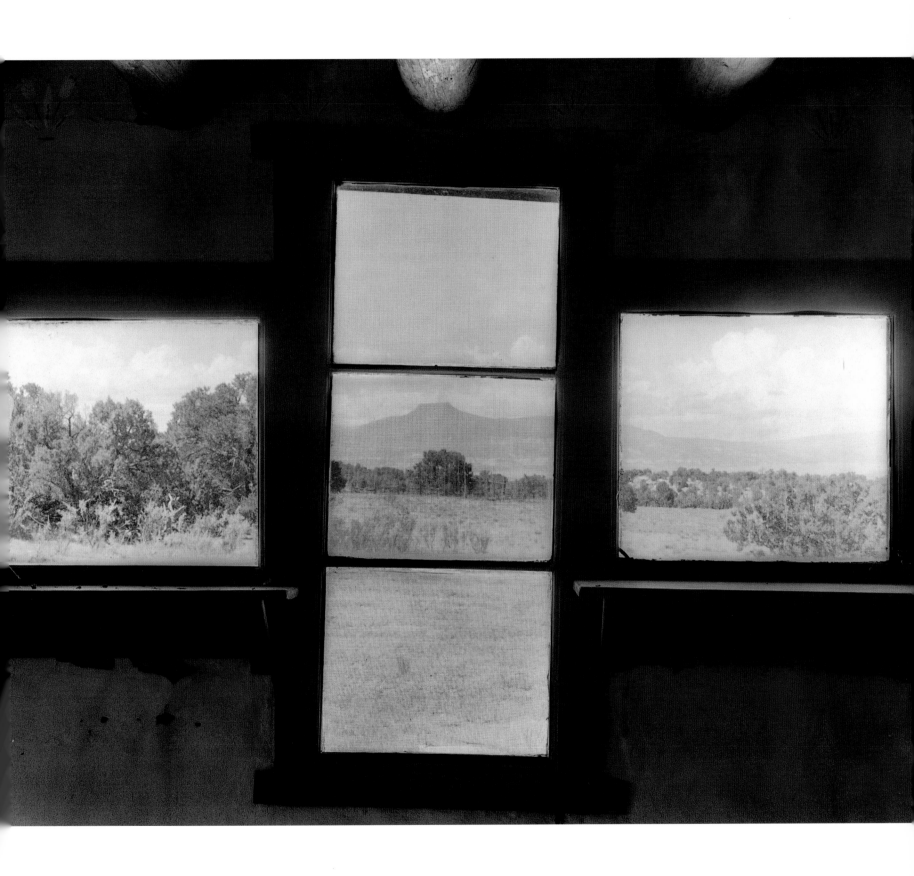

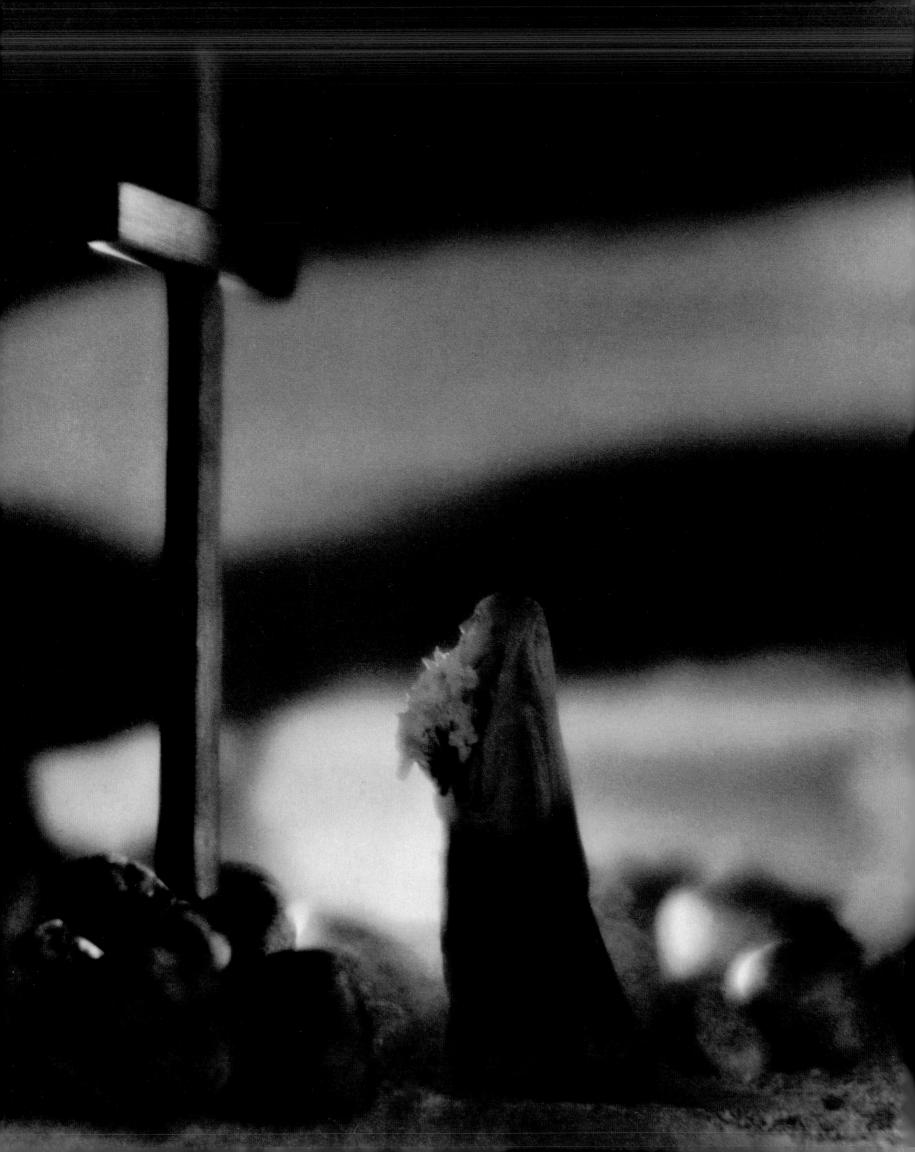

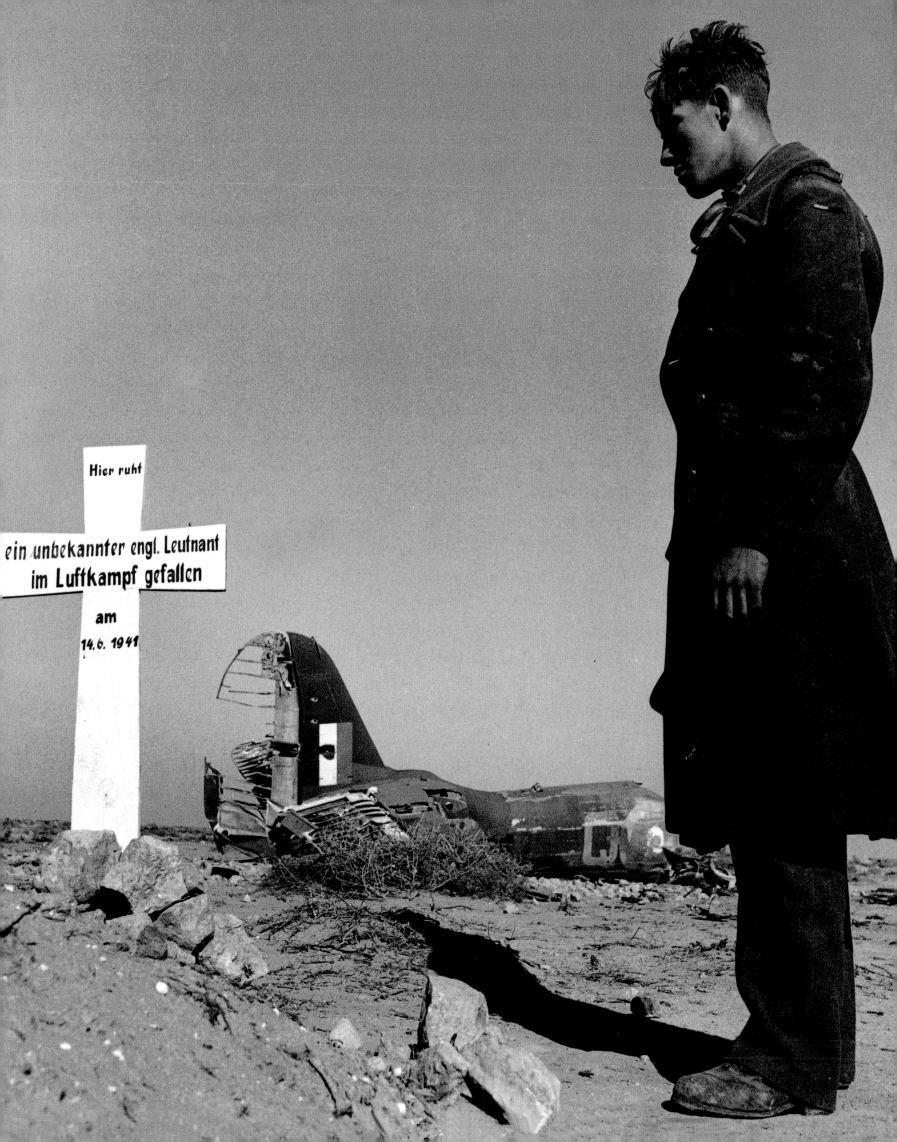

Hier ruht

ein unbekannter engl. Leutnant
im Luftkampf gefallen

am
14. 6. 1941

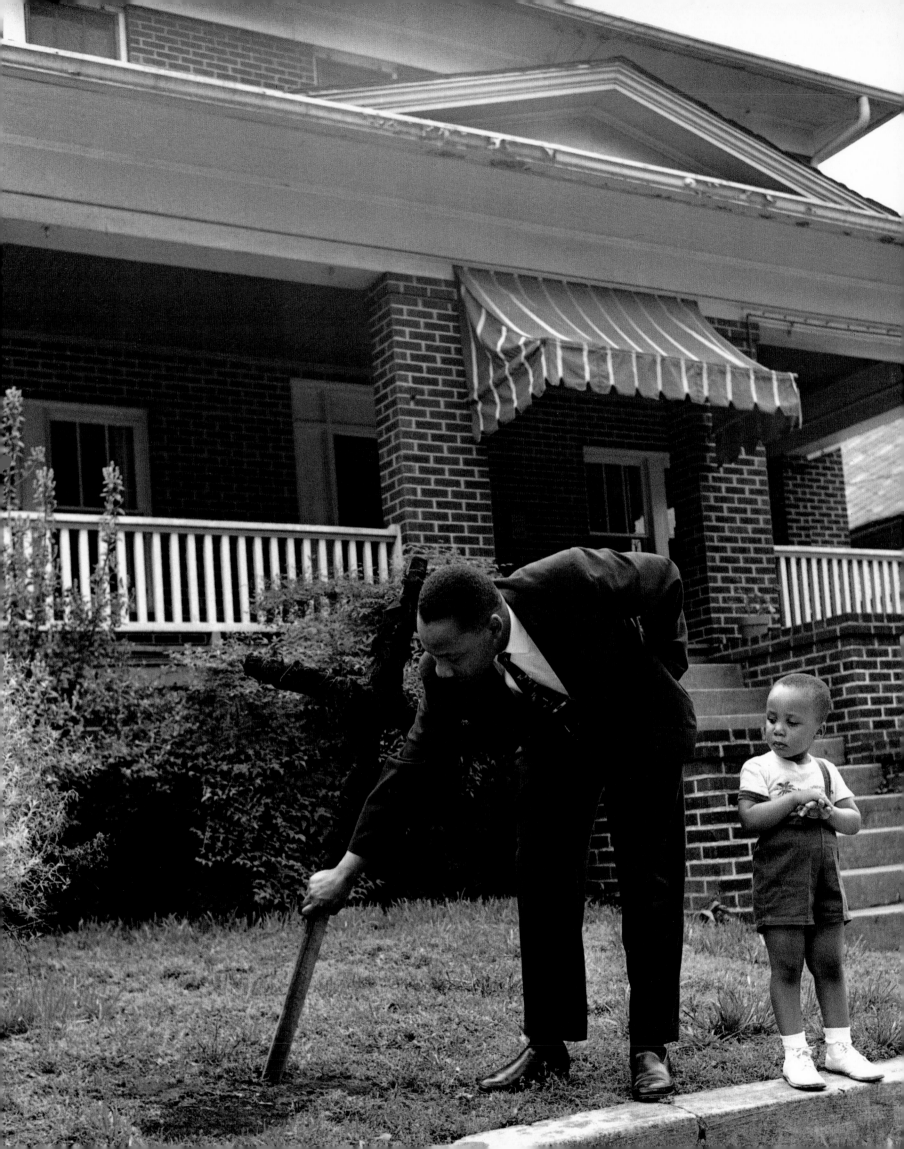

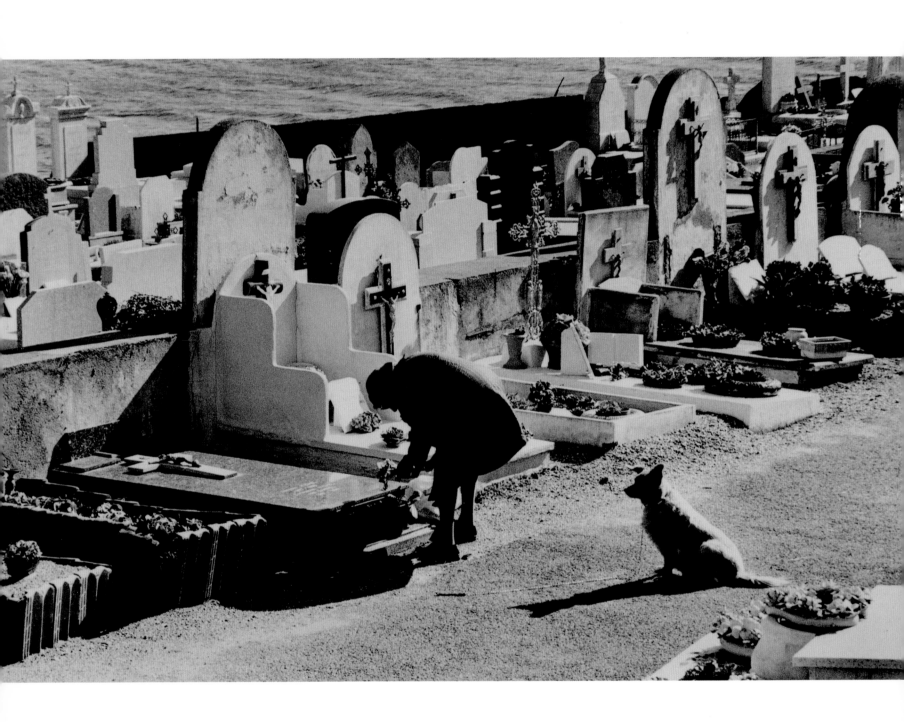

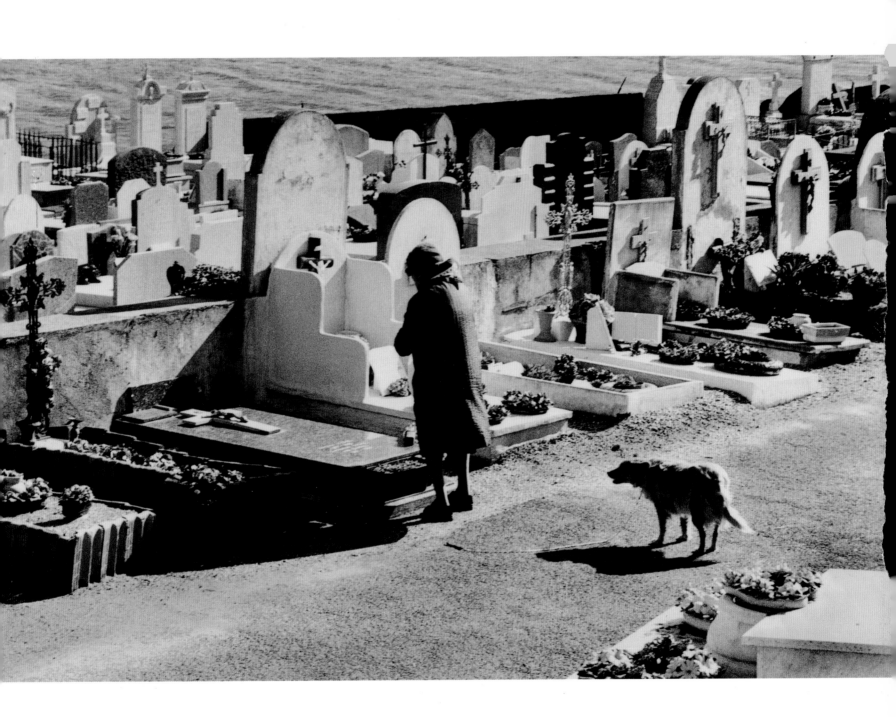

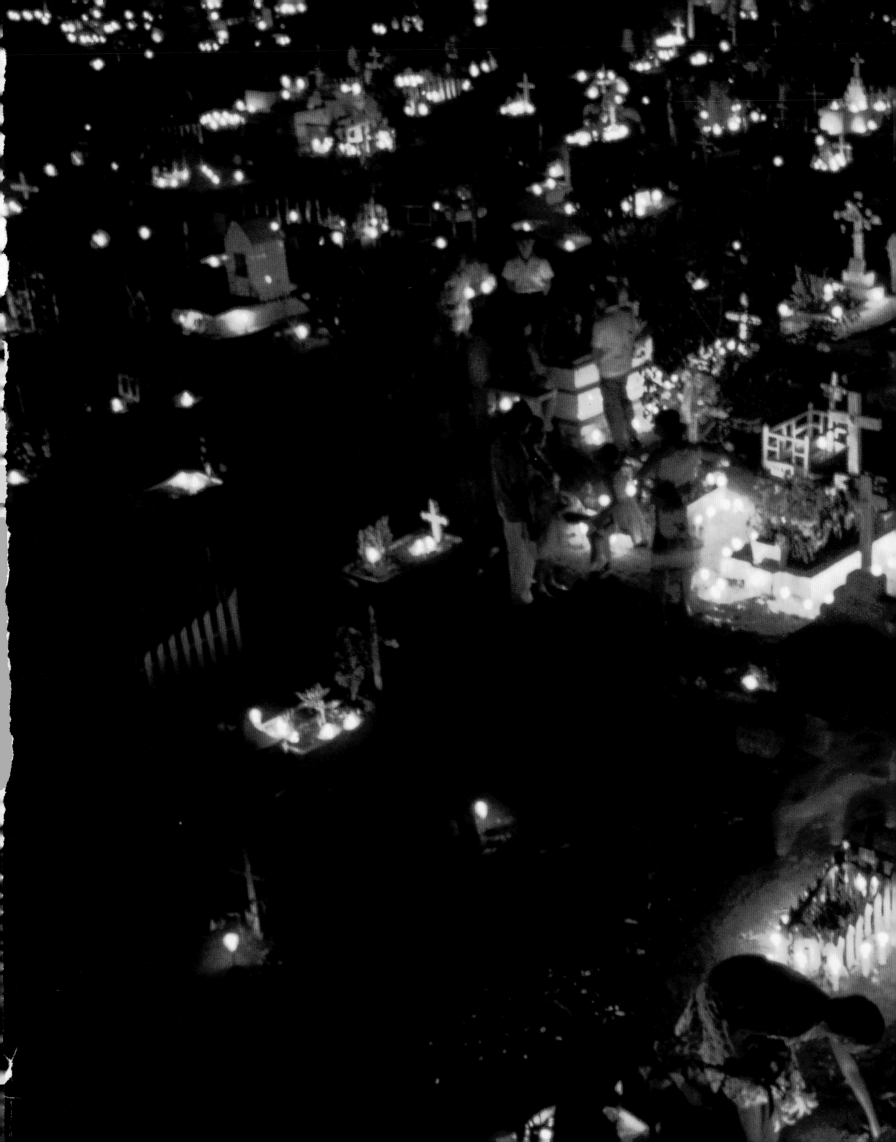

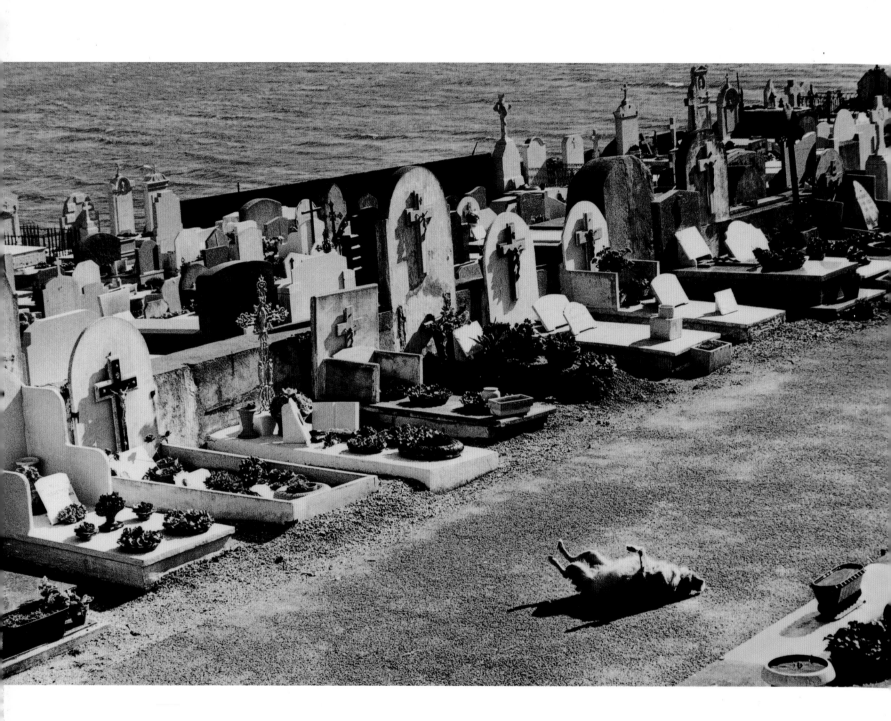

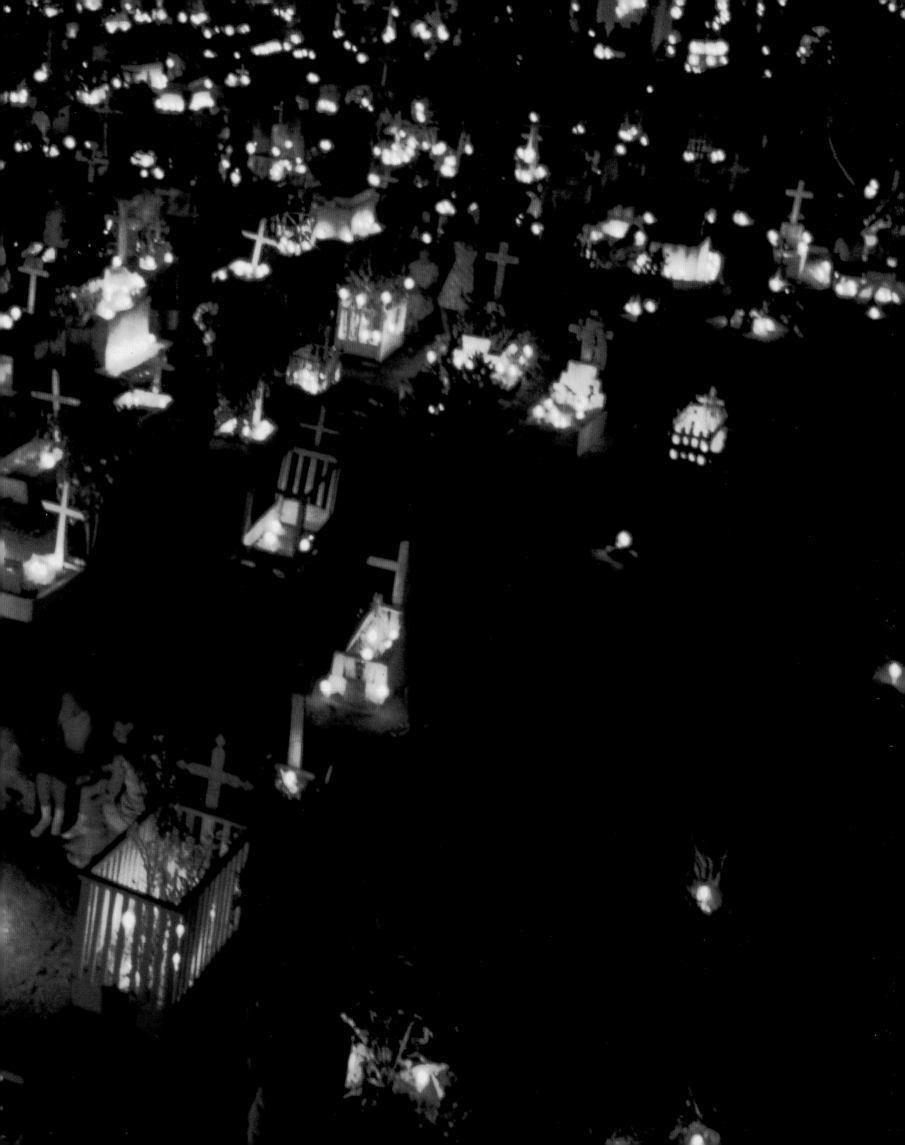

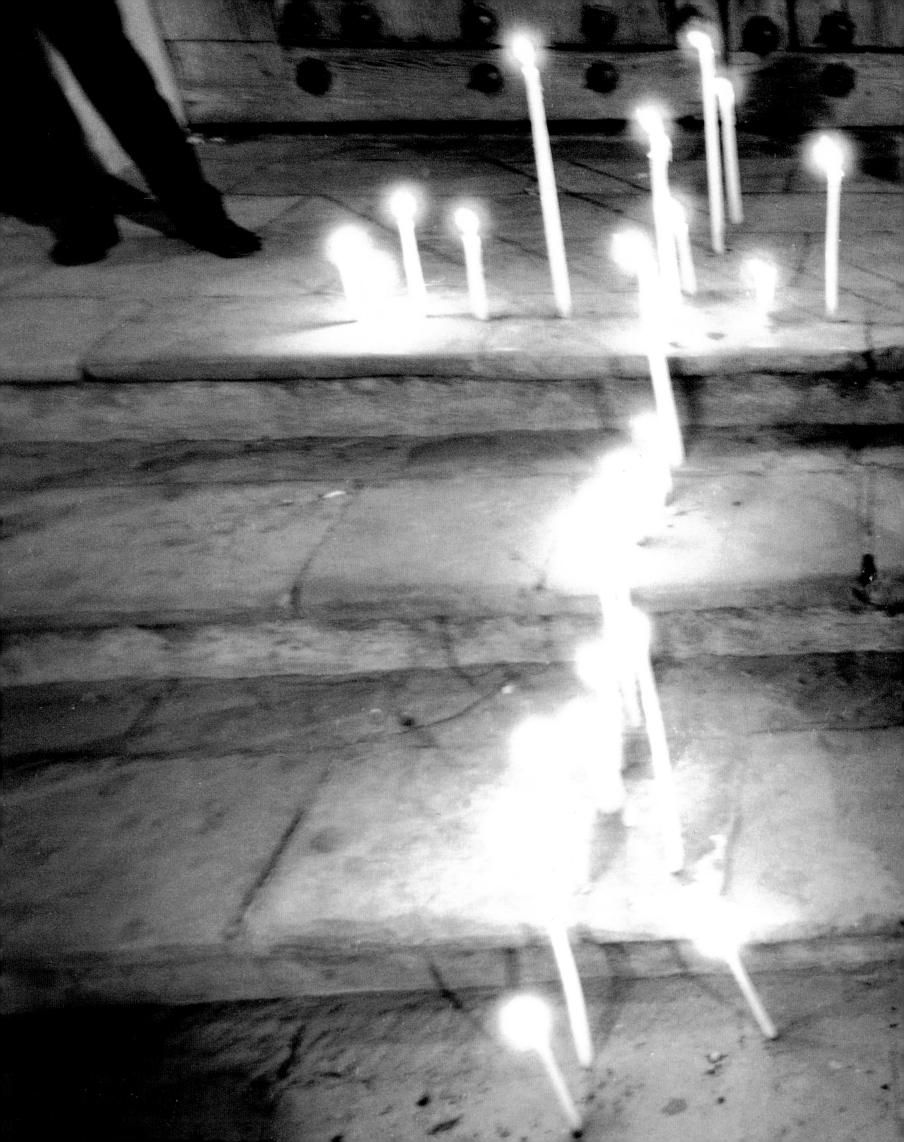

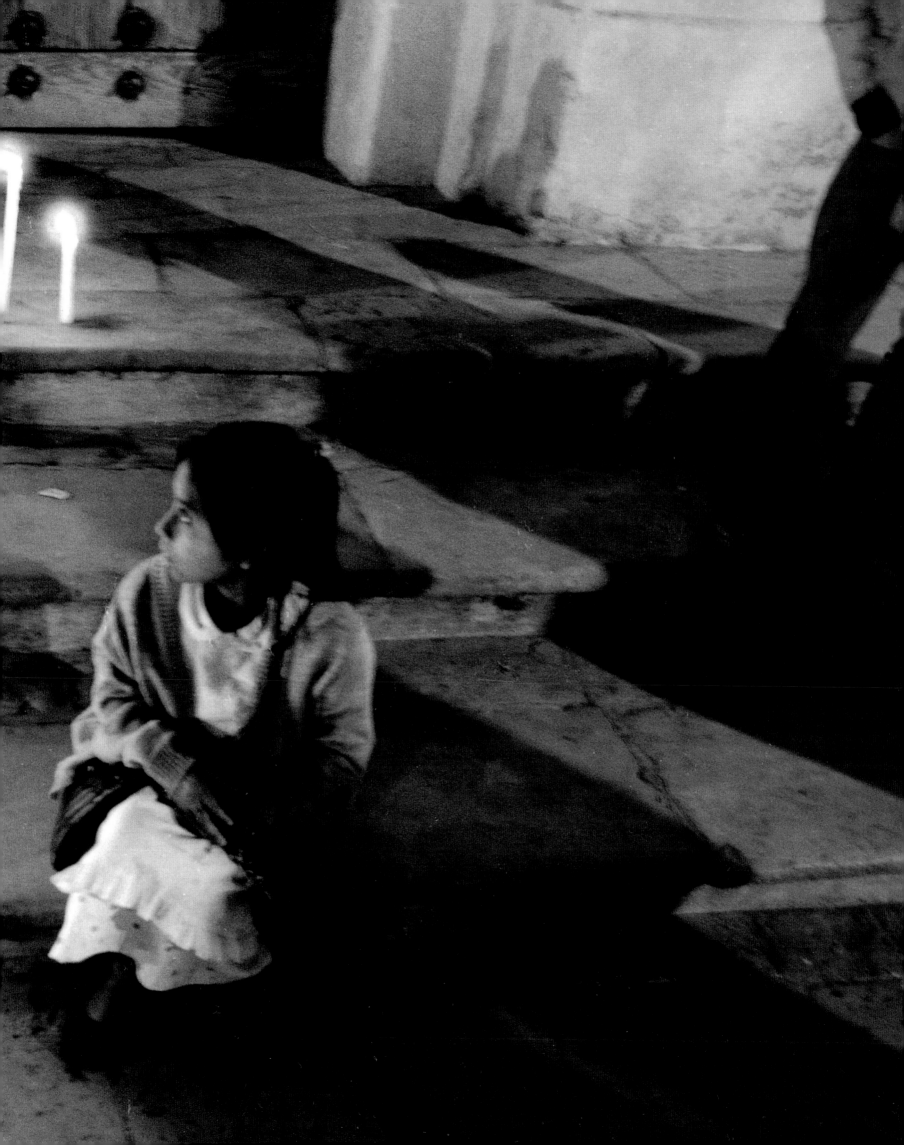

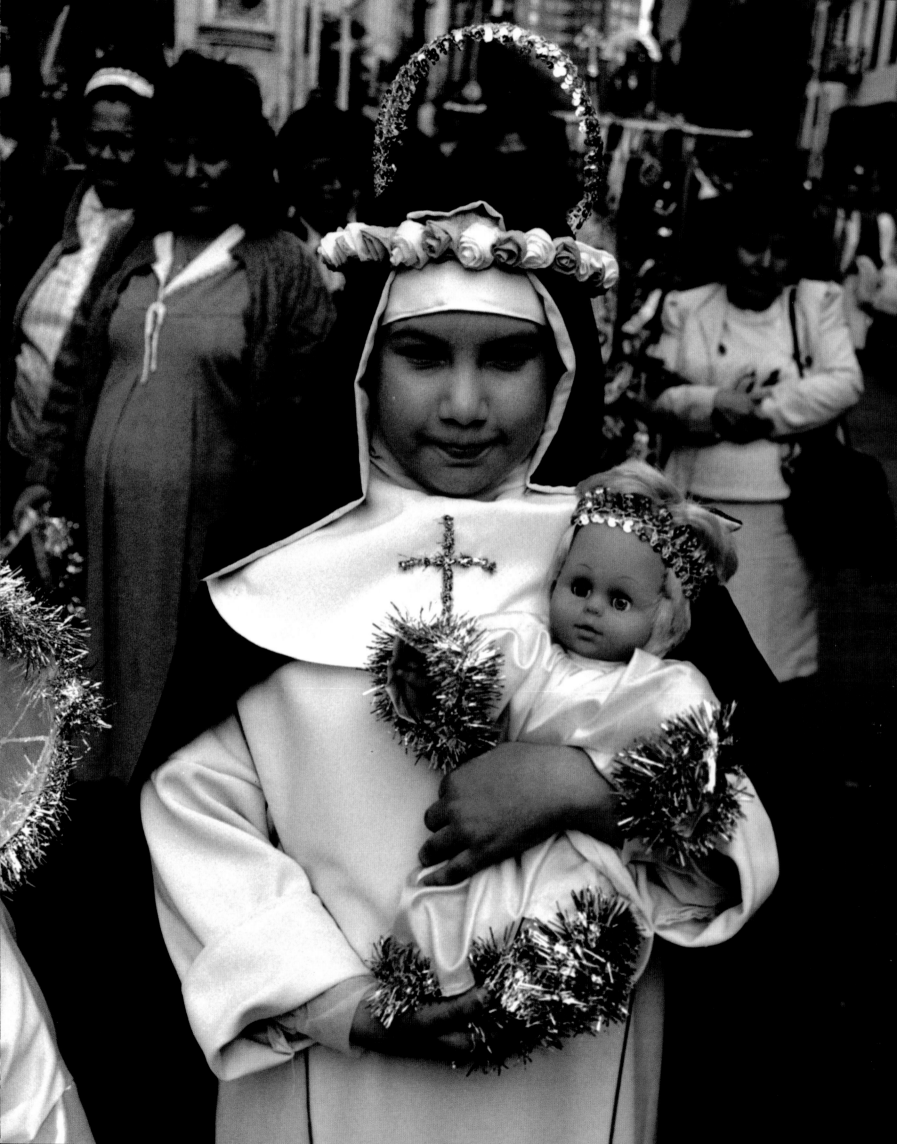

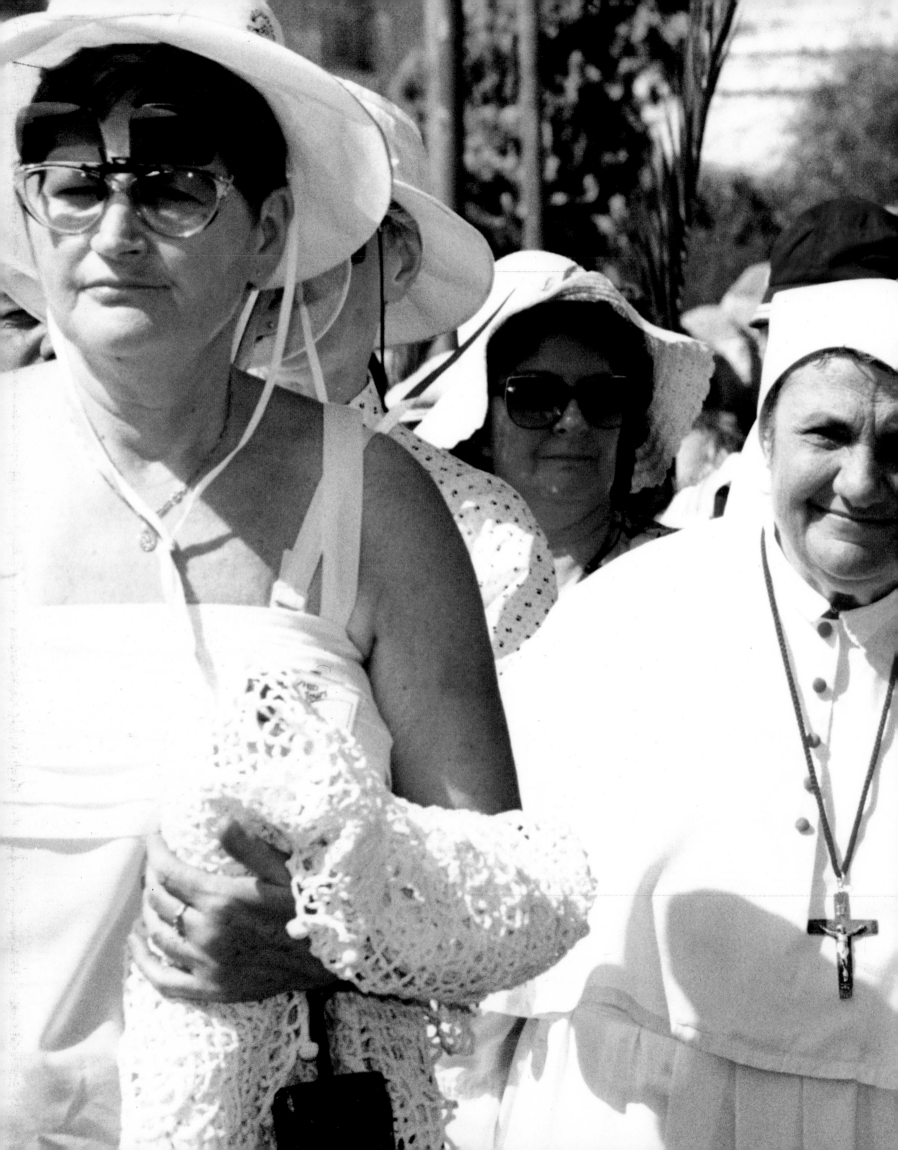

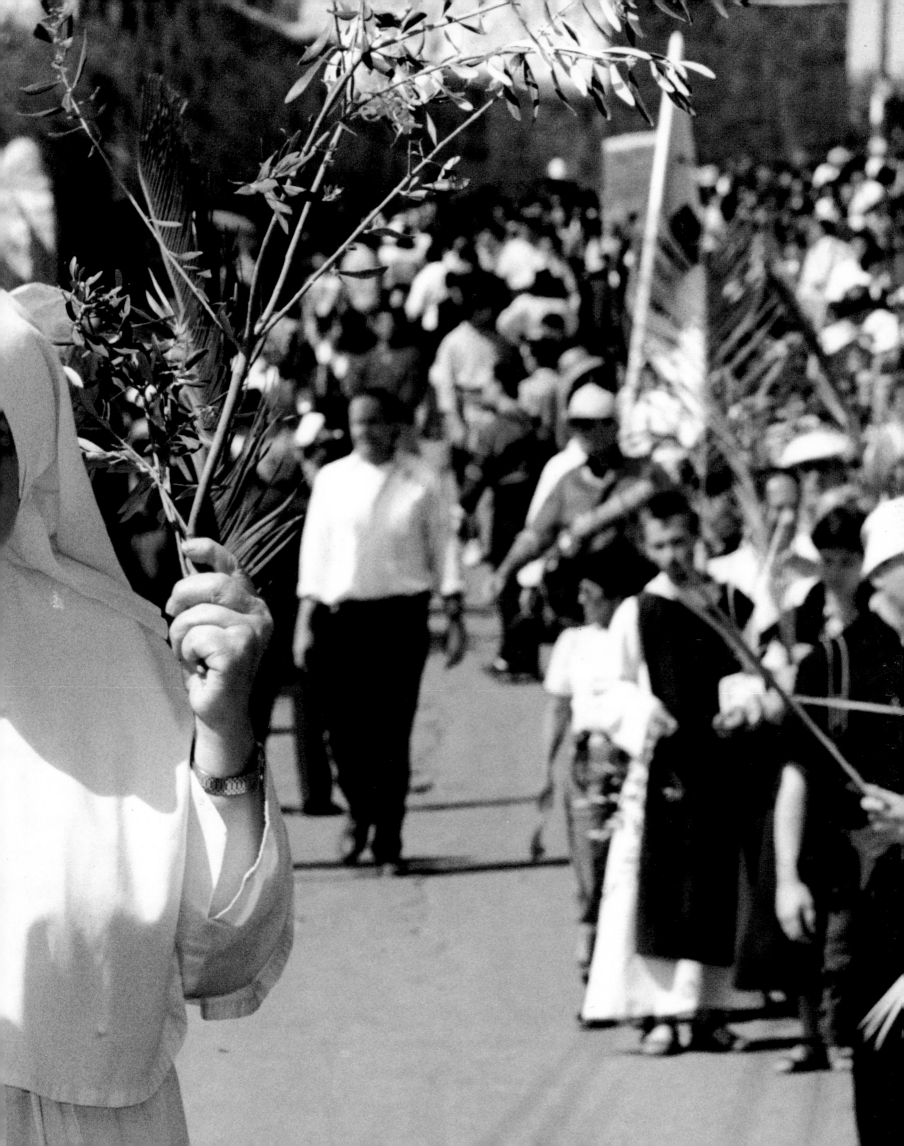

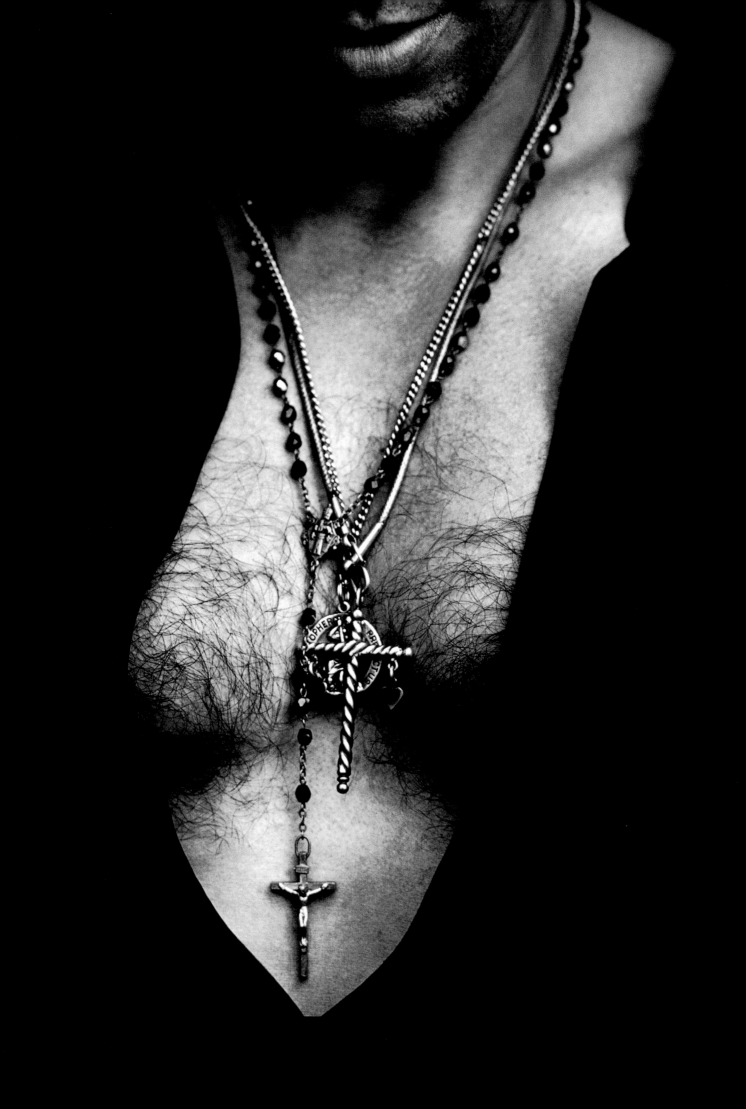

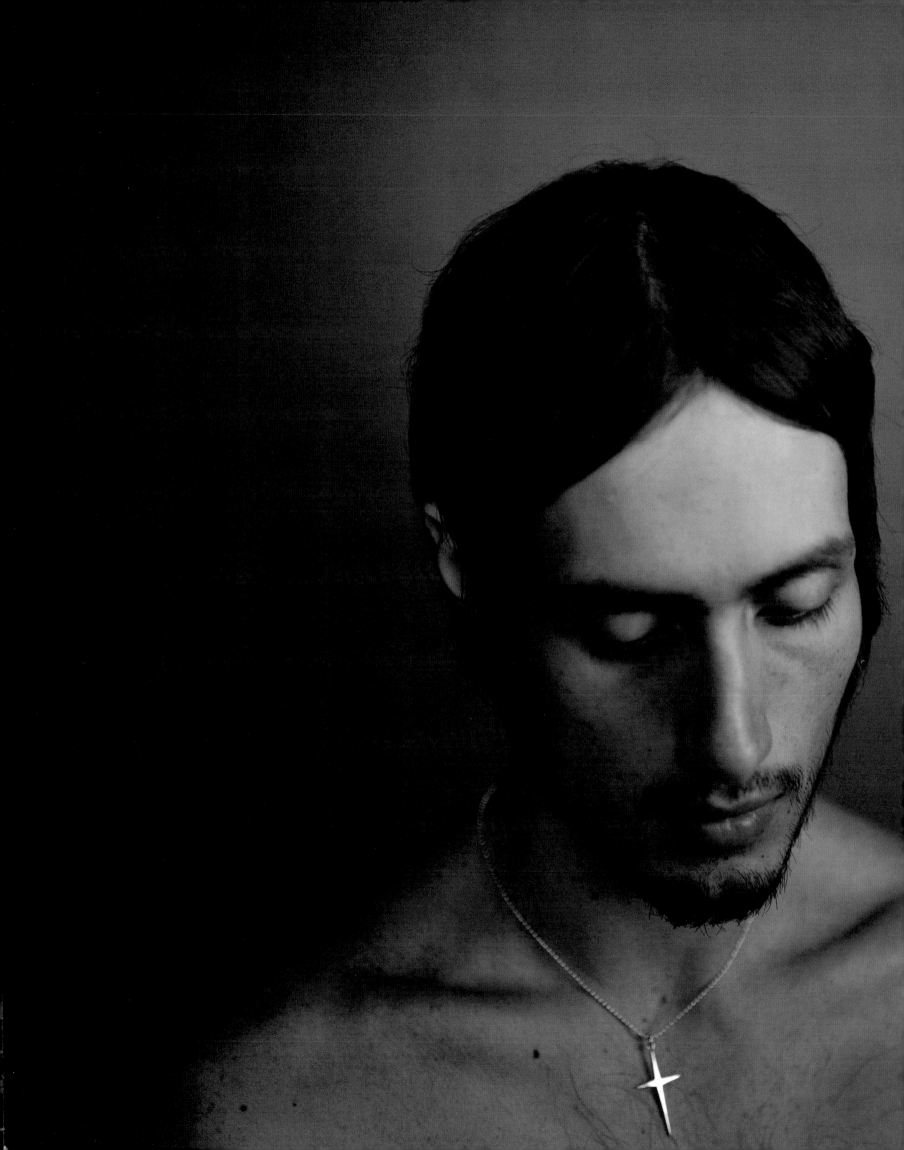

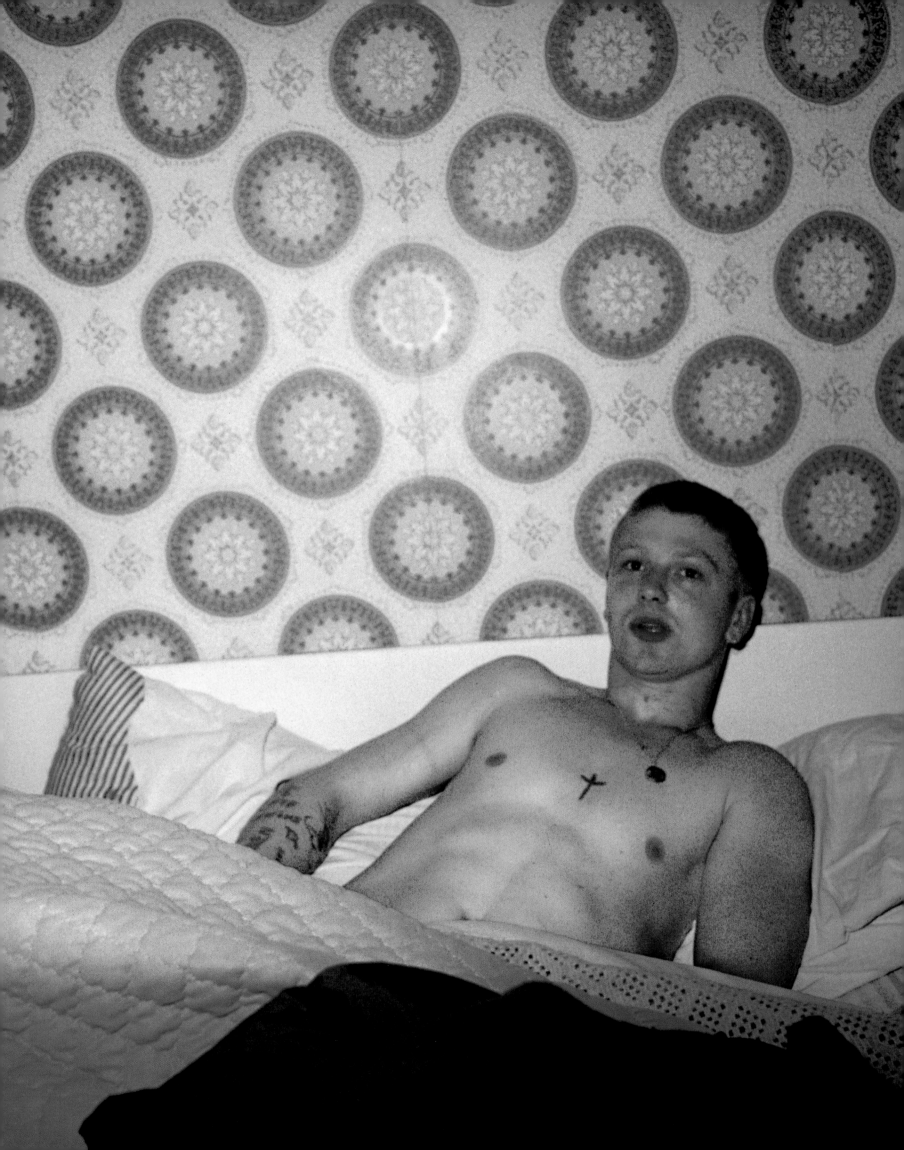

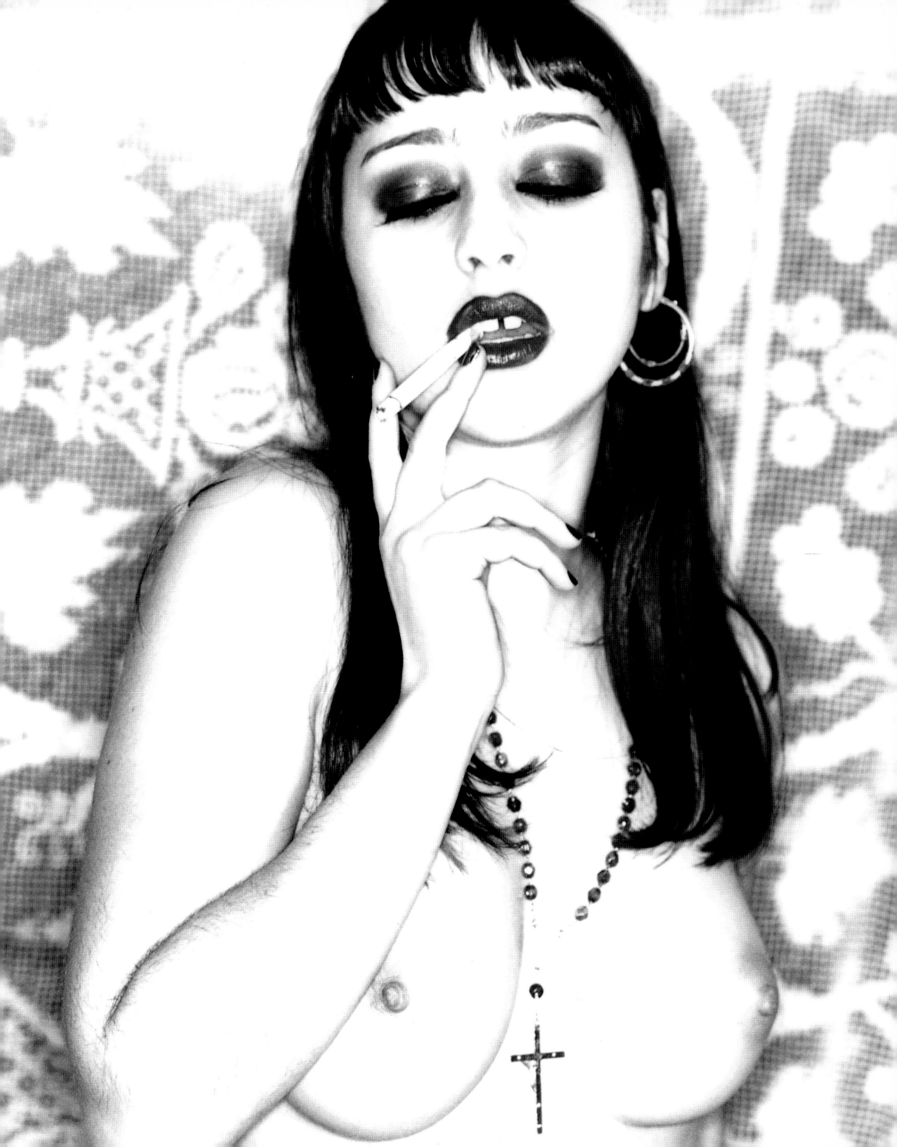

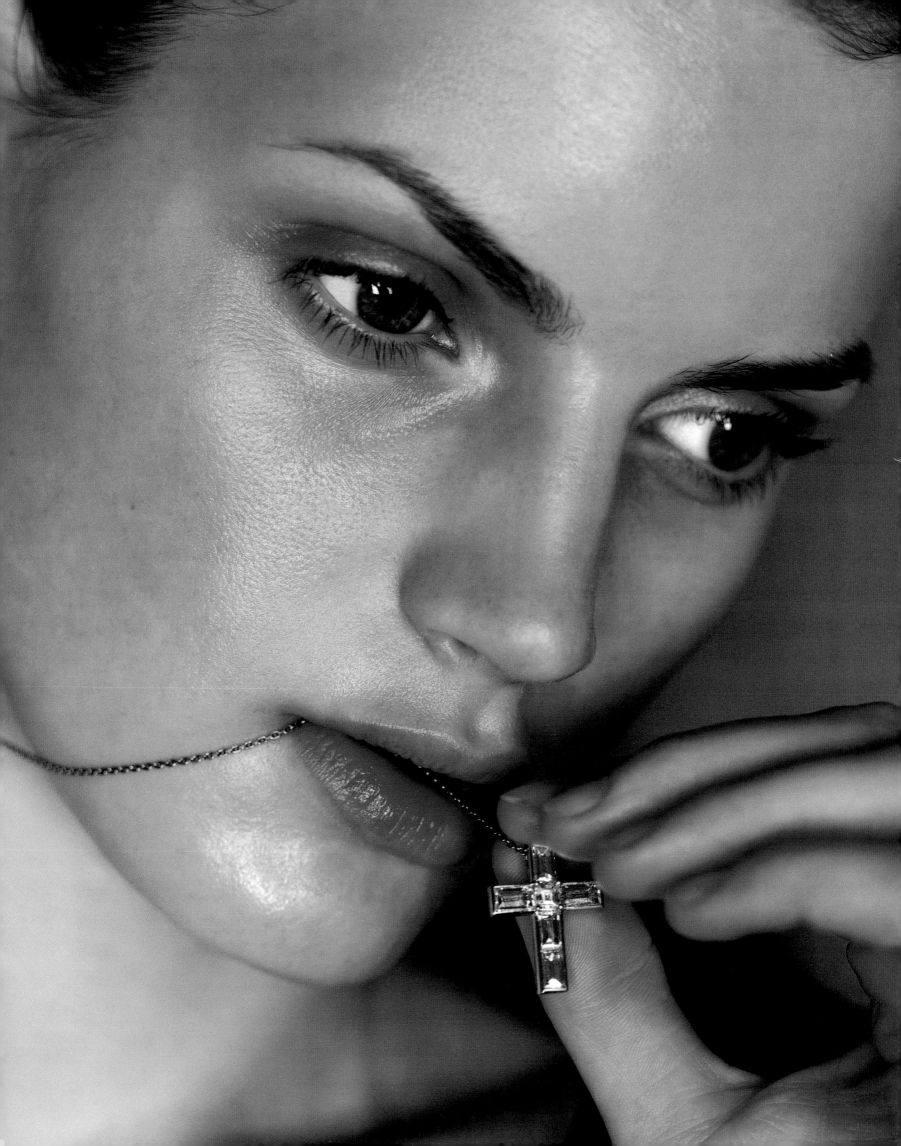

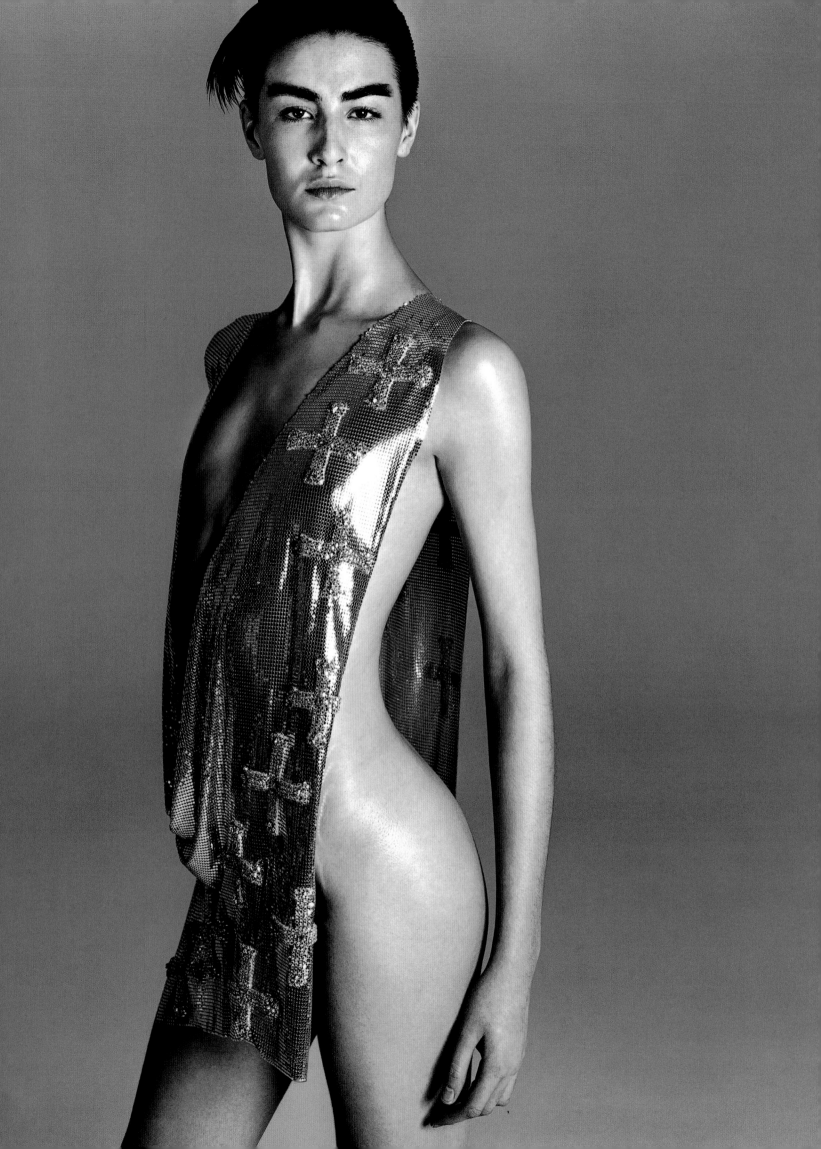

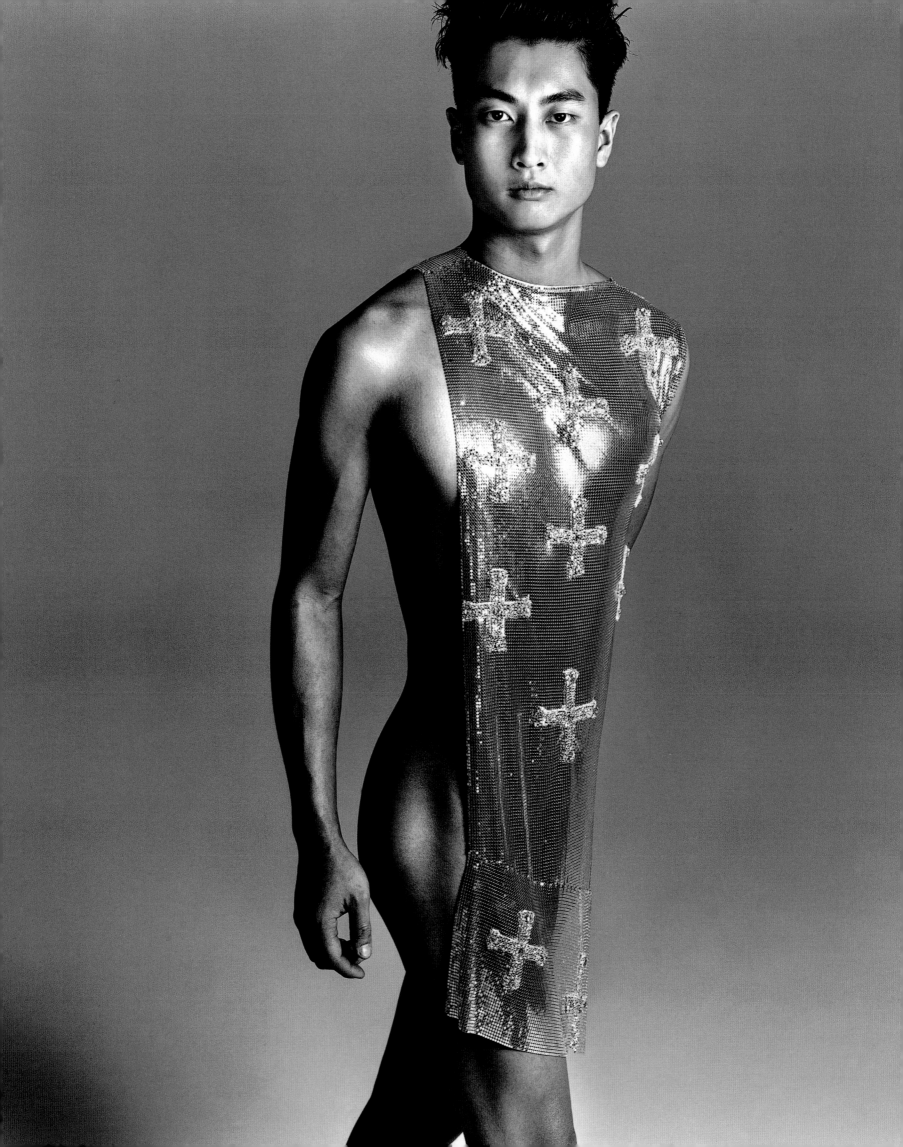

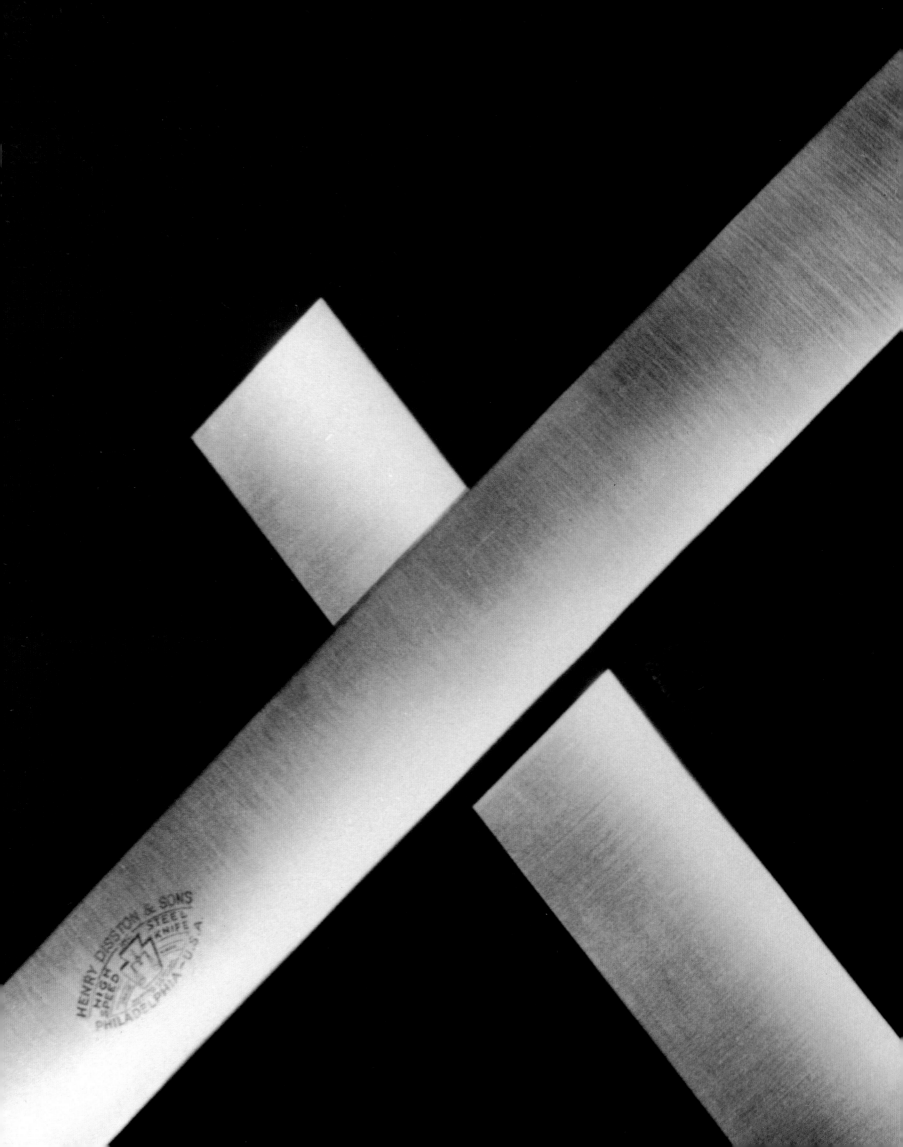

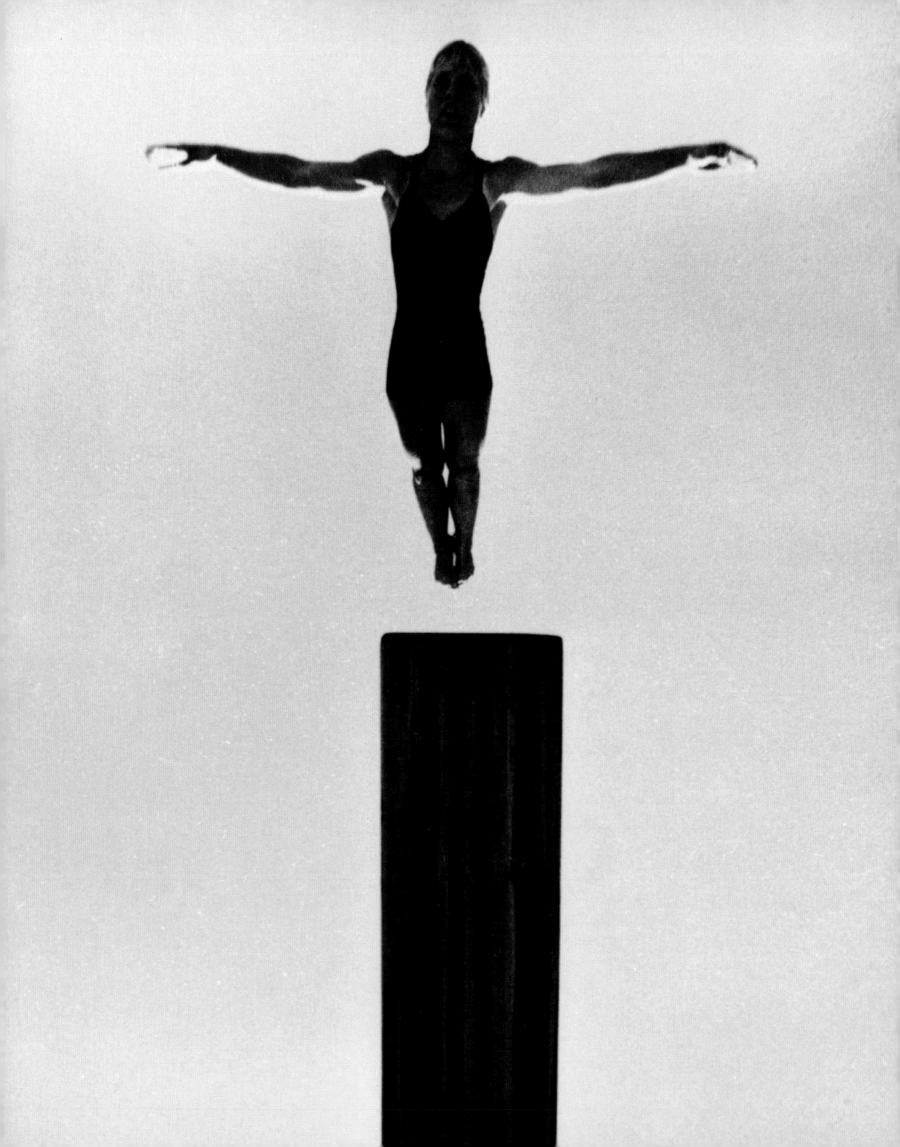

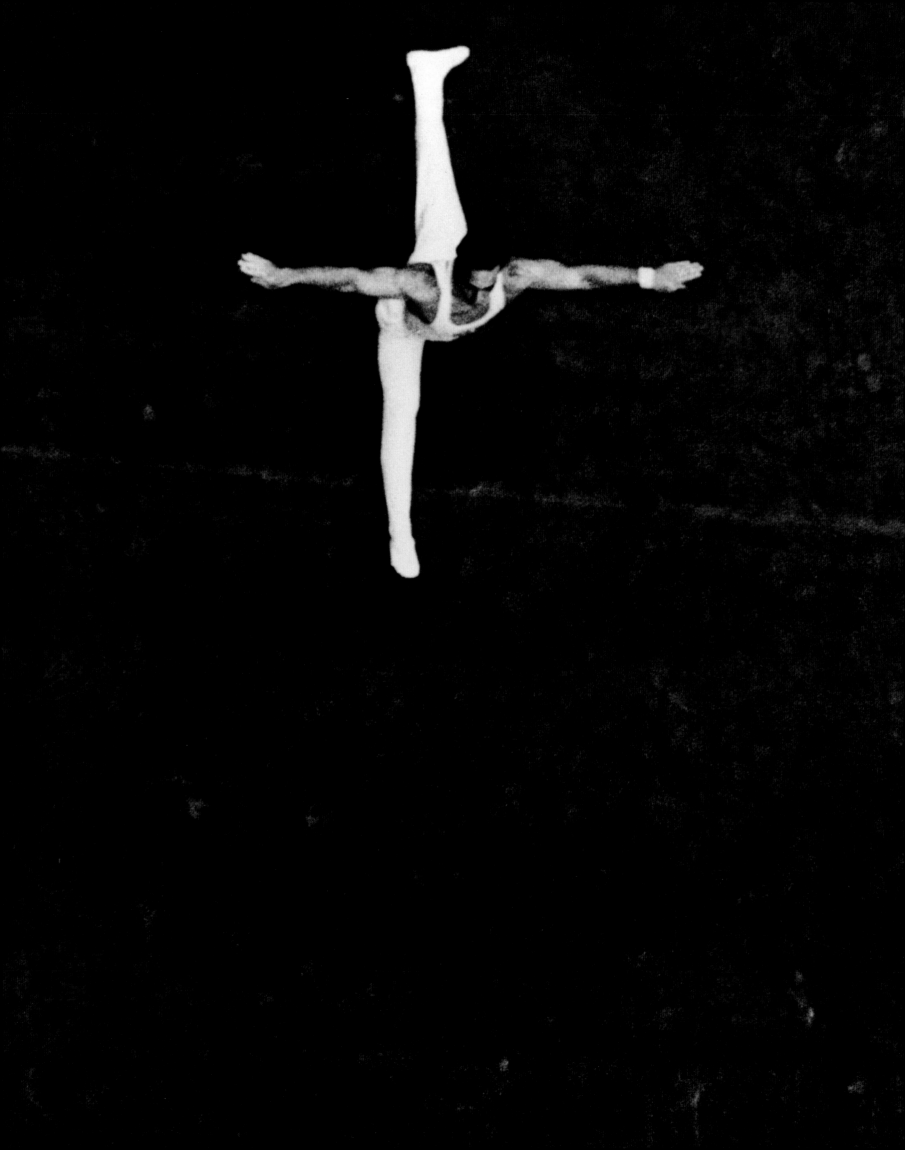

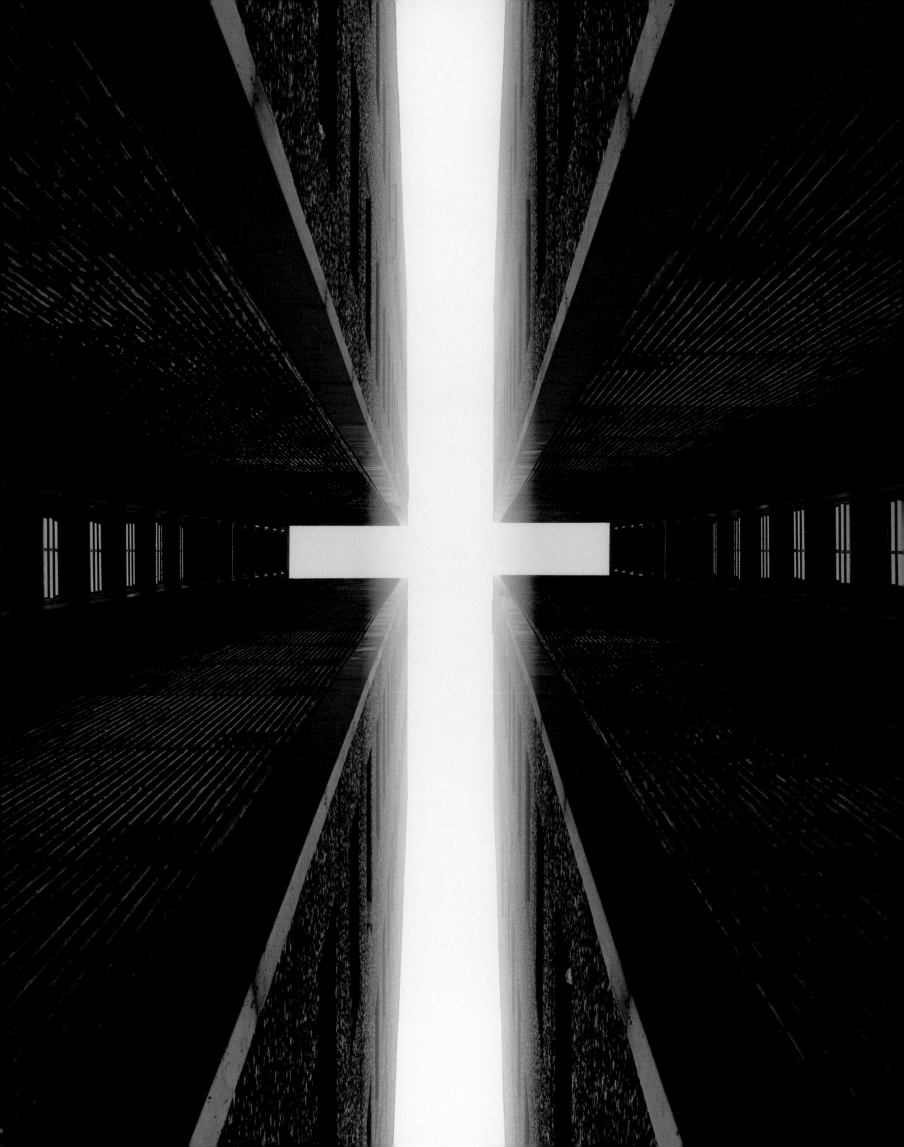

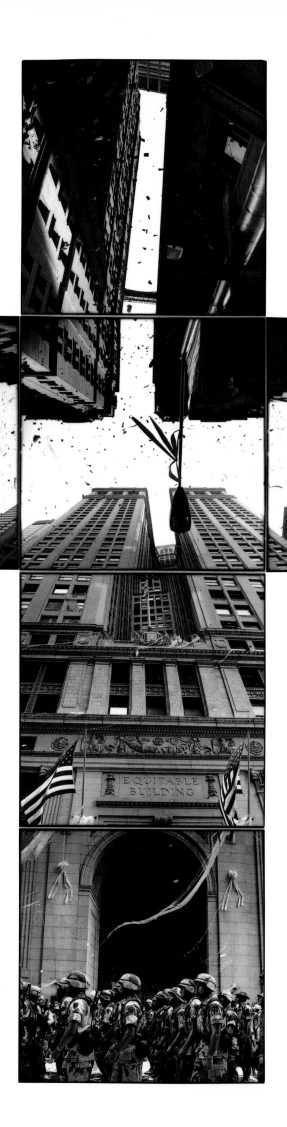

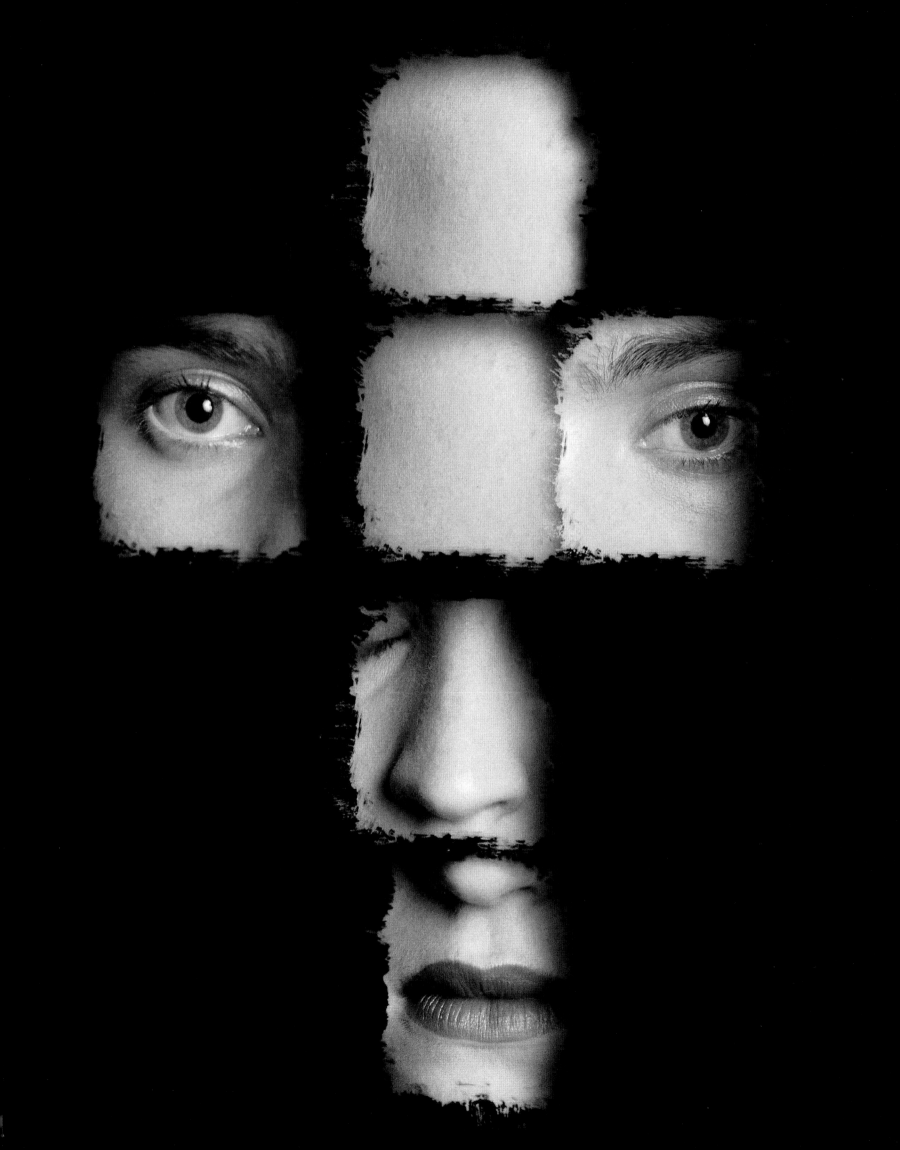

DEDICATION

To my mother, who has taught me to appreciate the beautiful things in life—such as the cross.

Front Cover: François Nars,
Untitled, 1998
© François Nars

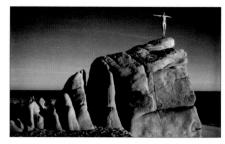

4 Enrique Badulescu, La Cruz de Vera, Mexico, 1992
© Enrique Badulescu
5 Harold M. Lambert, Date unknown
© Harold M. Lambert/Archive Photos

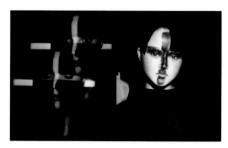

8-9 George Holz, Paula as Cross, Cabo San Lucas, Mexico, 1989
© George Holz. Courtesy Fahey/Klein Gallery, Los Angeles

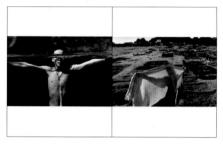

10 Sally Mann, One Big Snake, Virginia, 1991
© Sally Mann. Courtesy Edwynn Houk Gallery, New York
11 Larry Towell/Magnum Photos, Chamula, Mexico, 1995
© Larry Towell/Magnum Photos

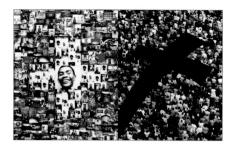

13 Bert Stern, Crucifix II, Los Angeles, California, 1962
© Bert Stern

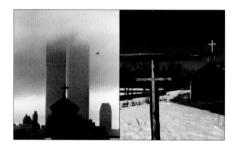

14 Erwin Blumenfeld, c.1948
© Blumenfeld Estate. Courtesy Bruno Bischofberger
15 Roxanne Lowit, Holy Devon, 1997
© Roxanne Lowit

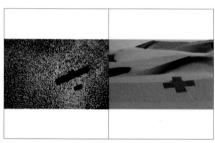

16 Y. Arthus Bertrand/Vandystadt/Allsport Photograph (USA), Inc.
Date unknown © Vandystadt/Allsport Photograph (USA), Inc.
17 Thomas Hoepker/Magnum Photos, Algeria, 1976
© Thomas Hoepker/Magnum Photos

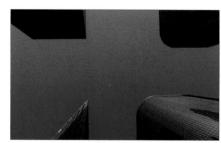

18-19 Mario Testino, Look Up, Los Angeles, California, 1997
© Mario Testino

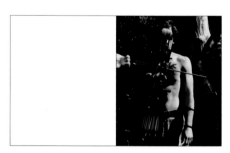

20 André Kertész, New York, February 23, 1972
© French Ministry of Culture, AFDPP, Paris
21 Joan Brooks Baker, A New Mexico Morada, 1992
© Joan Brooks Baker

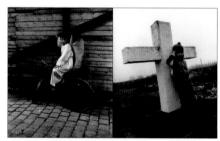

22 Josef Koudelka/Magnum Photos, Olomouc, Moravia,
Czechoslovakia, 1968 © Josef Koudelka/Magnum Photos
23 Janet Beller, Day of the Dead, Mexico, 1996 © Janet Beller

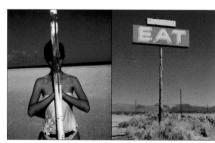

24 Steve Hiett, Juliette, Miami, Florida, 1980
© 1980 Linea Italiana
25 Jeff Brouws, Eat, Inyokern, California, 1991
© Jeff Brouws. Courtesy Robert Mann Gallery

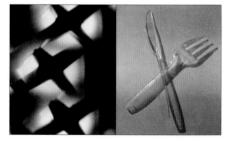

27 Steven Klein, Boy with Arrow, Lucky Star Ranch,
Chaumont, New York, 1998 © Steven Klein

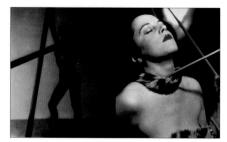

28 František Drtikol, Nude, 1927 © Ervina Boková-Drtikolová
29 Madame Yevonde, Lady Milbanke as Queen of the Amazons,
Penthesilea, 1935
Courtesy The Royal Photographic Society, Bath, UK

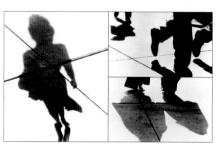

30 Marvin E. Newman, Sidewalk Cross, Woman's Shadow,
Chicago, Illinois, 1951
31 Top: Marvin E. Newman, Boys Running, Shadows,
Chicago, Illinois, 1951
31 Bottom: Marvin E. Newman, Two Nuns, Shadows,
Chicago, Illinois, 1951
Above: All © Marvin E. Newman. Courtesy Keith de Lellis Gallery

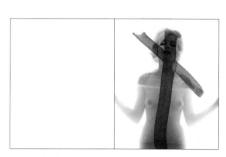

32 Edward Quigley, Airplane Photogram, Philadelphia, Pennsylvania,
1931. Courtesy Keith de Lellis Gallery
33 Len Prince, Fork and Knife, 1998 © Len Prince

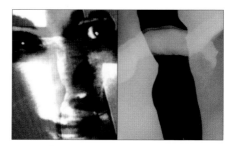

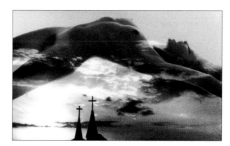

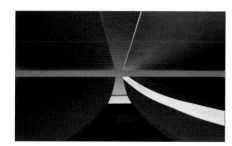

34 Steven Sebring, Ritual, 1999 © Steven Sebring
35 Man Ray, Untitled for Facile, 1935
© 2000 Man Ray Trust/Artists Rights Society, NY/ADAGP, Paris

36-37 Sam Haskins, Church Steeples,
Johannesburg, South Africa, 1967 © Sam Haskins
From November Girl by Sam Haskins

38-39 Fabien Baron, Silurian Dry Lake, California, 1999
© Fabien Baron

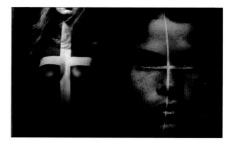

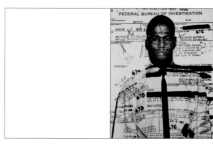

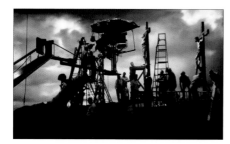

40 Walter Chin, Untitled, 1999 © Walter Chin
41 Michelangelo Di Battista, Zoe Gaze, 1999
© Michelangelo Di Battista

43 Albert Watson, Malcolm X Fashion Story, 1992
© Albert Watson

44-45 Ernst Haas, from The Greatest Story Ever Told, 1963
© Ernst Haas. Courtesy Hulton Getty

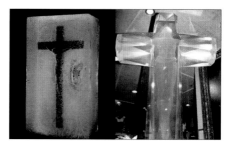

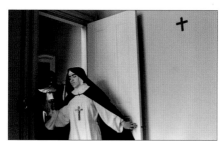

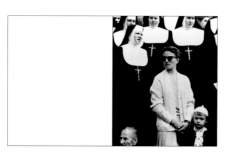

46 Mario Sorrenti, Untitled, 1999 © Mario Sorrenti
47 Martin Fishman, Crystal Christ, New York, 1996 © Martin Fishman
Represented by Private Eyes Noir Arts Ltd., New York

48-49 Mary Ellen Mark, Nuns, Rhode Island, 1967
© Mary Ellen Mark

51 Franco Antonaci, Madri e Sorelle, Italy, 1950
© Franco Antonaci
Courtesy Keith de Lellis Gallery

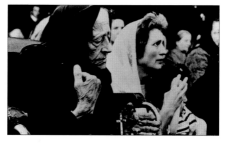

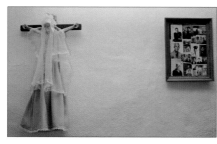

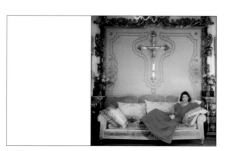

52-53 Pepi Merisio, Pelligrini Al Santurario di Caravaggio, Italy, 1957
© Pepi Merisio
Courtesy Keith de Lellis Gallery

54-55 Joan Brooks Baker,
A Church Wall in Northern New Mexico, 1991
© Joan Brooks Baker

57 Slim Aarons, Laura Chrisitana Cibrario, 1986
© Slim Aarons/Hulton Getty

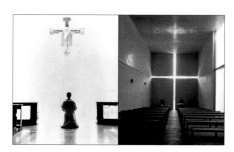

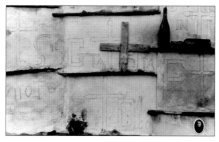

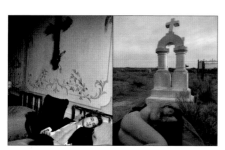

58 Antonio Migliori, Untitled, Italy, 1954
© Antonio Migliori. Courtesy Keith de Lellis Gallery
59 Shinkenchiku-sha, Church of Light, Hokkaidō, Japan, 1989
© Shinkenchiku-sha

60-61 Paolo Bocci, Eliar, Italy, 1957
© Paolo Bocci. Courtesy Keith de Lellis Gallery

62 Manuela Pavesi, Nicolò in Padova, 1997 © Manuela Pavesi
63 Ray Belcher, Amanda, 1993 © Ray Belcher

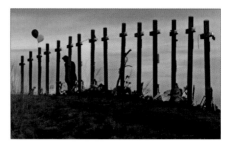

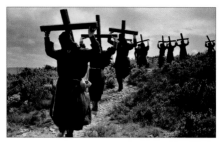

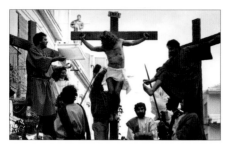

64-65 Photographer unknown,
Memorial for Columbine High School Victims, Littleton, Colorado, 1999
© AP/Wide World Photos

66-67 Cristina García Rodero, The Trinity,
Lumbier, Navarra, Spain, 1980 © Cristina García Rodero

68-69 Michael Roberts, Good Friday, Sicily, Italy, 1990
© Michael Roberts/Maconochie Photography

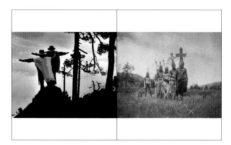

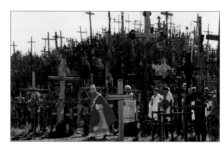

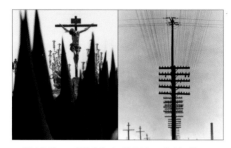

70 Sebastião Salgado, Mexico, 1980
© Sebastião Salgado/Amazonas Images
71 Edward Curtis, Apache Gaun (Dance of the Gods), Arizona, 1908
From The North American Indian by Edward Curtis
Courtesy Chris Cardozo, Inc.

72-73 Tom Szlukovenyi, Siauliai, Lithuania, 1993
© Tom Szlukovenyi/Reuters/Corbis-Bettman

74 Julio Munoz, 1994 © Reuters/Julio Munoz/Archive Photos
75 Tina Modotti, Telegraph Wires, c.1925 © The Estate of Tina Modotti
Courtesy Throckmorton Fine Art, New York

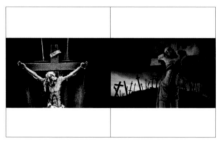

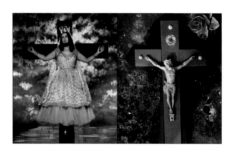

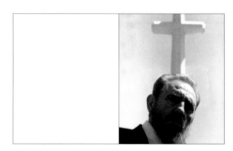

76 Anton Corbijn, Jesus, 1999 © Anton Corbijn
77 James L. Stanfield, 1995
Courtesy National Geographic Society Image Collection

78 Pierre et Gilles, Sainte Affligée, Pascale Borel, 1991
© Pierre et Gilles
Painted Photography, 133.5 x 106 cm. Private Collection, Buenos Aires
79 Ross Bennett Lewis, Sentimentality/Brutality, Boulogne, France, 1988
© Ross Bennett Lewis. Courtesy of the artist

81 Herberto Rodriguez, Kingston, Jamaica, 1998
© Herberto Rodriguez/Reuters/Archive Photos

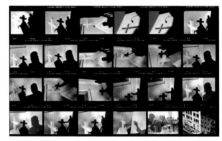

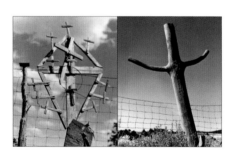

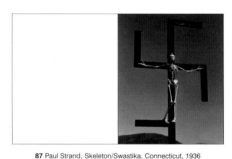

82-83 André Kertész, New York, Contact, 1977
© French Ministry of Culture, AFDPP, Paris

84 Dorothy Benrimo, Camposanto de Santa Rita Bernal, Serafina,
1935-65, Gelatin silver print, P1977.35.38.
85 Dorothy Benrimo, Camposanto de Viejo de San Pedro, Questa,
1965, Gelatin silver print, P1977.35.9.
Above: All courtesy of the Amon Carter Museum, Fort Worth, Texas

87 Paul Strand, Skeleton/Swastika, Connecticut, 1936
© Aperture Foundation Inc., Paul Strand Archive

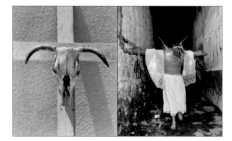

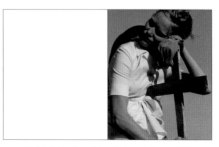

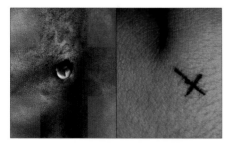

88 Gil Blank, Esperanza, Sonora, Mexico, 1990 © Gil Blank
89 Cristina Garcia Rodero, The Impaled, Valverde de la Vera,
Caceres, Spain, 1979 © Cristina García Rodero

91 Koto Bolofo, Anna K: Les Tendresses, France, 1988
© Koto Bolofo. Courtesy Italian Vogue

92 Robert Mapplethorpe, Belly Button, 1986
© The Estate of Robert Mapplethorpe. Used by permission
93 Dino Dinco, Joe, 1998 © Dino Dinco

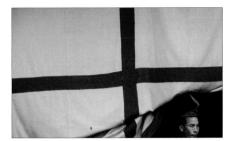

94-95 Sujoy Das, A Lama Looks Out on a Monastery Courtyard at Enchey, Sikkim, 1989 © Sujoy Das/Stock Boston

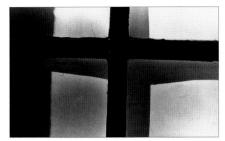

96-97 Ralph Gibson, from Quadrants, 1975
© Ralph Gibson
Courtesy Ralph Gibson

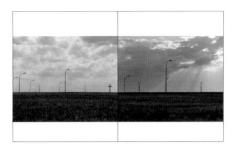

98 Nathaniel Goldberg, Brasilia I, 1998
© Nathaniel Goldberg
99 Nathaniel Goldberg, Brasilia II, 1998
© Nathaniel Goldberg

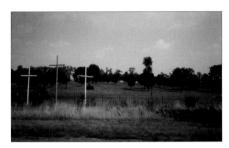

100-101 Terry Richardson, 3X, Virginia, 1999
© Terry Richardson

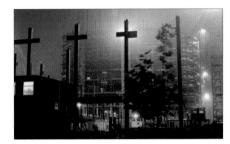

102-103 Alan Delaney, God & Steel, Canary Wharf, London Docklands, 1989 © Alan Delaney

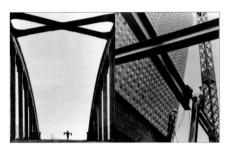

104 Tullio Tagliavini, Il Grosso Ponte, Italy, 1959 © Tullio Tagliavini
Courtesy Keith de Lellis Gallery
105 Paul Woolf, Crosses of Steel, New York City, 1938 © Paul Woolf
Courtesy Keith de Lellis Gallery

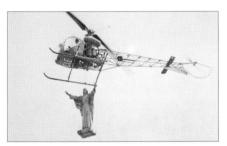

106-107 From La Dolce Vita, by Federico Fellini, 1960
Courtesy American International Pictures/Archive Photos

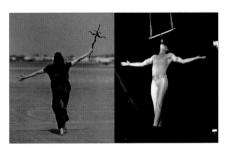

108 Peter Lindbergh, Kristen McMenamy for Commes des Garçons, Beauduc, France, 1990 © Peter Lindbergh
109 Bruce Weber, Florida, 1993 © Bruce Weber
Courtesy Robert Miller Gallery

111 Sante D'Orazio, Axl Rose, 1993
© Sante D'Orazio

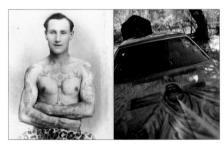

112 Photographer unknown, c.1920
Courtesy Amsterdam Tattoo Museum
113 Jack Parsons, 1973 Chevy Monte Carlo, (Owner Norman Sanchez, Mural by Randy Martinez), Española, New Mexico, 1993 © Jack Parsons

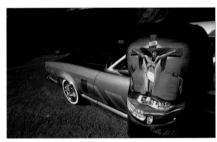

114-115 Jack Parsons, 1978 Ford Thunderbird, (Owner Bettie Cordova), Alcalde, New Mexico, 1996 © Jack Parsons

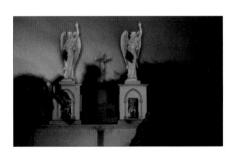

116-117 Nan Goldin, Twin Graves, Isla Mujeres, Mexico, 1982 © Nan Goldin

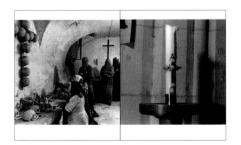

118 Photographer unknown, Rome, Italy, 1956
© Corbis-Bettmann. Courtesy UPI
119 David Sims, Date unknown © David Sims

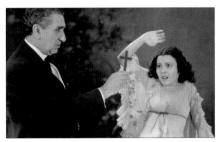

120-121 From Dracula, by George Melford and Enrique Tovar Avalos, 1931. Courtesy the Kobal Collection/Universal-MGM

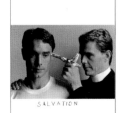

122-123 Duane Michals, Salvation, 1984
Text by Duane Michals. Photo and text © 1984 Duane Michals

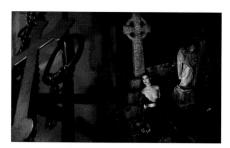

124 Len Prince, West's Cross Collection, New York,1998
© Len Prince
125 David Bailey, Catherine Bailey, for Italian Vogue, 1983
© David Bailey

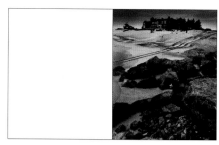

127 Jeanloup Sieff, East Hampton in Winter, New York, 1965
© Jeanloup Sieff

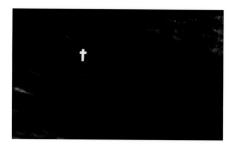

128-129 Craig Varjabedian, Cross Made of Palm Frond on Shutter of
Penitente Morada, Early Morning, Summer, New Mexico, 1993
© Craig Varjabedian

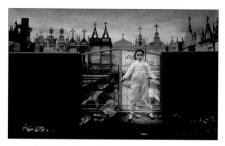

130-131 Cristina García Rodero, The Sleeping Soul,
Our Lady of Miracles, Saavedra, Lugo, Spain, 1981
© Cristina García Rodero

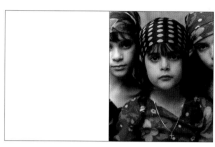

133 Bruce Weber, Florida, 1993 © Bruce Weber
Courtesy Robert Miller Gallery

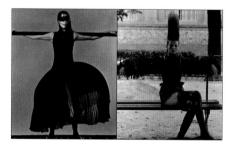

134 Mary Ellen Mark, Christian Bikers, Williams, Arizona, 1988
© Mary Ellen Mark
135 Mary Ellen Mark, Dublin, Ireland, 1991
© Mary Ellen Mark

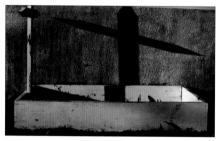

136 Lynda Churilla, Christian in the Keys, Florida, 1994
© Lynda Churilla
137 Mikael Jansson, Untitled, Dutch Magazine, Issue 18, 1998
© Mikael Jansson

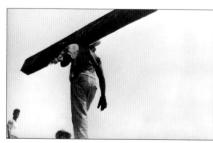

138-139 David Hockney, 3 Crosses by the Sea, Yorkshire, UK
1997 © David Hockney

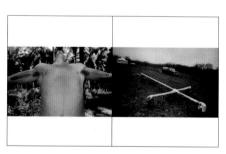

140 Steven Klein, Hannalore, 1999 © Steven Klein
141 Steven Klein, Bridget Hall: Fantasy Land, 1998 © Steven Klein

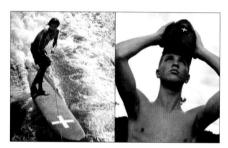

142-143 Didier Malige, Milan Cemetery '95 © Didier Malige

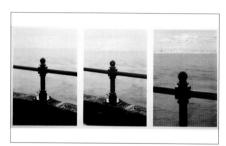

144-145 Tina Modotti, Trabajador Cargando una Viga, Mexico, c.1927
© Fototeca del INAH-SINAFO

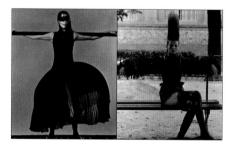

146 Kenny Nix, Mitchel's Wings, Costa Rica, 1998 © Kenny Nix
147 Mary Ellen Mark, KKK Homecoming, Pulaski, Tennessee, 1994
© Mary Ellen Mark

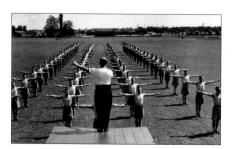

148-149 Photographer unknown, They Will Train the Militia, c.1940
© Hulton Getty

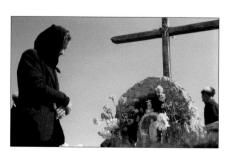

150-151 Jacques-Henri Lartigue, Bergalla, Italy, 1956
© French Ministry of Culture-France/AAJHL

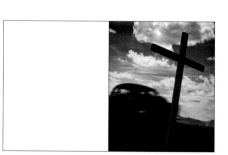

153 Andreas Feininger, Cross Near Site of Highway Accident,
Arizona, 1953 © Andreas Feininger/Life Magazine
Courtesy Center for Creative Photography, The University of Arizona

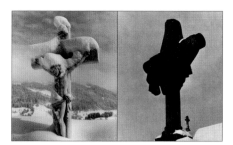

154 Horst, Kitzbühel, Austria, 1951 © Horst
Courtesy Staley-Wise Gallery
155 Jacques Du Bois, from Photographie, 1940
© Jacques Du Bois

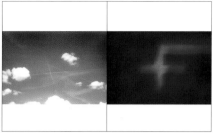

156 Martien Mulder, On the Way to the Beach, near Amsterdam,
Holland, 1998 © Martien Mulder/NEL
157 Masha Ann Calloway, Montreuil, France, 1998
© Masha Ann Calloway

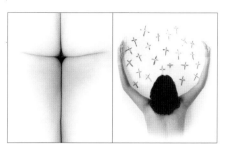

158 Erwin Blumenfeld, In hoc signo vinces, New York, 1967
© Blumenfeld Estate
159 Marta Maria Perez Bravo, Viven Del Cariño/They are Nurtured
by Affection, Monterrey, Mexico, 1994 © Marta Maria Perez Bravo
Courtesy Throckmorton Fine Art, New York

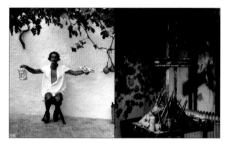

160 Photographer unknown, A Day with Salvador Dalí, 1955
© Hulton Getty
161 Linda McCartney, Bacon's Easel, 1997
© The Estate of Linda McCartney

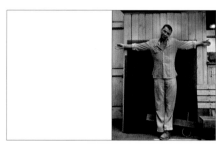

163 Phil Stern, Frank Sinatra, Date unknown © Phil Stern

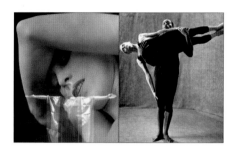

164 Imogen Cunningham, Martha Graham 2, 1931
© 1974 The Imogen Cunningham Trust
165 Frank W. Ockenfels III, Bill & Arnie, Date unknown
© Frank W. Ockenfels III. Courtesy Robert Longo

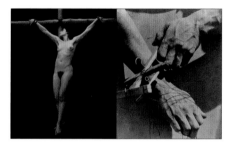

166 Annie Leibovitz, Diamond Galas, 1991
© 1999 Annie Leibovitz/Contact Press Images
167 Tina Modotti, Hands of the Puppeteer, 1926
Courtesy The Minneapolis Institute of Arts

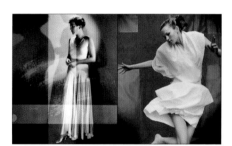

168 Man Ray, Publicité pour Bergdorf Goodman, 1930
© 2000 Man Ray Trust/Artists Rights Society, NY/ADAGP, Paris
169 Regan Cameron, Cross, 1998 © Regan Cameron

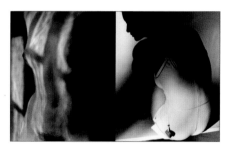

170 Edward Weston, Nude, 1920
© 1981 Center for Creative Photography, Arizona Board of Regents
171 Horst, Courrèges Bathing Suit, 1978 © Horst
Courtesy Staley-Wise Gallery

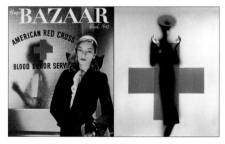

172 Louise Dahl-Wolfe, Lauren Bacall, 1943
Courtesy Harper's Bazaar
173 Erwin Blumenfeld, Model Standing Behind the Red Cross, 1945
© 1945 Vogue/Condé Nast Publications, Inc

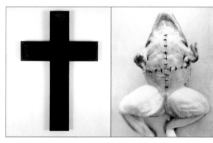

174 Robert Mapplethorpe, Blue Cross, 1983
© The Estate of Robert Mapplethorpe. Used by permission
175 Carlton Davis, Frog, 1998 © Carlton Davis

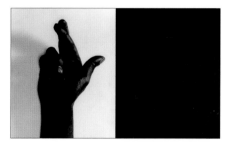

176 Nadav Kander, Mr. Fay's Hand, 1991 © Nadav Kander
177 Len Prince, Square Cross, Paris Cemetery, Paris, 1997
© Len Prince

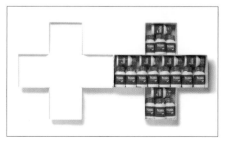

178-179
François Nars, The Cure, 1998
© François Nars

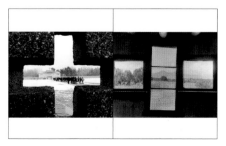

180 Reinhard Krause, Sachsenhausen Concentration Camp,
Germany, 1998 © Reinhard Krause/Reuters/Archive Photos
181 Janet Russek, Blackie's Living Room Window, Ghost Ranch,
New Mexico, 1991 © Janet Russek
Courtesy Scheinbaum & Russek Ltd., Santa Fe, New Mexico

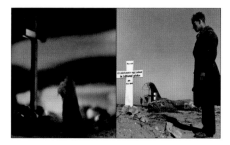

182 Clarence Sinclair Bull, Edwina Booth: Easter, 1931
Courtesy Keith de Lellis Gallery
183 George Rodger/Magnum Photos,
Western Desert, World War II, Africa, 1941
© George Rodger/Magnum Photos

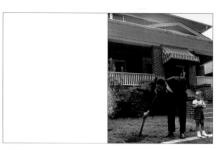

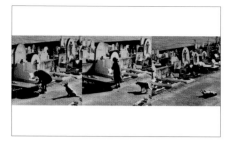

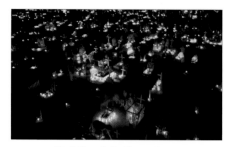

185 Photographer unknown, Cross Burning in Atlanta, Georgia, 1960
© Corbis-Bettmann. Courtesy UPI

186-188 Elliott Erwitt/Magnum Photos, St. Tropez, France, 1979
© Elliott Erwitt/Magnum Photos

190-191 Bruno Barbey/Magnum Photos,
Cemetery at Night on All Souls' Day, Manaus, Brazil, 1966
© Bruno Barbey/Magnum Photos

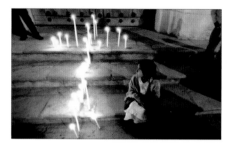

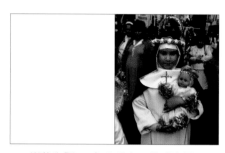

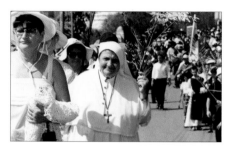

192-193 Larry Towell/Magnum Photos, Mexico, 1995
© Larry Towell/Magnum Photos

195 Martin Fishman, Sunday Madonna, New York, 1985
© Martin Fishman. Photographer represented by Private Eye Noir
Arts Ltd., New York

196-197 Jim Hollander, Easter, Jerusalem, Israel, 1993
© Jim Hollander/Reuters/Archive Photos

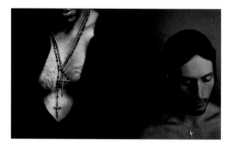

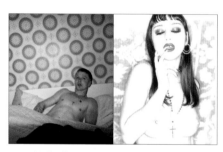

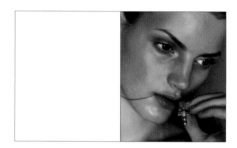

198 Herb Ritts, Bruce Springsteen, Detail I, New York, 1992
© Herb Ritts
199 Carlton Davis, 1998 © Carlton Davis

200 Nan Goldin, Warren in Bed, 1978 © Nan Goldin
201 Ellen von Unwerth, Vanessa, 1997 © Ellen von Unwerth

203 Michael Thompson, Untitled, 1995
© Michael Thompson

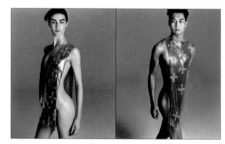

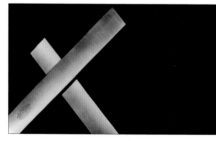

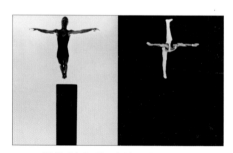

204 Richard Avedon, Erin O'Connor in Mesh Dress by Versace, 1997
© Richard Avedon
205 Richard Avedon, Sebastian Kim in Mesh Toga by Versace, 1997
© Richard Avedon

206-207 Edward Quigley, Disston Steel Knife, c.1958
Courtesy Keith de Lellis Gallery

208 Flip Schulke, Diver Joel Lenzi, Date unknown
© Flip Schulke. Courtesy James Danziger Gallery
209 Flip Schulke, The Gymnast, Date unknown
© Flip Schulke. Courtesy James Danziger Gallery

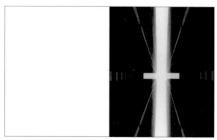

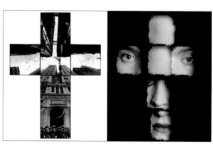

211 Sean Ellis, London Council Estate, 1998 © Sean Ellis

212 Jeffrey S. Kane, New York City Desert Storm Victory Parade,
New York, 1991 © Jeffrey S. Kane
213 David Seidner, Cross, 1986 © The Estate of David Seidner

Back Cover: François Nars,
Untitled, 1998 © François Nars

ACKNOWLEDGMENTS

Thanks, first, and most importantly, to all the independent photographers who donated
their photographs or who shot images specifically for this project,
and to all who contributed texts: Simon Doonan, Father Andrew Greeley, Patrick McCarthy,
Duane Michals, Bob Morris, and the estate of Robert Mapplethorpe.

I would also like to thank the photographic galleries, museums, archives, and historical
societies for all their support and their help in obtaining many beautiful images;
and for contributing their time to the wonderful cause to which my profits from this book
are being donated—the Elizabeth Glaser Pediatric AIDS Foundation.

Thanks to Raja from Color Edge, Jeffrey Kane from The Edge, and Chris Bishop from Bishop Studios.

I owe so much to my two wonderful assistants, Pam Sunshine and Milo Ritchey,
who worked forever on this book and without whom it would not exist.

Also to my publisher, Nicholas Callaway, for his instinctive belief in the beauty of the cross,
and to my editor, Antoinette White, always so helpful in her choice of great pictures.

And, finally, to my dear friend Sam Shahid, who, with his wonderful staff, Younie Kim
and Roger De La Rosa, designs the most beautiful books in the world.
You are not only a great inspiration to me, but you always make the book process a real pleasure!

CALLAWAY

64 Bedford Street, New York, New York 10014

Callaway and the Callaway logotype, and Callaway Editions, Inc., are trademarks.

Printed in China by Palace Press International

First Edition

10 9 8 7 6 5 4 3 2 1

Library of Congress cataloging-in-publication data available.

ISBN 0-935112-43-X

Visit Callaway at www.callaway.com

DATE DUE

MAY 0 9 2002

DEMCO, INC. 38-2931